PRINCETON
IMPRESSIONS

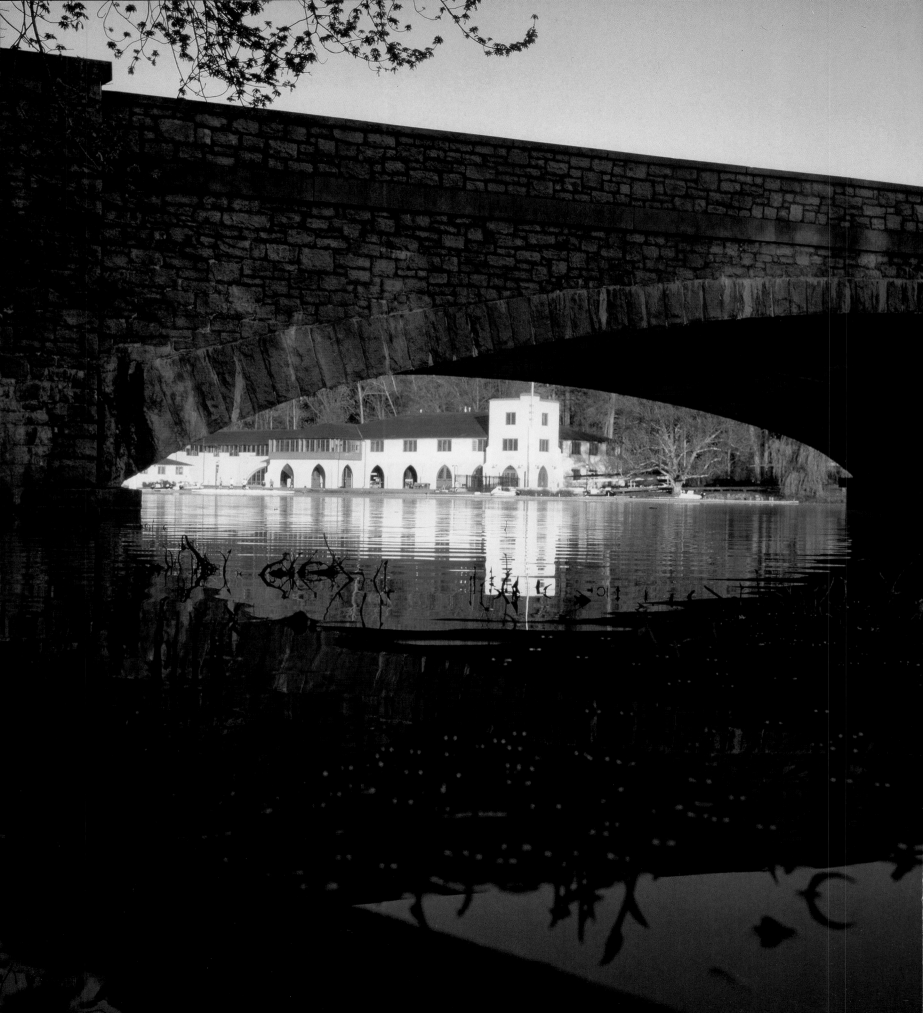

PRINCETON
IMPRESSIONS

Robert R. Gambee

additional photographs and editing by
Robert G. and Claire E. F. Gambee

Introduction by
Shirley M. Tilghman

W. W. NORTON & COMPANY

New York • London

For Phyllis Gregory Heard

Honoring her "little, nameless, unremembered acts of kindness and of love."

Publication of this book is made possible through the generosity and guidance of

Dennis J. Keller

Robert S. Murley, Clyde E. Rankin, III
and
Sarah Belk Gambrell

Library of Congress Cataloging-in-Publication Data

Gambee, Robert R.
Princeton impressions / Robert R. Gambee ; additional photographs and editing by
Robert G. and Claire E.F. Gambee ; introduction by Shirley M. Tilghman.—1st ed.
 p. cm.
ISBN 978-0-393-08306-4 (hardcover)
1. Princeton University—Pictorial works. 2. Historic buildings—New Jersey—
Princeton—Pictorial works. 3. Princeton (N.J.)—Pictorial works. 4. Princeton (N.J.)—
Buildings, structures, etc.—Pictorial works. 5. Princeton (N.J.)—History. 6. Princeton
(N.J.)—Biography. I. Gambee, Robert G. II. Gambee, Claire E. F. III. Title.
F144.P9 G36 2011
974.9'67–dc22 2011010020

Frontispiece: Early morning sunlight highlights the Shea Rowing Center, framed by
one of the arches of the Washington Road bridge.

Contents

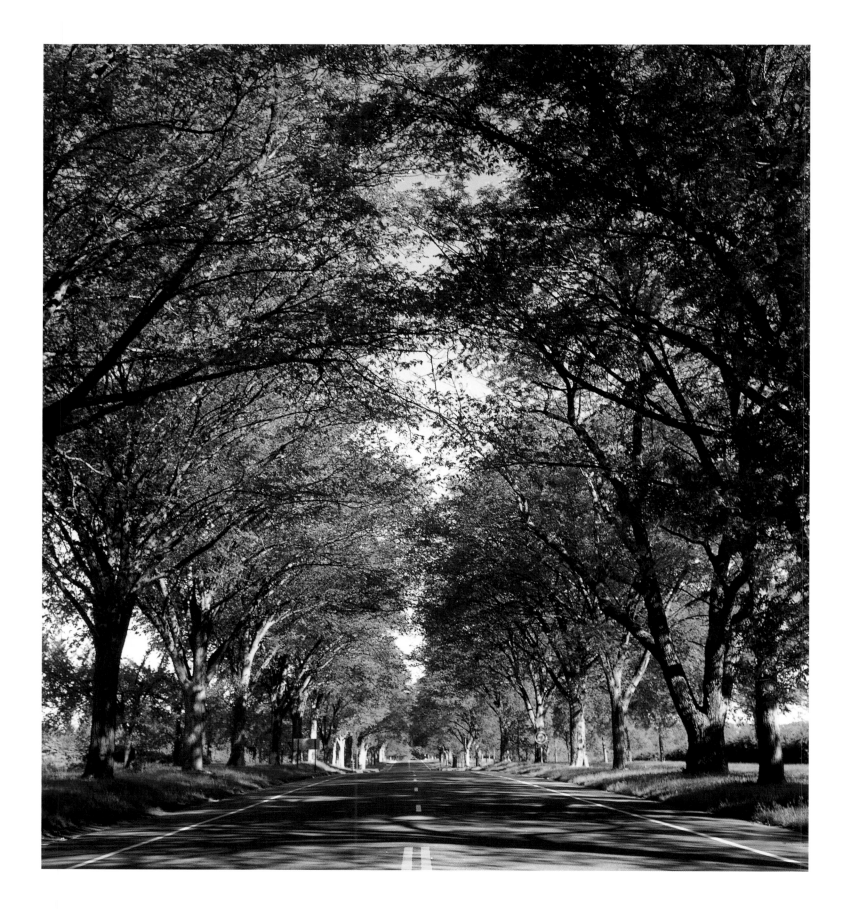

Introduction

The three Princetons—university, borough, and township—have changed significantly since the days of F. Scott Fitzgerald (Class of 1917), but they still retain much of the "lazy beauty" described in his autobiographical novel, *This Side of Paradise*, almost a century ago. Although our campus is more lively and its surroundings less bucolic than they were in the early 20th century, thanks to the growth of the university and the development of the Route 1 corridor, this superb collection of photographs affirms that much remains to please the eye and refresh the spirit of residents and visitors alike. Indeed, leafing through the pages of this volume, it is hard to dispute the excerpted words of Charles Thomson, secretary of the Congress of the Confederation, which met in Princeton in the summer and fall of 1783: "With respect to situation, convenience and pleasure, I do not know a more agreeable spot in America."

Princeton Impressions is the culmination of more than five years of assiduous camerawork in which Robert Gambee, a member of the Princeton Class of 1964, and his son and daughter, Robert and Claire—armed with vintage Rolleiflexes and a Nikon F-2—revisited the sites depicted in their first photographic tribute to the Princetons, published in 1987, as well as sites of newfound interest. Skillfully and affectionately, they have recaptured scenes that seem all but untouched by the passage of the years, while introducing others that reflect the constant flux to which all environments are subject. Joining photographs of iconic Nassau Hall, built in 1756, and the collegiate Gothic spires that made such an impression on Fitzgerald's literary alter ego, Amory Blaine, are images of recently erected buildings—from Frank Gehry's audacious Lewis Library to Demetri Porphyrios' monumental Whitman College, jointly reflecting the respect for tradition and commitment to innovation that define our institution.

Opposite: Beneath a canopy of century-old elms, Washington Road leads to Princeton's main entrance. From its initial ten acres on Nassau Street in the eighteenth Century, the university now holds approximately nine hundred acres.

Princeton University's human architecture has also undergone a substantial change between the publication of this volume and the previous one. As the ranks of our alumni have grown, new classes have stepped to the fore, but the camaraderie and institutional loyalty reflected in the Gambees' most recent Reunion photographs are as strong as ever, symbolized by the orange and black in which alumni of every generation bedeck themselves. Likewise, the books that filled the photographs of Firestone Library and other quiet corners of our campus in the earlier volume have now been joined by computers—a potent tool for students and faculty that may have transformed the *way* they carry out their research but not the *purpose* of this research, which is to acquire and create new knowledge that will, in time, enhance the lives of all.

While Princeton University is a major focal point of *Princeton Impressions*, Princeton borough and township and the nearby community of Lawrenceville are also well represented, as are the educational institutions, research centers, and corporate campuses that abound in the area. From The Lawrenceville School's venerable residence hall, Hamill House, built in 1814, to the contemporary facilities of Educational Testing Service, just down the road, this volume tells the story of many institutions and the communities from which they sprang. In doing so, it preserves a moment in time—today—while reaching back to the 18th century through the architectural heritage it documents. And one day, many years from now, it will itself form part of the historical record of the Princetons past.

Finally, *Princeton Impressions* is a testament to the art of photography and its power to hold our gaze; to capture different seasons and different times of day; to play with light and shadow and the reflective properties of water; to move with deceptive ease from entire streetscapes to architectural details that often pass unnoticed; and, above all, to evoke the extraordinary beauty—at once timeless and changing—in our midst.

Shirley M. Tilghman
President
Princeton University

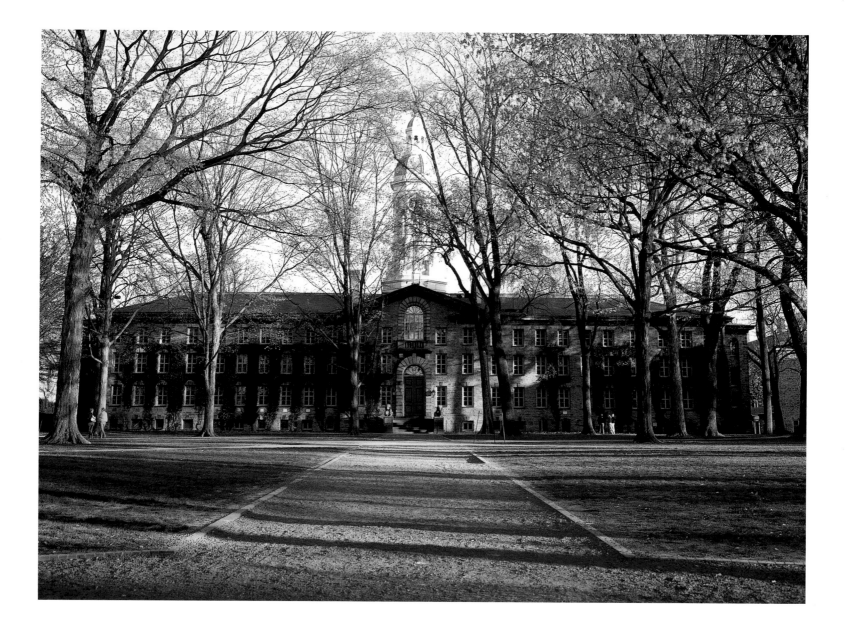

Nassau Hall (1756). This was the largest building in America when it was first built, and in 1783 it served as the capitol of the United States. Samuel Davies, fourth president of the college, is credited with raising the funds for its construction. In 1753 he sailed to England and had successful meetings with congregations and wealthy individuals from London to Edinburgh. His voyage to Europe took a customary six weeks. The return was three months, including a three-week layover in Plymouth (due to bad weather). At one point on the return, the captain admitted he was lost and the ship was in peril. When Rev. Davies finally arrived back in New York, with no one to greet him, he had to hire a horse to get back to Princeton. There were no coaches then. To this man who risked his life to obtain funds for this significant building we are all deeply indebted.

The next fundraising opportunity occurred in 1802 after a fire gutted its interior. The trustees turned to the preeminent architect at the time, Benjamin Latrobe, for the work. This time the town was among the first to contribute—in part because it feared the college might move elsewhere after its only major building was effectively destroyed. Latrobe made certain fireproofing modifications, including brick floors instead of wooden ones and stone stairs with iron railings. John Notman continued the fire-prevention trend after another fire in 1855. He also added the prayer room at this time.

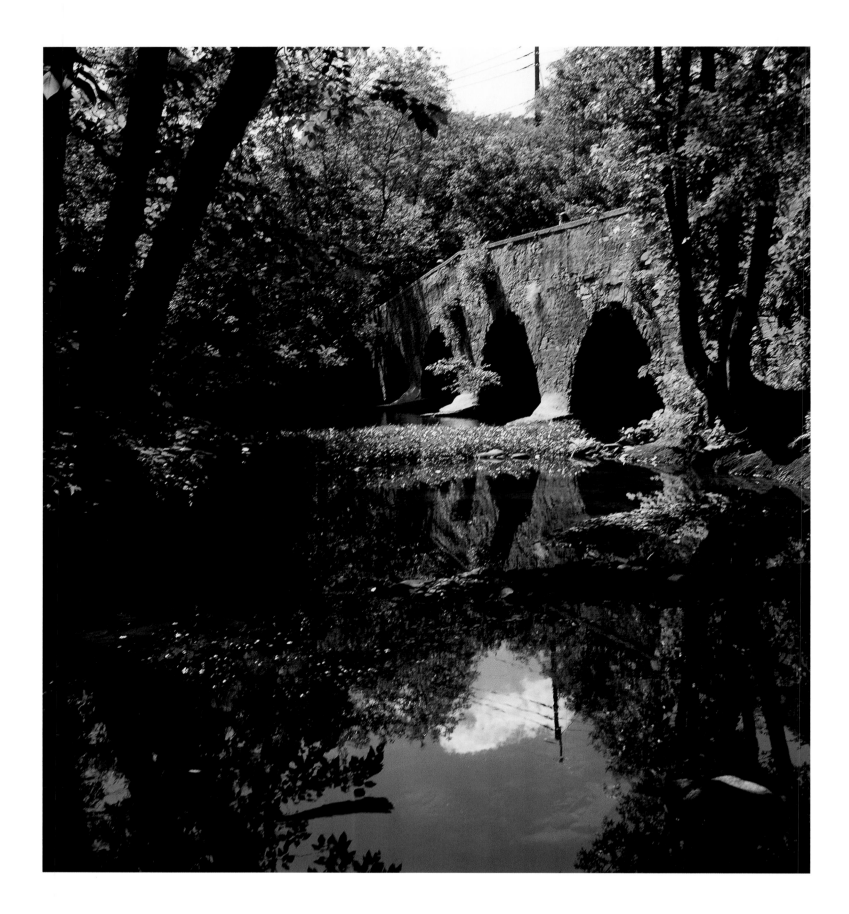

The History of Princeton

Although the town of Princeton was settled in the late 1600s, its name was not adopted until 1724. It was named in honor of William III, King of England and Prince of Orange-Nassau. The original settlement was located along Stony Brook on land William Penn had purchased earlier. When he decided to concentrate on his land west of the Delaware River, another Quaker, Richard Stockton, purchased properties between Stony Brook and the Millstone River in 1695. Shortly afterwards, Benjamin FitzRandolph purchased 316 acres along what is now Washington Road, some of which became the site of the College of New Jersey. The first industry came in the early 1700s, when Thomas Potts built two gristmills and a bolting mill at Stony Brook. The remains of one of the mills may be seen today at the edge of the Stony Brook Bridge. The earliest surviving structure, "The Barracks," was built around 1696 as part of Richard Stockton's home. Over the years, as the agrarian economy developed, the original style of the simple buildings along Stockton Street was expanded into a grander manor house style. Richard and Annis Stockton set a new standard in the third quarter of the eighteenth century when they built "Morven," a handsome example of the new Georgian style that was evolving in the colonies. This style of architecture, which derives from the late sixteenth-century architect Palladio, was popularized in England by Christopher Wren. It was enthusiastically adopted in America during the early 1700s due to its purity of style, its symmetry, and the spaciousness of its living areas.

At the same time that Princeton was growing in self-image, the College of New Jersey was looking for a new location. It had been conducting its classes in the front parlor of Jonathan Dickinson's home in Elizabethtown. Although both New Brunswick and Elizabeth were vying to be chosen as the new location of the young college, the Presbyterian Synod of Philadelphia thought that a location equidistant from New York

Opposite: Kingston Bridge (1798). Until recently, it handled all traffic, including buses and trucks, arriving at Princeton from the east. George Washington ordered the destruction of the first bridge in 1777 after retreating to Morristown. This was in order to impede General Cornwallis after the Battle of Princeton. The south side of the bridge contains a stone marker at its midpoint. It reads, "45 M. to Phi 50 M. to N.Y. 1798."

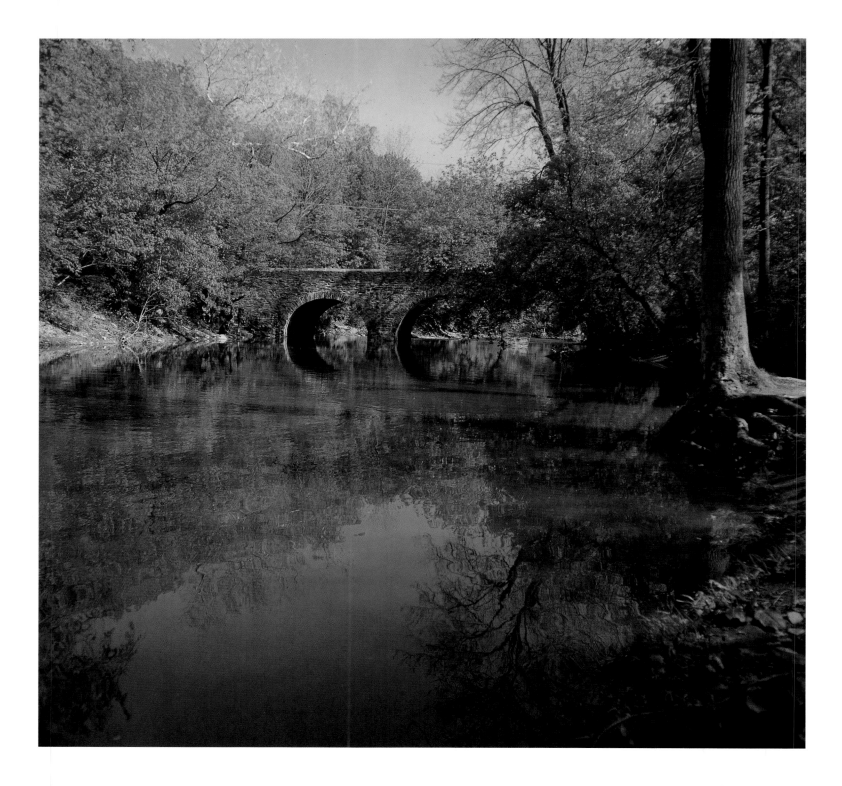

The graceful arches of the Stony Brook Bridge, built in 1792, carry most of the traffic entering Princeton from the west along what is now Stockton Street. This bridge replaced a wooden bridge that the American troops destroyed during the war in order to thwart the British. The stone sign embedded in the bridge indicates it is "40 Miles to Phila. 56 Miles to N. York." Originally settled in the late 1600s, Princeton retains many rural qualities and traditional colonial houses.

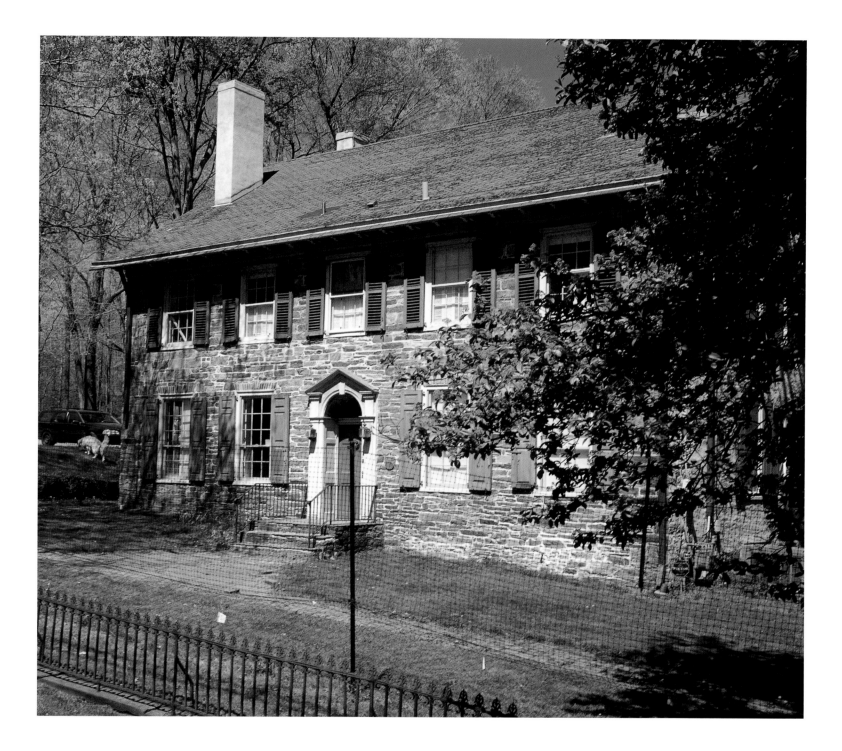

The Worth-Bruere House (ca. 1812) (front section). The house is located next to Stony Brook on Stockton Street, adjacent to the bridge. It was initially built by Joseph Worth, and a relative, Bruere, later inhabited it. In 1696 the first businesses came to Stony Brook, which was the name used by the community until well after 1724, when "Princeton" was adopted for the area. A miller from Philadelphia, Thomas Potts, established two gristmills and a bolting mill on the river. These properties came into the Worth family, which operated one of the mills for almost two hundred years, a remarkable feat. Joseph Worth was one of the founders of the Meeting of Friends at Stony Brook.

and Philadelphia might be advisable. Thus, when the college considered either New Brunswick or Princeton as final possibilities for its location, it stipulated that whichever community where it would relocate must provide ten acres of cleared land, two hundred acres of woodlands for fuel, and £1,000 in New Jersey currency. A group of citizens of Princeton, under the leadership of Nathaniel FitzRandolph and John Sergeant, announced to the college's trustees in January of 1753 that they had met the requirements. The town was selected, and construction of a new college building began the following year. Upon its completion in 1756, it was the largest building in the colonies. It was originally to be named in honor of Governor Jonathan Belcher, who mercifully declined the suggestion and said it should be named for King William III, Prince of OrangeNassau.

During the early years of the Revolutionary War, the Battle of Princeton was the first major victory for the Americans. It is believed to have been a significant shift in the war effort. The battle took place on January 3, 1777, after Washington had quietly carried out an end run around Lord Cornwallis and cut off his supply column. After the war, the Continental Congress moved to Nassau Hall from Philadelphia because it did not have enough funds to pay the wages of the troops and there was fear of mutiny. In fact, the Pennsylvania militia had surrounded the statehouse (Independence Hall). Congress appealed in vain to the governor of Pennsylvania for a guarantee of safe passage out of the city. Elias Boudinot suggested the move to Princeton because of its equidistance from Philadelphia and New York and the sanctuary offered by Nassau Hall, as well as the ability of the governor of New Jersey to offer a guarantee of safe passage. The haven provided by the village of Princeton enabled the legislators to focus on the future of the newly formed United States of America.

Since these early days, the town and the university have grown together, each benefitting from the presence of the other.

Opposite: Early morning sunrise on the Princeton Battlefield. All is quiet now.

Princeton Battlefield was the location of a strategic victory for George Washington over the troops of Lord Cornwallis, which many consider a turning point in the Revolution. After marching through New Jersey, Cornwallis felt confident that his troops would defeat Washington's ill-equipped army. Poised to confront the Americans, Cornwallis stopped a short distance from the American camp on a bitter January evening in 1777. The British were stunned to find that the entire American force had disappeared by daybreak. Within the hour, the Americans launched a surprise attack on their enemy from behind. Historians now view the Battles of Princeton and Trenton as brilliant displays of strategy that enabled a general with vastly outnumbered forces to defeat a formidable opponent. By the end of the day, Washington had recaptured Nassau Hall, the first significant American victory in the Revolution.

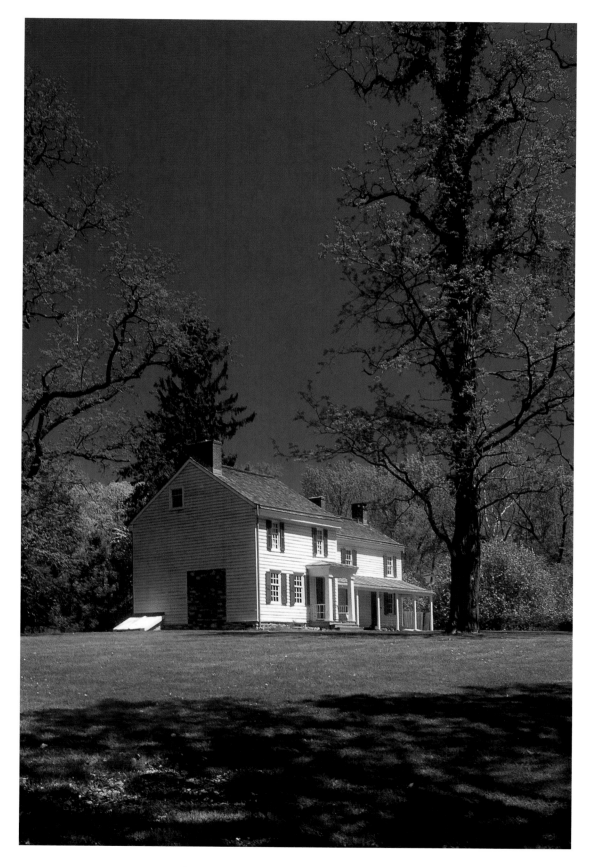

The Thomas Clarke House (ca. 1770). The land on which this house was built had been owned by the Clarke family since 1696. This two-story clapboard home has six rooms. It faced south onto a back road that was used by General Washington's troops but is no longer in existence. The Princeton Battlefield is behind it.

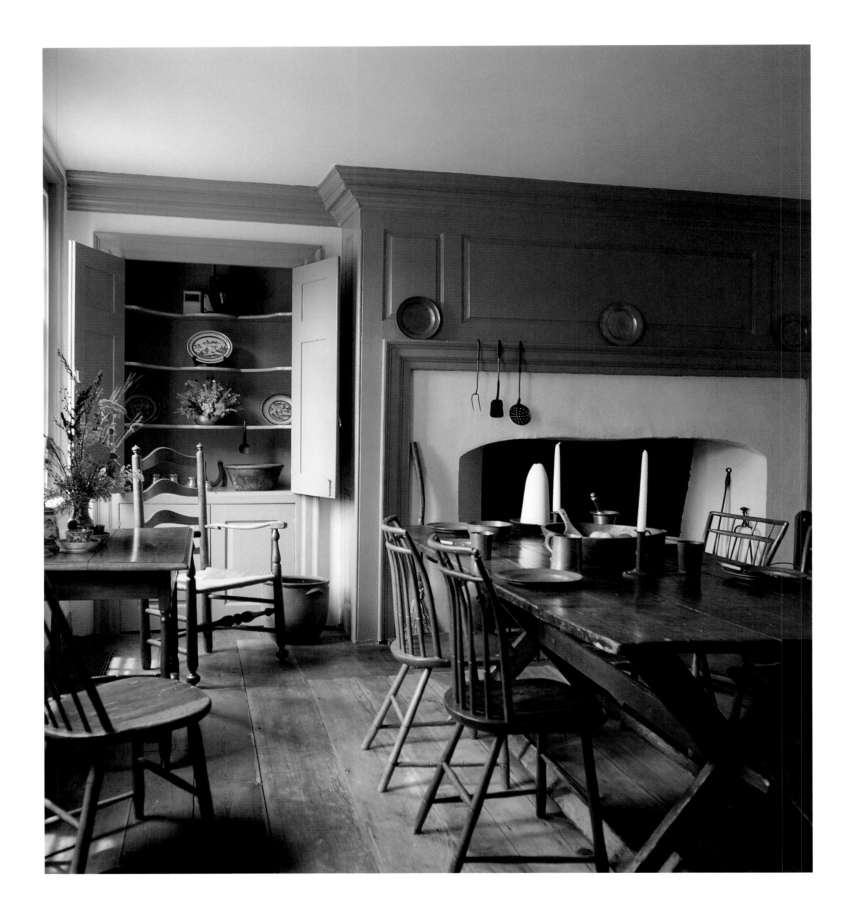

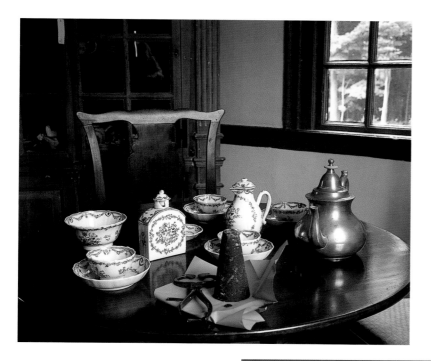

This page and next: Interior views of "Rockingham" include the tea room *(left)* and the main sitting room *(below)*. The tea room was intended for light refreshment when entertaining and as a space where the ladies could retire at the end of dinner, served midday.

Below: A suggested midday dinner meal features roast turkey, Brussels sprouts, and cauliflower. The tableware indicates this is an upper-class household.

Opposite: The keeping room of the Clarke House features a massive fireplace and a built-in butterfly cupboard. Birdcage Windsor chairs surround the substantial table, which displays a sugar loaf. Refined sugar was molded into loaves for transport and imported from the West Indies to the American colonies at a high price. This land was the site of a successful skirmish in which General Washington confronted the British troops. General Hugh Mercer was also instrumental and died of battle wounds in the Clarke homestead. The Americans successfully recaptured the town of Princeton and, subsequently, most of New Jersey.

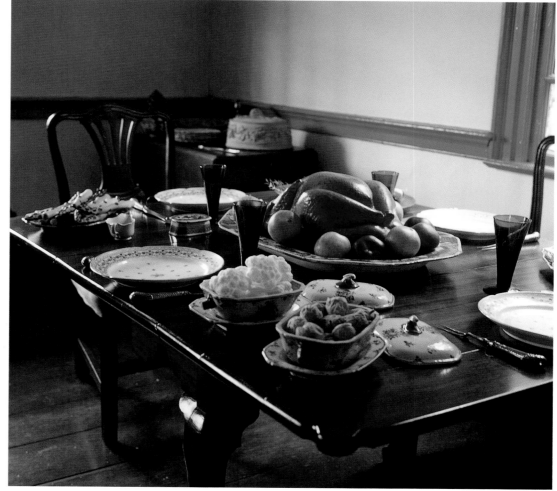

"Rockingham" (ca. 1710, 1764, early 1800s), originally located north of Princeton in Rocky Hill. It now sits in Kingston after being moved in 2001. In 1783, when Congress was meeting in Princeton, this farm homestead was rented from the widow of Judge John Berrien, who had been a New Jersey Superior Court justice, for use by General George Washington, his wife, and staff. The home became Washington's final wartime headquarters, as the Treaty of Paris was formally signed at the time he was in residence here, and this is where he wrote his *Farewell Orders to the Armies*. The parts that are original to the period when Jedediah Higgins built the oldest section bear a resemblance to early Connecticut homes, with gunstock corner posts that are flared to withstand the weight of structural beams.

The main bedroom displays a New Jersey wing chair and a trundle bed, which allowed a better use of space.

The Washingtons entertained during their time at "Rockingham," while also maintaining the home as the commander in chief's headquarters. They would have had members of Congress, prominent citizens of the area, other military personnel, and dignitaries visiting for dinner or other amusements (possibly cards, music and dancing, and conversation) in this room, the main space for entertaining in the Berrien home.

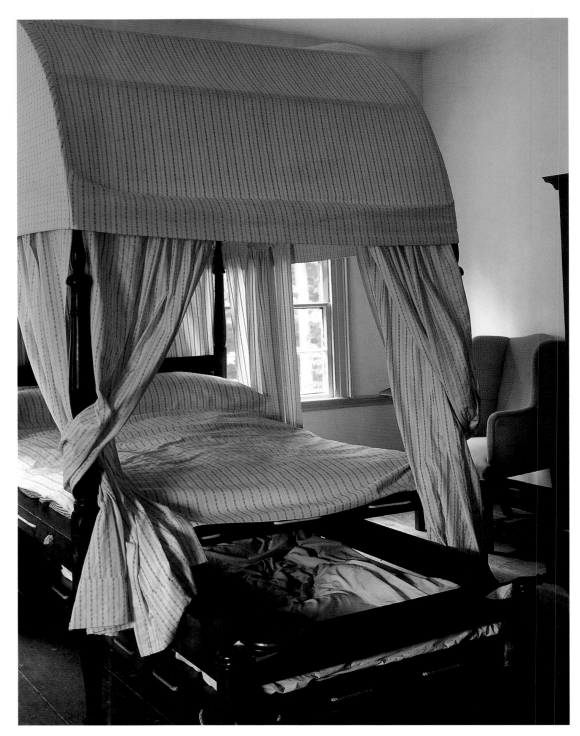

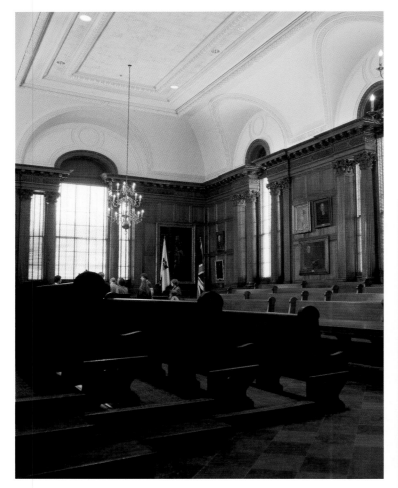

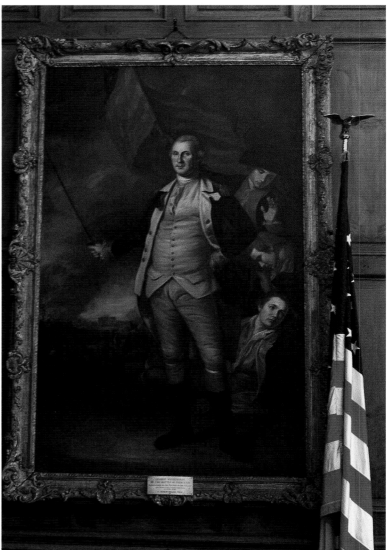

The Prayer Room of Nassau Hall. In 1783 the Continental Congress fled Philadelphia to escape a possible mutiny of American troops over the wages it was unable to pay. Because Nassau Hall was the largest stone building in the colonies, Princeton was selected as the capitol of the United States.

During this time, the trustees of the College of New Jersey persuaded Washington to sit for a portrait by Charles Willson Peale, who created one of the few renderings of him ever painted from a live sitting. This room was severely damaged by two fires in the nineteenth century and has been rebuilt and expanded. Under Woodrow Wilson it became the Faculty Room and now serves as a faculty and trustee meeting space.

The Princeton Battle Monument. This represents seventy-five years of endeavor by the citizens of Princeton, including Allan Marquand and Bayard Stockton. The design is by Thomas Hastings and the sculpture by Frederick Mac-Monnies, a Brooklyn-born artist working in Paris. It was unveiled in 1922 by President Warren Harding. It depicts George Washington on horseback, refusing initial defeat at the Battle of Princeton of January 3, 1777, and encouraging his troops to ultimate victory. Dean West of the Princeton Graduate School supplied the following inscription:

Here memory lingers
To recall
The guiding mind
Whose daring plan
Outflanked the foe
And turned dismay to hope
When Washington
With swift resolve
Marched through the night
To fight at dawn
And venture all
In one victorious battle
For our freedom.

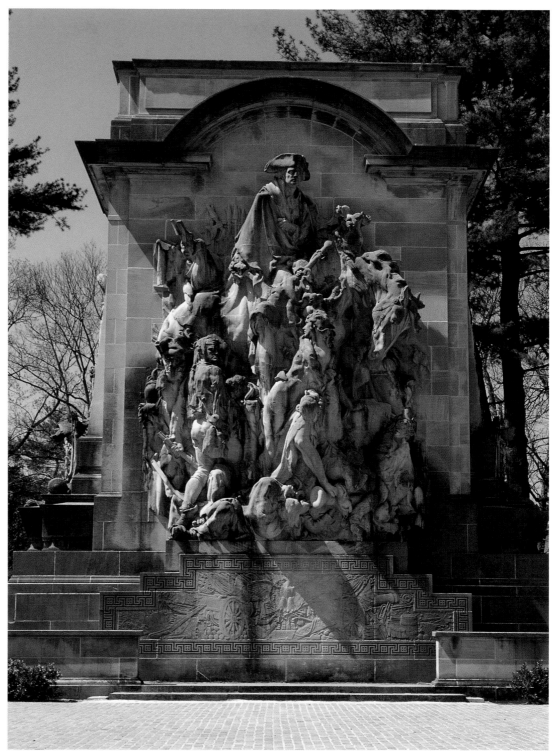

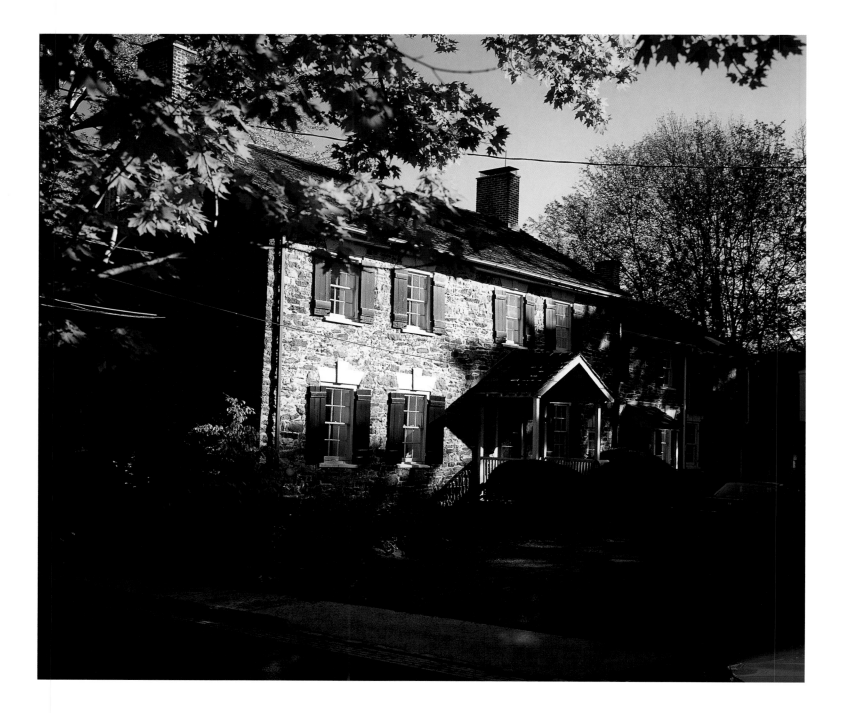

"The Barracks" (ca. 1696), 32 Edgehill Street. This is the oldest house in Princeton, built by Daniel Brinson and subsequently inhabited by Richard Stockton. The Stocktons moved from Long Island to the rich farmland of central New Jersey. Richard Stockton bequeathed the house to his son, John, whose own son, also named Richard, was a signer of the Declaration of Independence and lived at "Morven." The name of the house indicates it may have been used to quarter British troops during the French and Indian Wars. From 1689 to 1763 there were frequent conflicts between the United Kingdom and France over control of the American territory. In the 1760s the Stocktons sold the property. One of its subsequent owners was Thomas Lawrence, who is believed to have accommodated Alexander Hamilton, the delegate from New York, when Congress met in Princeton.

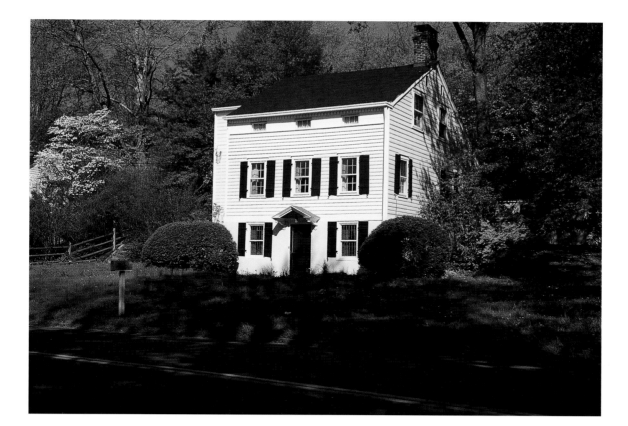

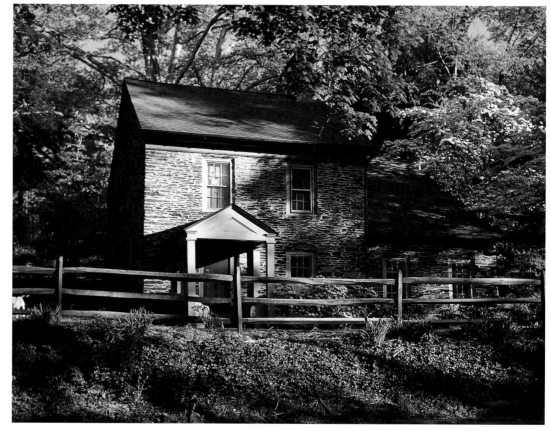

487 (*above*) and 481 (*left*) Stockton Street. These prerevolutionary homes are located in the original settlement of Stony Brook. The land is part of a section purchased by Benjamin Clarke from Thomas Warne in 1696. These homes were built near the brook, which supplied the houses and livestock with water until a well was created. Number 487 has been determined to be the older of these houses. It displays an unusual three-story design. As the land was cleared, stones were brought in to construct the house. Next door, number 481 was built on the foundation of the barn for number 487.

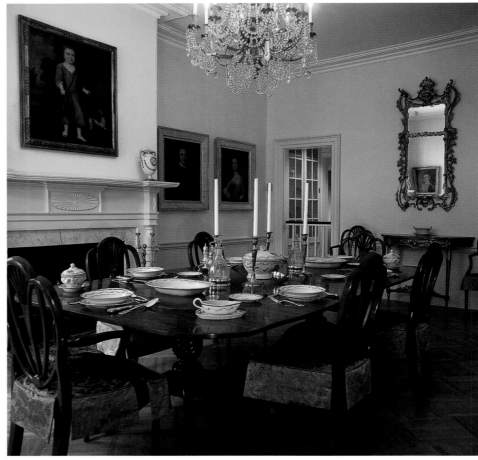

55 Stockton Street (ca. 1755, 1848), commonly known as "Morven." This was built by Richard Stockton, a signer of the Declaration of Independence. It is named after the mythical home of Fingal in *The Poems of Ossian*. The formal, elegant, and sophisticated Georgian style reflected the ideas of the Age of Enlightenment, when man was thought to be capable of bringing order to society and considered independent of the whims of nature and God. This house has had many additions over the years. The impressive entry hallway afforded privacy to the surrounding rooms, including the formal dining room. "Morven" was held to be the most distinguished of Princeton's houses and housed the governors of New Jersey for many years. Richard Stockton, a member of the first graduating class of the College of New Jersey (1748), was asked by the trustees to invite John Witherspoon to become president of the college. Stockton was also a delegate to the Continental Congress in 1776. During the war his wife, Annis Stockton (née Boudinot), buried the family silver to prevent the possibility of its being melted down for money. After the war and her husband's untimely death, she and her brother, Elias Boudinot, continued to welcome visiting congressmen and their families here.

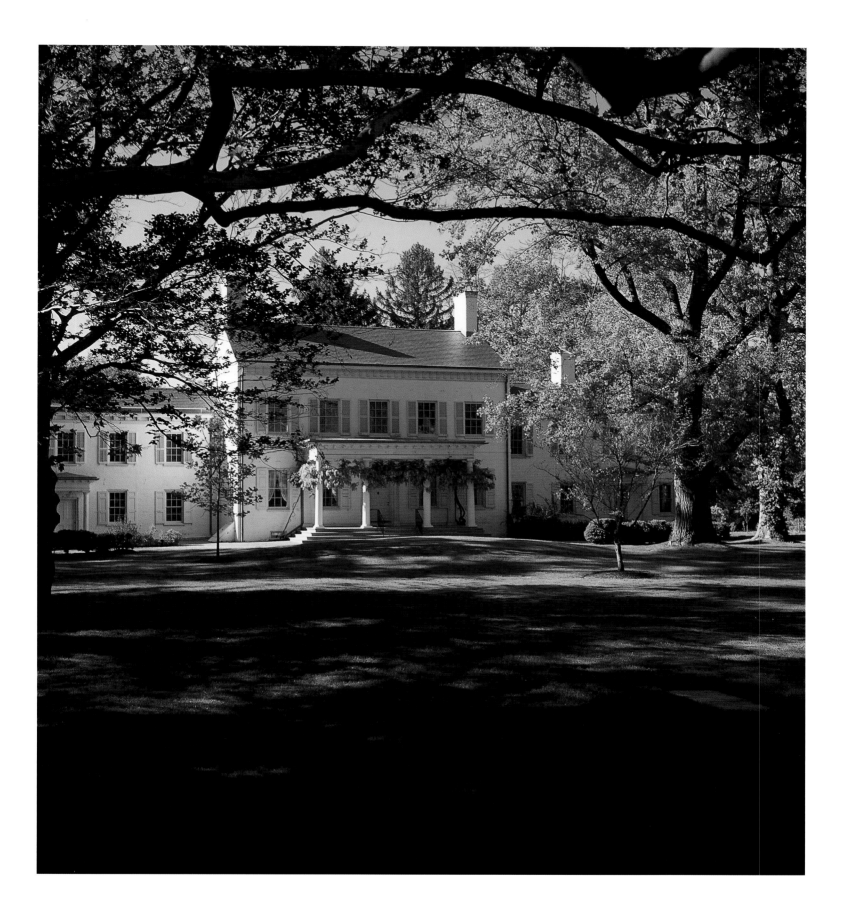

"Tusculum" (1773) was built by John Witherspoon on Cherry Hill Road. Witherspoon was the sixth president of the College of New Jersey, from 1768 until 1794. He helped create a new constitution for New Jersey, became the state's spokesman at the Continental Congress, and signed the Declaration of Independence. He was revered for increasing both the enrollment and endowment of the college. He assured its success as a viable institution by providing it with a solid financial foundation. The house was built in the country Georgian style and is named after an ancient summer resort where the Romans had summer villas. Also on the land is a stone barn, built around 1838. The expanded sitting room at the back of the house shows the original exterior wall, built with local stones and heavy mortar as was traditional in this part of New Jersey.

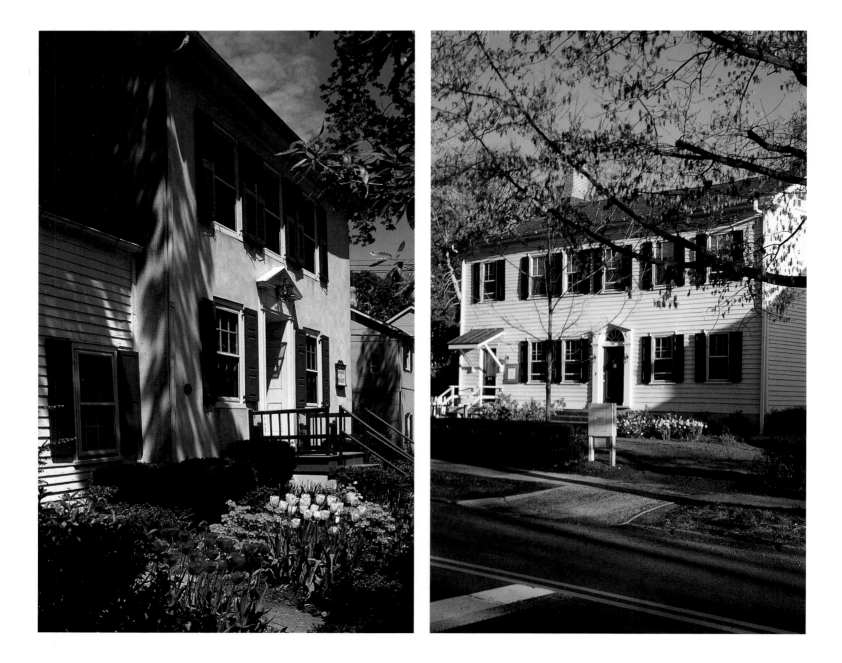

342 Nassau Street (ca. 1730), also known as the Scott House. The wing on the west side was originally on the opposite side but was moved when Harrison Street was widened. During the stay of the Continental Congress, Mrs. Scott offered lodgings to the delegates. Later it is thought to have been a stop on the Underground Railway.

338 Nassau Street. This Federal-style house is believed to have been built between 1810 and 1830. It is located to the west of the house in the adjacent photograph. The left section of the house may have been added later, giving it a six-bay appearance and a second entrance.

"Queen's Court," 341 Nassau Street, was built by Mahon Taylor around 1784 and expanded by John Harrison after he bought the house in 1804. The name refers to a girls' preparatory school that was housed at this location in the nineteenth century. The girls were preparing for Evelyn College, which was established in 1887 to be the all-female counterpart of Princeton University. Evelyn College lasted ten years. Queenston, which was the area between Kingston and Princeton, lay at the intersection of Nassau and Harrison Streets. It had become known as "Jugtown," after the potteries that operated here between 1760 and 1860. The clay deposits were located on Harrison Street.

Above: 333 Nassau Street. This house is believed to have been built around 1830 and has simple Charles Steadman proportions. It is the site of one of the first potteries in "Jugtown." Later the land was owned by the Hamilton family. Samuel R. Hamilton was an alumnus of the College of New Jersey and later became the mayor of Trenton. The Hamiltons were a prominent family in Princeton during the nineteenth and twentieth centuries.

Right: 298 Nassau Street (ca. 1830). This is certainly of a Charles Steadman design. Steadman designed numerous Greek Revival residences in the Princeton area during the 1830s, many of which are located on Alexander Street. For the smaller residences, he favored a three-bay design with an entrance in the first or third bay and a blend of Federal and Greek Revival ornamentation.

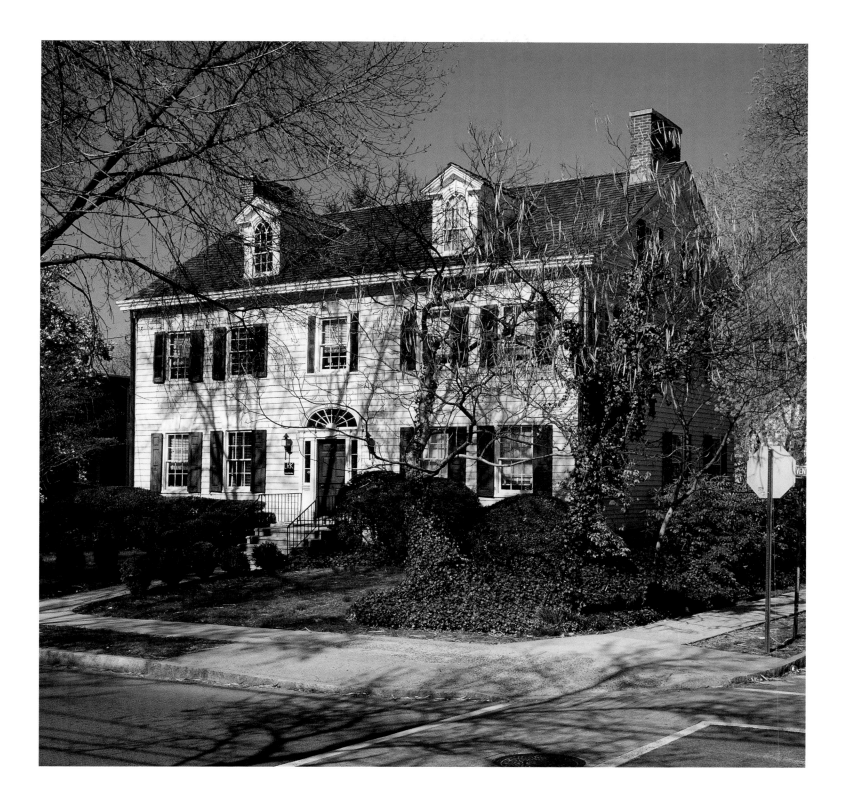

Beatty House, 19 Vandeventer Avenue, was built by Colonel Jacob Hyer around 1780. In 1816 Colonel Erkuries Beatty purchased and expanded the house. He was a former aide of the Marquis de Lafayette, who stayed here in 1825. The house was moved from where it originally stood during the Revolution and where Firestone Library now stands.

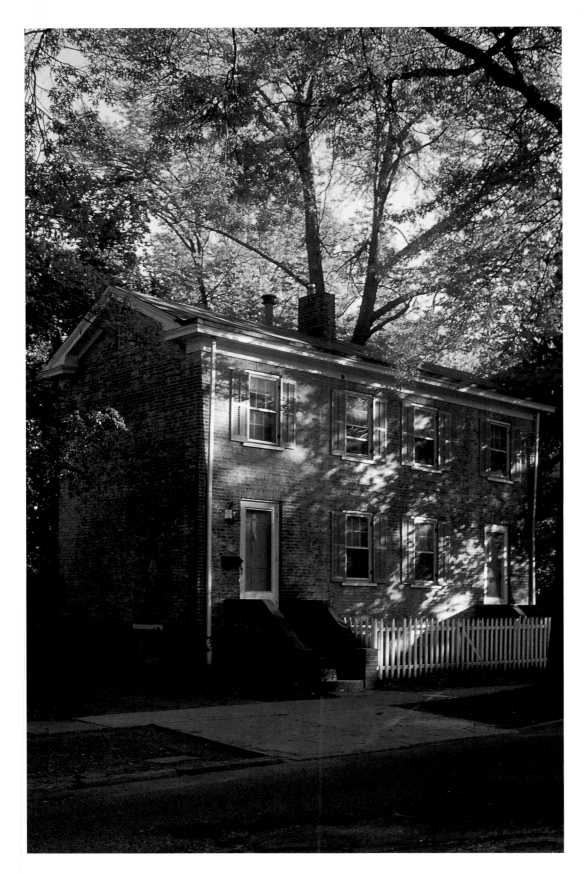

Left: 325 Nassau Street, believed to be a prerevolutionary home from around 1750. It is one of the few all-brick houses of the period; most of the others are constructed of fieldstone or clapboard. It is believed that the modest scale of this double house is more typical of the period than that of others that have survived.

Opposite above: 274 Nassau Street (ca. 1820). Note the unusual triangular lintels over the windows and the delicate portico. This is a refined design predating the Greek Revival style of Charles Steadman and his followers.

Opposite below: 159 Nassau Street is one of the earliest homes in the area, dating from about 1763. The plain style seems almost Quaker in design. There were about one hundred houses in Princeton by the end of the eighteenth century, many located on small lots close to the street and to each other, giving the feeling of a small village. Houses were often set high on their foundations.

Albert Einstein House. One of the most famous houses in the community is this modest one at 112 Mercer Street, built in 1840 by Samuel Stevens. Albert Einstein lived here when he was a distinguished member of the faculty at the Institute for Advanced Study from 1935 to 1955. On his first visit to Princeton University in April of 1921, he said, "Raffiniert ist der Herrgott, aber boshaft ist er nicht" (Subtle is the Lord, but malicious He is not).

Woodrow Wilson House, 72 Library Place. The Wilsons lived here beginning in 1890. It was considered to be one of Charles Steadman's finest designs when completed in 1836, due to its pleasing proportions and attention to fine detail throughout. Note the second story center window complementing the entrance. It was originally called "The Ridge" after its first owner, John Breckenridge of the Princeton Theological Seminary.

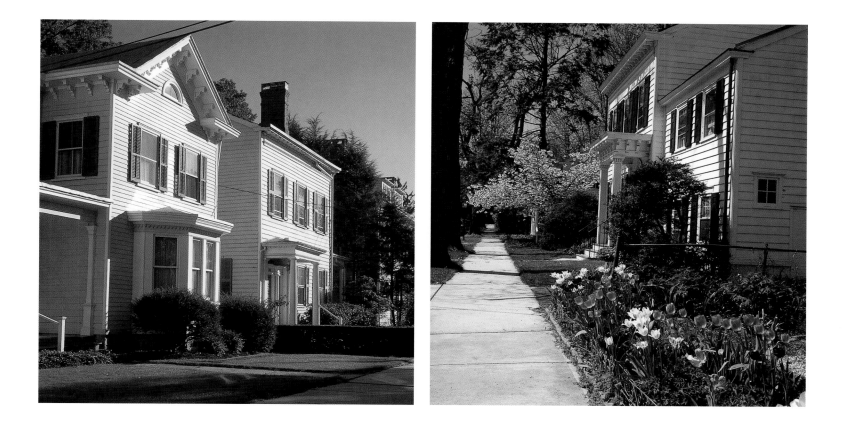

Greek Revival houses built by Charles Steadman on Alexander and Mercer Streets. *Above, left:* 34 and 36 Mercer Street. Two attractive houses from the 1830s are basking in the afternoon sun on the east side of Mercer Street. Note the accentuated gable of the house on the left, framing a small half-round window that serves to exaggerate the massive detailing. It was built in the 1820s and was owned by Charles M. Campbell, a carriage maker. In 1870 a larger addition was made with the gable end facing the street. The addition of the front porch and the heavy brackets on the gable completed this Italianate transformation.

The house on the right is of more modest detail, yet it has an additional bay. It was built in the 1830s by Charles Steadman for James S. Green.

Above, right: When Alexander Street was opened in 1832, it was originally called Canal Street. It was renamed in honor of Rev. Archibald Alexander, the first professor of the seminary. Steadman's designs represent Princeton's earliest and best examples of cohesive urban design.

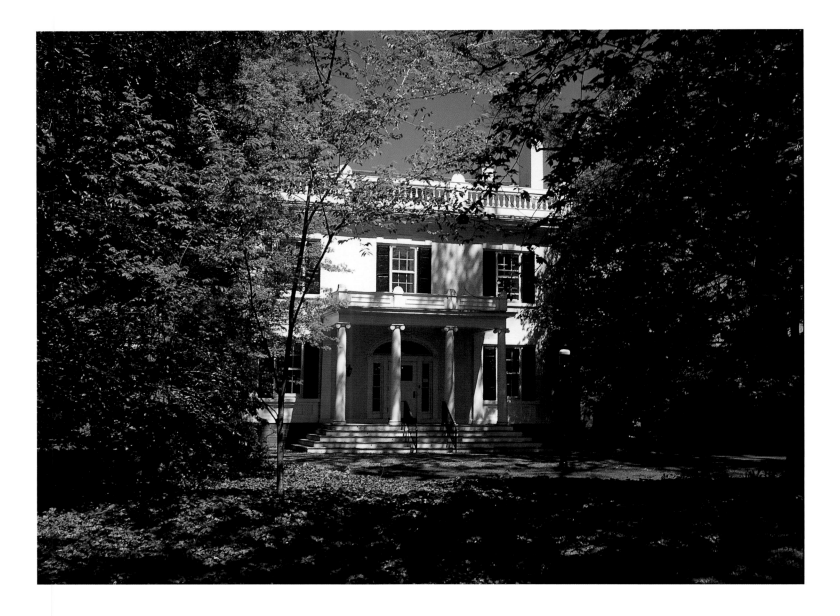

Above: Palmer House, 1 Bayard Lane. This Greek Revival residence was built by Charles Steadman in 1825 for Robert Field Stockton. In 1923 Edgar Palmer, class of 1903, moved into the house. He was a Charter Trustee and donor of Palmer Stadium in 1914. His greatest gift to the community was the tastefully designed Palmer Square, located down Nassau Street from his home.

Opposite: Sheldon House (ca. 1840), 10 Mercer Street. The Rev. George Sheldon inherited this house on the condition that he agreed to live in it. Since the house was then in Northampton, Massachusetts, that was not convenient for this Princeton resident. He had already made plans to build a house on the grounds of an orchard belonging to the adjacent house of Dr.

Samuel Miller (which is now the Nassau Club). Therefore, in 1868 he had this structure moved to the Connecticut River and thence onto barges to New Brunswick and down the canal to Princeton. Such was the ingenuity of the time! This magnificent Greek Revival house is currently the home of the Corella & Bertram F. Bonner Foundation, which acquired it in 1996 as its headquarters. The foundation supports service-based scholarship programs on numerous college campuses around the country that provide students "access to education and an opportunity to serve." In addition, the foundation provides support to organizations that help prevent hunger in their communities. Both of the Bonners were born into poverty and established this spiritually motivated vehicle as a way to "help the person who was hurting by displacing despair with opportunity."

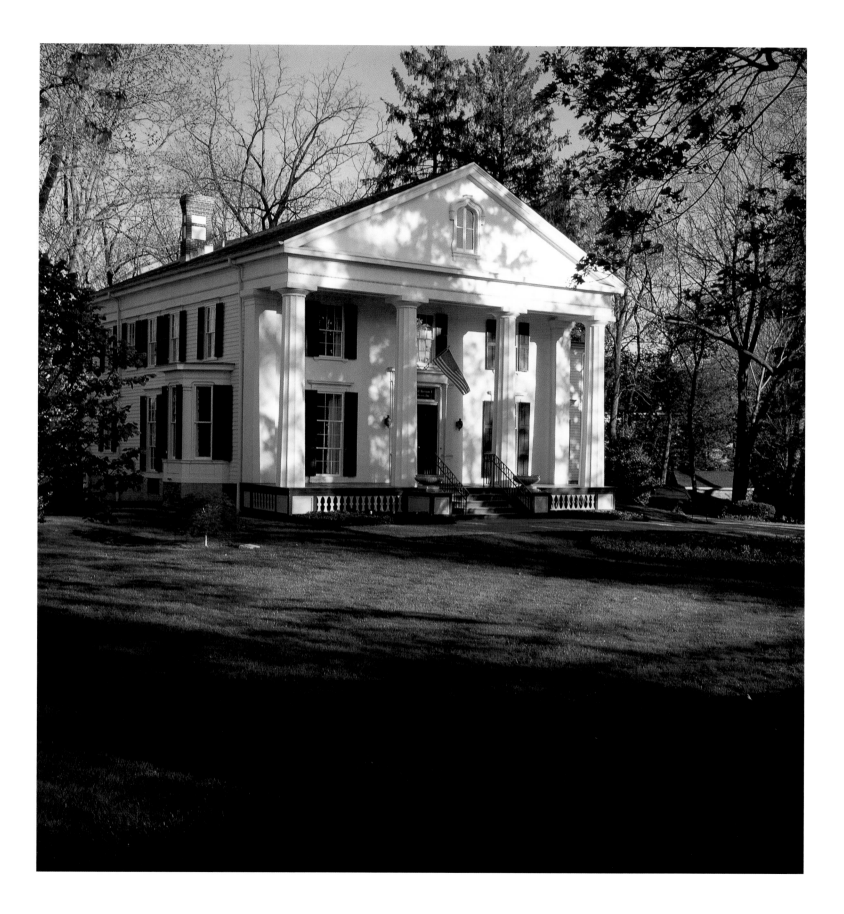

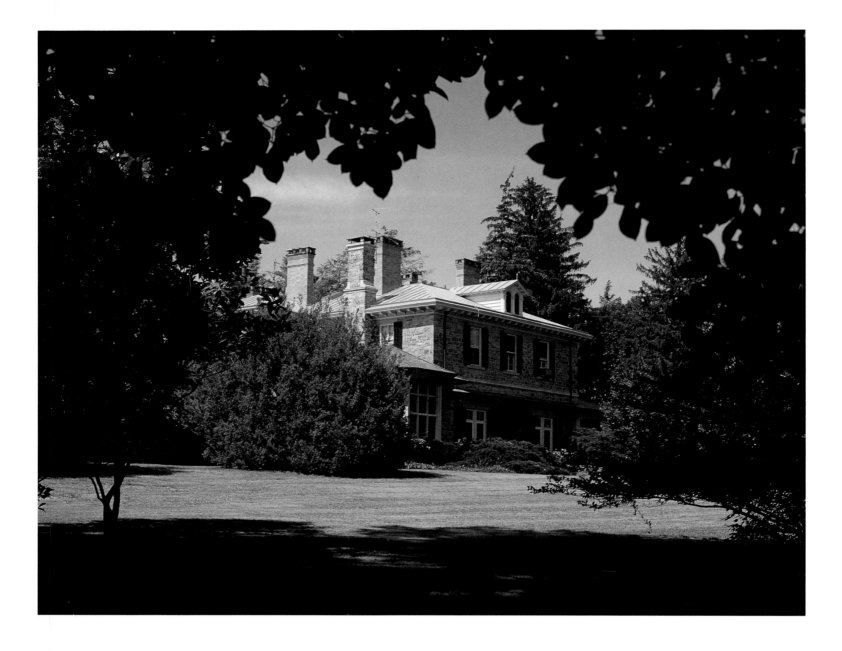

Above: "Lowrie House" and *opposite:* "Drumthwacket." The Walter Lowrie House, 83 Stockton Street, was built by John Notman for John Potter Stockton and his new wife, Sara Marks. Stockton was a son of Commodore Robert F. Stockton, attorney general of New Jersey and a United States senator. Notman was a Scottish-born mason who came to Philadelphia in 1831 and soon became a fashionable architect. The present name of the house commemorates Walter Lowrie, class of 1890, whose wife, Barbara Armor, grew up there. The Lowries lived in it from 1930 until 1960, when Barbara bequeathed it to the university to be used as a guesthouse. This was the first of a new Italianate style of house for Princeton, the villa. Others that followed were "Prospect" in 1852, "Guernsey Hall" in 1850, and Archibald Russell's "Edgerstoune" in 1903. The latter is now the main building of the Hun School. In 1860 this house became the residence of a Princeton alumnus, Paul Tulane. In 1882, when the College of New Jersey was planning to change its name to Princeton University, Mr. Tulane offered a large amount of funds if the college

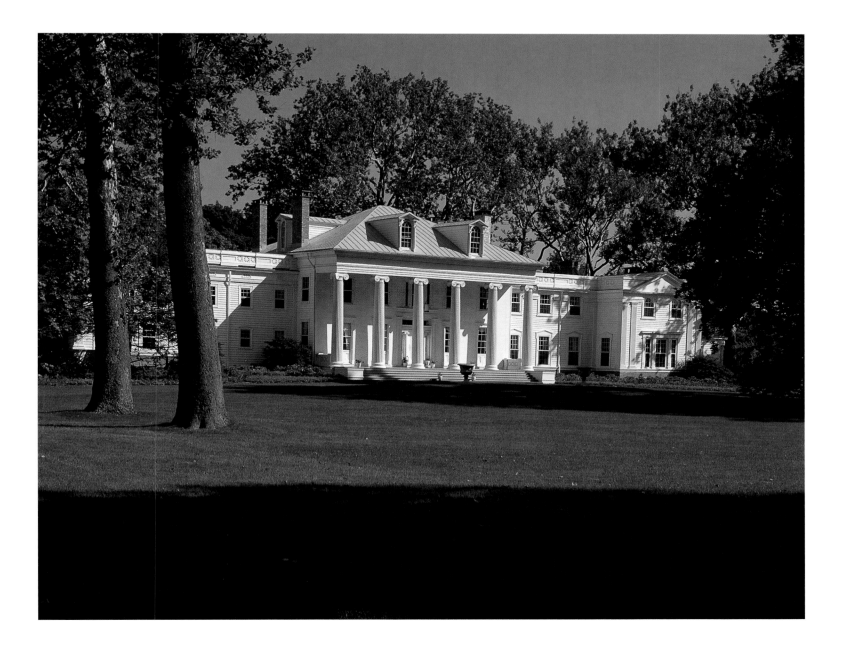

would change its name to Tulane. The college trustees declined the offer and Tulane subsequently founded a university in New Orleans. Elihu Yale had better luck with the Collegiate School of Connecticut, which changed its name in his honor (for a stipend) in 1718. Timing is everything.

"Drumthwacket," 344 Stockton Street, built around 1835 for Charles Smith Olden, governor of New Jersey. It was probably designed by Charles Steadman and it was modified in 1896. Its name is Gaelic for "wooded hill." Industrialist and banker Moses Taylor Pyne subsequently lived in this house. Pyne was one of Princeton University's most substantial benefactors and encouraged the development of its Collegiate Gothic style. During Pyne's residency at "Drumthwacket" it became the center of social activities for both the university and the town. Its grounds were always open to visitors, who enjoyed pleasant hours strolling the paths through parks and woods. More recently, "Drumthwacket" has been the official residence of New Jersey governors.

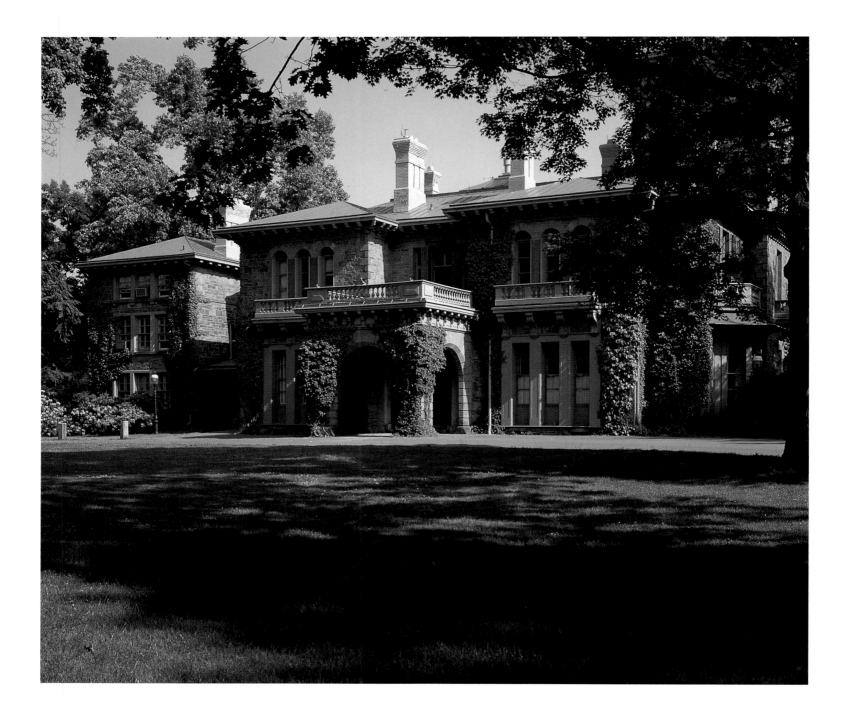

"Prospect" was built in 1852 by John Notman for John Potter. Potter was the son of a wealthy merchant from South Carolina who also built a handsome Greek Revival structure at 1 Bayard Lane for his daughter and her husband Commodore Robert F. Stockton.. "Prospect" is in the Italianate style, which shows a departure from organized Georgian symmetry. The house was given to the college in 1878 by the Stuart brothers (also benefactors of the Princeton Theological Seminary) to be used as the home of President McCosh. He believed it to be the finest college president's home and is reported to have said, upon retiring and leaving it, that he felt like Adam leaving Eden. President Goheen moved off-campus to Lowrie House (also a Notman design), which has become the university's official presidential residence. "Prospect" has been the home of the university's Faculty Club since 1968.

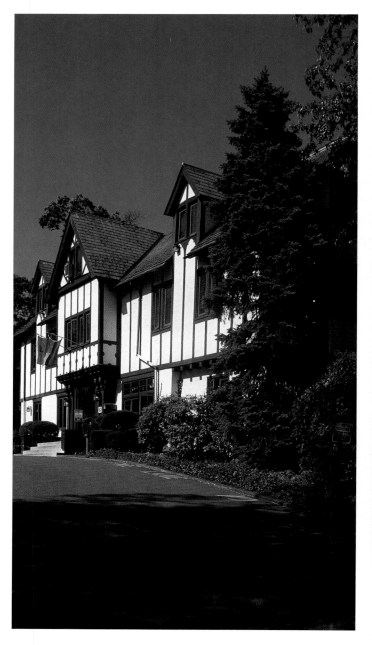

Above: Terrace Club, established in 1904. Shortly after its founding, the club acquired the Washington Road home of Professor John Grier Hibben, who ultimately succeeded Woodrow Wilson as the university's president in 1910. The house was originally of Colonial Revival design, with a large porch in the front. In 1916 the club commissioned Frederick Stone to remodel the building and the present-day Tudor-style structure emerged. The style was influenced by that of Tiger Inn, which also has traditional exposed beams.

Above: The Center for Jewish Life on Washington Road. This new postmodern center was commissioned in 1981 and designed by Robert A. M. Stern of New York. Donors were the Boesky Family Fund, Michael Jay Scharf, class of 1964, and the Posner family. A short distance down Washington Road is another gift from a member of the class of 1964, the Streicker Bridge, given by John Harrison Streicker.

Opposite: Nassau Club, 6 Mercer Street, built in 1814 as the home of Samuel Miller. Dr. Miller was the second head, after Dr. Archibald Alexander, of the Princeton Theological Seminary. Miller Chapel on the seminary grounds is named for him and was designed by Charles Steadman in 1833. In 1903 this residence became the Nassau Club.

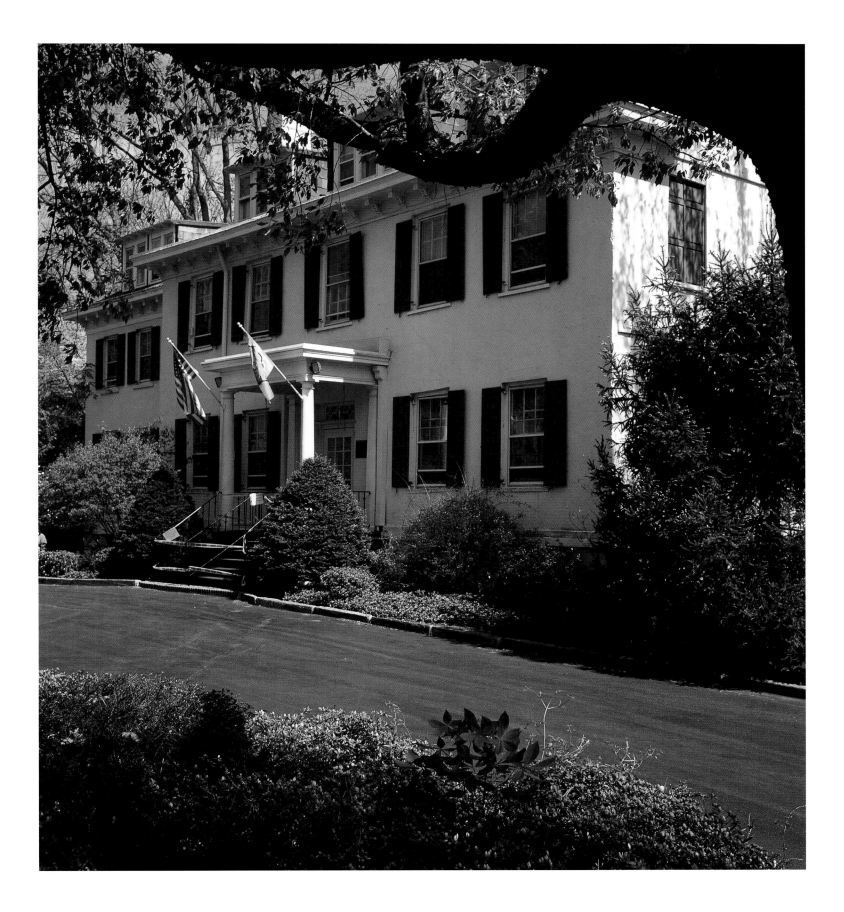

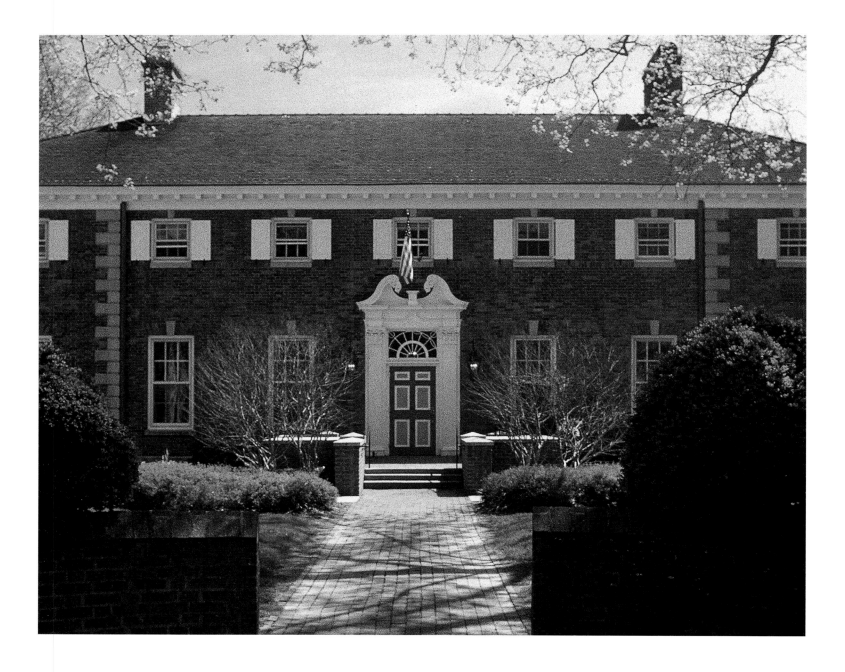

The Princeton eating clubs were first organized by the students in 1855 to provide improved dining accommodations. The campus food had become so intolerable that the students had undertaken a dramatic form of protest, including flinging tablecloths and all contents thereon. The eating clubs were never affiliated with the university but were organized as, and remain, private institutions. Their graduates helped them to build handsome brick and stone clubhouses on Prospect Street. Woodrow Wilson was concerned that many students were not members of these clubs and therefore proposed his "quad" or residential college plan, which has now been implemented.

Above: Quadrangle Club, founded in 1901. H. O. Milliken designed its clubhouse in 1916. He was a university trustee.

Opposite: University Cottage Club, founded in 1886. This handsome Georgian structure with its distinguished white quoins and arched pediment was designed by Charles McKim of McKim, Mead & White in 1904. It is clearly one of the most distinguished structures in the town. The firm had just designed the front gates of the university campus.

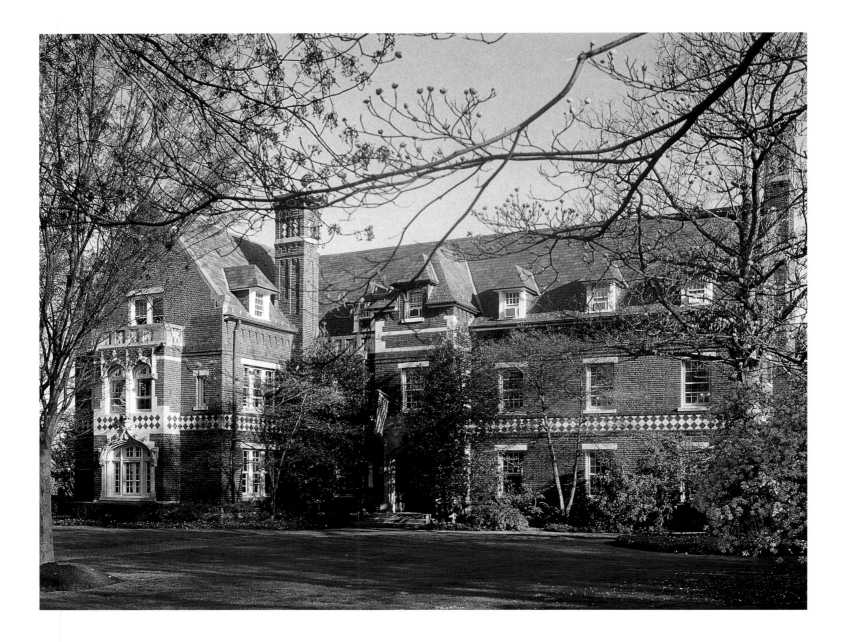

Above: Cap & Gown Club, founded in 1890. This Tudor Revival clubhouse was commissioned in 1908 and was a gift of Moses Taylor Pyne, class of 1877, and Cyrus H. McCormick, class of 1879. Cyrus McCormick was also responsible for the university's art museum. The clubhouse was designed by Raleigh C. Gildersleeve of New York.

Opposite: Colonial Club, founded in 1891. This gracious columned clubhouse was commissioned in 1907 and was designed by Francis Gray Stuart, class of 1896. During clement weather, lunch on the front terrace under the portico is popular with students, as are games on the front lawn.

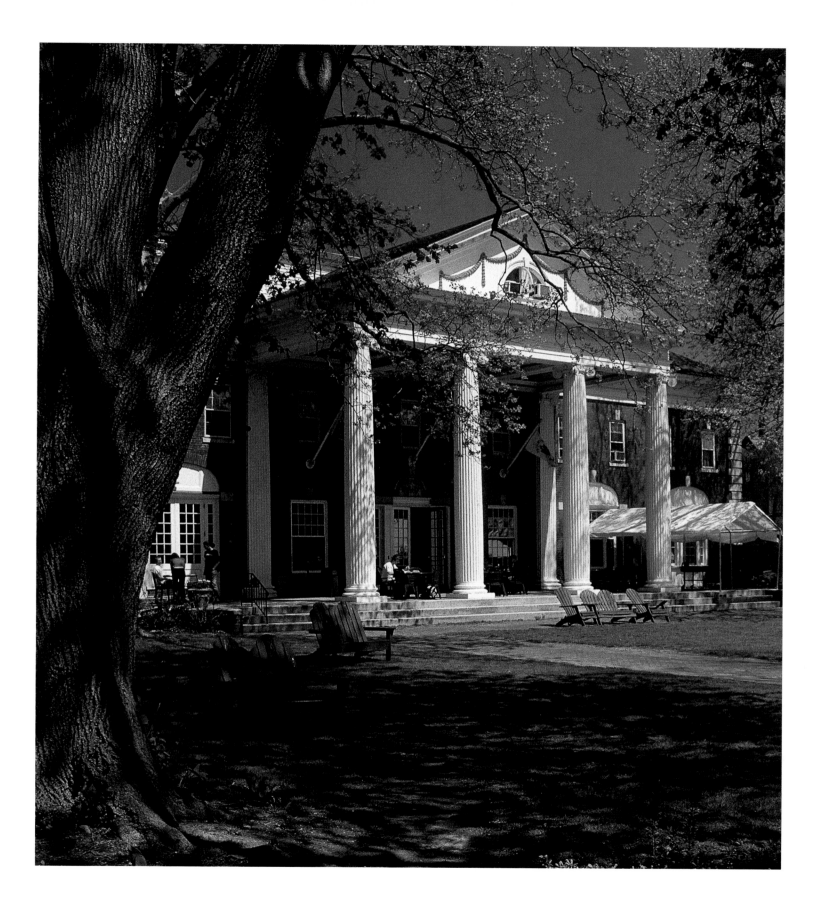

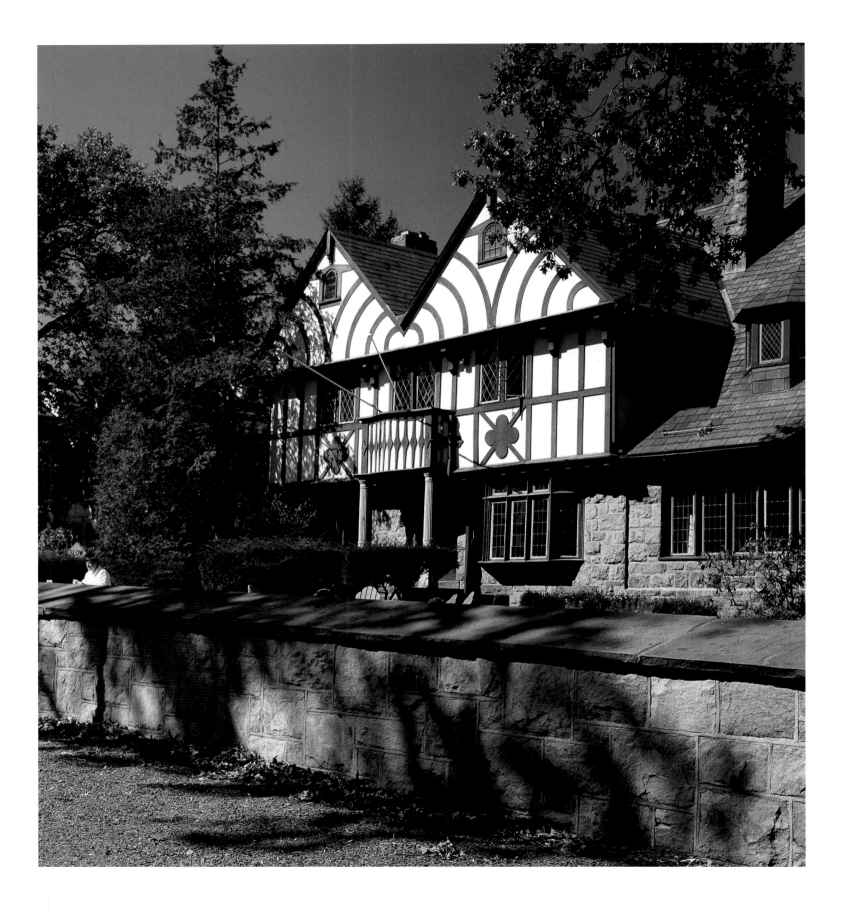

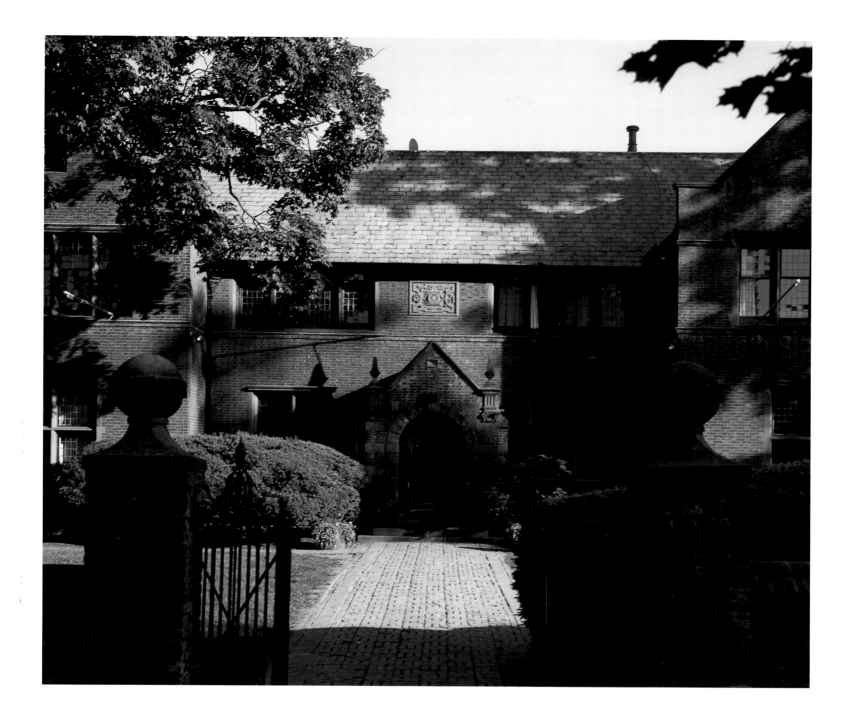

Opposite: Tiger Inn, founded in 1890. This is the oldest continually occupied clubhouse on the street, and it was the first to adopt the English Tudor style. This building was commissioned in 1894. It was designed by Aymar Embury II, class of 1900, Howard Crosby Butler, class of 1892, and G. Howard Chamberlain of New York. They modeled it after an inn in Chelsea, London. Expansion and modifications occurred in 1926. The Garret family and other alumni members were the benefactors.

Above: Ivy Club, founded in 1879. This is one of the university's oldest and most distinguished clubs. Cope & Sewardson of Philadelphia designed this Tudor Revival facility in 1900. It is modeled after an inn in Derbyshire, England. The clubhouse was a gift of alumni members. It is significant that the alumni chose the same architects that the university had hired to create Blair and Little Halls. The club was not interested in anything less.

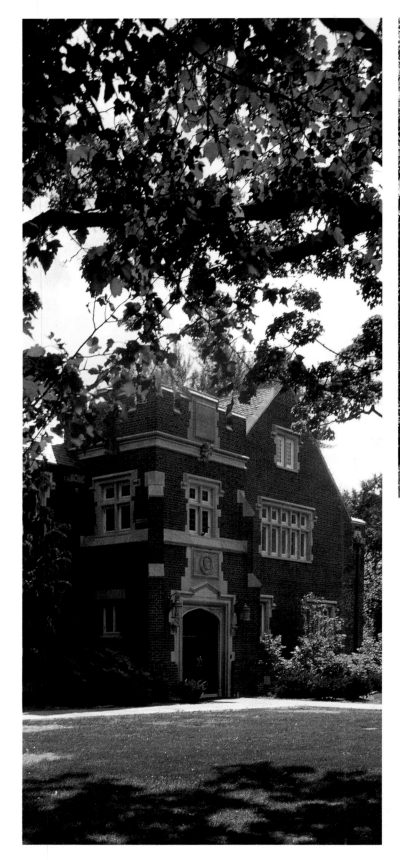

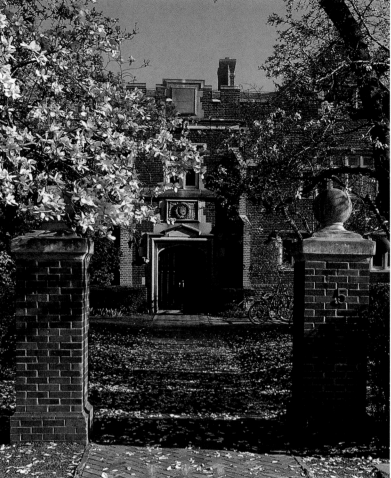

Left: Campus Club. This handsome Gothic-style eating club was designed by Raleigh Gildersleeve of New York. He also was the architect for McCosh Hall and Upper and Lower Pyne, as well as the Cap & Gown and Elm Clubs. Campus was founded in 1900, and this new facility opened in 1909. After almost one hundred years of operation, Campus has become owned and developed into a center of entertainment by the university, which refurbished and reopened it in 2009 after extensive renovations; these included a new geothermal system for heating and cooling with twelve geothermal wells on the grounds.

Above: Tower Club. This Tudor Revival building was commissioned in 1915 and designed by Roderick Barbour Barnes, class of 1903. The club was organized in 1902.

Opposite: Charter Club, founded in 1901. This distinguished building was commissioned in 1914 and designed by Arthur Ingersoll Meigs, class of 1903, of Mellor and Meigs of Philadelphia. Its style is Georgian Revival, resembling that of an eighteenth-century Philadelphia Georgian mansion.

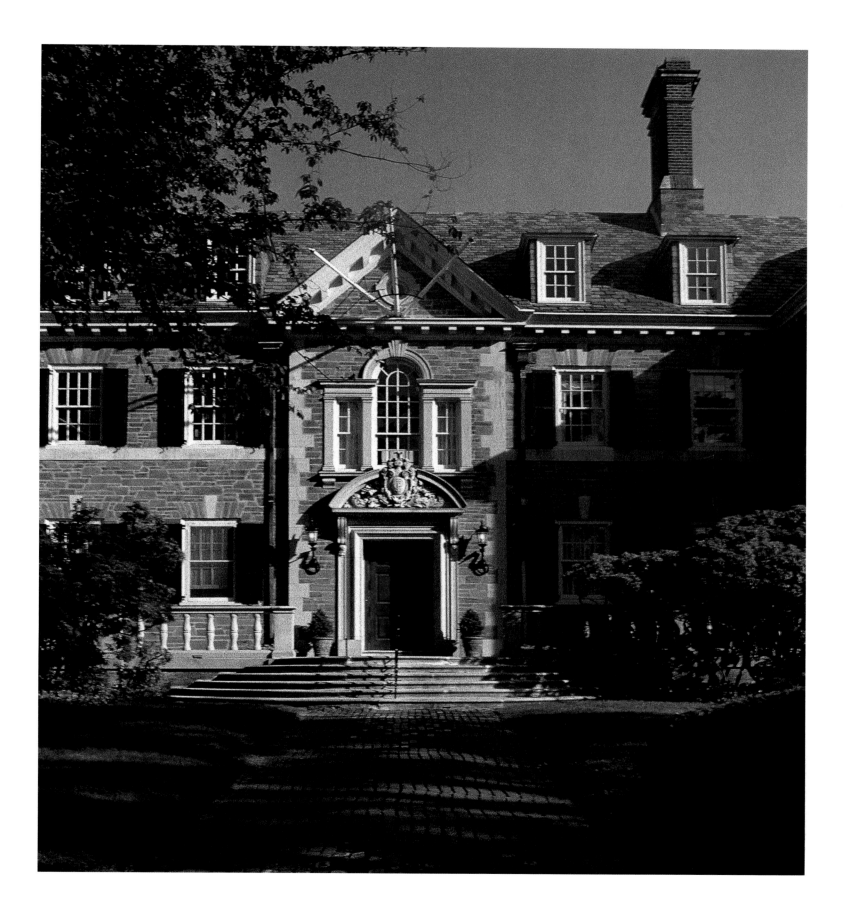

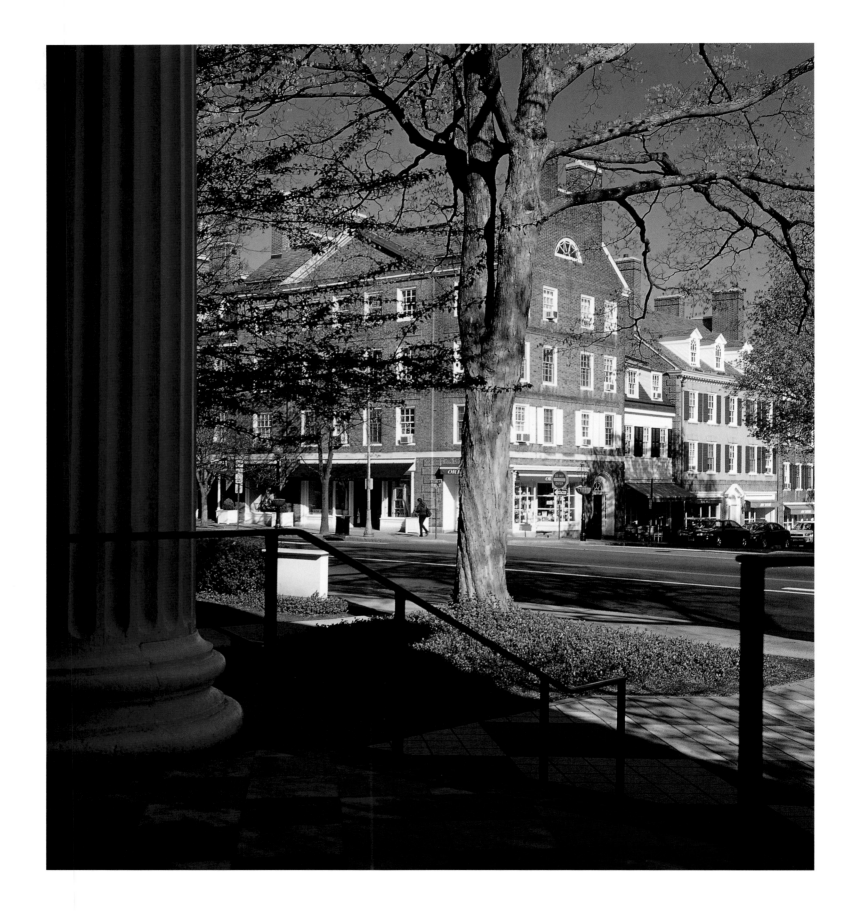

The Town of Princeton

During the early 1800s, the college was having a difficult time. Nassau Hall burned in 1802, and student unrest was a serious concern. Meanwhile, the town was doing very well as a stopover between New York and Philadelphia. First there were the stage-coaches, and local inns maintained over one hundred horses to accommodate the thirty daily coaches. Later came the canal, followed by the railroad in 1839. At this time a young developer and carpenter, Charles Steadman, began erecting residences in a distinctive style. Not only did he develop and build the houses, he was also a financier. For the houses, many of which are located in town, he chose a blend of Federal and Greek Revival styles. His most notable achievements are the Nassau Presbyterian Church and the seminary's Miller Chapel.

Even though many locations across the country bear the name Princeton, New Jersey is home to the two originals: Princeton Borough and Princeton Township. The former is the older and smaller of the two and was incorporated on February 11, 1813. The latter, which surrounds the borough, was formed with the creation of Mercer County in 1838. The two communities have roughly equal populations, with a combined total of approximately thirty thousand.

The borough and the township are distinct municipalities, each with its own elected officials, court system, and police department. The only person to have been mayor of both was B. Franklin Bunn, a man beloved by all, known fondly as "Uncle Ben." Bunn founded and served as an officer of both the Princeton Savings and Loan Association and the Princeton Laundry, directed the Princeton Water Company, and acted as president of the trustees of the First Presbyterian Church for thirty years. He was a director of the Princeton Hospital, the Chamber of Commerce, and the United Fund, as well as the manager of the university store and the McCarter Theatre. He was also a trustee of Westminster Choir College and graduate treasurer of the *Daily Princetonian,* the *Princeton Tiger,* and the Triangle Club. Moreover, he was an official timer of the

Opposite: Palmer Square, West, from the steps of the Nassau Presbyterian Church.

university's track, swimming, basketball, and football contests and grew all of his own vegetables in his garden during his free time.

One of the grandest enterprises in the town's evolution was the construction of Palmer Square by Edgar O. Palmer in the mid-1930s. Thomas Stapleton designed the buildings, which are the product of one of the earliest major colonial restoration efforts in the nation, after the Rockefellers' work in Williamsburg in the 1920s. The development of Palmer Square continued into the 1980s with the expansion of the Nassau Inn. The tasteful evolution of the community around Palmer Square and along neighboring streets has enabled the town to expand into the twenty-first century without neon lights and is a tribute to the preservation of the heritage of this college town.

When Samuel Davies returned from England in 1754 with contributions for the construction of Nassau Hall, the only way for him to return to Princeton from New York was by horse. There was no coach service and the railroad only came through in 1867. When the main rail line was straightened, Princeton lost its direct connection but regained it via the PJ&B (Princeton Junction & Back, also known as "the Dinky"). Turnpikes have improved the overland service in recent years, but Princeton has remained anchored to its history and offers residents, students, and visitors a glimpse of the past while remaining present in the moment.

Opposite: The sculpture of the tiger at Palmer Square was made from melted athletic trophies, resulting from the 1944 fire that destroyed the university gymnasium.

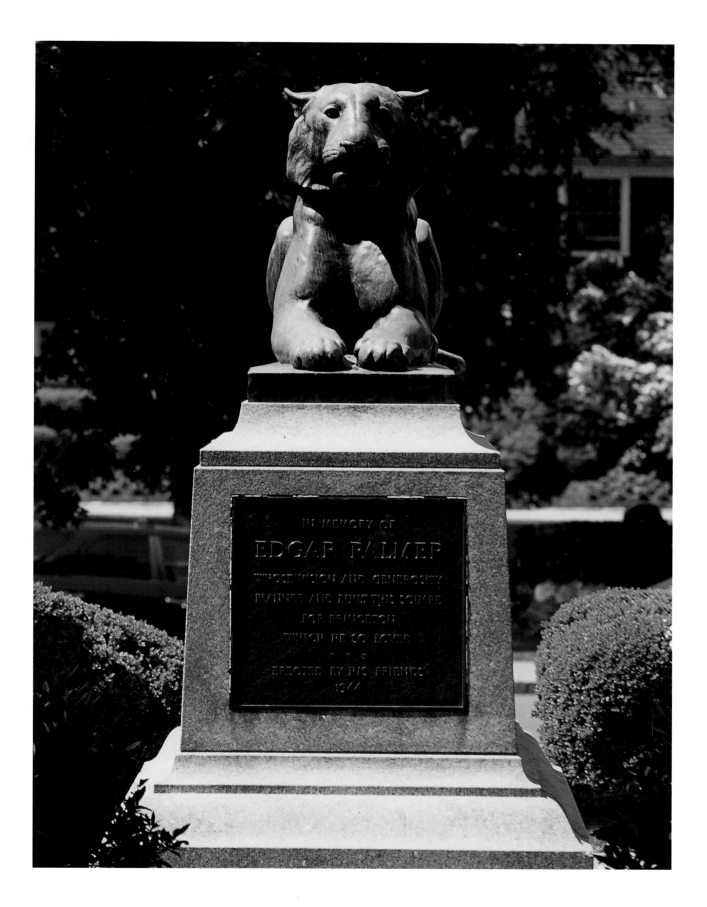

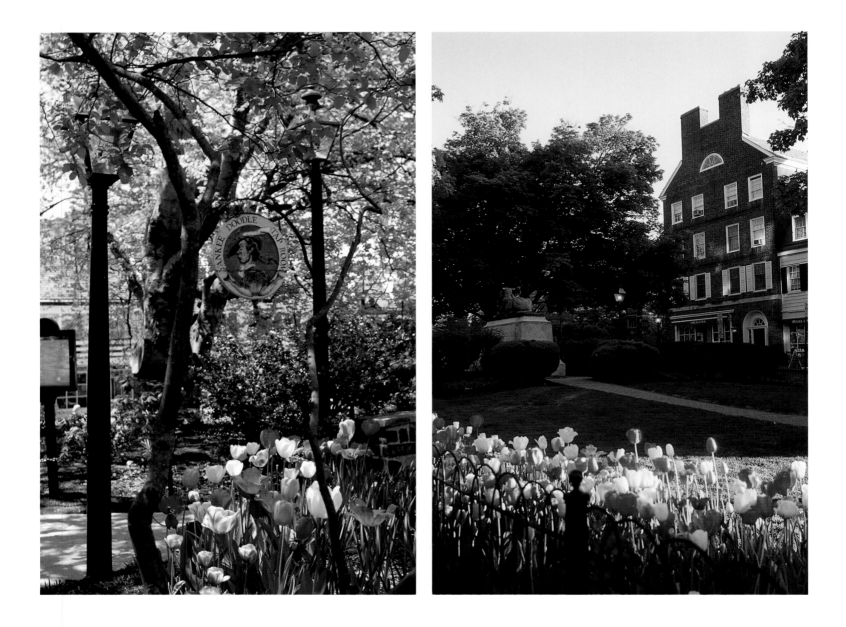

Palmer Square. Thomas Stapleton designed these buildings around the square in 1936 at the request of Edgar Palmer, class of 1903. Palmer conceived of the idea and financed its development. Stapleton worked for the Rockefellers and, under their aegis, was involved in the restoration of Colonial Williamsburg in the 1920s.

Before the square, Nassau Street was simply a straight thoroughfare. There was no village green with a church or municipal building. The square was created, and a substantially modified Nassau Tavern was selected as its anchor at the far end.

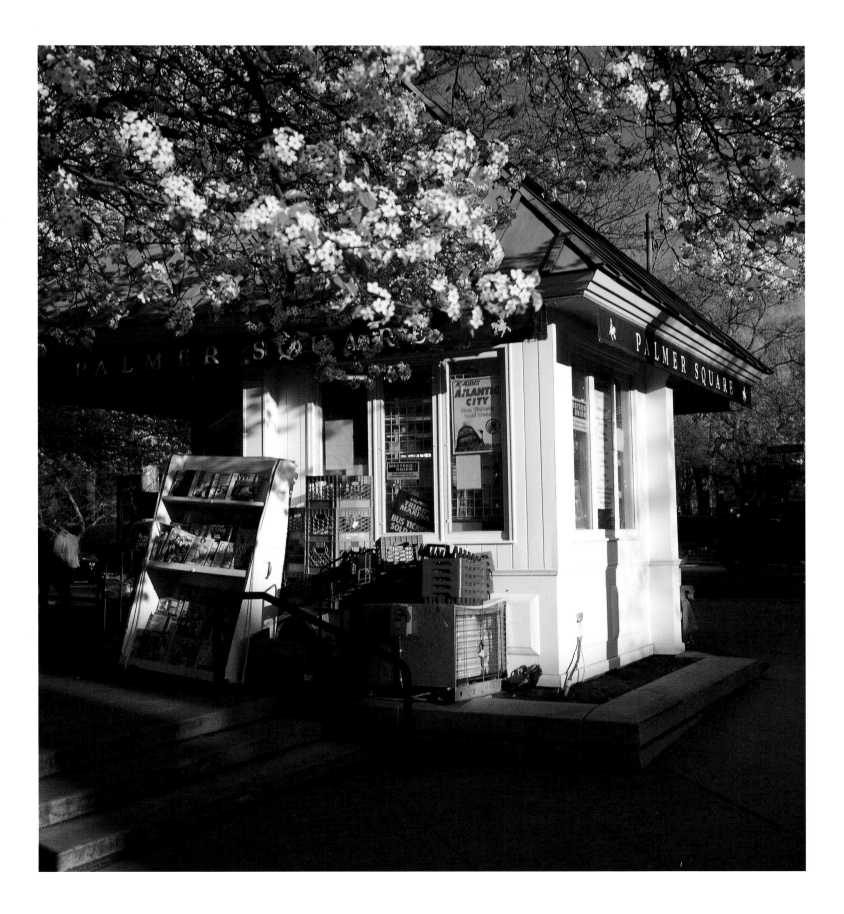

Above: The Nassau Inn has been operating continually as an inn since 1757. It was moved to its present location, in the center of Palmer Square, and to a new building in 1937. Its name was officially changed, in 1967, from the Nassau Tavern to the Nassau Inn. One of its features is the collection of eating tables in the Yankee Doodle Tap Room deeply carved with signatures of former students and friends.

Opposite: Dusk in the springtime at the Seward Johnson statue. This spot, as well as the green in front of the Nassau Inn and the garden around the tiger statue, provides an attractive openness to the town that otherwise did not exist before the square was created in the late 1930's.

Breathtaking bowers of Callery pears on Witherspoon Street. These handsome trees *(Pyrus calleryana)* are native to China, and their blossoms form a spectacular spring canopy in town.

John Witherspoon emigrated from Scotland in 1768 to become the college's sixth president. He was a member of the Continental Congress and signed the Declaration of Independence. His namesake street was laid out about 1850 directly opposite the college's campus and joining the route to Rocky Hill.

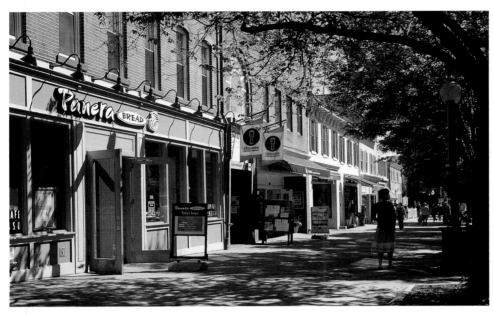

Left: The leafy canopy along Nassau Street provides a gentle softness to the area.

Below: The brick building located at 158 Nassau Street was built around 1765 by Job Stockton. It is currently the headquarters of the Historical Society of Princeton. Founded in 1938, the society's purpose is to encourage interest and promote research in local history. It provides many lectures, walks, publications, and exhibits.

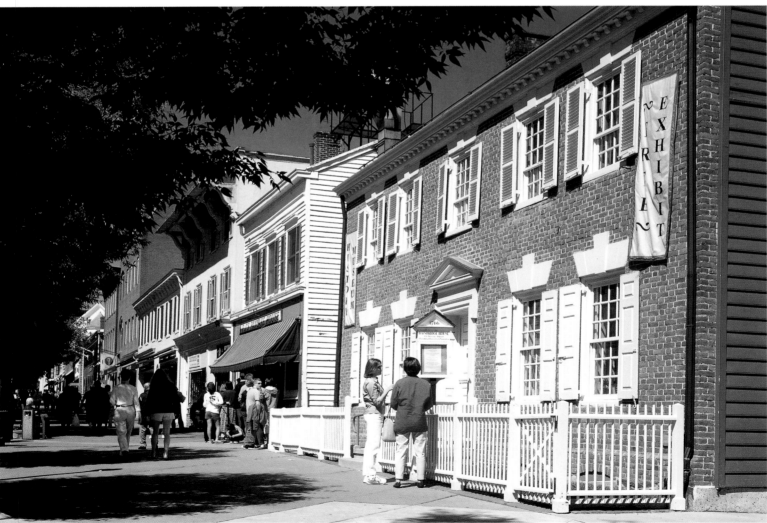

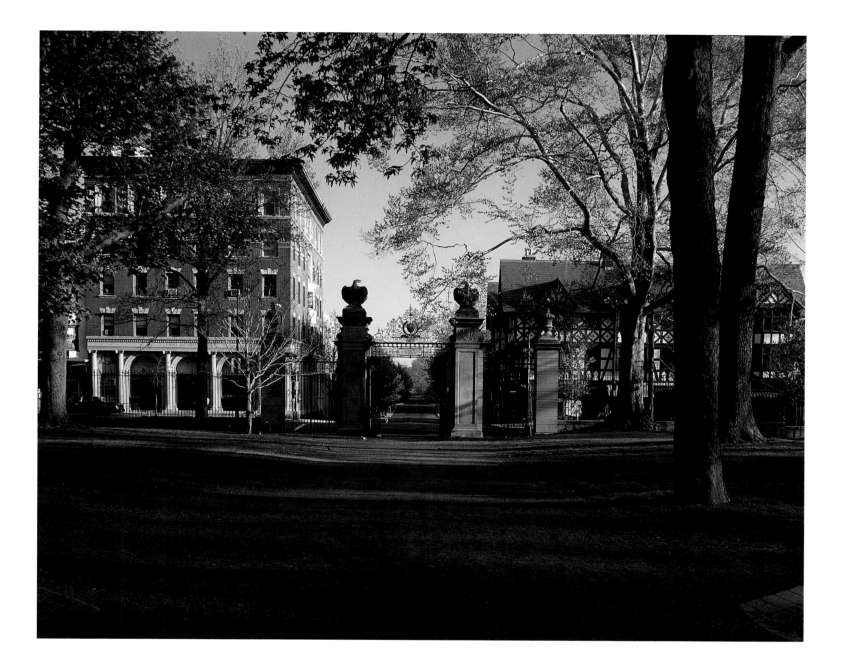

The FitzRandolph Gateway of Princeton University. This gateway was designed by McKim, Mead & White in 1905 and is located at the head of Witherspoon Street. The former First National Bank of Princeton may be seen on the left and the Tudoresque structure on the right was previously Lower Pyne, a student dormitory. On its ground floor were, in succession, the Western Union office, Suburban Bus Terminal, and now Hamilton Jewelers. The gateway is named for Nathaniel FitzRandolph, who gave the land on which Nassau Hall now stands. In the mid-eighteenth century, more than anyone else in the town, he was responsible for raising the requisite financing and providing the land that enabled the College of New Jersey to relocate from Elizabeth.

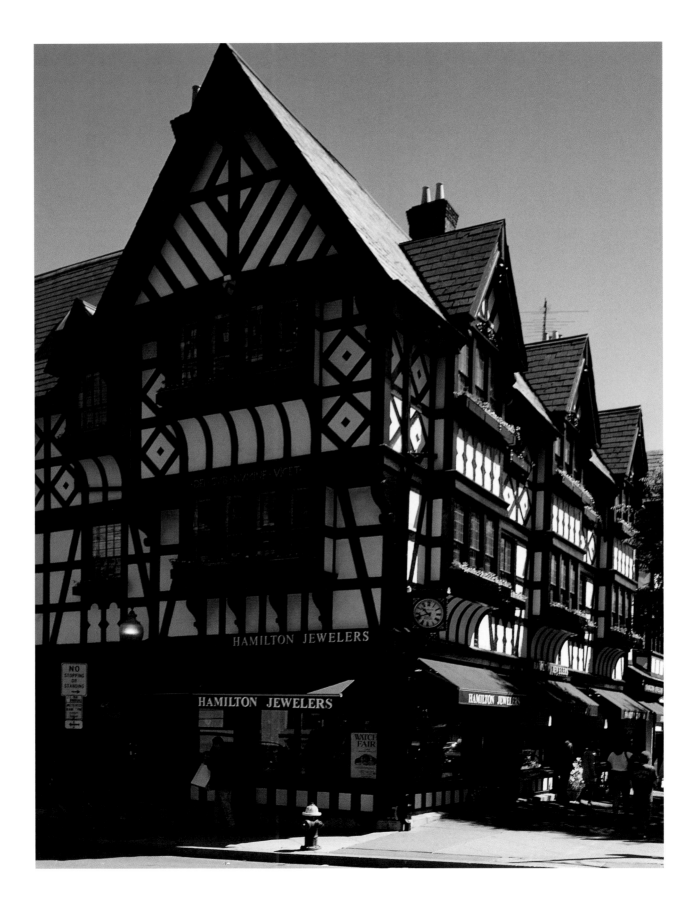

Opposite: Lower Pyne was a gift from Moses Taylor Pyne in 1896. Raleigh Gildersleeve designed it after sixteenth-century houses in Chester, England. Both Lower Pyne and its companion Upper Pyne (demolished in 1964) were designed for shops on the lower floors and dormitory rooms for students above. Students lived there until 1950. Before the days of radio and television, football scores from "the Game" between Princeton and Yale were transmitted periodically by wire from New York to the Western Union office at Lower Pyne. The games had become so popular that they were held in the city. Occasionally there were differences between the information transmitted by wire and the results conveyed out the window to the large gathering of students on Nassau Street. But such pranks aside, the final score was ultimately known by all.

This page: Nassau Street is the main pike through Princeton and was previously referred to as the King's Highway. Countless people have traveled this road, including Paul Revere in December 1773 with news of the Boston Tea Party. In fact, during a brief period, the armies of three countries marched along this road: the Americans under George Washington, the British under Lord Cornwallis, and the French under the Comte de Rochambeau. At the time, this was the main north–south thoroughfare, not what later became known as the Boston Post Road or US Route 1. As the halfway point between New York and Philadelphia, Princeton soon became a place to stop on the journey, as did Lawrenceville, which was a few miles down the road. The importance of the location was greatly increased when Elias Boudinot suggested the relocation of Congress to the town in 1783. Boudinot had been elected president of the Continental Congress in 1782. He stayed at "Morven" with his sister and brother-in-law, Annis and Richard Stockton. A trustee of the college for forty-nine years, Boudinot is best remembered for initiating the congressional resolution that led to the establishment of Thanksgiving as a national holiday in 1789.

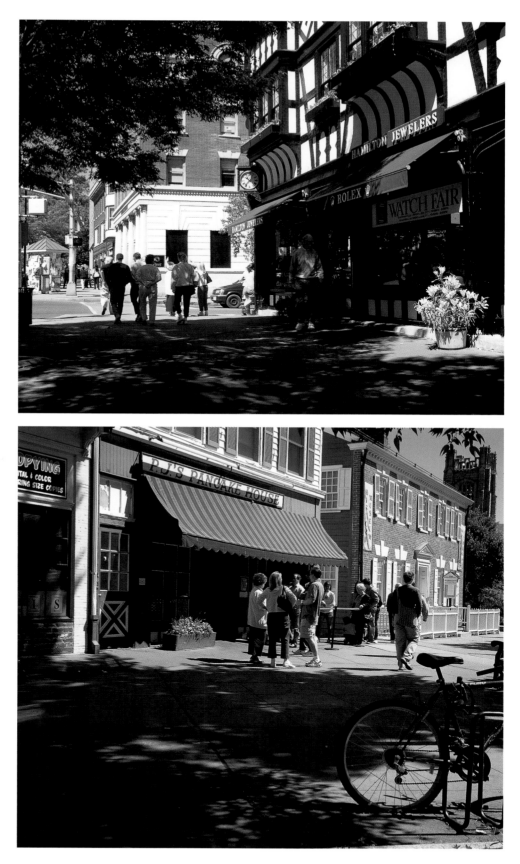

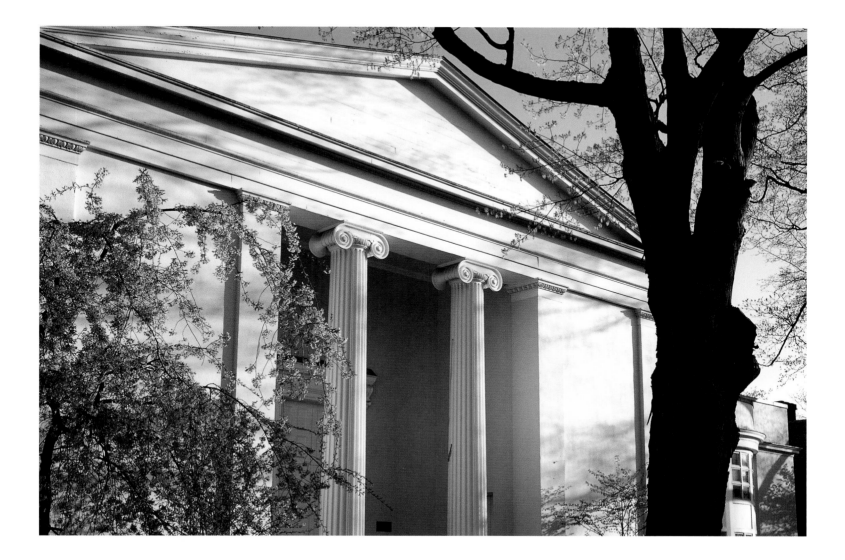

Opposite: Nassau Christian Center. This handsome Gothic church at 26 Nassau Street was dedicated in 1868 and designed by Henry Leard. It was previously known as St. Andrew's Presbyterian Church and named by a congregation organized in 1847. The sanctuary was built to accommodate a thousand people with an opera-style balcony. In 1978 the congregation merged with the First Presbyterian Church and together they formed the Nassau Presbyterian Church of Princeton. The Nassau Christian Church believes in a basic interpretation of the Bible and especially the teachings of Jesus.

Above: Nassau Presbyterian Church, designed by Thomas Walter in 1835, replacing earlier structures built in 1762 and 1813. Charles Steadman executed this design from plans purchased from Thomas Walter of Philadelphia, as was the practice at the time. It represents one of the earliest Greek Revival churches in New Jersey along with Miller Chapel at the seminary and the former Trinity Episcopal Church. Until Alexander Hall was built at the university in 1892, commencement exercises of the college were held at this location. The commencement of 1783 was particularly memorable insofar as it was attended by George Washington and the entire Congress of the United States. The Presbyterian congregation dates from 1755. Its ministers included several presidents of the college: Aaron Burr, Sr., Jonathan Edwards, and Samuel Davies. The first church building was completed in 1766 on land given by the neighboring college. Samuel Davies, the fourth president of the college and minister of the church, is credited with raising funds in England and Scotland to build Nassau Hall (1753). In 1768 John Witherspoon began his twenty-five-year tenure as pastor. During the Revolutionary War, when the British briefly occupied Princeton, they used the church's wooden pews as firewood. In 1978 this church combined with the former St. Andrews to form a new organization, Nassau Presbyterian Church.

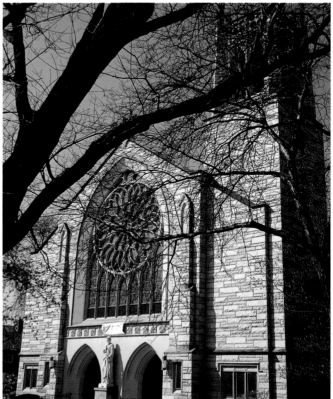

Above: Princeton United Methodist Church. Circuit-riding Methodist ministers began preaching in Princeton as early as 1810. Eventually a congregation was formed and by October 1, 1849, a separate church building was built to house the Princeton Methodist Episcopal congregation. This church was not on the corner of Vandeventer Avenue and Nassau Street but one lot away. The corner lot was occupied by a doctor and member of the parish. When his home and office were purchased by Moses Taylor Pyne for the benefit of the church, a new facility was built in 1910. This is the magnificent structure we enjoy today, replete with stained glass windows, some by Louis Comfort Tiffany's studio. The educational wing was built in 1959 and a new organ was installed in 1990 as part of a sanctuary renovation.

Right: Saint Paul's Church, completed in 1957. This replaced earlier structures built in 1850 and 1879 for the Roman Catholics. The first Catholic chaplain came to Princeton in 1795, privately ministering to a small congregation in their homes. Rev. John Scollard was the first resident pastor, appointed in 1850. He purchased land on Nassau Street for a church and school. Rev. Alfred Young sold this property and erected another structure on the site of the present facility. Rev. Edward C. Henry oversaw the design and construction of the new church buildings. The stained glass windows were designed and executed in the studios of Hiemer & Company in Clifton, New Jersey.

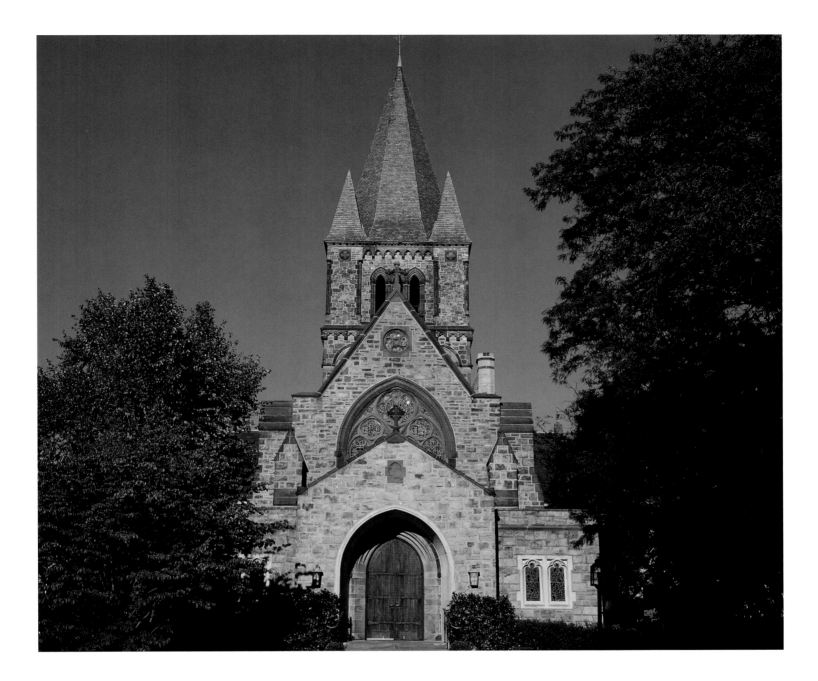

Above: Trinity Church, completed in 1879 and designed by Richard M. Upjohn. He was the son of the architect of New York's Trinity Church. This is the community's Episcopal church, and the style evokes that of an old English country parish. Ralph Adams Cram added the stone choir and sanctuary in 1915. The original church building was remarkably similar to Miller Chapel at the seminary—all white, with a raised columned portico set beneath a Greek pediment. Even the interior was painted white. Indeed, the same architect, Charles Steadman, was involved. This was the Episcopal parish's first structure—a relative latecomer to the largely Calvinistic area of central New Jersey. The present structure, built in 1868, reflects a more typical Episcopalian country style. The church has a history of long-tenured rectors, one of whom stayed forty-eight years. In 1850 the Gothic schoolhouse was built, serving as a Sunday school for parish children and also as a school for African-American children whom the local schools did not serve. Over the years its active congregation has expanded to include professionally trained choirs, the St. Paul's Society, counseling services, and other outreach activities.

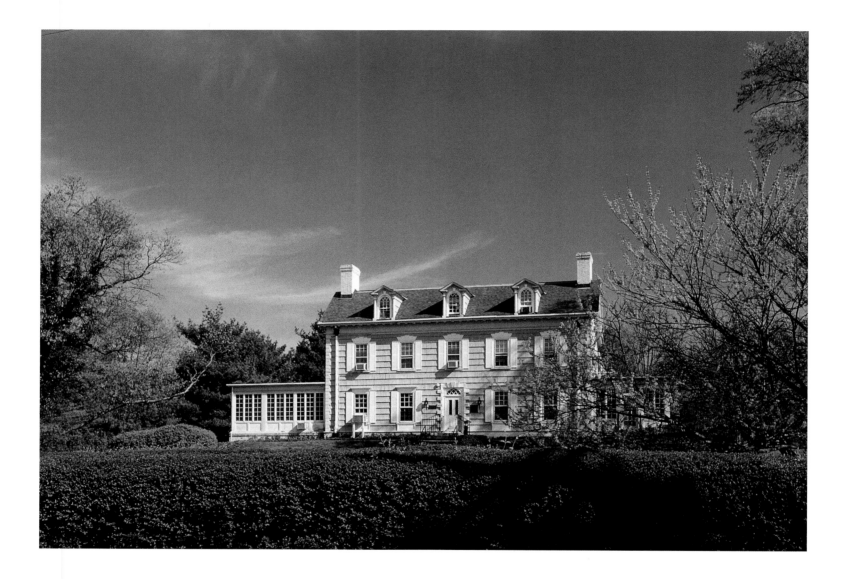

The Jewish Center on Nassau Street. Pictured here are the sanctuary building at 435 Nassau Street *(opposite)* and the school building at 457 Nassau Street *(above)*. The latter was once a dormitory called Parker House that belonged to the Princeton Preparatory School. The center acquired it in 1974. The adjacent main building was completed in 1958 and expanded in 1983. For many years the Jewish citizens of the community rented the facilities of other organizations to accommodate their increasing number of members. The center was formally organized in 1950, although members of its faith had been living in the Princeton area since the early part of the eighteenth century. In 1845, John Potter Stockton married Sara Marks, a Jewish woman from New Orleans, and together they lived in the family home of "Morven." In 1849 they moved into their new home, now known as Lowrie House. The number of Jewish people in the community

increased in the latter part of the nineteenth century and beyond. One of its most illustrious members was Albert Einstein, who came to the Institute for Advanced Study in the early 1930s. With its new facilities, the center has been able to accommodate a synagogue and a children's school in one permanent location. The center has been affiliated with the United Synagogue of Conservative Judaism since 2005. Over the years, it has maintained close ties with Princeton University, which in 1971 established a kosher dining facility on its campus, the third university to offer this option after Yeshiva and Brandeis. And in 1985, for the first time in its history, Princeton rescheduled the opening day of its classes so as not to conflict with Rosh Hashanah. This was before the arrival of Harold T. Shapiro as president two years later. Today the center is strong and vibrant, serving the community with its many activities.

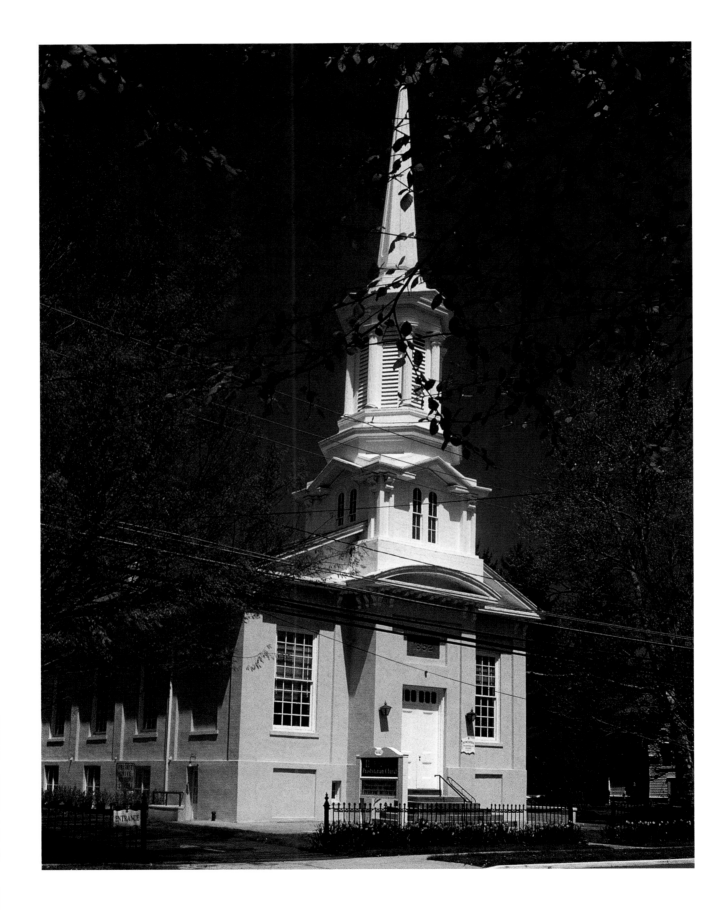

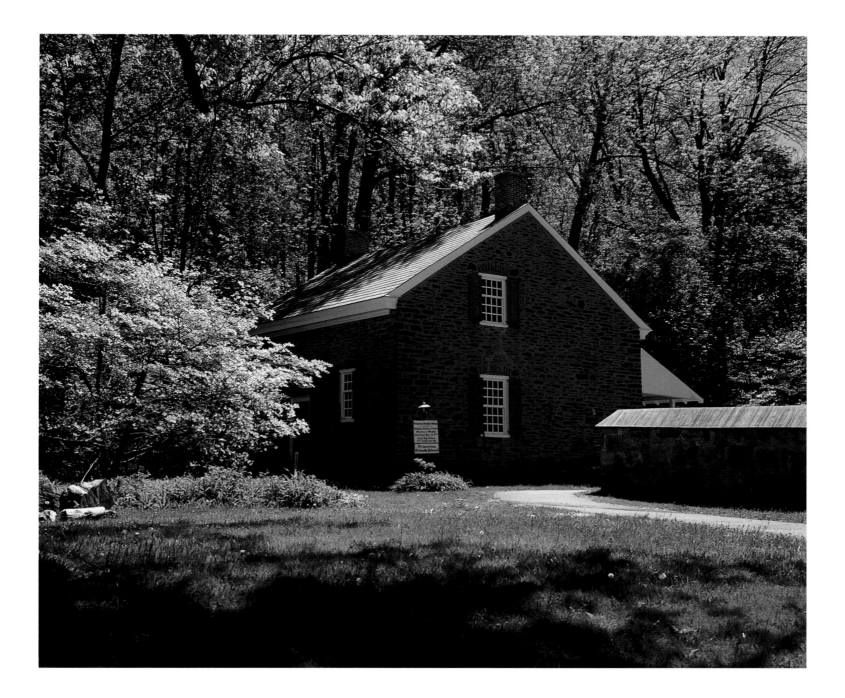

Opposite: The Kingston Presbyterian Church. The congregation was organized in 1723, shortly after the one in Lawrenceville was established, which is believed to be one of the oldest in the country. The present church building, with its striking colonial spire, dates from 1852. The congregation has been experiencing growth over the years. It sent its first foreign missionaries to China in the early 1800s and continues to sponsor other missionaries today. It funds camps and fellowships in the United States and also in the Caribbean and Asia.

Above: The Quaker Meeting House (ca. 1759). This replaced a wooden structure that was built in 1724. The Quakers settled along Stony Brook in the 1680s. During the Battle of Princeton, this new meetinghouse was a hospital for the American troops. The warm ochre sandstone that was used in Nassau Hall was incorporated here a few years later, probably by the same mason.

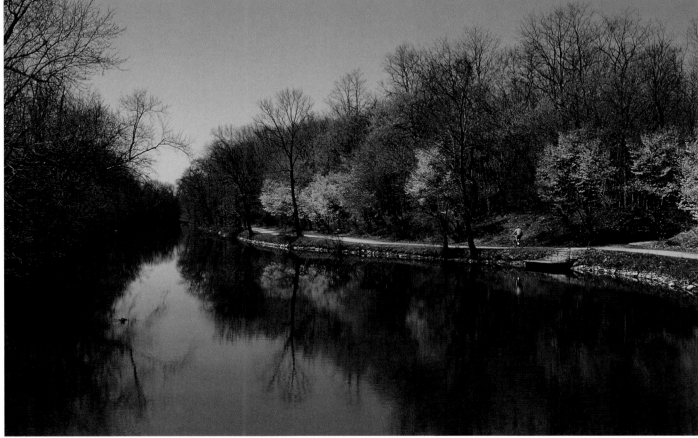

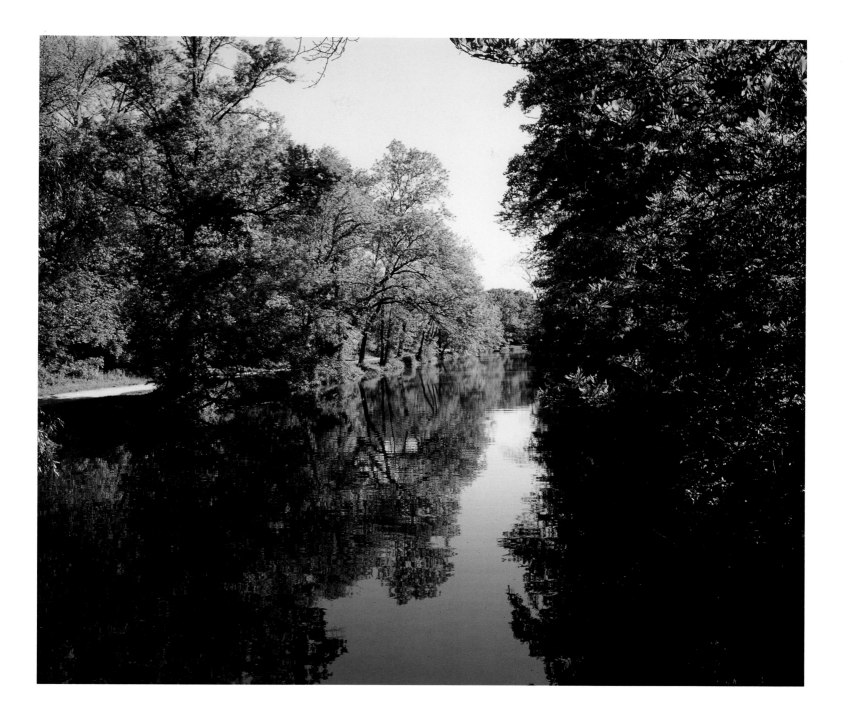

The Delaware and Raritan Canal. The canal opened in 1834 and was built under the auspices of Robert Stockton and other Princeton entrepreneurs. At its peak in 1859, it carried more tonnage than the Erie Canal, with fourteen hundred barges operating between Trenton and New Brunswick. The large barges required up to twenty mules to tow them. Since there is only one towpath, one might wonder how the mules avoided becoming entangled in the lines of the oncoming barges. The answer lies in how the barges and mules passed each other. The barges passed port-to-port, which is customary in maritime traffic. The mules, however, passed on their right sides. One team would stop, and the momentum of its barge created enough slack for its lines to drop to the bottom of the canal. The other barge would glide over while its mules would step over the lines, passing on the inside of the halted team.

Left: A view of the Millstone River after it has been transformed into Lake Carnegie. Andrew Carnegie gave a lake that is 3 ½ miles long with a rowing course that is among the finest on the east coast.

Opposite: Rowing began at Princeton in 1870, initially on the canal. In 1874 the college was admitted to the Rowing Association of American Colleges and participated at the Saratoga Sprints, despite the objection of Amherst that "a line must be drawn somewhere." The crews were not very successful because their training was on a narrow canal filled with barge traffic. By this time, barges were steam-driven, and passing them was challenging, especially for the bow oar, who served as a coxswain and steered with his right foot as he rowed.

One of the participants at Saratoga was Harold Russell Butler, class of 1876, who pursued a career in engineering and also in painting following his graduation. While raising funds for the American Fine Arts Society in New York, he befriended Andrew Carnegie. Carnegie asked to have his portrait painted, and while sitting for it, he reflected on the lochs (lakes) that he had built in Scotland. Butler commented that the rowing conditions on the narrow canal were challenging at best, and would it be possible to have a lake to row on? Thus, Butler inspired Carnegie to donate a lake, over the objections of President Woodrow Wilson who was hoping for a library instead.

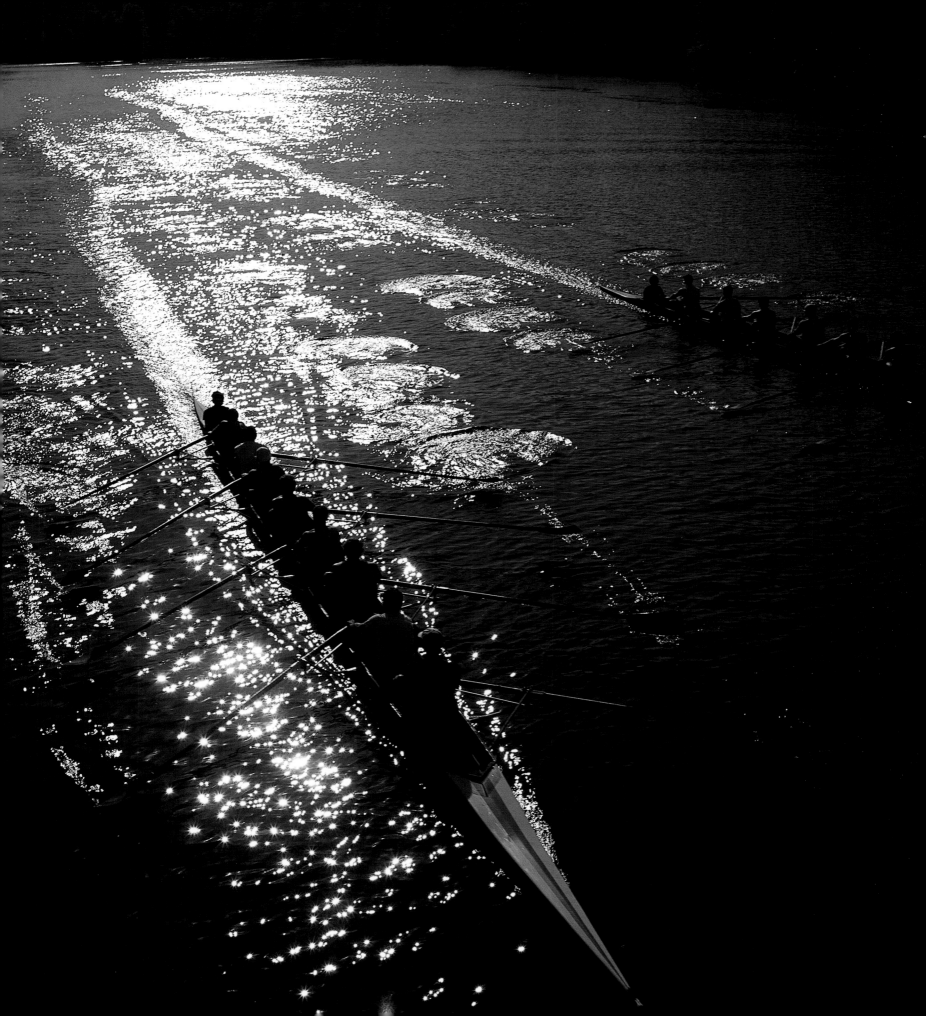

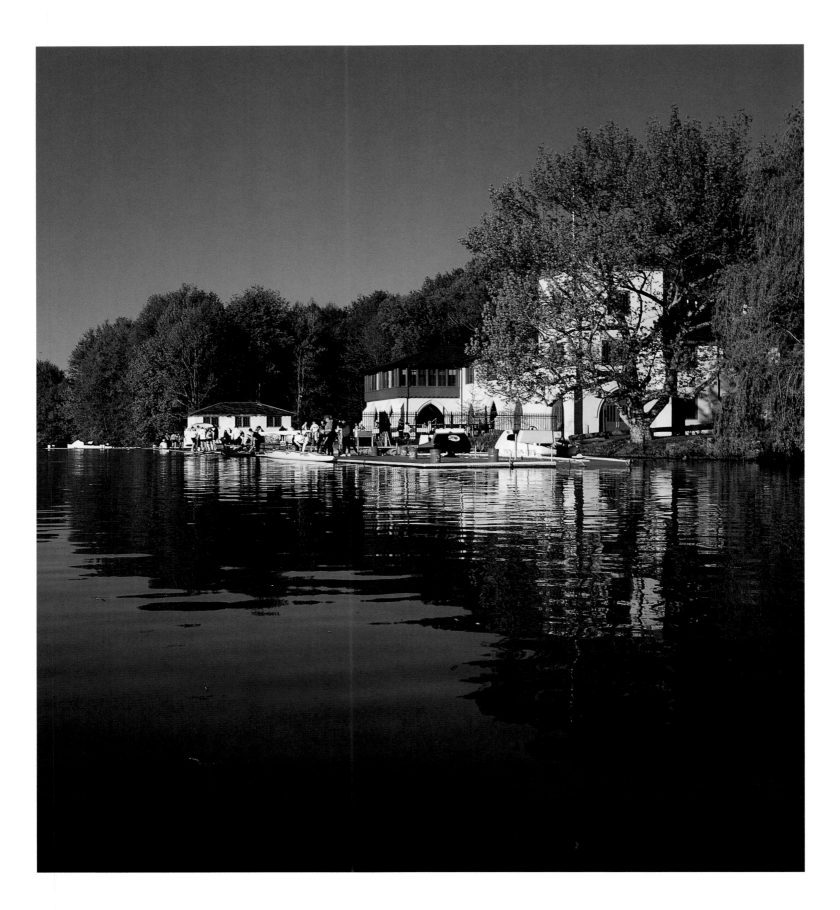

The Class of 1887 Boathouse was built in 1913 and designed by Pennington Satterthwaite, class of 1893. It was substantially renovated in 2000 and is now called the Shea Rowing Center, named for C. Bernard Shea, class of 1916.

The newly renovated and expanded center, which includes advanced training facilities, was spearheaded by a gift from Irene Shea in honor of her late husband, a lifelong fan of Tiger rowing and Princeton athletics. The project also received a broad base of generous support from members of the Princeton University Rowing Association and more than a thousand friends of Princeton rowing.

The first use of the familiar orange and black as Princeton's athletic colors is attributed to the crews of 1874. At the time, all athletic teams wore orange jerseys in honor of King William III, House of Nassau and Prince of Orange. During the sprints at Saratoga, the crews chalked black numerals on their orange shirts. In the 1890s a sports writer for the *New York Herald* originated the idea of the tiger mascot when he noticed Princeton football players wearing socks and sleeves striped in orange and black. He simply referred to the squad as "the tigers."

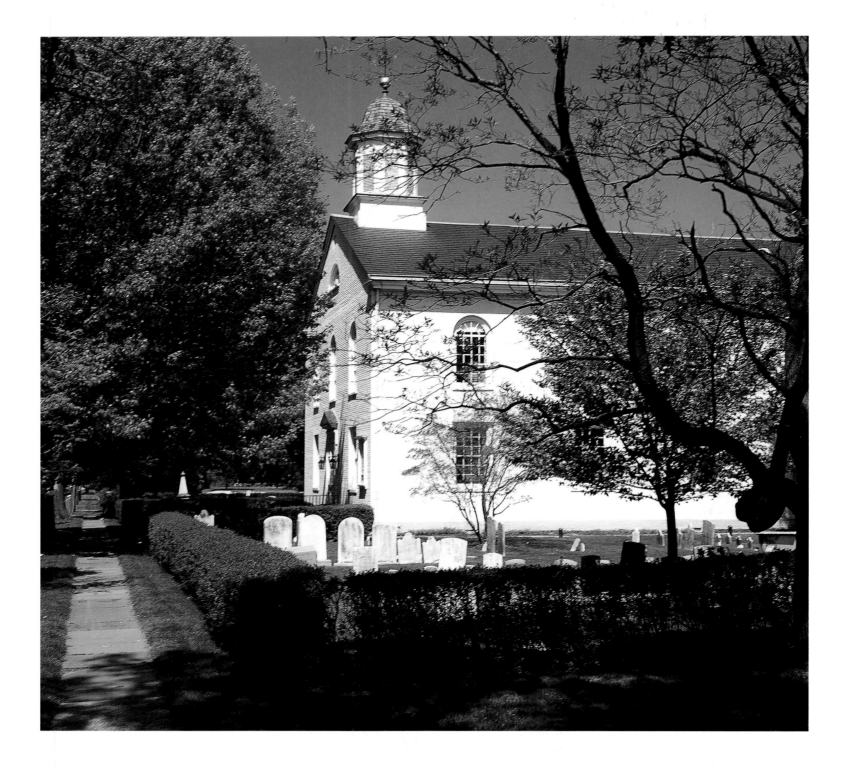

The Presbyterian Church of Lawrenceville. This congregation, established in 1698, is one of the oldest in the country. The section of the church fronting the Lawrenceville Pike was constructed in 1764, the other sections in 1835. The church traces its beginnings to a 1666 migration of Puritans from New Haven to northern New Jersey, where they established the community of Newark. Soon thereafter came Presbyterian churches in Elizabethtown, Woodbridge, Fairfield, and Maidenhead. The Presbyterian congregation in Princeton was not organized until 1755.

Lawrenceville

The town of Lawrence was one of the earliest municipalities in this part of New Jersey. It was settled in the early 1690s and organized in 1697 under the name Maidenhead, a reference to a town on the River Thames in England. The village was officially part of West Jersey and called the West Jersey Society. It was located on the Province line in Burlington County. In 1714 it became part of Hunterdon County and after the war, in 1798, it was legally incorporated under the name of Maidenhead. Only in 1816 did the name of the township become Lawrence, after Captain James Lawrence, a New Jersey naval hero during the War of 1812. Rev. Isaac V. Brown, the first full-time minister of the community's Presbyterian church, led the movement to change the name. In 1838 the town became part of newly formed Mercer County.

The first settlers were John Brearley, Richard Ridgeway, Mary Davis, and Thomas Green. By 1694 settlers began to arrive from Newtown in Brooklyn. No trails existed to accommodate wagons, so travel was by horse and mule. The congregation of Maidenhead was among the first to be organized in this area. It grew to become the largest settlement in the county due to its location on the trade route between what are now Trenton and New Brunswick. The Lawrenceville Presbyterian Church was established in 1698, and soon there were shops and taverns to accommodate the travelers going between New York and Philadelphia. Mary McCauley was born here. She is best remembered as "Molly Pitcher" for her heroism in carrying water to American soldiers during the Battle of Monmouth in June of 1778.

During the Revolutionary War, General George Washington led his troops through the town after the two Battles of Trenton at the end of 1776. His army clashed with the British just north of the town line at what became the Battle of Princeton. The section of the King's Highway between New Brunswick and Trenton—which ran through Kingston, Princeton, and Lawrenceville—saw a lot of troop movement at the time. In fact, in a brief period the armies of three countries marched through Maidenhead: the Americans under George Washington, the British under Lord Cornwallis, and the French under Comte de Rochambeau. This was the route between New York and points south, not what later became the Boston Post Road and is now known as US Route 1.

In 1810 Presbyterian minister Dr. Isaac Van Arsdale Brown established the Academy of Maidenhead. It later became known as the Lawrenceville Classical and Commercial High School, a name eventually shortened to the Lawrenceville School. John Cleve Green, a member of the school's first class, later bequeathed a large sum of money that enabled the school at the turn of the twentieth century to construct nine buildings that have placed Lawrenceville in the national and local registries of historic buildings. In 1972 the village was listed in the New Jersey and National Registers of Historic Places, becoming one of the first registered historic districts in the state. The Circle, an area of the Lawrenceville School campus, has its own designation as a National Historic Landmark.

One of the legendary institutions of the township is the Jigger Shop, which began operations in the DeWitt Drug Store over a century ago. Serving boys ice cream rather than liquor, the store created the "jigger," a concoction of ice cream, syrup, nuts, meringue, and whipped cream. It was ordered by the desired number of ice cream scoops, not in ounces. Boys from the Lawrenceville School gave the mixture its name. The shop received national attention with its inclusion in the 1950 MGM film *The Happy Years,* based on Owen Johnson's "Lawrenceville Stories." The Jigger Shop has now relocated from the town to the school's campus.

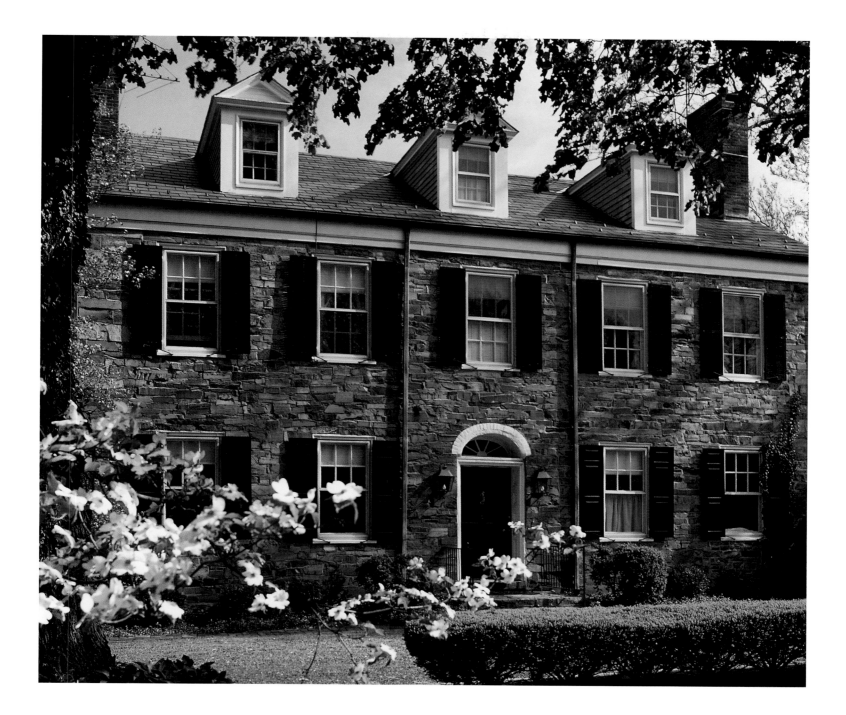

Opposite: The William Phillips House (ca. 1734). This magnificent stone house on the Lawrenceville Pike was originally a tavern and is one of the oldest buildings in the area. Its cellar has a beehive bake-oven that is over five feet in diameter. The interior doors of the house are solid cherry.

Above: The Samuel Hunt House (ca. 1760). Samuel Hunt was the brother of Ralph Hunt, another settler. Along with Theophilus Phillips, he arrived in Maidenhead from Newtown (Brooklyn) in 1694. One of the house's eight fireplaces is eight and a half feet long. The windows are held in position by springs in the sashes, and in the attic is an unusual chamber that was used as a smokehouse, with a flue leading into the chimney. The Cherry Grove quarry probably supplied the stone, as it did for other houses in the area, including Lawrenceville as well as Princeton.

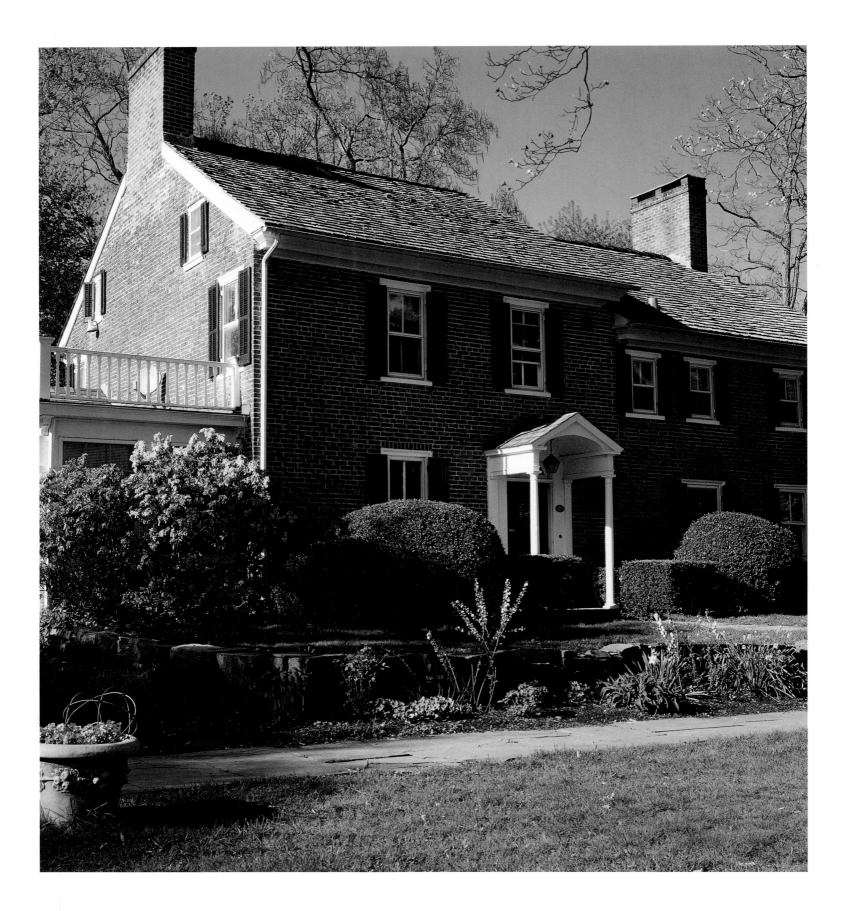

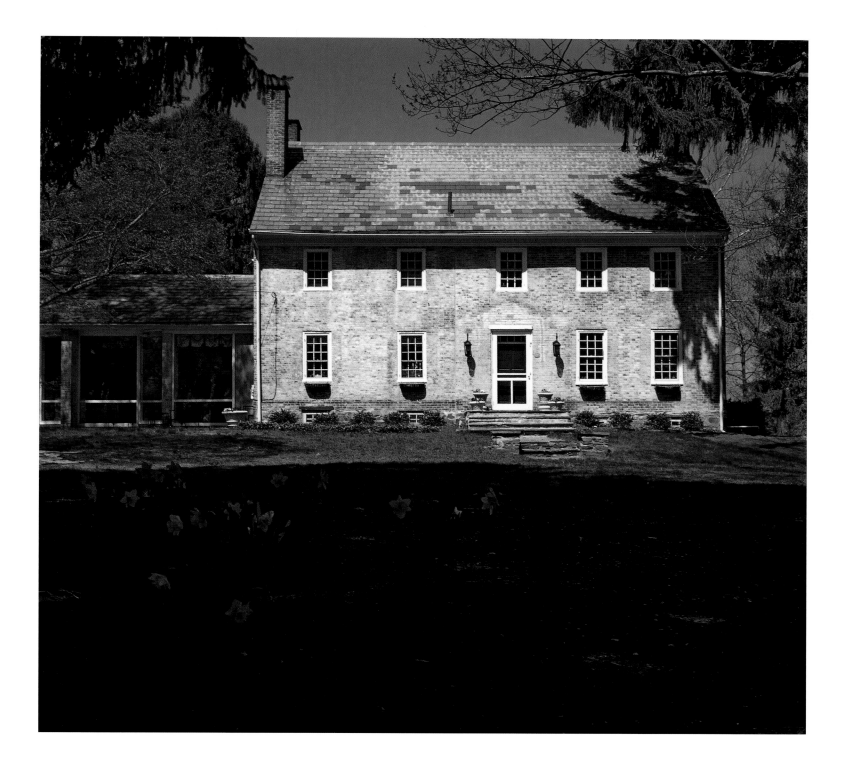

The Ralph Hunt House (1706), also known as "Old Brick," *(opposite)* and the John Brearley House *(ca. 1690, above)*. These are among the oldest homes in the community. Ralph Hunt settled in Maidenhead in 1694. His house has had many uses over the years—as a farmhouse, a school infirmary, a faculty residence, a dormitory, and a home for the Lawrenceville School librarian. Its design is similar to that of "The Barracks," which is Princeton's oldest house.

John Brearley and his family were also among the original settlers, arriving in 1690.

Opposite: The Richard Montgomery Green House (ca. 1815). Richard Green named this house "Harmony Hall." It was built with stone from the Cherry Grove quarry and remained in the Green family for four generations. Richard Green was among the first trustees of the Lawrenceville School, which later acquired the house as a master's residence.

Right: The Farm House of Richard Montgomery Green. The side of this handsome home dates from 1860, and the front from 1916. During the early 1900s, the Green family built several houses along the street that became Green Avenue. The widow of Simon J. McPherson, head of the Lawrenceville School, lived here for a few years after her husband's death.

Below: The Theophilus Phillips House (1750, 1790). Phillips was the son of one of the early settlers. He was a judge in the county courts until 1752, when he retired and set up a public house. His grandson added the larger section of the house in 1790. The house was built with the distinctive stones from the Cherry Grove quarry. Inside is an unusual seven-foot cooking fireplace. Over the years the building has served as a tavern, a boarding house, and a dormitory for the Lawrenceville School. In 1944 the governor of New Jersey sought to purchase the home as a residence for himself and future governors of the state. He was unsuccessful and subsequently purchased "Morven" in Princeton, which served as the governor's mansion until 1990.

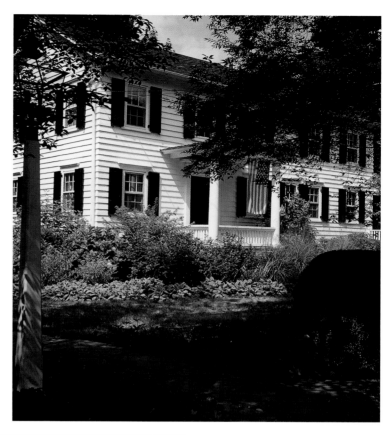

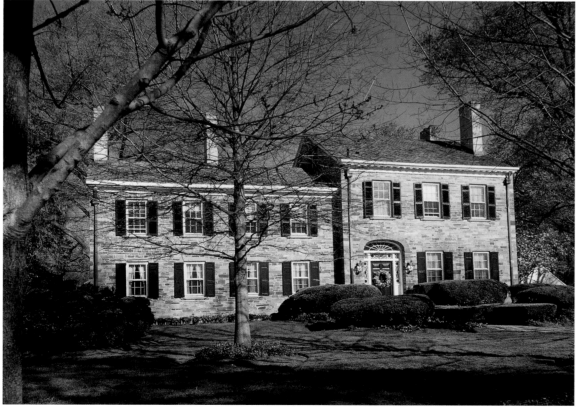

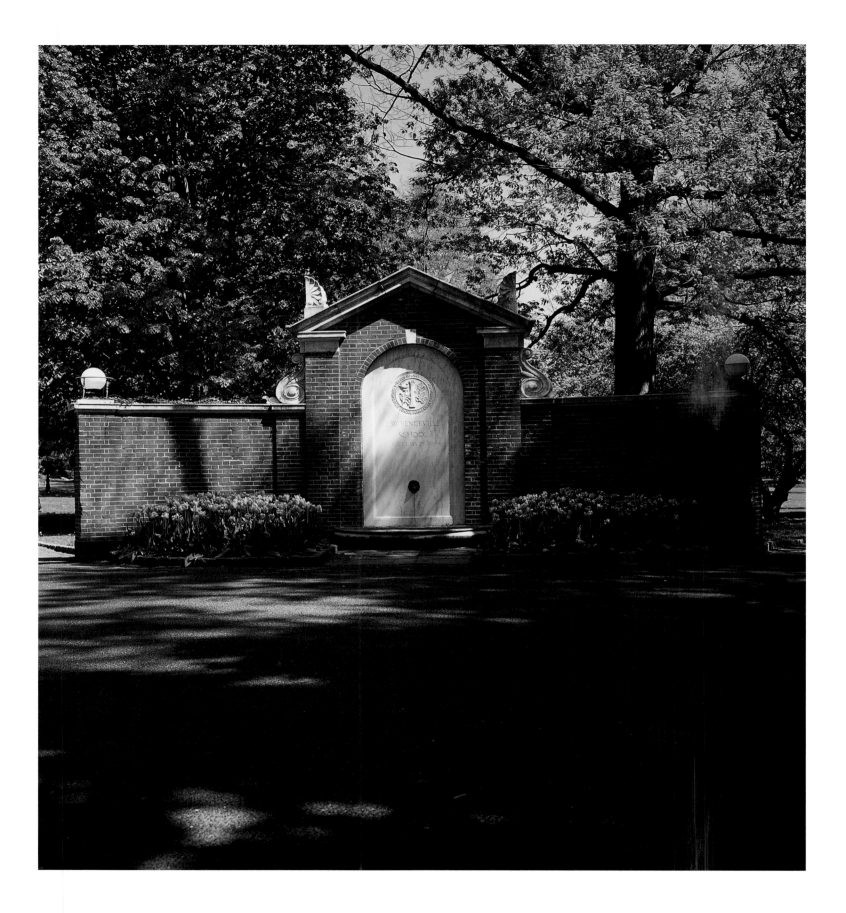

The Lawrenceville School

Virtus Semper Virdis: Virtue Ever Green

In 1810 the local Presbyterian minister of Maidenhead, Dr. Isaac Van Arsdale Brown, established a school for young boys from his parish called Maidenhead Academy. He started with nine boys from the church, including John Cleve Green, who later willed a substantial sum to the school. The school outgrew Dr. Brown's front parlor and built its first structure, Hamill House, in 1814. Students began to arrive from as far away as the Carolinas and Georgia. Within a few years, boarders also included boys from England.

Dr. Brown offered a curriculum of classics and other traditional subjects, as well as a program of gymnastics and other exercises designed to "invigorate the physical system." There were ten boys to a teacher and they all lived together as a family. This tradition continues in principle today.

In 1834 Dr. Brown was succeeded as head master by Alexander Hamilton Phillips, a cousin of the founders of Exeter and Andover Academies. The mission of these schools was to be open to all, unlike the Latin schools, which were more elitist. Public schooling was essentially nonexistent for many years afterwards, and much credit goes to Horace Mann for his efforts in the 1840s to foster public education for all children at local schools, not just boarding academies.

After Phillips came Samuel McClintock Hamill, who was head master for almost fifty years and for whom the school's first building is named. He was the first to establish the practice of avoiding a large number of written rules and regulations. Instead, he relied on the adherence to moral principles, a philosophy still practiced by the school today.

Opposite: The Class of 1891 Memorial Gate was designed by William Adams Delano, class of 1891, of the Delano & Aldrich architectural firm in New York, who also designed all of the buildings around the Bowl. It was built in 1932 and given anonymously by a member of the 1891 class—presumably Delano himself. This stately gate stands on Main Street (US Route 206) and provides access to roads on either side of the school's picturesque Circle, with Foundation House and Upper to the right and the Circle Houses to the left.

Dr. James Cameron Mackenzie was the next head master, serving from 1883 until 1899. The start of his tenure coincided with the refounding of the school. He initiated the school's house system, which was patterned after that of English public schools. Just prior to becoming head master, he had been asked by the school's trustees to visit schools in England and study its educational system. Thus Lawrenceville received guidelines for its new campus based on the house system of English boarding schools. Residences were to be designed for twenty-four boys plus a master and his family. A new classroom building and a chapel were to be built, and all new structures were to face a central green area. Much of the financing was provided by the estate of John Cleve Green, one of the school's original students. Frederick Law Olmsted was retained to lay out the campus, and the Boston architects of Peabody & Stearns designed the first houses.

Today the school has twenty houses in which the students live, along with a housemaster and, in some cases, other faculty members (and their families). There are three separate groups of houses: the lower school; the Circle and Crescent houses; and the upper school. The lower school has four houses within two buildings, Dawes and Raymond. The Circle Houses are named for the circular campus layout designed by Olmsted. They consist of Cleve, Dickinson, Griswold, Hamill, Kennedy, and Woodhull, and provide small, homelike residences to members of the third and fourth forms (tenth and eleventh grades). The Crescent Houses are Carter, Kirby, McClellan, Stanley, and Stephens. Seniors live in separate quarters, which afford them a feeling of independence and prepare them for ensuing college life. The upper school houses are Kinnan, Haskell, Upper West, and Upper East for the boys, and McPherson and Reynolds for the girls.

The next head master after Mackenzie was Dr. Simon John McPherson, who added an additional form in 1904, created the school's first student council, and encouraged alumni participation in the school. His term lasted twenty years—until his death in 1919, when he was caring for ill students during the worldwide influenza epidemic. Next in line was Dr. Mather Abbott, who was head master from 1919 until 1934. During his long tenure, the school built its lower school, library, and Fathers' Building (all surrounding a new campus called the Bowl, which was designed in the Georgian style by school alumnus William Delano). Dr. Abbott also added two new Circle Houses. Dr. Allan Heely was the next head master and continued the momentum established by his predecessors. He expanded the school's curriculum and initiated an advanced placement program. He adopted the conference approach to teaching, utilizing the famous round tables of the "Harkness Plan," which were also used at Phillips Exeter Academy

and St. Paul's School. There were no back rows in the Harkness classrooms, and the masters or teachers sat at the tables to be integral to the learning process. Under the leadership of Dr. Heely, more buildings were constructed, including a science building, an administration building, and a field house. In 1951 educators from Lawrenceville, Exeter, and Andover met with their counterparts at Harvard, Yale, and Princeton to consider the best use of the final two years of high school and the first two years of university. Their report, published by Harvard University Press the following year, led to the establishment of the Advanced Placement Program.

One of Dr. Heely's teachers, Dr. Bruce McClellan, became Lawrenceville's next head master and successfully led the school through the challenging period of social unrest in the late 1960s and early 1970s. He also remained a teacher and continued to teach English literature while serving as head master. But he recognized the challenges that the school was facing and commissioned a turning-point study to examine such issues as religious life and coeducation. Women began to join the faculty, and in 1985 the trustees voted to admit girls to the school. In 1987 Josiah Bunting III became the next head master. He was the former president of Briarcliff College and Hampden-Sydney College as well as a Rhodes scholar, veteran, and novelist. Among his early undertakings was the launching of a $125 million capital campaign, the largest of any secondary school at the time. Upon the retirement of Dr. Bunting in 1995, Philip Harding Jordan, Jr., a former trustee and member of the class of 1960, succeeded him. He served until 1996, when Michael Scott Cary was named head master. Cary focused on improving life and learning for both students and faculty—for instance, through the continuation of the program of forum lectures by pioneers in various fields that was started by head master Heely. Upon Cary's retirement, the school turned to Elizabeth A. Duffy, its first woman head, fifteen years after girls were first admitted. Her mission includes a review and redesign of the school's curriculum, environmental sustainability of the campus, growth in the performing arts, and an increase in international outreach. Under her leadership, the school is strengthening its endowment, thanks in part to a large donation from Henry and Janie Woods—the largest gift since that of the John Cleve Green estate. The Lawrenceville School turned two hundred years old in 2010 and looks forward to another century of successfully educating boys and girls to become future leaders in their endeavors.

Much of the information in the captions that follow was provided by John Gore, the school's director of alumni relations, whose knowledge and patience are most appreciated.

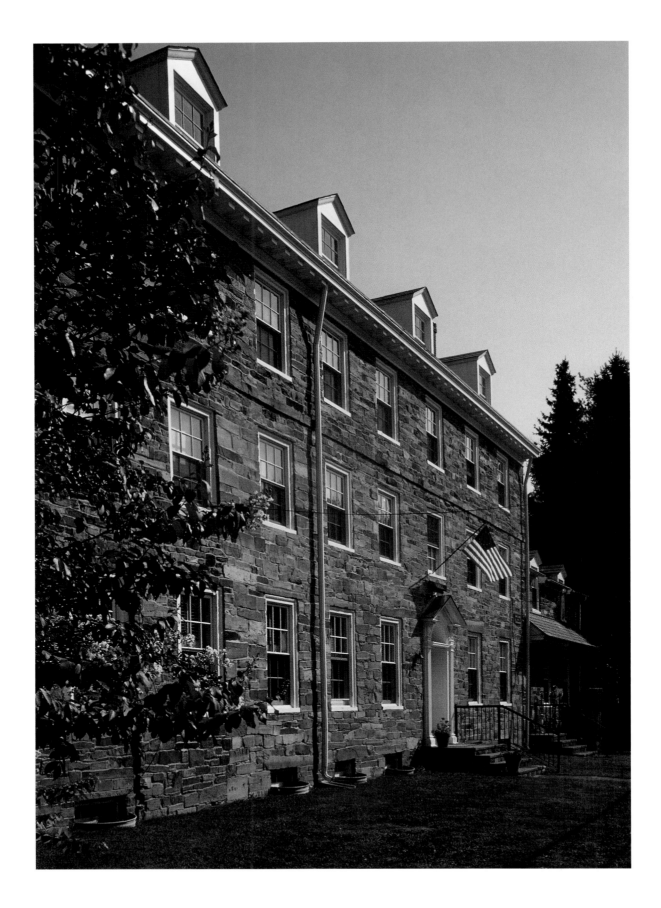

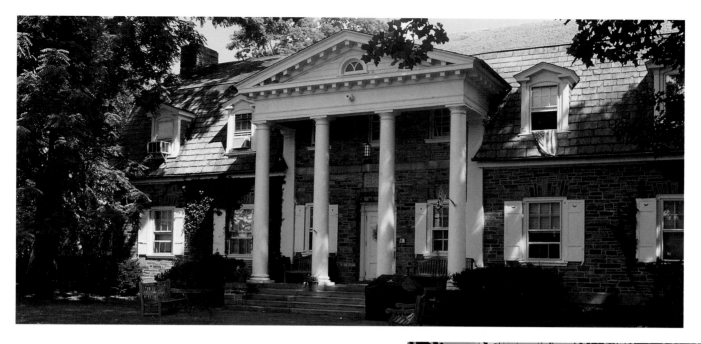

Opposite: Hamill House was completed in 1814 and was the school's first independent structure. It was built by the school's founder, Dr. Isaac Brown. The stone was quarried at Cherry Grove farm, the birthplace of John C. Green. Additional wings were added in 1827 and 1849. It is named for the school's third and longest-serving head master, Samuel Hamill, who served from 1837 to 1883. It is a national historic landmark and it was the first of the Circle Houses, where students live with a housemaster. Lawrenceville's house system was patterned after that of English public schools like Eaton and Rugby, whereby students remained in houses until their senior year and took their meals there as well, much like the college systems at Harvard, Yale, and now Princeton.

Right: Shortly after Hamill House came neighboring Haskell House, which was built in the same gray stone and completed in 1834. This was the school's first classroom building. It has also served as a gymnasium, a meeting spot for the school's debating societies, and from 1913 until 1951 the science building. In 1955 the building was converted into housing through a generous gift from industrialist and philanthropist Fred K. Haskell, class of 1901.

Above: A third gray stone house, Kinnan, was built in 1913. As the headquarters of the school's debating societies, Calliopean and Philomathean, it was originally named Society Hall. In 1930, with the demise of the societies, it was converted into boys' housing and named in honor of Alexander P. W. Kinnan, class of 1873, the first president of the Alumni Association. He led the fundraising efforts for the conversion.

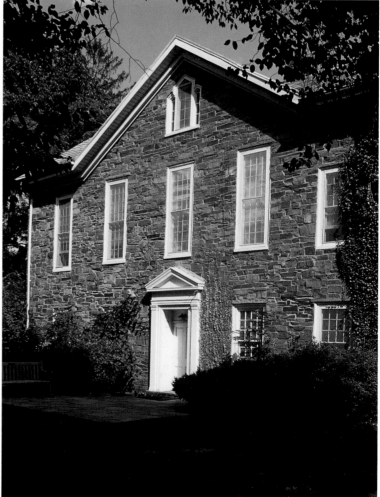

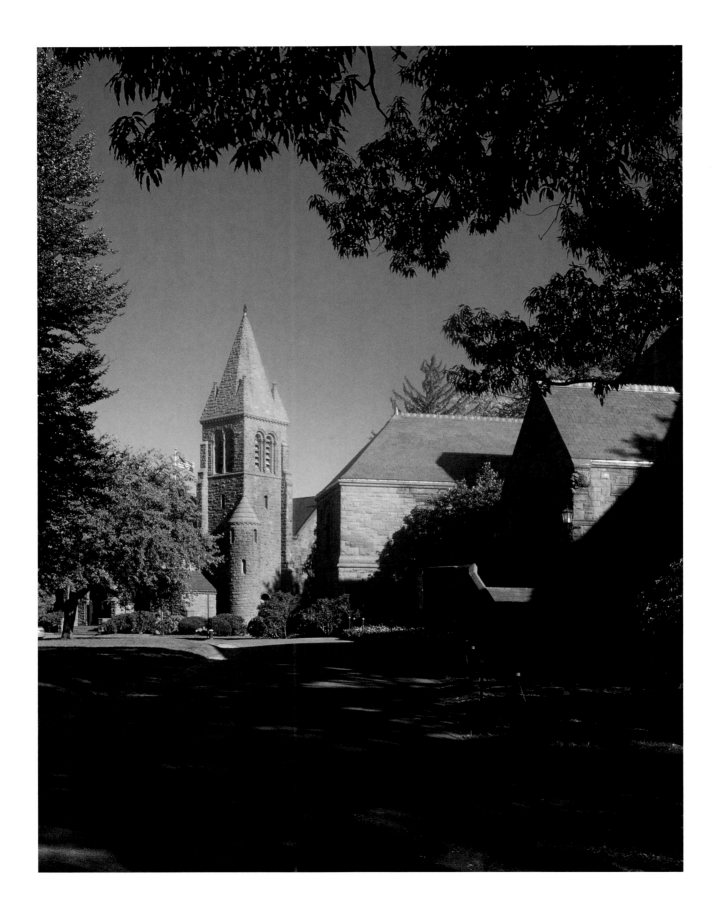

Edith Memorial Chapel and Woods Memorial Hall. The chapel was built in 1895 in a Romanesque style following designs made popular by architect H. H. Richardson. The church is laid out in the shape of a Latin cross and has a massive three-story tower on one side. It was built with a $100,000 bequest from Sarah Helen Griswold Green, widow of John Cleve Green, in memory of her daughter, Edith. The transept windows came from the Tiffany Studios. According to Head Master James Mackenzie, the chapel was to be used for prayer and meditation, not as a school assembly hall.

Prior to 1972, all students gathered here promptly at 8:00 a.m. for "daily chapel." Attendance was taken and daily announcements prepared the students for their day. Today, the chapel is used for services of many religious groups as well as secular events. Fidel Castro spoke here during his 1959 visit to the States. Lawrentians have used the chapel for weddings, funerals, and baptisms. It is most full with Lawrentians during

"Lessons and Carols," a ceremony before the beginning of winter break, where students gather regardless of religion to listen to Lawrenceville's orchestras, choirs, and bands.

In 1968 the building was extended to accommodate a new organ—an Opus 60 pipe organ from the Andover Organ Company that was the largest tracker organ when it was installed. It was a gift from Henry C. Woods, class of 1914, father of the school's legendary English master Henry C. Woods, Jr. In 2010 the latter bequeathed $60 million to the school—the largest single gift in its history, surpassing the gifts of John Cleve Green's estate of $1,250,000 in 1882 and Edward Harkness of $5,000,000 in 1934. He had been chairman of the English Department and also a trustee. In recognition of this gift, Memorial Hall was renamed in honor of him. Built in 1890 in the strong Romanesque style, this is a forceful presence on the Circle and is now named for a munificent donor.

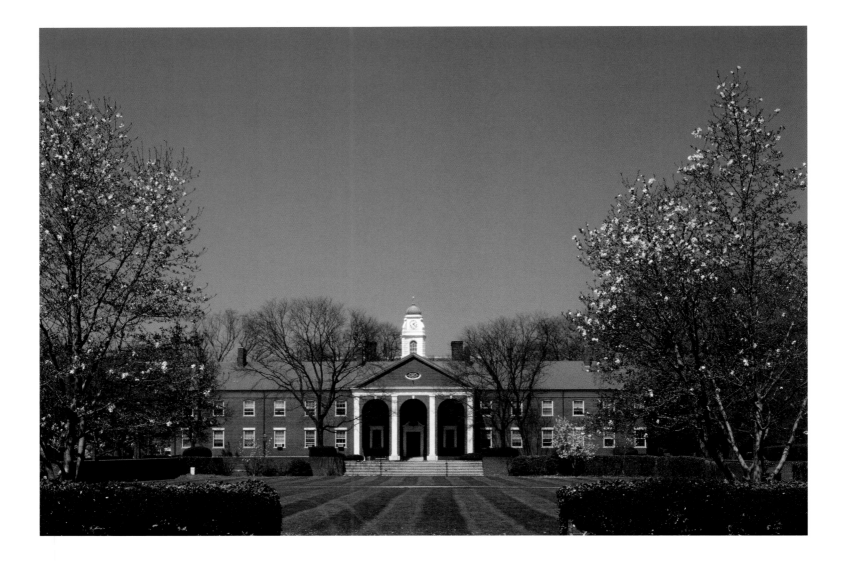

Fathers' Building (*above*) and Dawes House (*opposite*). In the fall of 1924 the board of trustees accepted the Fathers' Association's gift of $200,000 to construct a new classroom building for recitation and administration. Fathers' Building was designed by William Adams Delano, dedicated in 1925, and immediately christened Pop Hall by the boys. Today, Pop Hall houses the Language and Religion Departments. Delano & Aldrich, along with McKim, Mead & White, were responsible for much of New York's greatest architecture in the early twentieth century. The Lawrenceville buildings on the Bowl are deliberately distanced from the older Peabody & Stearns campus so as not to intrude on its design.

Dawes House was built in 1929 and named in memory of Rufus Dawes, class of 1909, by his father, General Charles Dawes, later vice president of the United States.

Opposite Dawes House is its twin, Raymond House. These are now lower school buildings. Dawes is a girls' residence (divided into the Cromwell and Perry Ross houses) and Raymond is a boys' dorm (divided into the Davidson and Thomas houses).

Between these two dormitories lies the Bowl, a sunken terrace with tree-lined roadways on either side. In the mid-1920s the school decided to expand and hired the Boston firm Delano & Aldrich to create a secondary campus in the Georgian Revival style (Jeffersonian). It was meant to be traditional, hierarchical, and structured in appearance, with the "father" (Pop Hall) at the head of the table (the Bowl) and the "children" (Dawes and Raymond Houses) along the sides. The Bowl has a symmetrical appearance unlike the free-flowing romantic style of the Circle Houses. It is an appealing space in the middle of the Delano & Aldrich campus and it has formal and informal uses: Students enjoy it for recreation and socializing, while the school uses it for concerts and commencement.

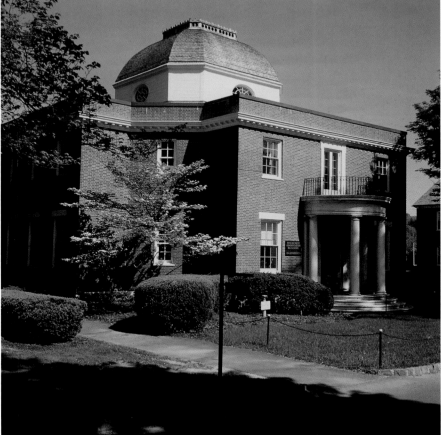

Above and left: Mackenzie Administration Building. This structure houses the offices of the head master, the dean of faculty, the dean of students, and the dean of academics, as well as the admission office. It was designed by William Delano, built in 1937, and made possible by a gift from Edward S. Harkness. This Georgian Revival building was named for James Cameron Mackenzie, head master from 1883 to 1899 and, as the plaque in the building announces, "Builder of the historic Circle, and originator of Lawrenceville's unique House system."

Opposite: Gruss Center of Visual Arts. This was originally the John Dixon Library. Until this handsome building was constructed in 1931, the school's library occupied one room of Memorial Hall. Head Master Mather Abbott wanted a library facility that would make the students feel welcome. It was named for Rev. John Dixon, president of the board of trustees from 1924 to 1930.

In 1996 a new library facility was built—Bunn Library—and the 1931 structure was enlarged and renovated to become the Gruss Center of Visual Arts. It is named in honor of private investor Martin D. Gruss, a member of the class of 1960 and a trustee of the school.

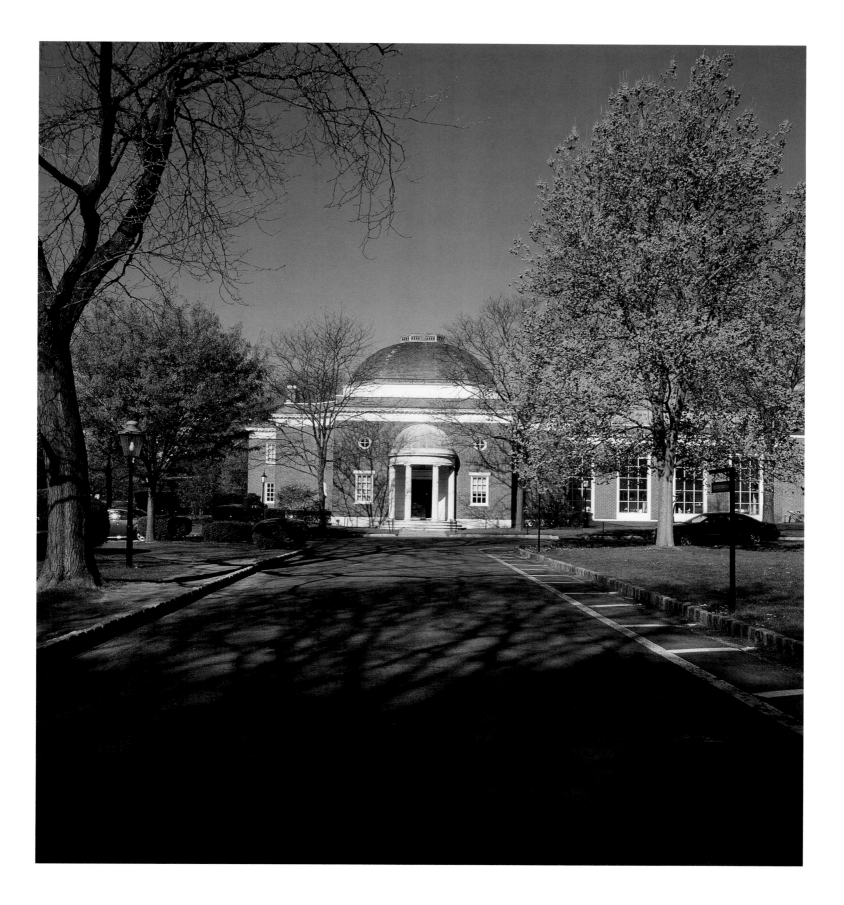

Opposite: Allan P. Kirby Arts Center. Known as KAC, the Kirby Arts Center was made possible by a gift from the F. M. Kirby Foundation in honor of Allan P. Kirby, class of 1913. Allan Kirby's father, Fred Morgan Kirby, owned a successful five-and-dime store chain that merged in 1911 with a similar business founded by two Woolworth brothers. The building was designed by Smith and Thaete of Philadelphia and built in 1963. Its style echos that of Pop Hall, built forty years earlier. It is located at the southwestern end of the Bowl and includes a spacious theater foyer, an 865-seat auditorium, a full stage with an extensive fly system and orchestra pit, dressing rooms, a costume shop, a set-building shop, a lounge, a dance studio, two acting studios, and a small café.

Above: Noyes History Center. This building was designed by the Hillier Group of Princeton in 1999 and was named for Jansen Noyes, class of 1905. He was chairman of the investment banking firm that became known as Hornblower & Weeks-Hemphill Noyes. This building, located between Dawes and Reynolds, was the school's math and science center until 1998. It is now used by the History Department. In addition to academic facilities, the center houses the registrar's office on the second floor and, on the first, the Jigger Shop, which sells school supplies, textbooks, clothing, and snacks. The shop is an old Lawrenceville landmark that used to be located in town and was best known for its jigger-scoop ice cream servings.

Above and opposite: Bunn Library. The school's official library was designed by Graham Gund and opened in 1996. It incorporates much of the feeling of the Circle Houses of a hundred years earlier. It offers an online catalog, direct access to national databases through 340 public on-site ports, CD-ROM databases, and electronic classrooms. The library's collection encompasses 50,000 volumes, 450 videotapes, over 200 periodicals, and 14 newspapers. The library was a gift from the Bunn family, whose members have included Henry Bunn, class of 1936, and George Bunn, inventor of the fluted coffee filter and founder of the Bunn-O-Matic Corporation. Additional funds came from Harold W. McGraw, Jr., class of 1936, chairman of McGraw-Hill; Arthur G. Hailand, Jr., class of 1934, member of the board of trustees of Lawrenceville and the Hun School; David P. Reynolds, class of 1934, chairman of Reynolds Metals Company; and Artemis A. W. Joukowsky, class of 1950, executive at American International Group and former chancellor of Brown University. The library also houses a special and extensive collection of works by Lawrenceville alumni and masters as well as the school's archives.

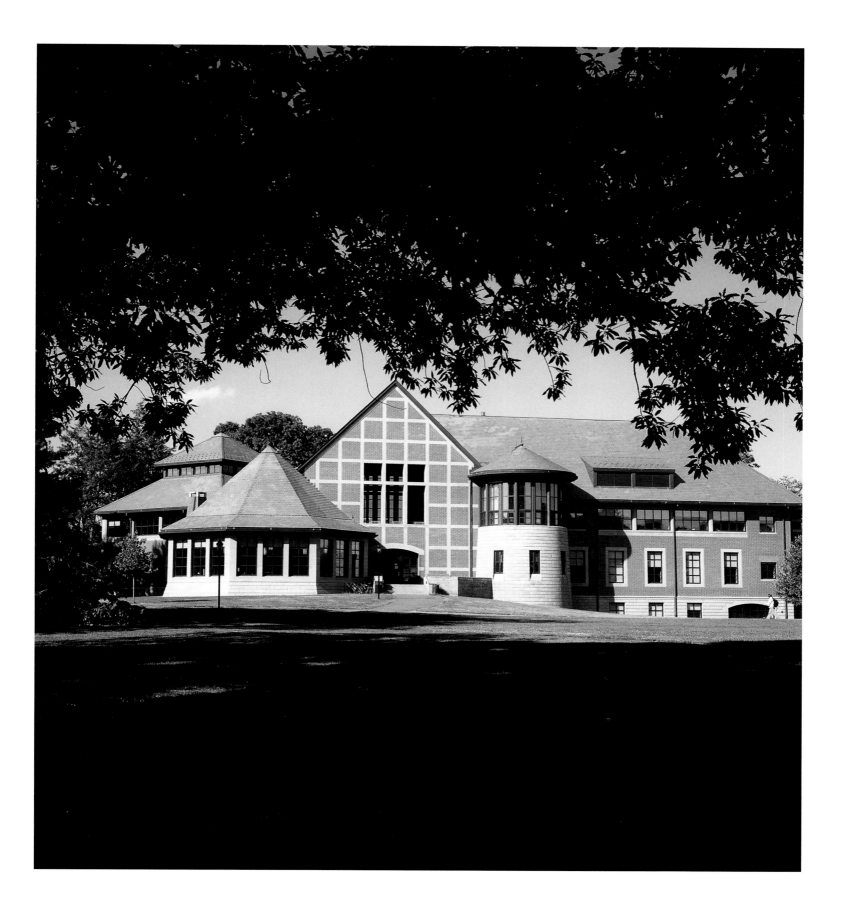

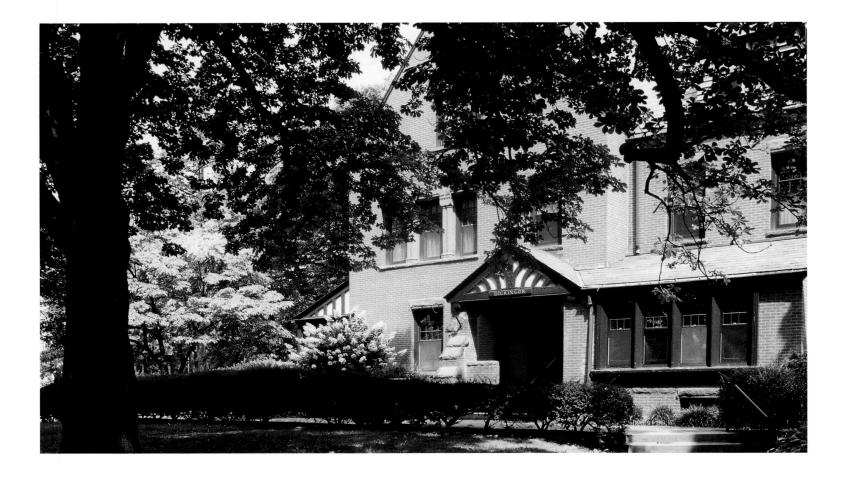

Dickinson House *(above)*, and Cleve House *(opposite, above)*. These were designed by the most noted architectural firm of the time, Peabody & Stearns of Boston.

Dickinson was among the first of the Circle Houses. It was built in 1885 and named in honor of Martha Dickinson, John C. Green's great-grandmother and daughter of Jonathan Dickinson, first president of Princeton College. Over the years the house has been known for academic achievement and gracious living. It was one of the first "cooking houses" and served meals in a pleasing atmosphere.

Cleve House, like Dickinson, was among the first of the five Queen Anne style houses built on the Circle. It was constructed in 1885 to house twenty-four boys plus a housemaster and his family. It is named for John Cleve Green, one of the school's original students.

One of Cleve's most memorable housemasters was Marshall "Marsh" H. Chambers, who lived in the house for thirty-seven years, from 1954 until 1990, together with his wife, Ginnie. She was known for throwing birthday parties and an annual eggnog party just before winter break.

Cleve House was modernized and enlarged in 1960 with a

150th-anniversary gift to the school from Nicholas H. Noyes, a member of the class of 1901 and a brother of Jansen Noyes. Further renovations were made in 2003. Nicholas Noyes was the first comptroller and later chief financial officer of Eli Lilly and Company and also served as director of the Federal Reserve Bank of Chicago.

Opposite, below: McClellan House. This is one of the Crescent Houses, the girls' equivalent of the Circle Houses. Built in 1987, it was a gift of trustee Bert A. Getz, class of 1955, former chairman of the Lawrenceville School board of trustees and president of the diversified investment company Globe Corporation. The house is named for Head Master Bruce McClellan and his wife, Mary Elizabeth. Its architecture, like that of the relatively new Bunn Library, is tastefully in keeping with the appearance of its neighbors of a century earlier. McClellan's house colors are purple and yellow, displayed on its flag with a yellow thistle that is sometimes mistaken for a pineapple. The thistle's true meaning is just one of the mysteries known only to McClellan girls.

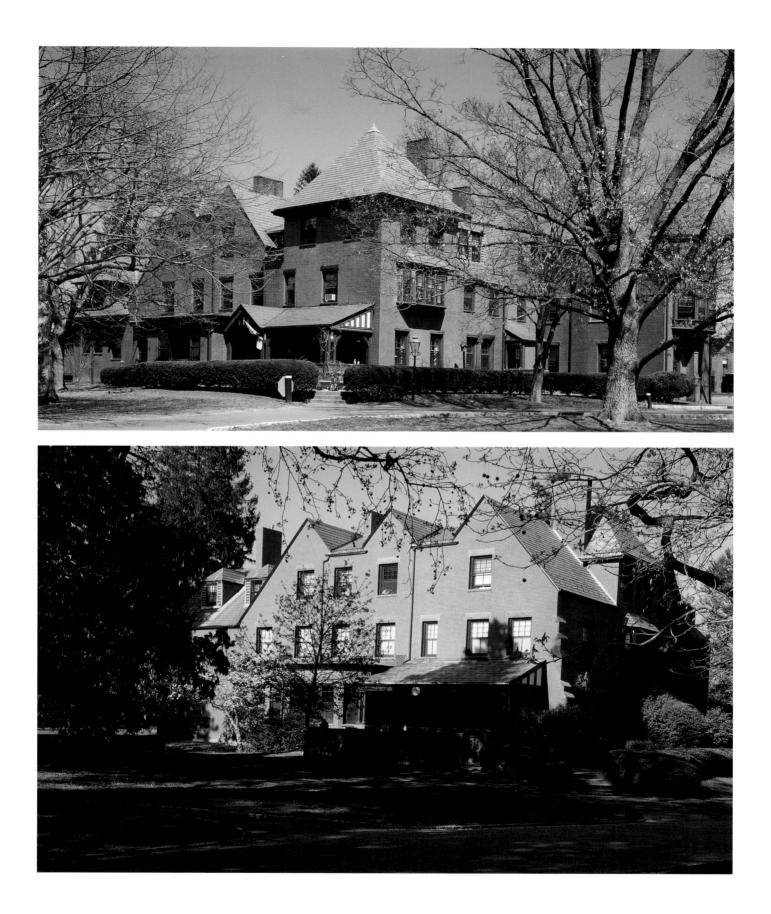

Above: The pond and the back of Raymond. One of the school's largest and most useful community service projects took place in 1832, when students dug Lawrenceville's pond to provide a reservoir of water in case of fire in the village. The pond served as the primary bathing facility for the boys until the Bath House was built in 1882. It also provided an opportunity for ice-skating during the cold winter months.

Today, the pond is used as an ecology laboratory for environmental studies.

Opposite: Eglin Memorial Track and Lavino Field House. The track was dedicated on September 25, 1987, to Thomas W. Eglin, dean of students and master of mathematics.

The six-lane, quarter-mile track surrounding Tiihonen Field in Keuffel Stadium is used by the boys' and girls' track teams and is the start and finish for cross-country races. The field is named in honor of Laurence H. Tiihonen, who was the school's director of athletics for thirty years, from 1936 to 1966. The stadium was rededicated on November 10, 2007, to the school's legendary head coach Ken Keuffel.

The driving force behind the Field House was Edwin M. Lavino, class of 1905, one of the school's most generous benefactors. He was president of a family business, and in 1947, as head of the school's board of trustees, he set about building Lawrenceville's endowment. But his pet project was the Field House, which he dedicated to the memory of his father. The Field House cost $1.2 million and early visitors were impressed by its scale and opulence.

When it was officially dedicated on Alumni Day on May 19, 1951, before a crowd of 3,700 guests, the *New York Herald Tribune* judged it "the biggest, most expensive and the best prep school athletic plant in the country." Everyone marveled at the separate rooms for varsity basketball and wrestling, the lounge, the press room, the offices for coaches, and the hockey rink off the back. The centerpiece was a vast open space measuring roughly 36,000 square feet, with a floor of hard-packed dirt and a glass roof that rose 44 feet. It was designed for indoor football, baseball, or lacrosse practice, though in the winter months it housed a three-lane, 176-yard board track that quickly came to be known as the fastest on the East Coast.

Also featured was a six-lane, 25-yard swimming pool, with bleachers accommodating over five hundred spectators, an underwater viewing window, and heated benches for the swimmers. Updated along the way to incorporate current needs, the Field House remains today an important focal point in the school's athletic programs.

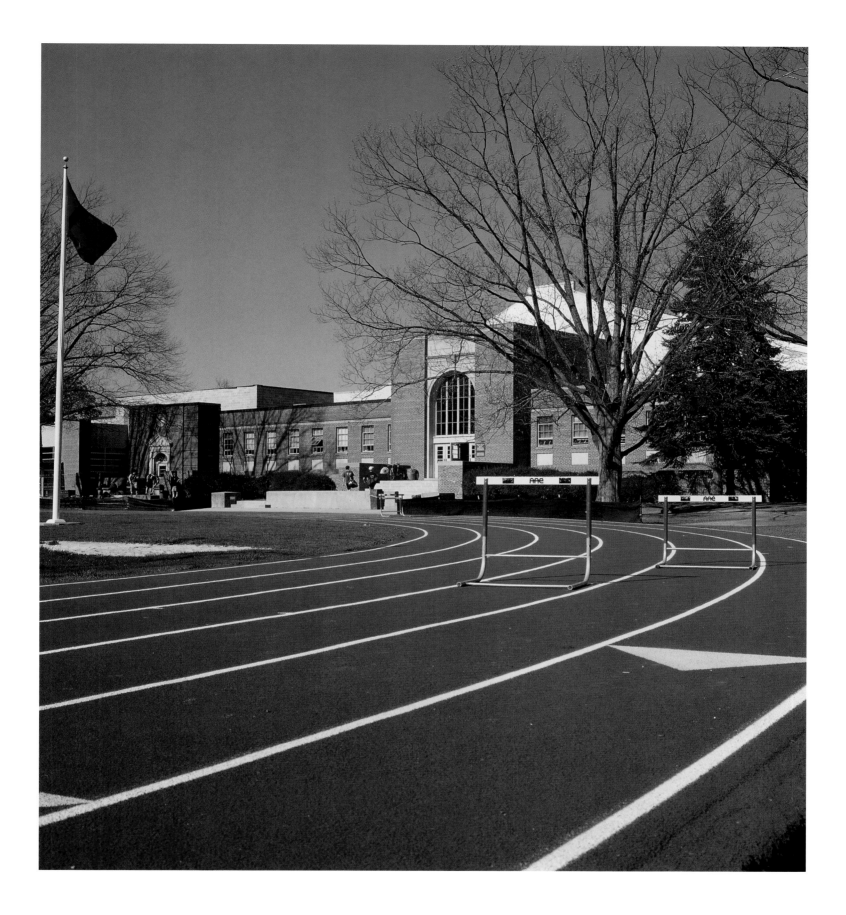

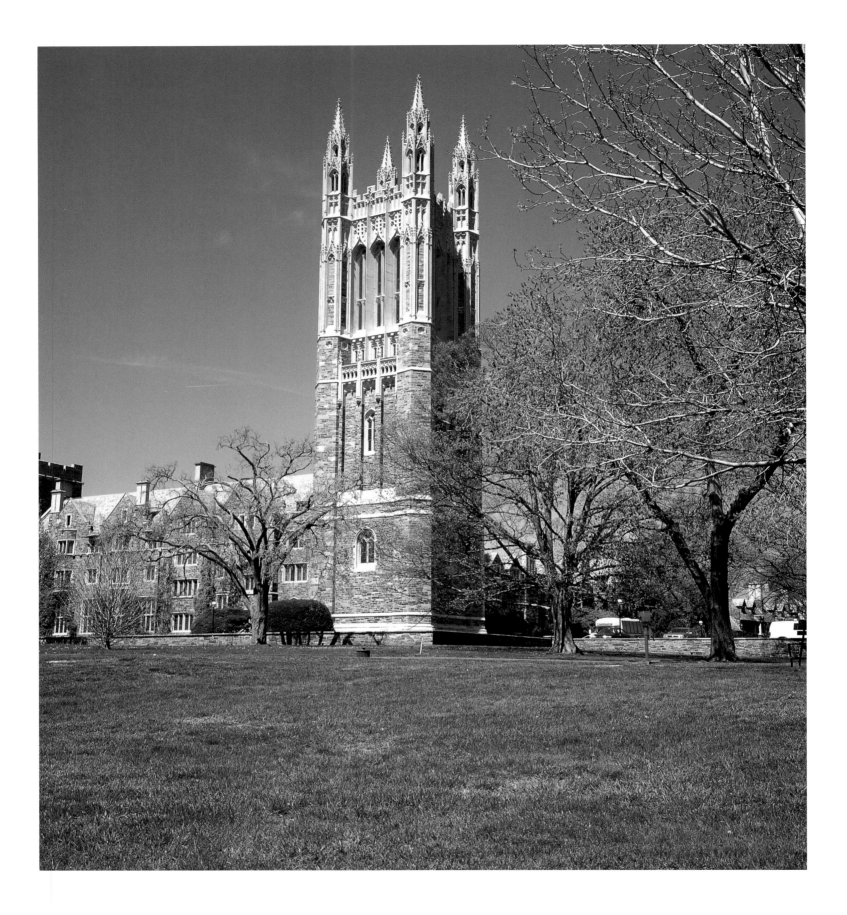

Schools and Research Centers of Princeton

The Princeton University Graduate School

The graduate school was established in 1900, although its foundations may be traced back almost to the university's beginnings. One of Princeton's first graduate students was James Madison, class of 1771. In 1868 James McCosh formed the basis for a graduate school, which opened its doors in 1900 with Andrew West, class of 1874, as its first dean. There may have been differences of opinion between University President Woodrow Wilson and Dean West as to the location of the graduate college. One possible location was on the main campus, as a college within a college, in a spot that ultimately became that of McCosh Hall. But when a gift of land atop the rolling hills of Springdale became available, West turned his sights thither. Isaac Chauncey Wyman, class of 1848, left his estate, including the tract of land, to the university to assist in the development of the school. His father and grandfather had been engaged in the French and Indian War and in the Revolutionary Battle of Princeton. The graduate college was built in 1913 with financial assistance from William Cooper Procter, class of 1883, who was chairman of the firm his grandfather, a candle maker, started in 1837—a firm now known as Procter & Gamble. William Cooper Procter was head of the company from 1907 to 1930. He and his heirs have made significant contributions to the college over the years.

Opposite: Cleveland Tower of the Princeton Graduate College. While Ralph Adams Cram was the university's first Master Planner, appointed in 1907, only the Princeton University Chapel bears his signature on that campus. At the graduate school, however, he had a free hand to design with few limitations. The tower, completed in 1913, is named in honor of Grover Cleveland, who moved to Princeton after his second term as president of the United States and served as a university trustee from 1901 to 1908. It was during this time that he was befriended by Andrew Carnegie, who proposed donating a lake to the university. The tower is patterned after Oxford's Magdalen Tower. At 173 feet, it is a striking presence in the countryside.

In the usage at Princeton, the term "graduate college" refers to the residences and dining halls, while "graduate school" refers to the program of instruction.

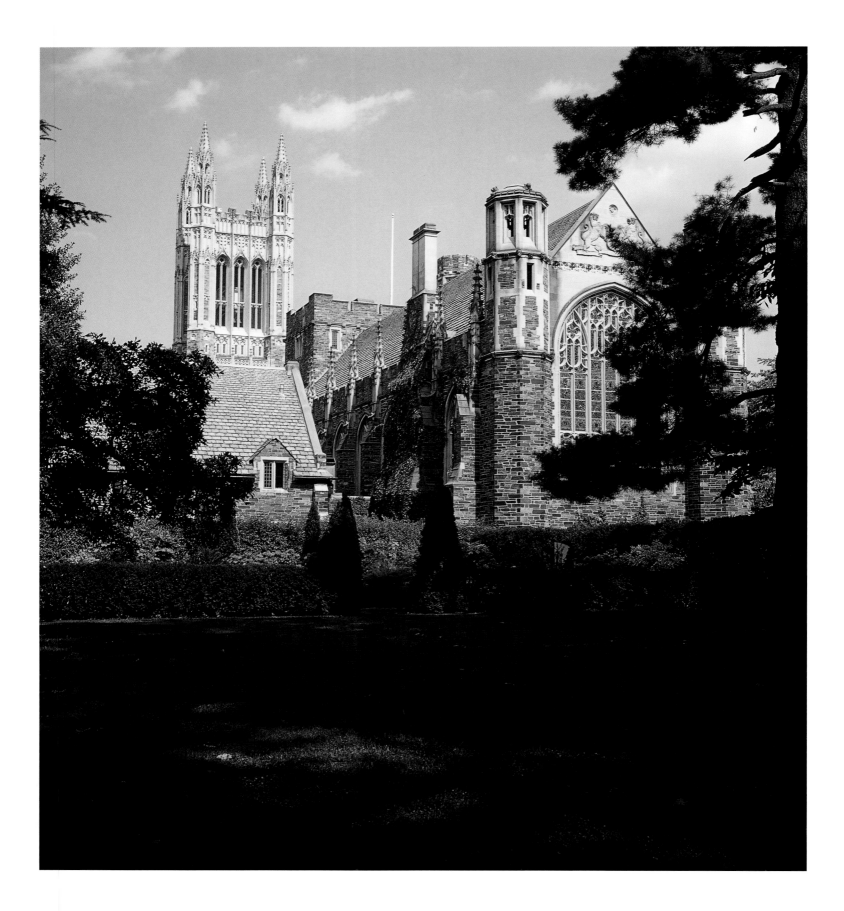

This was the first residential graduate college in the country. The assemblage of handsome buildings was designed by Ralph Adams Cram's firm—Cram, Goodhue & Ferguson of Boston. Cram had been serving as the master planner for the undergraduate campus since 1907 (a position he held through 1927), but he had designed few of its buildings. He saw the designing of an all-new graduate college, with a clean slate and set high on a hill apart from the town and the undergraduate colleges, as an extraordinary opportunity. Referring to the central complex of the graduate college, he wrote, "I have taken enormous pride in this particular building and have tried to make it not only the best thing we ourselves have ever done, but the most personal, as well, and also, if it might be, the best example of Collegiate Gothic ever done in this country." The approach to the graduate college along the road hugging the Springdale golf course is unique. Soaring up ahead is Cleveland Tower, 173 feet above the green of the course. And then, farther up the road, the tower suddenly disappears behind the trees and reappears, majestically soaring over the parking courtyard. The buildings that open up from this entry are the result of close collaboration between Dean West and Cram. They had been to England to study the leafy quadrangles of Cambridge and the great halls of Oxford. To both men, the Gothic style was an expression of high moral values and spirituality.

Thus the grouping of buildings that comprise the graduate college consists of a lofty tower; a great dining hall with a hammerbeam roof, an organ, and stained glass; a refectory; a library; a lounge; and an enclosed English garden with ivies imported from Oxford. Further details include numerous carvings and gargoyles, both inside and out. In a relatively concentrated space, Ralph Adams Cram, encouraged by Dean West and the Procter estate, spared no expense. Current students should treasure this architectural endowment.

Opposite: A rare view of the College. Shown here are the grand Proctor Dining Hall West Window with the Cleveland Tower in the background and the walled gardens in front. This is an unusual view insofar as most students and visitors approach the college from the East, up the graceful drive by the golf course.

The tower was a gift in honor of Grover Cleveland, the twenty-fourth president of the United States, who retired to Princeton. He was also a university trustee and friend of Dean West. Funds for the tower were received from public subscription opened up by Dean West. No gift was too small, including pennies from school children nation-wide. A similar approach to raising funds for the base of the Statue of Liberty had been successful. The class of 1892 gave the five-octave carillon that was installed in 1922 and restored in 1994 with the addition of eighty tons of new bells. The design of the tower is intriguing. It is not a single shaft but is divided into four elements, each appearing lighter as they progress, with the stonework stepping up from rough, darker argillite to smooth pale limestone.

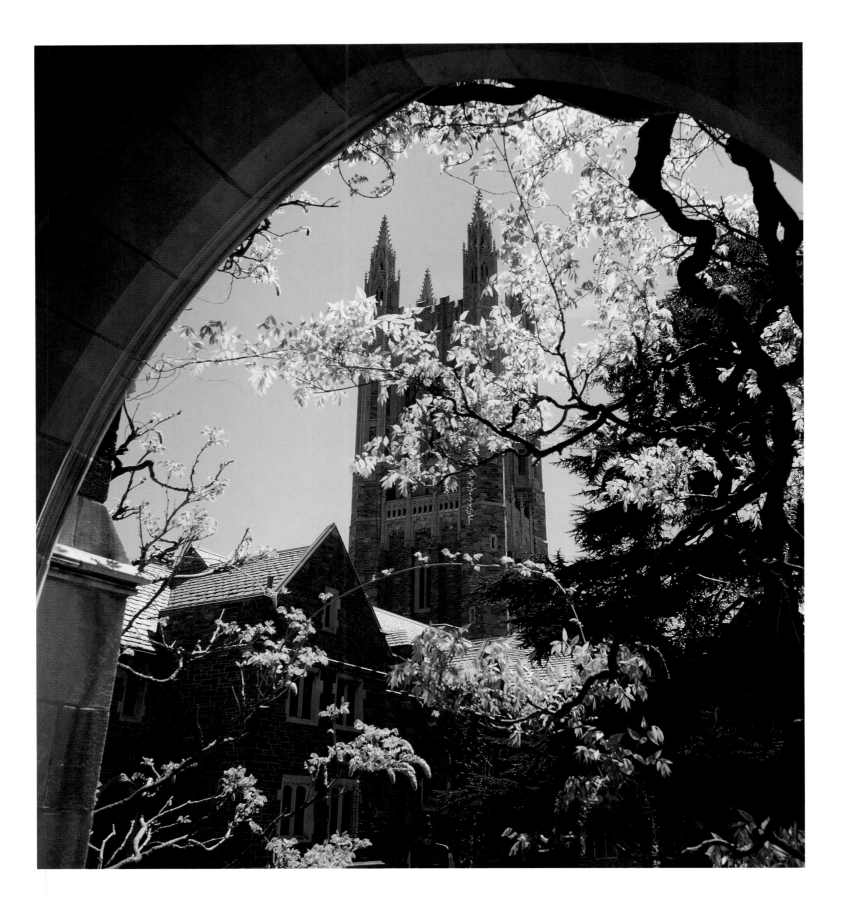

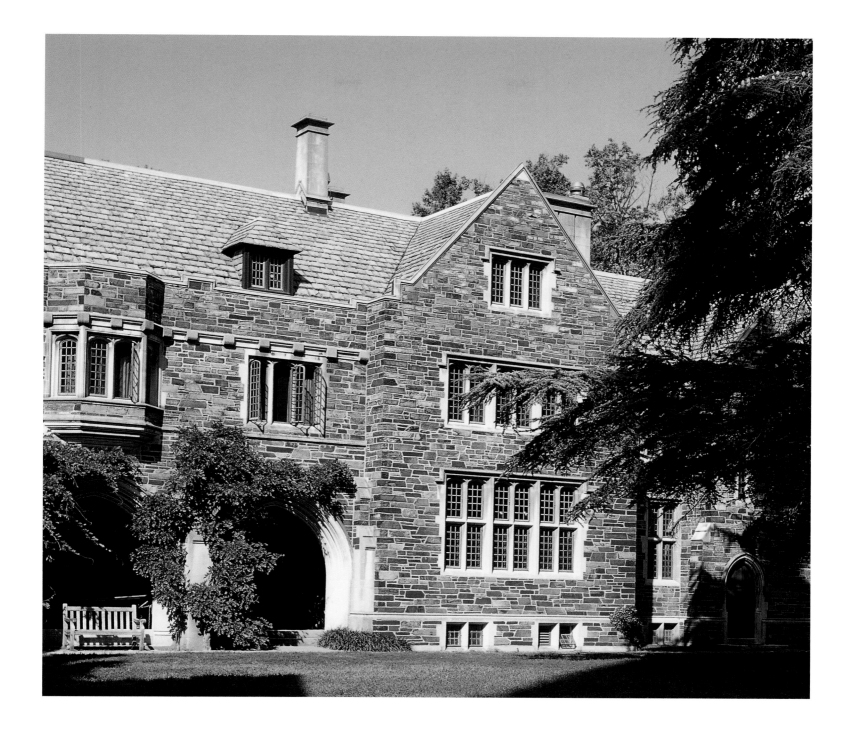

Opposite and above: Thomson Court. This is the college's main quadrangle. It was named in honor of Senator John R. Thomson, class of 1817, by his widow, Mrs. J. R. Thomson Swann, one of the college's first benefactors. The suites for graduate students all have their own fireplaces and are located in two tiers, opening onto the central courtyard. The stairs and entryways to the suites are all slightly different, by Cram's design, and all entryways are connected underground.

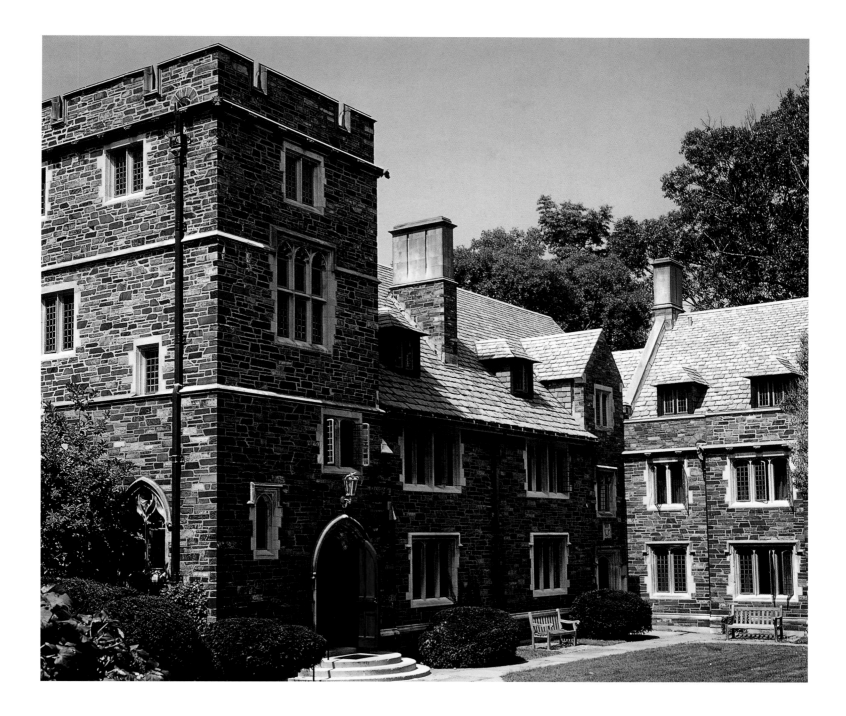

Opposite: Presiding over this extensive space in Thomson Court is an imposing bronze statue of Dean West, designed by R. Tait McKenzie and donated by William Cooper Procter. The statue was dedicated in the spring of 1928.

Above: North Court. This quadrangle known as the North Court was added in 1927, with contributions from William Cooper Procter together with university funding.

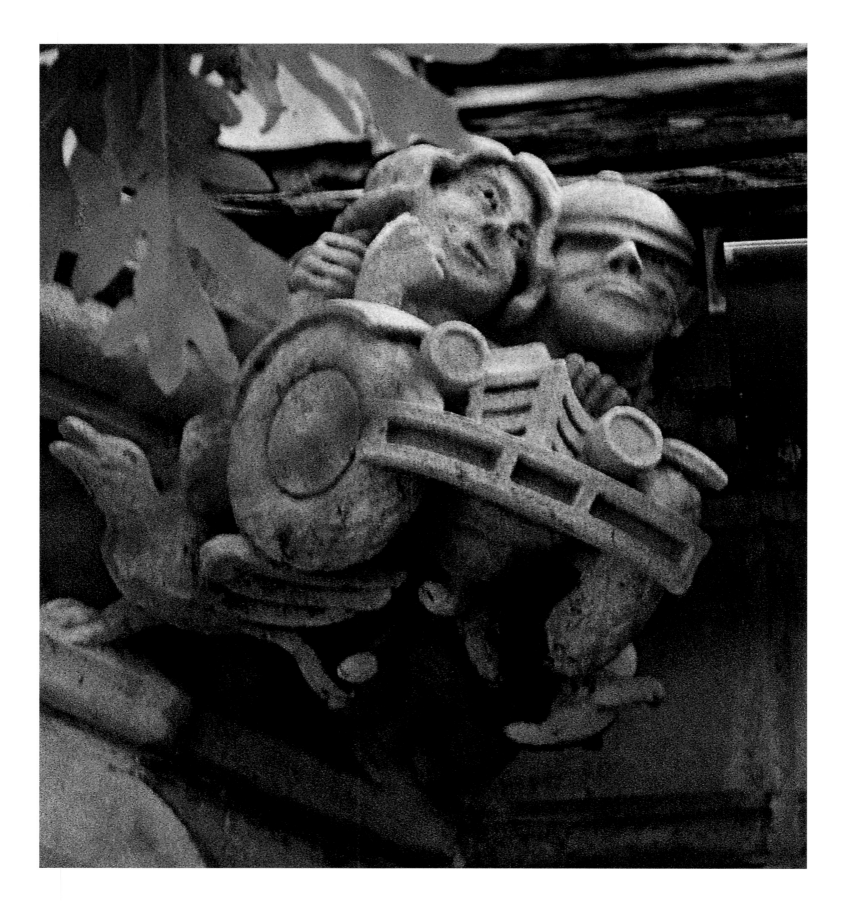

Gargoyles at the graduate college. *Opposite:* A favorite of ours is *Joy Ride,* which sums up the fun our family has had in creating this book. All of life is a journey, a ride. And what could be more pleasant than a ride of joy—a ride in an open-topped car? The silliness of the metaphor becomes more meaningful when pondered.

Here is how a June 8, 1927, article in the *New York Sun* described *Joy Ride:*

> *Too long now have the gargoyles adorning the buildings on the Princeton campus represented grotesque and mythical figures, in the opinion of the architect designing the new Graduate College addition. Therefore, the architect has introduced some ideas of his own. In this instance, it's a student abandoning care in favor of an automobile and a gay companion. She's quite modern, this young lady. Note the cigarette, the bobbed hair, and the expression of unconcern as her 'boy friend' manipulates the steering wheel with a single dexterous hand. It might be added, too, that, in view of the recent ban on student-owned motor cars, this particular gargoyle is an especially significant commentary.*

Above and right: Adjacent to *Joy Ride* are gargoyles of students reading under a gooseneck lamp and also listening to the sounds of a wind-up Victrola.

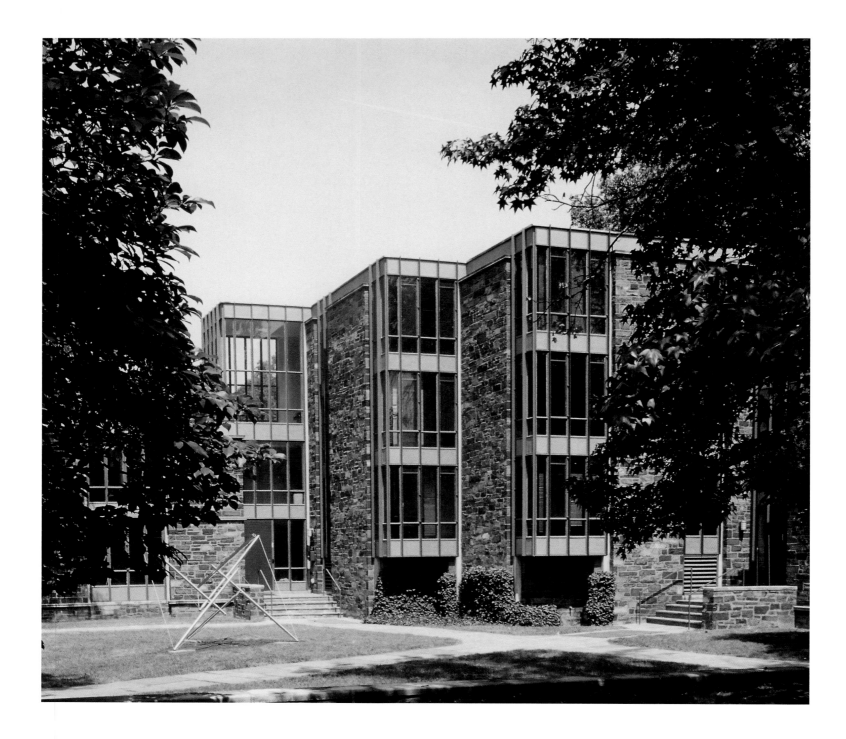

Procter and Compton Quadrangles. Two additional quadrangles built northwest of the original group in 1963 are named for Procter and three illustrious alumni of the graduate school—the Compton brothers, Karl, Wilson, and Arthur. Unsurprisingly, they are commonly known as the "New Graduate College." These represent a modern architectural interpretation of the basic elements of the old graduate college. They were designed by Ballard, Todd & Snibbe.

The sculpture *(opposite)* is Gaston Lachaise's *Floating Figure* from 1935.

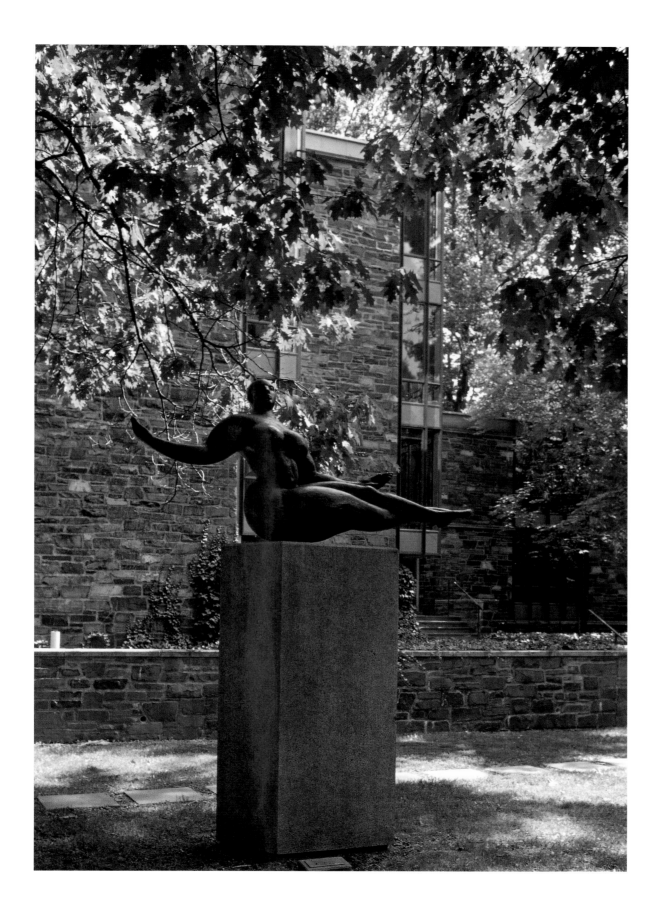

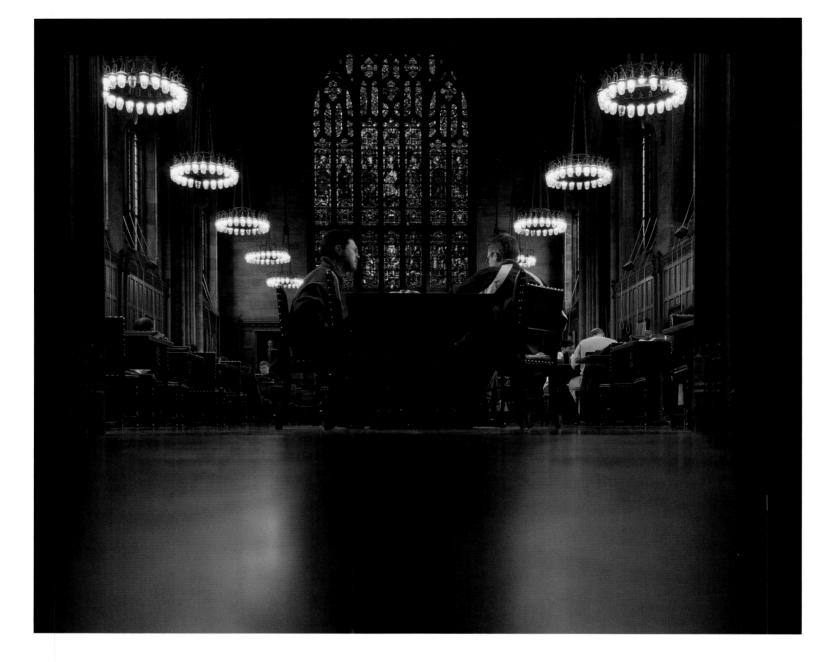

Procter Hall is one of the jewels of the graduate college. With its tall ceilings and stained glass windows, it is essentially a cathedral. Working together, West and Cram succeeded in designing a non-church church. This is the college's formal dining hall and chief public room, admired by experts in the field as a distinguished example of Collegiate Gothic. The great stained glass window faces west in order to capture the light of the setting sun at dinnertime. Few sectarian organizations have such lofty monuments. This celebration of the graduate school community surpassed even the grand stained glass tribute to the legal profession at the Lawyers' Club of New York at 115 Broadway. The Procter Hall window was donated by William Cooper Procter in memory of his parents. Once a month, Procter Hall serves as the splendid setting for the college's tradition of convening faculty, deans, and students at the "high table."

The High Table tradition was established by Dean West after the tradition of the English colleges at Oxford and Cambridge. Select students and distinguished masters and

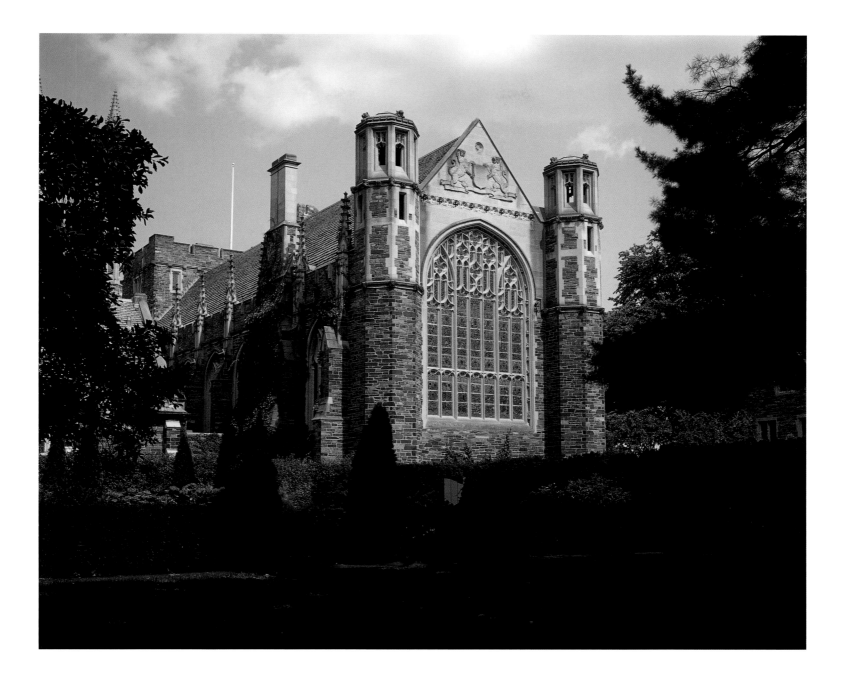

lecturers sat together during the dinner hour and discussed important matters among themselves.

Until the early 1970s, dinner in Procter Hall was at a predetermined time and opened with an appropriate prayer or grace in Latin. Graduate students were required to wear academic gowns to dinner. With the master or dean presiding, High Table brought together selected students, faculty, and guests of the administration.

High Table is now a monthly event. The dean of the graduate school invites faculty members and students to attend. The evening begins with refreshments at Wyman House. After a talk from an honored guest, the group adjourns to neighboring Procter Hall and assembles at the high table. The dean of the graduate school sits at the middle of the table just below the portrait of Dean West. After dinner, the dean leads the party back to Wyman House for dessert and coffee. The purpose of High Table is to provide an additional opportunity to bring faculty and graduate students together.

Above: Wyman House, completed in 1913, is the dean's residence. As with the other structures, it was designed by Ralph Adams Cram and the gardens were designed by Beatrix Farrand. She was the university's principal landscaper for many years, and the graduate college was her first major undertaking. The house is named for Isaac Chauncey Wyman, class of 1848. Dean West took a particular interest in the plans for Wyman House, which was designed in a Tudor style to stand apart from the majestic west gable of Procter Hall.

Opposite: The walled garden next to Wyman House incorporates many of the principles of formal English garden design, including a shady quadrangle and parterres planted with seasonal flowers. The ivy comes from University College at Oxford. In 2005 the garden was recreated by Lynden Miller of New York, who has also been responsible for the successful restoration of the Conservatory Garden of Central Park and the redesign of Bryant Park's plantings.

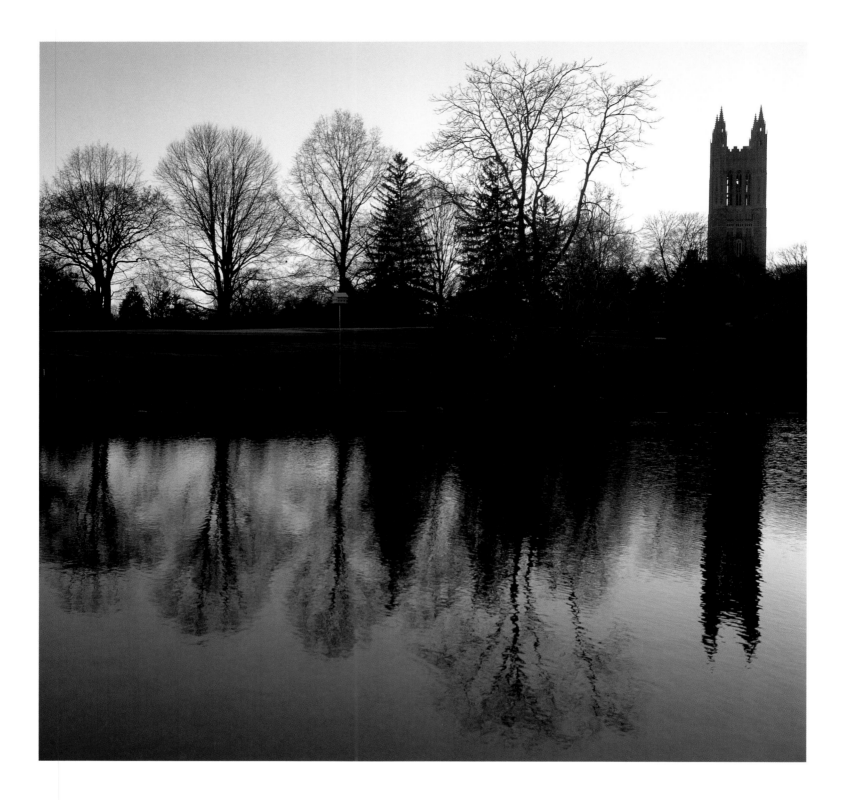

Above: The pond on the Springdale golf course. From all directions, Cleveland Tower is a majestic presence. Driving along Washington Road from US Route 1, it is the first structure one notices. This view shows the reflective pond just east of the graduate college. *Opposite:* Facing the pond from the other side is the former Princeton Inn, now Forbes College.

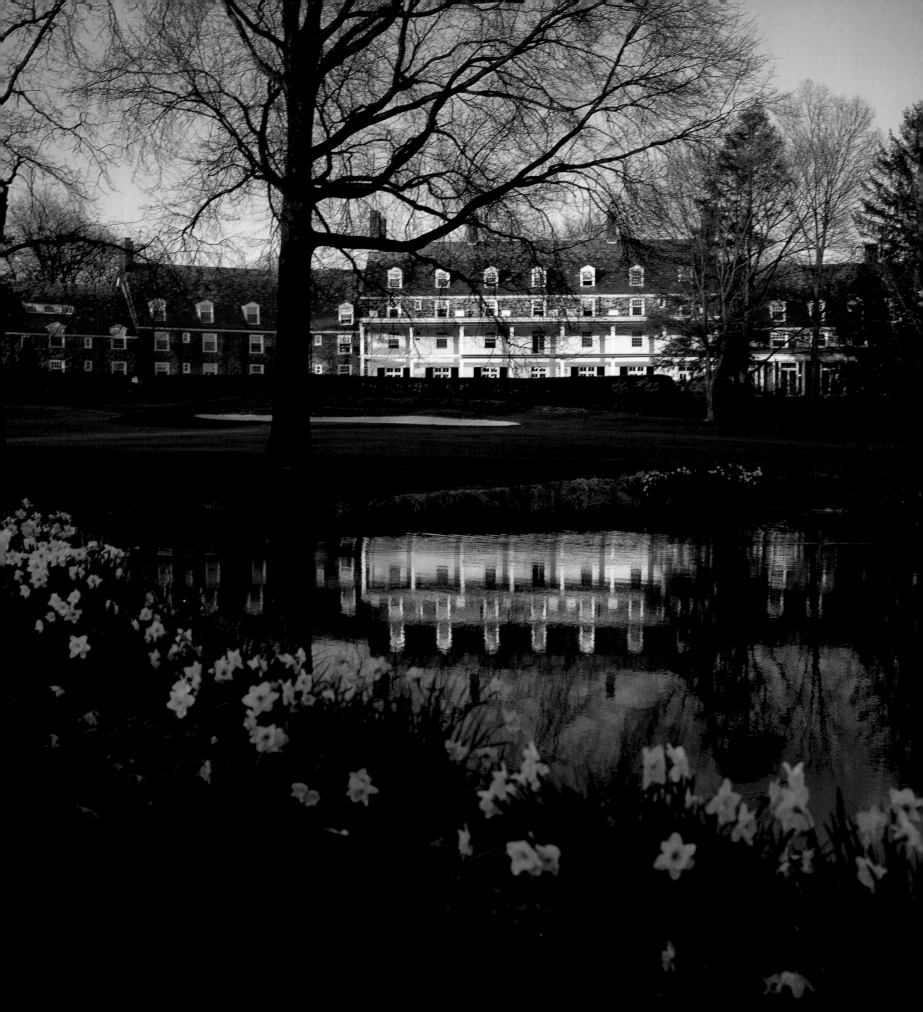

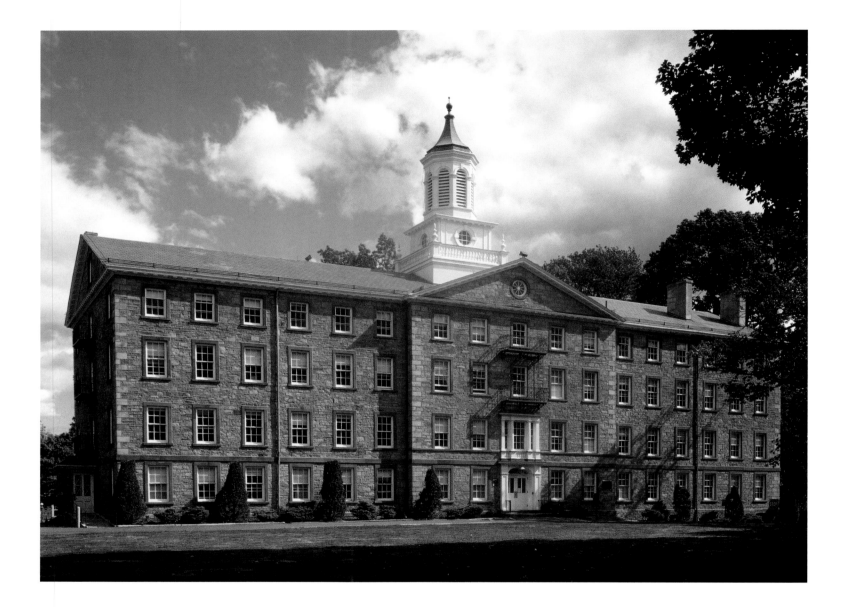

Alexander Hall was the first building built by the Presbyterian Church in the United States for seminary purposes. Alexander Hall is named for Rev. Dr. Archibald Alexander, Princeton Theological Seminary's first professor. The building was designed by John McComb, Jr., who also designed New York City Hall and "Old Queens" at Rutgers University. It resembles Nassau Hall but is more elegantly proportioned. Students and faculty moved into this handsome building in 1817.

Princeton Theological Seminary

Princeton Theological Seminary was founded in 1812 by the General Assembly of the Presbyterian Church. It grew out of the College of New Jersey (also founded by the Presbyterian Church and now known as Princeton University). With the westward expansion of the country, a more formal and concentrated approach to developing young ministers was deemed necessary. Following the example of the Congregationalists, the Presbyterian Church drew up a plan for a seminary, establishing a dedicated full-time faculty, gathering a major theological library, and providing a setting where future pastors of the church could come to know one another and form lifelong friendships.

Rev. Dr. Archibald Alexander of Philadelphia was elected the first faculty member, and the first classes were held in his rented Princeton home in August 1812, with three students attending. By the following May there were fourteen students and the highly learned Rev. Dr. Samuel Miller of New York was called to be the second professor. The facilities of Nassau Hall were placed at the disposal of the fledgling institution until the seminary could move into its own newly constructed quarters on Mercer Street in 1817. This was an era when professional schools—law and medical schools as well as divinity schools—began to play an increasingly important role in the American higher education system. The seminary flourished with the support of the Presbyterian Church, eventually becoming the largest theological school in the nation. The College of New Jersey, on the other hand, went into serious financial decline and only survived through the support of its alumni.

A distinguished group of presidents have served the seminary over the years, including Francis Landey Patton (1902–1913), a former member of the seminary faculty who returned after having been president of Princeton University, and J. Ross Stevenson (1914–1936), who expanded the institution's vision and program. Then came John A. Mackay (1936–1959), who enlarged the faculty and expanded the campus. He also ushered in a new ecumenical era for theological education and was one of the founders of the World Council of Churches. Following Dr. Mackay was James I. McCord (1959–1983), who created the first center of continuing education at a theological seminary. He was also responsible for the establishment of full endowments for twenty-six faculty chairs, and he oversaw the construction and renovation of major campus residences and academic facilities. He led many councils on religious topics both nationally

and overseas. Upon retirement, Dr. McCord won the 1986 Templeton Prize for "affirming life's spiritual dimension" and for his contributions to the study of religion. Dr. McCord donated the prize funds to assist in the establishment of the Center of Theological Inquiry, located adjacent to the seminary campus. Thomas W. Gillespie was the seminary's next president, serving from 1983 until 2004. He increased the size of the faculty, established nine new endowed chairs, and significantly lowered the student–faculty ratio. Dr. Iain R. Torrance became the seminary's sixth president in 2004, after serving as moderator of the General Assembly of the Church of Scotland and as dean of the Faculty of Arts and Divinity at the University of Aberdeen. He has led the seminary's curriculum changes and has strengthened the school's governance. He has fostered the growth of information technology at the seminary and has overseen the development of a new strategic plan for the institution.

Affiliated from the beginning with the Presbyterian Church and the wider Reformed tradition, Princeton Theological Seminary is today a denominational school with a worldwide constituency. This is reflected in the faculty, in the curriculum of studies, and in the student body. There are currently over six hundred students enrolled in six degree programs.

Opposite: Brown Hall, a student residence, was designed by J. P. Huber and was given by Isabella Brown, the widow of George Brown of Baltimore, who was a wealthy investment banker and a main figure in the founding of the pioneering Baltimore & Ohio Railroad, the first chartered railroad in the United States. Built in 1864 and 1865, Brown Hall was the only substantial building constructed in Princeton during the Civil War.

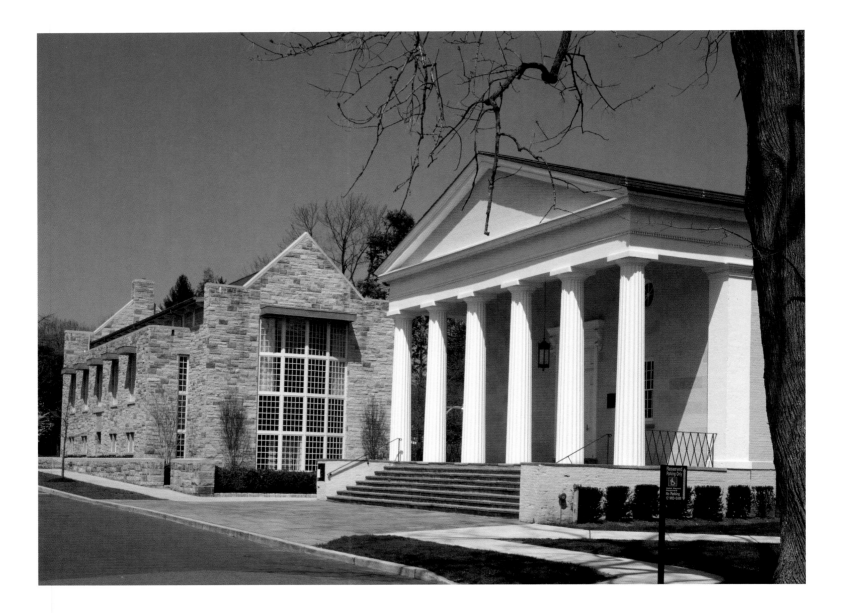

Miller Chapel and Scheide Hall. This striking chapel was designed by Charles Steadman in 1833. It was originally located near the seminary's Alexander Hall and was moved to its current site in 1933. Dr. Samuel Miller, for whom the chapel is named, was the seminary's second professor. Miller Chapel bears a striking resemblance to Nassau Presbyterian Church in town, which was also designed by Charles Steadman. In addition, Steadman was responsible for the construction of many of the fine houses along Alexander Street and elsewhere in this section of Princeton.

Also seen in the photograph is one of the seminary's most recent buildings, Scheide Hall. It provides a striking contemporary companion structure to Miller Chapel and houses offices for the minister of the chapel, the director of music, and the director of student counseling. A floor-to-ceiling bay window at the south end of Scheide Hall looks out onto a small meditation garden and amphitheater between the two buildings. The bright and airy Gambrell Room on the second floor provides rehearsal space for the seminary choirs and offers a venue for small musical and dramatic productions or receptions. It was a gift of former seminary trustee and philanthropist Sarah Belk Gambrell. William H. Scheide, for whom the hall is named, also served many years as a trustee, as did his father before him. The lead architect of Scheide Hall was Michael Farewell of Ford Farewell Mills and Gatsch. The building was dedicated in 2000.

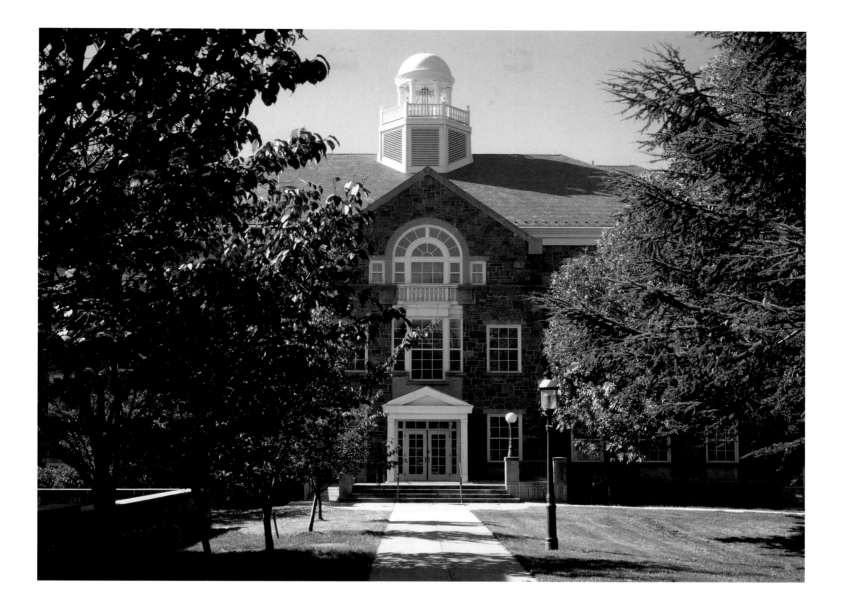

Templeton Hall. This building was designed by Ewing, Cole, Cherry and Parsky and completed in 1989. It houses many of the seminary's administrative offices and a state-of-the-art recording studio and media center. The designers chose an appealing neoclassical design with a front featuring three distinctive architectural treatments on each of the three floors and with a domed cupola on top. The building is named for John M. and Irene R. Templeton. Knighted in 1987 by Queen Elizabeth II, Sir John was a trustee of the seminary for thirty-seven years, from 1951 until 1988. From the 1940s through the 1960s he was a well-known and successful investor who regularly devoted half of his working hours to religious and charitable work. The Templeton Funds were among the best-performing investment funds of the era. But Sir John's philosophy was even more noteworthy. Each meeting of his investment committee began with a prayer for guidance. And he made sure that the Templeton Prize—awarded for exceptional contributions to affirming life's spiritual dimension and to understanding the many and diverse manifestations of God—was more financially rewarding to the recipient than the Nobel Prize.

What is the best way to live? How large is God? How are finite beings related to the infinite? What was God's purpose in creating the universe? How can we be helpful? These ageless questions can inspire people today just as they have inspired people throughout the ages, linking the human soul to philosophy and to the love of wisdom.

SIR JOHN TEMPLETON

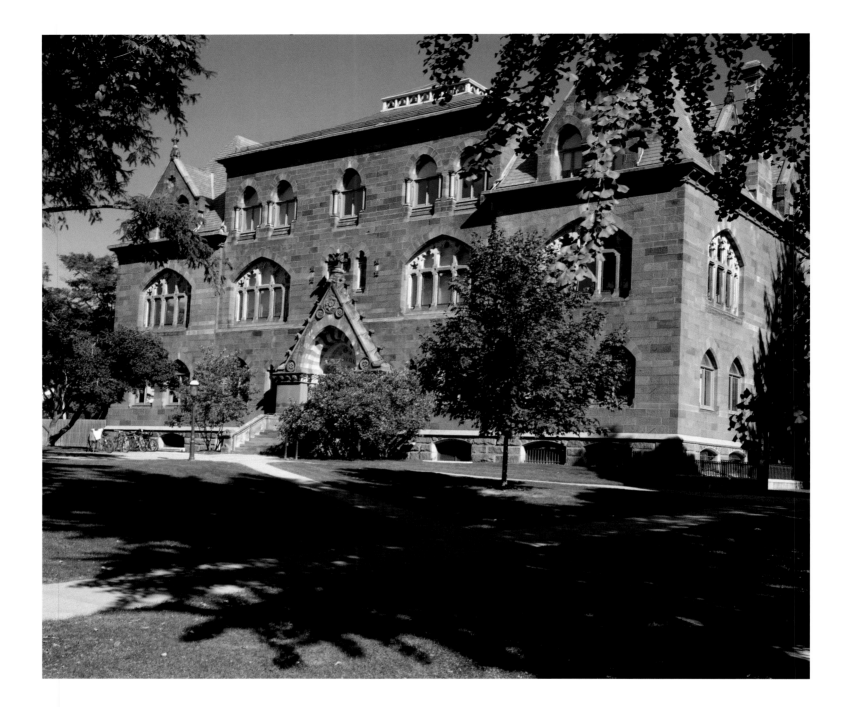

Stuart Hall was designed by William Potter and built in 1876. It is one of the few truly Victorian buildings on either the seminary's or the university's campus. At the time of its construction it was celebrated for both its workmanship and materials, and it was noted for its imposing presence. Architect Potter attended to all aspects of the building, including ventilation. The main staircase is located in the middle of the building to circulate fresh air from the ground floor to the towers above. In addition, the ceilings are high and have large windows that can be opened. The Stuart brothers, for whom the building is named, were New York merchants, philanthropists, and generous donors to both the seminary and the university. Among their many gifts is Prospect House—known simply as "Prospect"—and its surrounding grounds on the university campus, donated to the university as a home for its presidents.

Princeton Seminary libraries. The corner of Mercer Street and Library Place has long been the site of the seminary's various libraries. The first freestanding library in Princeton was built on this site in 1843. It was a gift from James Lenox, a Presbyterian elder and philanthropist, who owned a personal library that was one of the largest in the country at the time and that later became one of the founding collections of the New York Public Library. By 1879 the seminary needed a second library building. It, too, was donated by James Lenox and it was located to the rear of the first library. In the 1950s the two structures were razed (despite much local opposition) and replaced with the more modern Speer Library, which was designed by G. A. and G. T. Light and dedicated in 1957.

Shown in this photograph is the Henry Luce III Library, designed by Alan Chimacoff and dedicated in 1994. It was added at the back of Speer Library to provide additional library space and study areas for doctoral students and visiting scholars. A capital campaign was launched in 2009 to raise funds for a new library to be constructed at the traditional Mercer Street and Library Place location in connection with the seminary's two hundredth anniversary in 2012. Though the buildings change, the Princeton Seminary Library remains one of the preeminent theological library collections in the world.

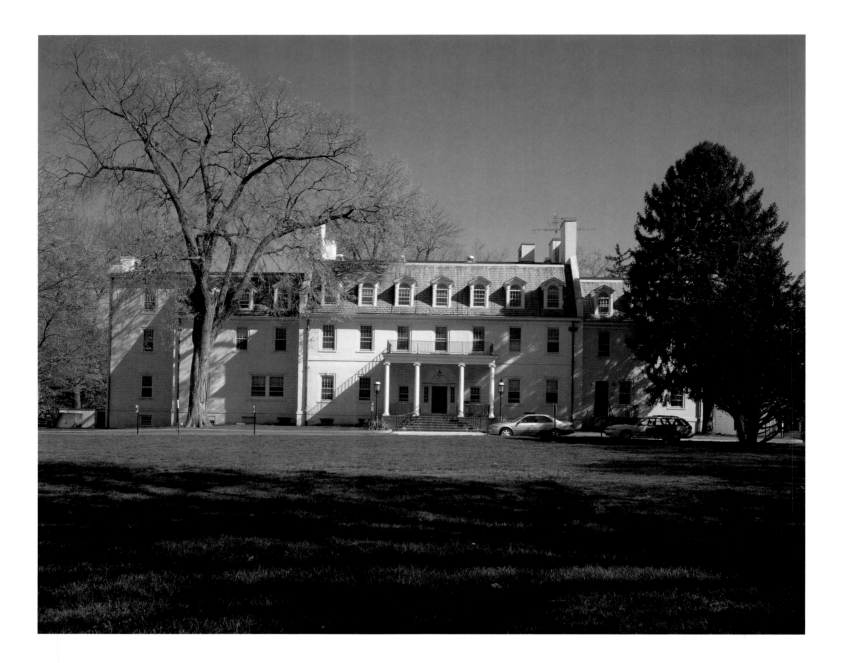

Tennent Campus, including Tennent Hall (*above*), Roberts Hall (*right*), and the Whiteley Gymnasium. This campus is located the former property of the Edgehill School, a prominent private in the decades before the Civil War. In 1869 it relocated and sold its property to private hands. In the 1920's the property became a location for a school again, this time the Hun School for Boys. The central building was destroyed by fire in 1925 and was reconstructed under the direction of Rolf W. Bauhan, who also designed the flanking classroom, dormitory and gymnasium buildings. In 1943 the property was purchased by the Seminary. The Tennent College of Christian Education, which trained women for professional Christian service, was relocated here from Philadelphia. Tennent Hall, as the central building was re-named, became the Seminary's first dormitory for women. Roberts Hall, named for Dr. Edward H. Roberts, Dean of the Seminary from 1945 until 1954, provided classroom space and offices for the Seminary's Christian Education program, and its north and south wings provided dormitory space for married couples. Today Roberts Hall and its wings have been renovated into apartments which often house the families of some of the Seminary's international students, among others.

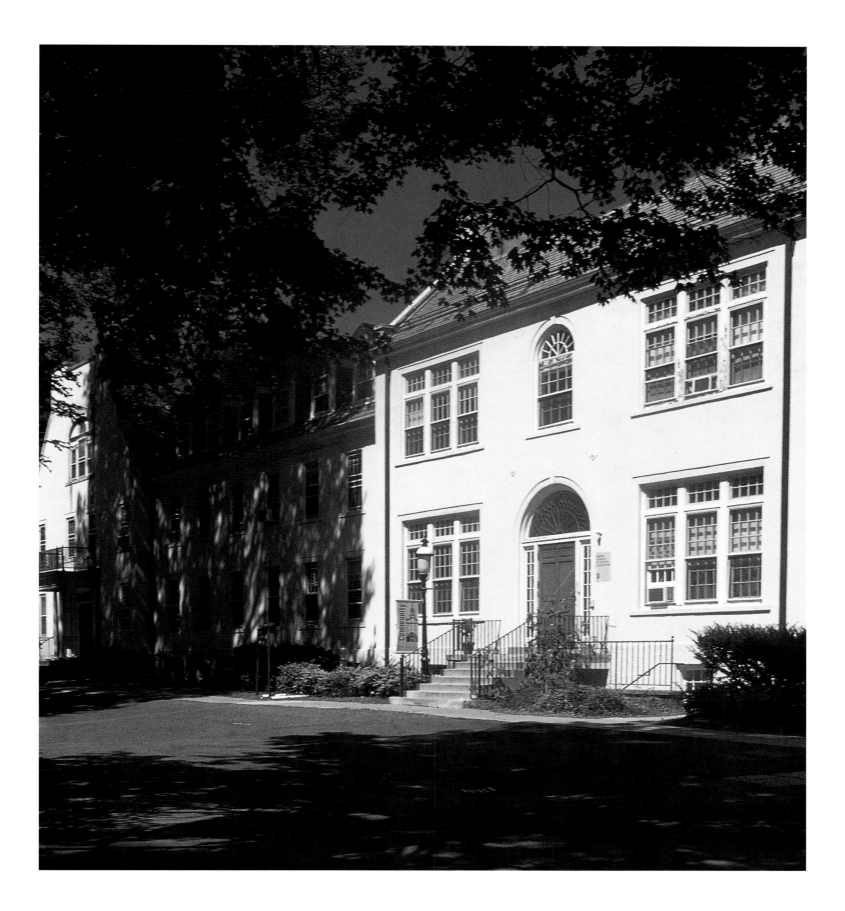

Left: "Springdale" was built in the early 1850s as a wedding gift to Richard Stockton from his father, Commodore Stockton of "Morven." It is named for the family farm that now accommodates the Springdale Golf Club. Unlike earlier Stockton homes, which are expressions of Georgian symmetry, this one is of a more irregular, romantic design. The architecture is attributed to John Notman. He also designed "Prospect" at the center of the Princeton University campus and nearby Lowrie House—now the university president's residence—and he oversaw the rebuilding of Nassau Hall after a fire in 1855. "Springdale" was purchased by the seminary in 1903 and since that time it has served as the home of all presidents of the Princeton Theological Seminary.

Opposite above: "Hodge House." This house was designed by John Haviland and completed in 1825 for Charles Hodge. Charles Hodge would go on to teach the students at Princeton Theological Seminary for the next fifty-eight years and became one of the most respected theologians of his generation. British-born John Haviland had moved to Philadelphia at the urging of John Quincy Adams, whom he had met at the court of the Russian czar in Saint Petersburg. This was one of Haviland's earliest American commissions. Over the front door of "Hodge House" is a central Palladian window with a sunburst motif— a rather sophisticated element for Princeton at the time and one not encountered elsewhere in the community. "Hodge House" is now a residence for a senior faculty member.

Opposite below: "Archibald Alexander House." This handsome residence was built in 1818 for use by the seminary's first professor, Archibald Alexander. It was a simple yet strong Georgian structure that sent a statement of dignity from the new institution. Oversight of its construction is usually attributed to John McComb, Jr., who was supervising the work on Alexander Hall while this house was built next door. It remains a faculty residence.

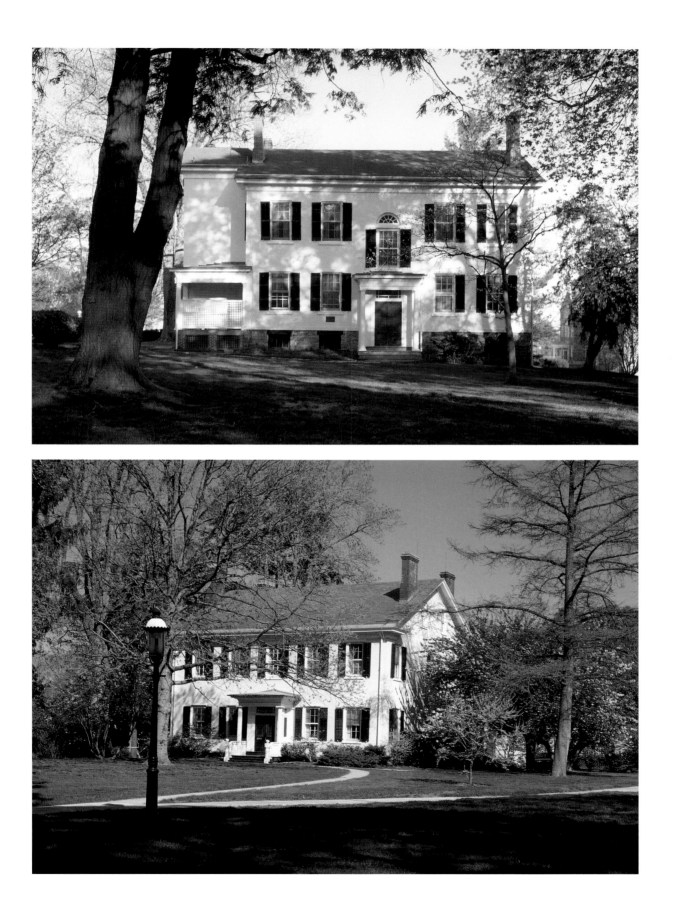

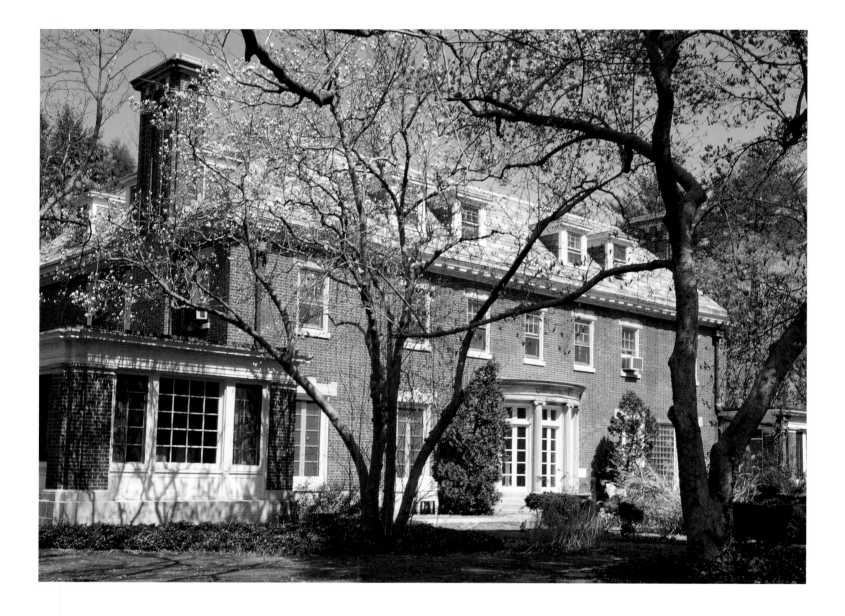

The Aquinas Institute

The headquarters of this Catholic study center are located at 65 Stockton Street. The house was originally intended as a residence for Archibald Russell, but it was completed in 1907 for Henry Lane Eno, who was an associate professor in psychology at the university and gave the funds for the construction of Eno Hall. Thomas Mann, winner of the 1929 Nobel Prize in Literature, lived in this house when he was a lecturer at the university. It was a short walk from the home of Albert Einstein, with whom Mann had been friends in Germany. The Aquinas Institute was formed by Dr. Hugh Taylor, dean of the Princeton Graduate School, and by David McCabe, one of Woodrow Wilson's preceptors. It was organized in 1928 as the Catholic Club, open to students but separate from the university. The institute is currently under the aegis of the Office of Religious Life at the university and is described as Princeton University's Catholic Chaplaincy. Catholic students now make up the largest religious group—approximately 25 percent—of the undergraduate student body. Throughout the year, Aquinas provides various opportunities and resources to help students grow closer to Christ, individually and as a community, irrespective of their background or knowledge of Catholicism. It offers liturgy studies, sacraments, Bible studies, the Rite of Christian Initiation of Adults (RCIA), community service, retreats and pilgrimages, lectures, musical gatherings, dinners, and overall fellowship.

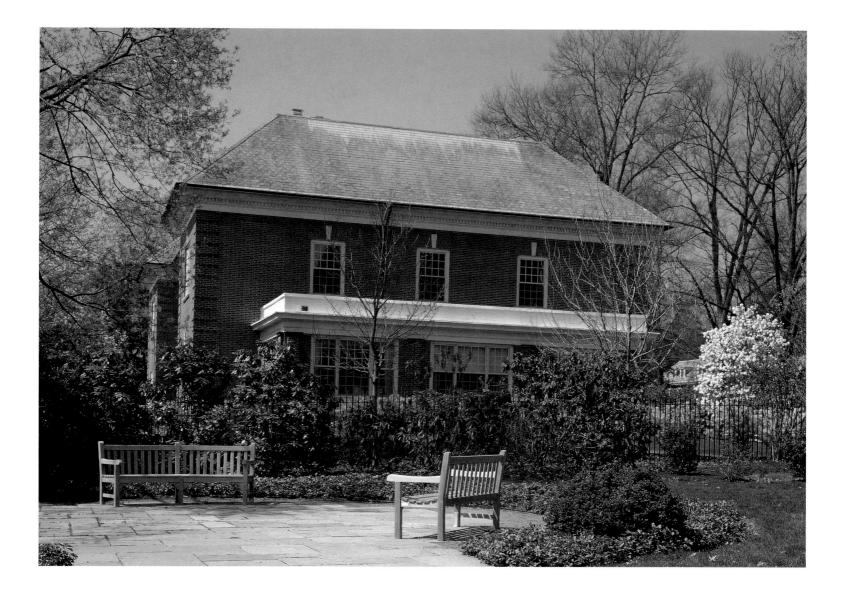

The Center of Theological Inquiry

The main building at 50 Stockton Street was designed by Michael Pardee Erdman and completed in 1984. It was given by the Henry Luce Foundation. Henry R. Luce, the founder of *Time, Life,* and *Fortune* magazines, was born in China to missionary parents. His father was an alumnus of Princeton Theological Seminary. Throughout his life, Luce was concerned about the lack of communication between science and religion. As he once wrote, "The man of faith fails to know the full truth about this terrestrial universe, which is the concern of science. Conversely, the man of science fails to know the full truth of the destiny of man, which is the concern of religion."

In 1978 a visionary generation, led by James McCord, planted a tree on the commons of advanced research in Princeton called the Center of Theological Inquiry (CTI). CTI is an independent research institution in Princeton with a residential program for visiting scholars. The center's mission is to foster fresh thinking on global questions by nurturing new theological inquiries across disciplines, religions, and cultures. CTI fulfills this mission by convening international groups of outstanding scholars to pursue interdisciplinary theological inquiries on questions of global import. The scholars are invited to become resident members of the center for periods of up to one academic year. CTI's collaborative work is enhanced by its Princeton location, residential facilities, and ecumenical ethos. This unique environment for innovative thinking sustains CTI's distinctive approach to advanced research—small-scale conversations with a global impact.

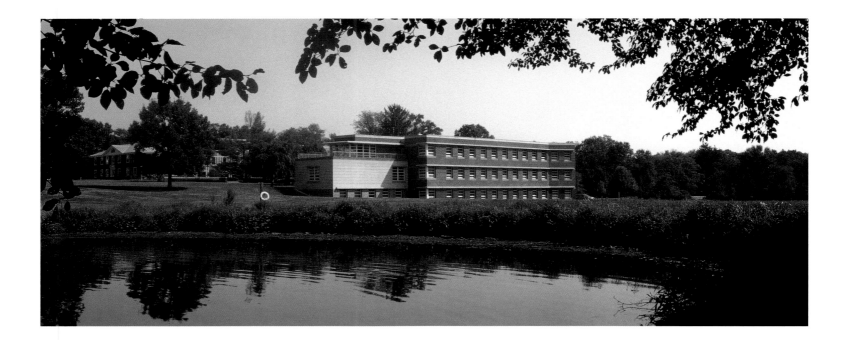

The Institute for Advanced Study

One of the world's leading centers for theoretical research and intellectual inquiry, the Institute for Advanced Study was established in 1930 by Louis Bamberger and his sister Caroline Bamberger Fuld. It is independent of the university, but there are close intellectual ties between the two institutions. The institute awards no degrees and typically admits scholars and scientists, known as "Members," who have already received the highest degree in their field. Members are typically accepted for a period of one year to pursue research and other scholarly work outside their normal academic activity. The institute has four schools: the Schools of Historical Studies, Mathematics, Natural Sciences, and Social Science. It has an enrollment of approximately two hundred scholars each year and has over six thousand former members who hold positions of intellectual and scientific leadership. Its members represent about one hundred universities and research institutions around the world.

This was the first such research institute in the United States and it has served as a model for many others that were subsequently established around the world. As one of the largest such residential institutes of its kind in this country, it allows for the study of both science and the humanities. Past faculty have included Albert Einstein, who remained at the institute until his death in 1955, and other distinguished scientists and scholars such as Kurt Gödel, J. Robert Oppenheimer, Erwin Panofsky, Homer A. Thompson, John von Neumann, George Kennan, and Hermann Weyl.

The Bambergers were in the retail business and were fortunate to sell their store, L. Bamberger & Company, to R. H. Macy in 1929. They initially planned to dedicate some of the proceeds of the sale to establishing a medical school. They hired Abraham Flexner, an esteemed educational reformer, who subsequently convinced them that a model school for postdoctoral research would be of greater service.

Jens Fredrick Larson, the architect-in-residence at Dartmouth College, designed Fuld Hall, which opened in 1939. Its Georgian design might seem out of step with the modernist vision of the institute, but Flexner had an ulterior motive in going the traditional route: He realized that a new institute needed instant credibility and that potential donors, as well as faculty and students, would be more inclined to support a school with a familiar and traditional edifice. Architectural ties to Nassau Hall and Colonial Williamsburg may also be seen in Larson's design, and the distinctive cupola is similar to that of Philadelphia's Independence Hall. The buildings on the land behind Fuld Hall are of a more contemporary design and include structures by Marcel Breuer (housing facilities), Wallace Harrison (Historical Studies–Social Science Library), Robert Geddes (the dining hall, Bloomberg Hall, and West Building), and Cesar Pelli (Simonyi Hall and Wolfensohn Hall).

Above: Simonyi Hall as seen from the lake, housing the School of Mathematics. It is named for Charles Simonyi, chairman of the institute's board of trustees as well as president and CEO of Intentional Software. Surrounding the institute are over eight hundred acres of woods and wetlands, equaling the holdings of the university itself. *Opposite:* Fuld Hall.

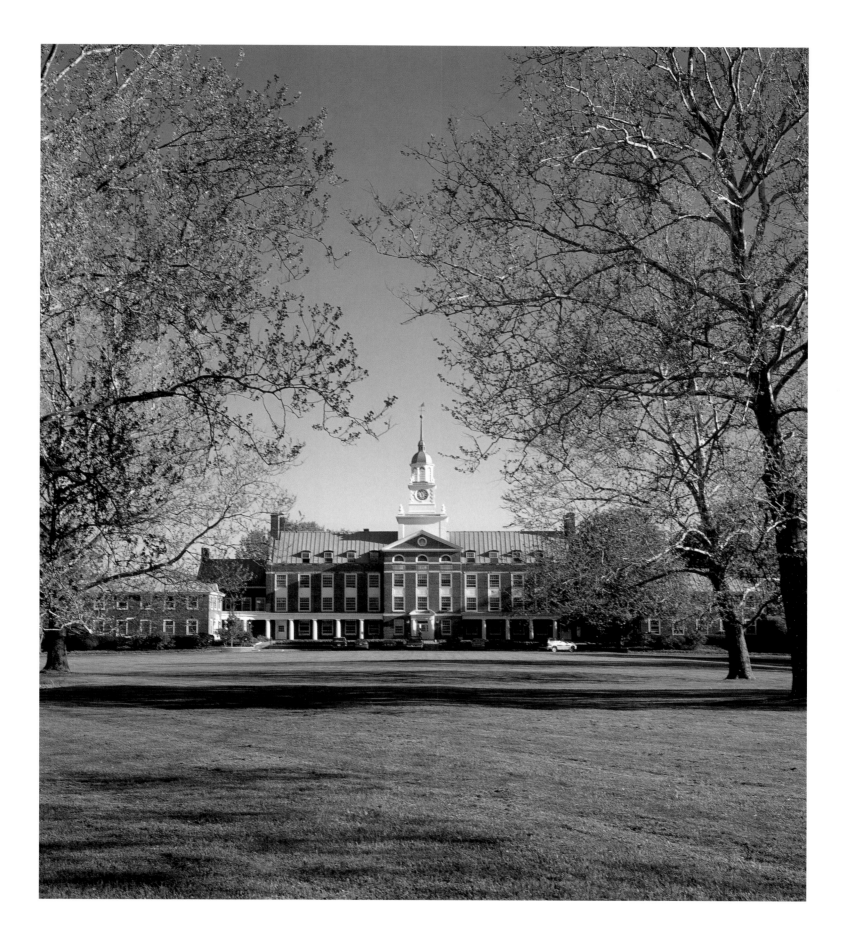

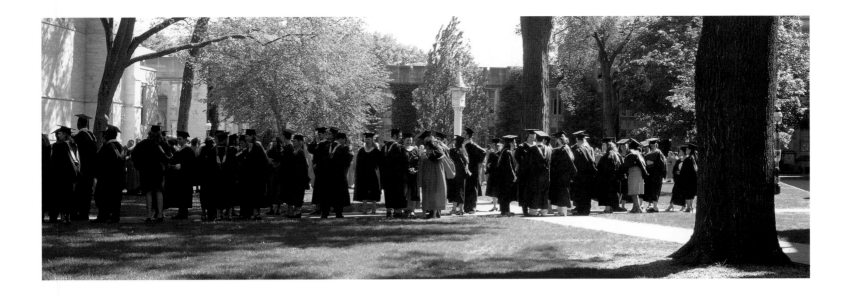

Westminster Choir College

Williamson Hall, on Hamilton Avenue, is named after John Finley and Rhea Williamson, who founded the college in 1925 at the Westminster Presbyterian Church in Dayton, Ohio. Graduates of the original three-year program were called "ministers of music," a term still widely used today. The Westminster Choir School, as the college was then called, moved to Princeton in 1932. It added a master's program in 1934 and became known as Westminster Choir College in 1939. The move to Princeton was motivated by a desire to have ready access to the great metropolitan centers and orchestras of the eastern seaboard. Following the move, classes were initially held in the First Presbyterian Church and the Princeton Seminary until 1934, when the Choir School relocated to its present twenty-three-acre campus. This was made possible by a large gift from the philanthropist Sophia Strong Taylor. The dedication of the new campus was marked by a performance of Johann Sebastian Bach's Mass in B minor at the Princeton University Chapel by the Westminster Choir, soloists, and the Philadelphia Orchestra conducted by Leopold Stokowski. Because of his high esteem for the choir, Stokowski offered his services, as well as those of the soloists and the orchestra, as a gift on this special occasion. Since then Westminster has performed hundreds of times and made many recordings with the principal orchestras of New York, Philadelphia, Washington, Pittsburgh, Boston, and Atlanta. Conductors of the choir have included Bernstein, Ormandy, Shaw, Steinberg, Stokowski, Toscanini, and Walter, as well as contemporary figures such as Abbado, Chailly, Levine, Maazel, Masur, Muti, Ozawa, Robertson, and Sawallisch.

The Westminster Choir has been performing since 1925. In 1928 it made its first coast-to-coast radio broadcast with the Cincinnati Symphony Orchestra, an unusual feat in its day. It was the first American choir to appear in concert in England (in 1929) and in the Soviet Union (in 1934). Westminster Choir and the New York Philharmonic first performed together in 1939 and, since then, they have set a record for the number of joint performances—more than 350—by a single choir and orchestra. In 1957 the choir completed a tour of twenty-two countries under the US Department of State's cultural exchange program, appearing before approximately a quarter of a million people. At the opening of the New York World's Fair in 1964, it sang during a Telstar telecast that was believed to have the largest audience of any television show at the time, and in 1980 it was the first choir to be featured on the *Live from Lincoln Center* broadcast series on National Public Television.

In recent decades the college has expanded by adding programs in music education, performance, composition, music theater, and a Bachelor of Arts in Music degree. In 1992 Westminster Choir College merged with Rider University, a private institution tracing its origins to 1865. In 2007 Rider University established the Westminster College of the Arts, integrating Westminster Choir College and Rider's School of Fine and Performing Arts, offering programs on Rider's campuses in Princeton and Lawrenceville. Today the college prepares men and women at both the undergraduate and graduate levels for careers as teachers and performers of sacred music. Present enrollment is approximately five hundred.

Above: Students gather for graduation exercises at the Princeton University Chapel. *Opposite:* The main campus of the college was dedicated in 1934. This principal building was designed by Sherley Morgan in a magnificent Georgian style. Morgan was the director of the School of Architecture at Princeton University from 1928 until 1952.

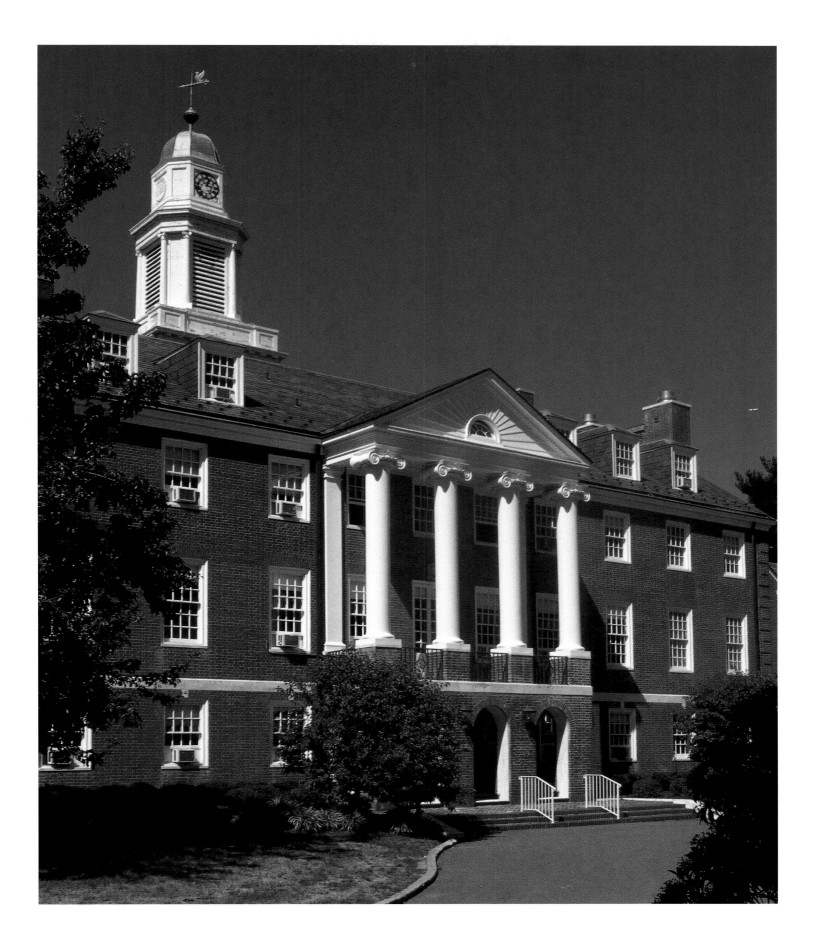

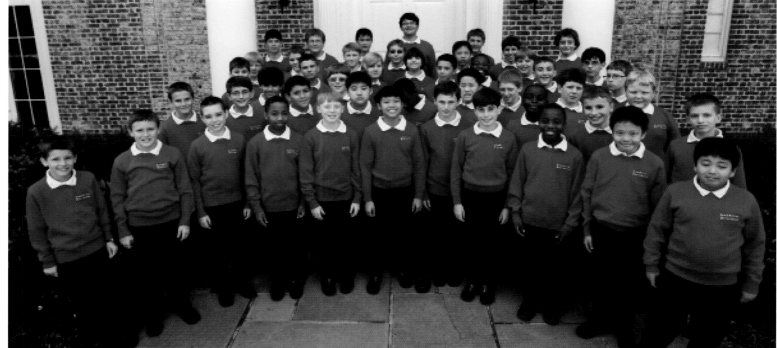

The American Boychoir School

This school was founded in 1937 in Columbus, Ohio, by Herbert Huffman, a graduate of Westminster Choir College and the music director of Columbus's Broad Street Presbyterian Church. In 1950 John Finley Williamson, founder and president of Westminster Choir College, invited the Columbus Boychoir (as Huffman's group was known at the time) to join his college in Princeton. The advantages of relocation were immediately clear. Princeton was a community that enthusiastically sponsored the arts and was close to the nation's musical centers of New York and Philadelphia. Williamson presented to Huffman the mutual benefits of a relationship between a choir college and a choir school: The choir school's students would provide a training group for the choir college's students, and the choir college would provide advanced musical opportunities in voice, instrument, and performance for choir school graduates. Following the example of Westminster, which had itself relocated from Ohio to Princeton in 1932, the school moved to Princeton and purchased "Albemarle," the former home of Gerard B. Lambert, the pharmaceuticals executive. The name of the estate derives from the Anglicized version of Aumale in Normandy. It was a dream come true for Huffman and his students: a beautiful, fifty-two-room Georgian mansion surrounded by extensive grounds with meadows, gardens, woods, and a stream.

The American Boychoir School is the only nonsectarian boys' choir school in the nation. It provides a rigorous education to young boys in the fourth through eighth grades, focusing on music and experiential learning on tours. Both at the school and on the road, choir leaders from across the country continue a long tradition of training the choral voices of their students. In addition to music, the boys are educated in language arts, mathematics, social studies, science, and select foreign languages. Approximately eighty students from across the country and overseas live at the Boychoir School.

The American Boychoir is regarded as one of the nation's premier choral groups and sings in many concerts across the United States and abroad. The choir makes over two hundred appearances in four to five major tours annually. In its prolific history, the choir has performed with the New York Philharmonic, the Berlin Philharmonic, the Boston Symphony Orchestra, and others.

Following the completion of their educational experience, students continue on to other schools around the country, including Blair Academy, Choate Rosemary Hall, Concord Academy, The Hun School, The Lawrenceville School, The Masters School, The Peddie School, Phillips Academy Andover, St. Andrews School, St. Paul's School, Tabor Academy, and Woodberry Forest School.

Above: The boys on the front porch, and *opposite:* the main school building, "Albemarle."

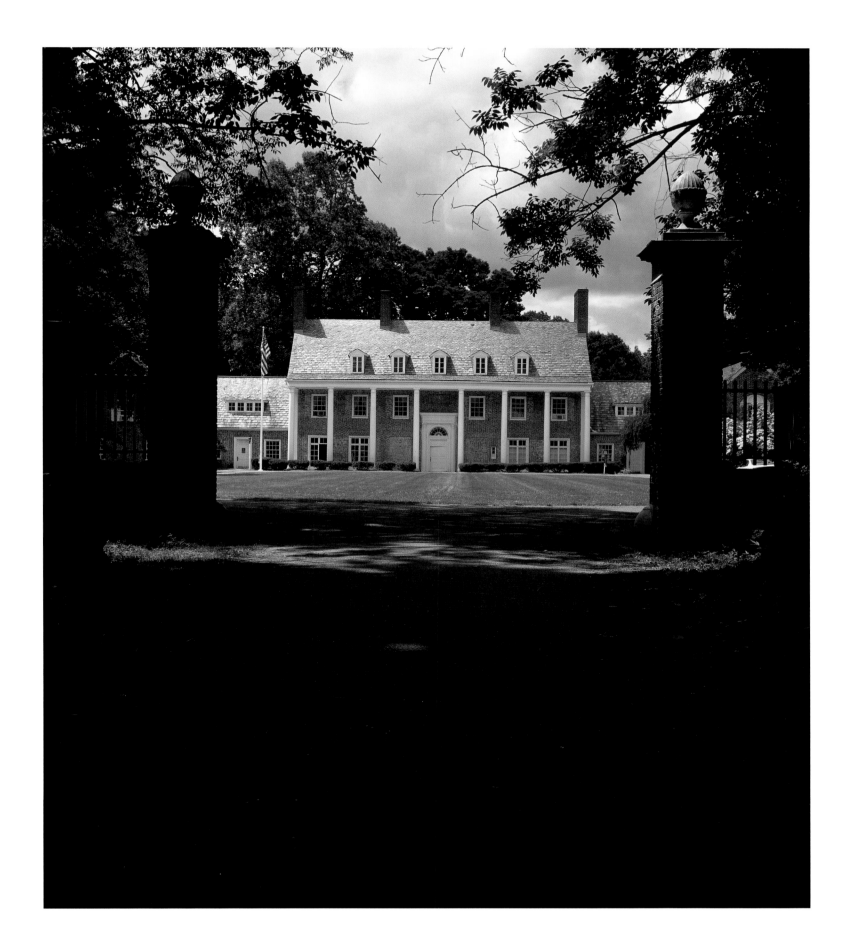

Educational Testing Service

ETS is the world's largest private nonprofit organization devoted to educational measurement and research. It was founded in 1947 by the American Council on Education, the Carnegie Foundation for the Advancement of Teaching, and the College Entrance Examination Board. Each year ETS administers fifty million tests in 180 countries. This includes over seven million English exams that allow international students to study abroad or work in the international marketplace. ETS also offers the GRE test worldwide, which helps nearly three quarters of a million students attend graduate or business school.

Above and opposite: Wood Hall and Conant Hall, both constructed in 1958. The headquarters building of ETS is named for James Bryant Conant, first chairman of the ETS board of trustees, former president of Harvard University, and former US ambassador to the Federal Republic of Germany.

The College Board, a not-for-profit membership association composed of more than 5,700 schools, colleges, universities, and other educational organizations, contracts with ETS to develop and administer its SAT I and II tests, which are taken by high school juniors and college-bound seniors each year. ETS also develops and administers the College Board's Advanced Placement (AP) examinations and scores them over a one-month period each June. During that month, thousands of teachers at multiple locations across the country read and score approximately 300,000 essays. In addition, the firm administers the GRE General and Subject Tests, the Test of English as a Foreign Language (TOEFL), the Test of English for International Communication (TOEIC), and the Praxis Series teacher licensing exams. Since 1983 they have also designed and administered the National Assessment of Educational Progress (NAEP), known as "The Nation's Report Card," under contract to the US Department of Education.

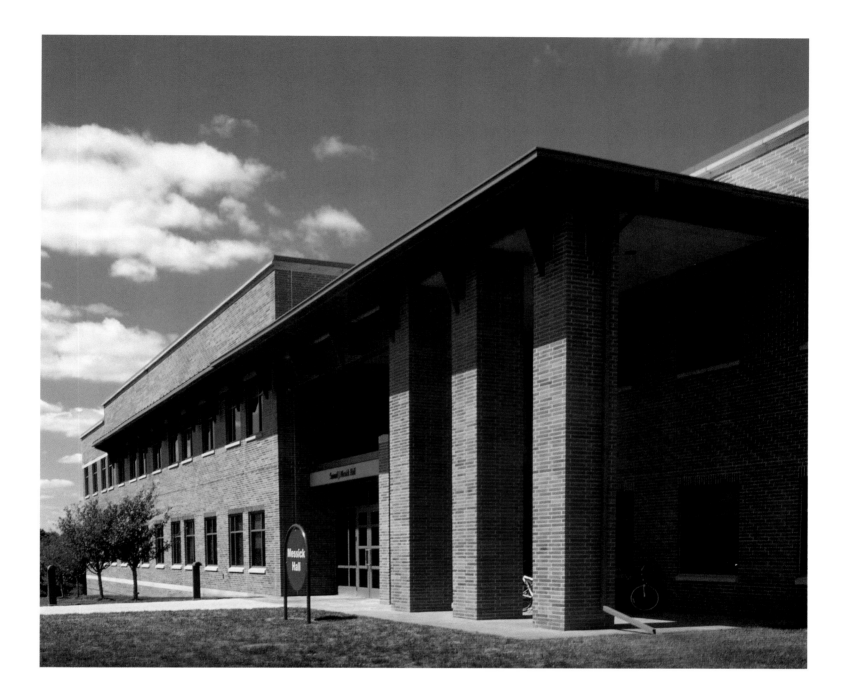

ETS also created computer-adaptive testing and pioneered Internet-based testing. With 4,500 centers worldwide, they have the world's largest computer-based testing network.

Opposite: Another section of the ETS campus features Messick and Lord Halls, named for Samuel Messick and Frederic Lord, two pioneers in the field of educational measurement whose innovative work was instrumental in helping ETS advance quality and equity in education. Lord Hall was completed in 1995, Messick Hall *(above)* in 1996. Both were designed by Princeton-based Hillier Architecture, which merged with RMJM in 2007. Together they house ETS's test development, graduate, and college programs; the TOEFL, TOEIC, GRE, and Praxis programs; and ETS's marketing and public affairs departments. In all, there are approximately 2,700 full-time employees at ETS, in addition to hundreds of part-time employees.

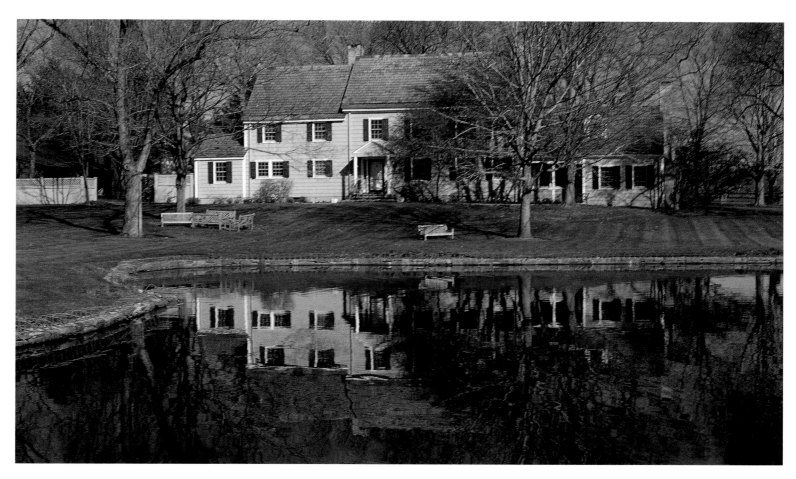

Left: On the extensive grounds of ETS is the Chauncey Conference Center, which was dedicated in 1974. It incorporates the charming Laurie House, a historic farmhouse and the former home of ETS's first president, Henry Chauncey, and his wife, Laurie. The house (*above and right*) dates back to 1810 and served as the main homestead of the van Kirk family, who ran a successful farm here for sixty-one years, until 1928. Then the house became the headquarters of the Stony Brook Hunt Club. It is reflected in a mirror inside the Chauncey Conference Center.

The full-service Chauncey Conference Center is available to the public for meetings, weddings, and special events. In a serene lakeside setting, the center features luxurious guest rooms, a conference center, event space, and an award-winning restaurant.

Henry Chauncey was president of ETS from its founding in 1947 until his retirement in 1970. He first acquired the farmhouse in 1955. Chauncey and his wife entertained staff and visitors there, including foreign dignitaries, local educators, visiting professors, advisory committees, and lecturers. Eventually, the farmhouse became an executive retreat within the Chauncey Conference Center. It has six private guest rooms, private dining facilities, and a full, dedicated staff. It is primarily used for high-level strategy sessions and policy committee meetings.

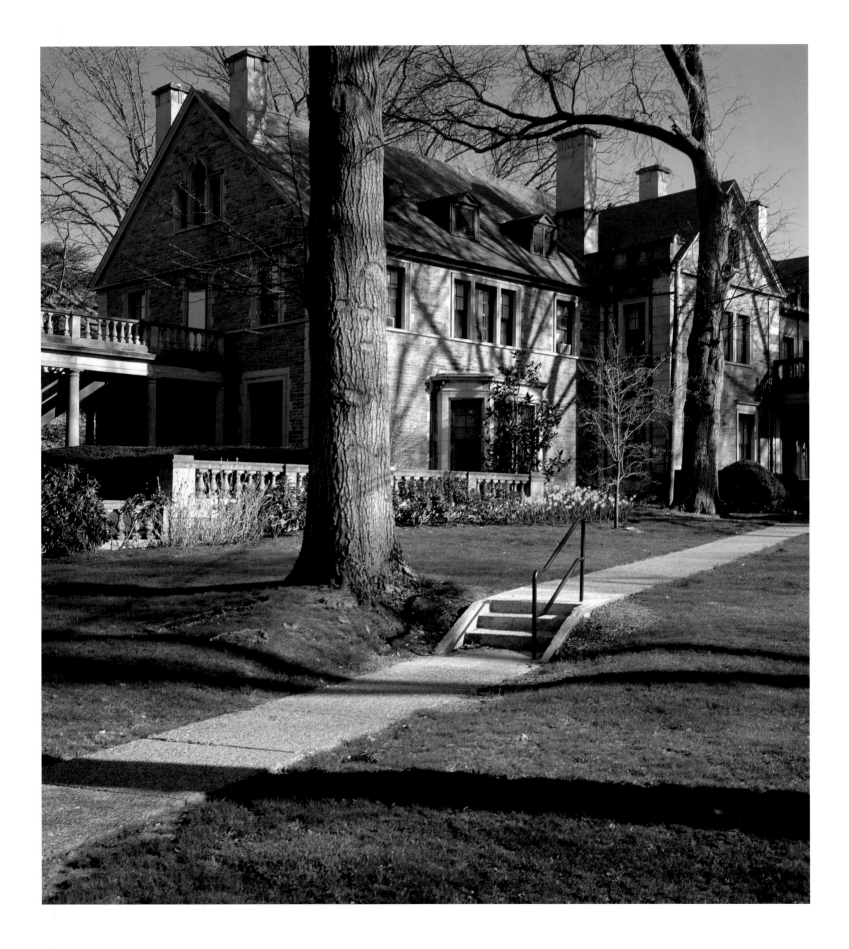

The Hun School

Preparing students to thrive in a world of constant change.

The Hun School is a private, coeducational boarding school that was founded in 1914 by Dr. John Gale Hun as the Princeton Math School. Dr. Hun was a professor of mathematics at the university. As a result of his success working with and tutoring his students, he decided to open a separate school dedicated to preparing young people for entrance into the nation's top colleges. He soon expanded its curriculum to encompass all areas of college-preparatory work. Distinguished for the quality of its teachers and the thorough preparation of its students, the school reflected Dr. Hun's own high standards and his abiding faith in young people.

The school assumed its present name in 1920. That same year, because the school had outgrown its initial home in town, Dr. Hun purchased property on Stockton Street, where he built a new school complex with facilities for 150 boarding students. He further expanded the curriculum to offer a general college-preparatory program for both day and boarding students. Five years later, in 1925, the school acquired "Edgerstoune," the forty-five-acre former home of Archibald Russell and one of Princeton's great estates. Russell was a trustee of the university and brother-in-law of Moses Taylor Pyne, whose "Drumthwacket" was the only other estate in town that could equal the Russell home's grandeur. "Edgerstoune" was designed by William Russell of the New York firm of Clinton & Russell and completed in 1903. The house is over two hundred feet long and ninety feet wide; it had ten master bedrooms and, originally, thirteen servants' rooms. Both Archibald Russell and Moses Pyne traveled to New York and back on a private train—not just in a private train car—which they kept on a siding at the Princeton station, then below Blair Arch at the university.

Opposite: The original building of the Hun School on this campus was "Edgerstoune," built as a private residence in 1903.

At first, "Edgerstoune" served as the school's junior campus, while the upper school remained on Stockton Street. In 1930 Dr. Hun constructed a junior school building at "Edgerstoune." This is presently the Landis Fine Arts Building. In 1942 the upper school was relocated from Stockton Street. The following year the Hun School of Princeton was officially incorporated as a nonprofit institution under the direction of a board of trustees.

Over the years, the school has added numerous buildings to the Edgerstoune campus for classes, dining, boarding, athletics, and various student activities. In 1971 female students were admitted, the middle school was established in 1973 and a sixth grade was added in 1977.

In December 2008 the school announced that Jonathan G. Brougham had been selected as the school's tenth headmaster.

Today the Hun School has a student body of approximately six hundred students from around the country and overseas. Approximately a third are boarders. Boarding students attend grades nine through twelve, while day students may begin in the sixth grade. The presence of foreign students enriches the cultural experiences of the student body, and all foreign students have guardians residing in the United States who are able to assume responsibility for the students' affairs and take them into their homes for vacations. The school's senior graduating class now matriculates at ninety-five colleges and universities throughout the country.

Opposite: The Chesebro Academic Center. *Above:* Landis Fine Arts Building.

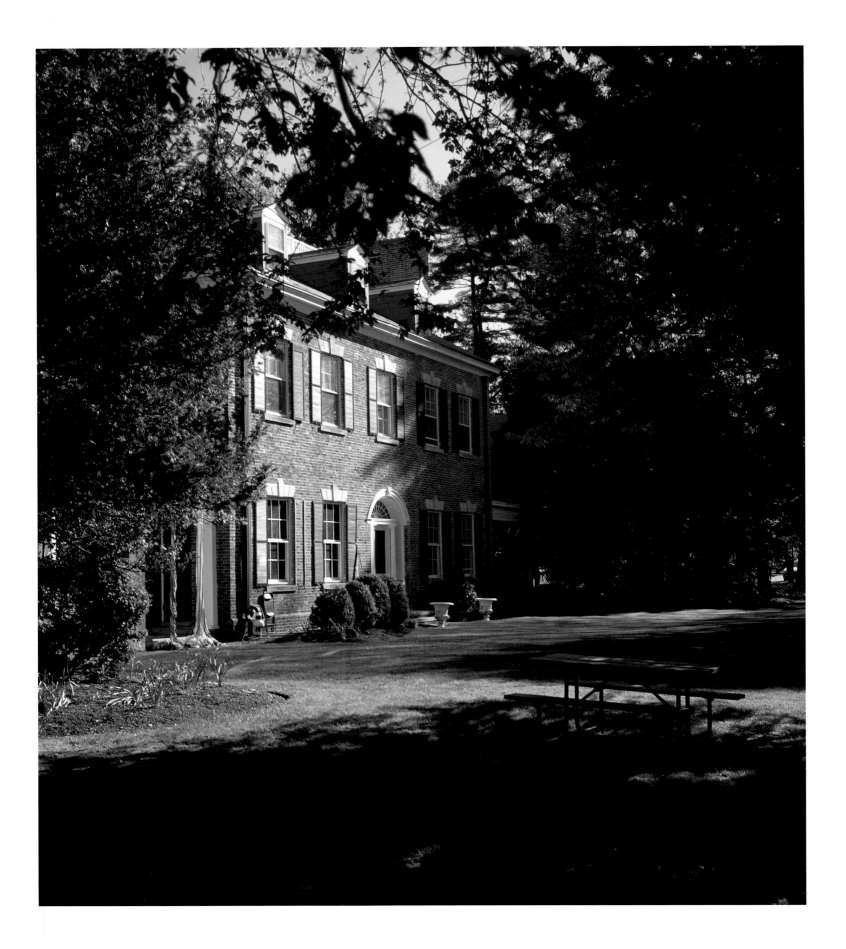

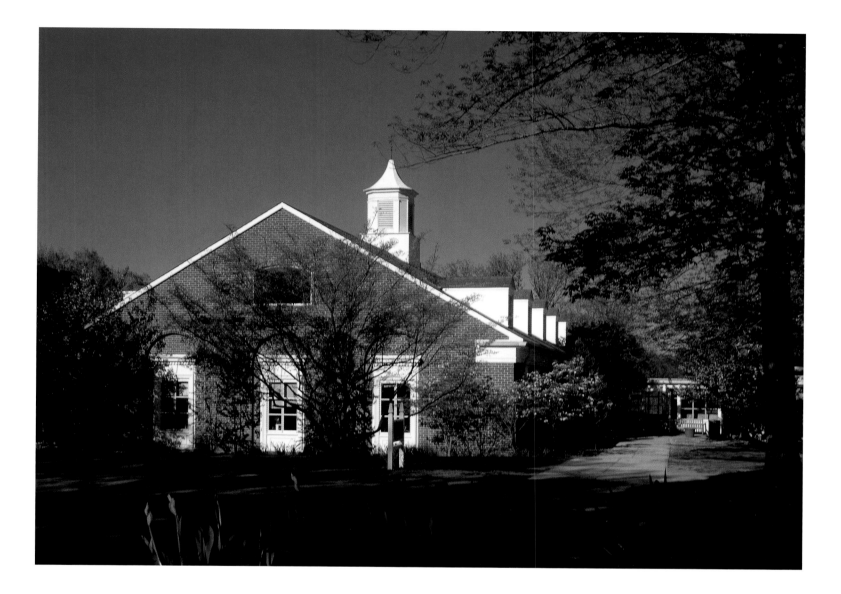

Princeton Day School

Semper Luceat: May it always shine

Princeton Day School was founded in 1965 through a merger between Miss Fine's School, a private school for girls founded in 1898, and Princeton Country Day School, a private school for boys founded in 1924.

When May Margaret Fine started her school for girls with a broad curriculum that prepared them for college, it was a bold move insofar as women were not expected to attend college, and few children in the country even attended school at the upper grade level. In 1924 a group of parents established an elementary school for boys on Bayard Lane, next to Miss Fine's School. It became known as Princeton Country Day School.

Shortly after its founding, the boys' school moved to a new campus with purpose-built buildings near the university's Palmer Stadium. It had an excellent academic reputation and most graduates went on to New England boarding schools for their secondary education. In 1965 Miss Fine's and Princeton Country Day merged to create a fully integrated, coeducational, private day school.

Opposite: "Colross," the school's main office building. *Above:* the principal classroom building for the upper school.

159

Princeton Day School has several handsome Georgian buildings on its one-hundred-acre Great Road estate, including "Colross," a manor house built in 1799 in Alexandria, Virginia. The house was moved to Princeton, brick by brick, in 1929. The school acquired "Colross" in 1965, thanks to the generosity of Dean Mathey, and now houses some of its offices and classrooms there. Dean Mathey was a successful investment banker and a Princeton University trustee under three of its presidents. He lived on the adjacent property. It is believed the name "Colross" derives from a royal borough of Scotland on the Firth of Forth, north of Edinburgh.

The school's mission is to offer students of above-average potential an exceptional opportunity for intellectual development, self-realization, and moral growth. Today it has an enrollment of approximately nine hundred boys and girls from prekindergarten through twelfth grade. It enjoys a very low student–teacher ratio and distinguishes itself through its high academic standards and a strong reliance on its four core values: integrity, independent thinking, respect, and compassion for others. It encourages learning that involves some risk taking. The focus of the experience is the classroom, where students share ideas and sharpen their skills with the guidance of a skilled faculty. Students are encouraged to apply their learning to problem solving across the boundaries of traditional academic disciplines.

The school prides itself on its attention to the individual student and its recognition of differences in learning styles, with personal contact between students and teachers at all levels.

Above and opposite: The Lower School Building of Princeton Day School.

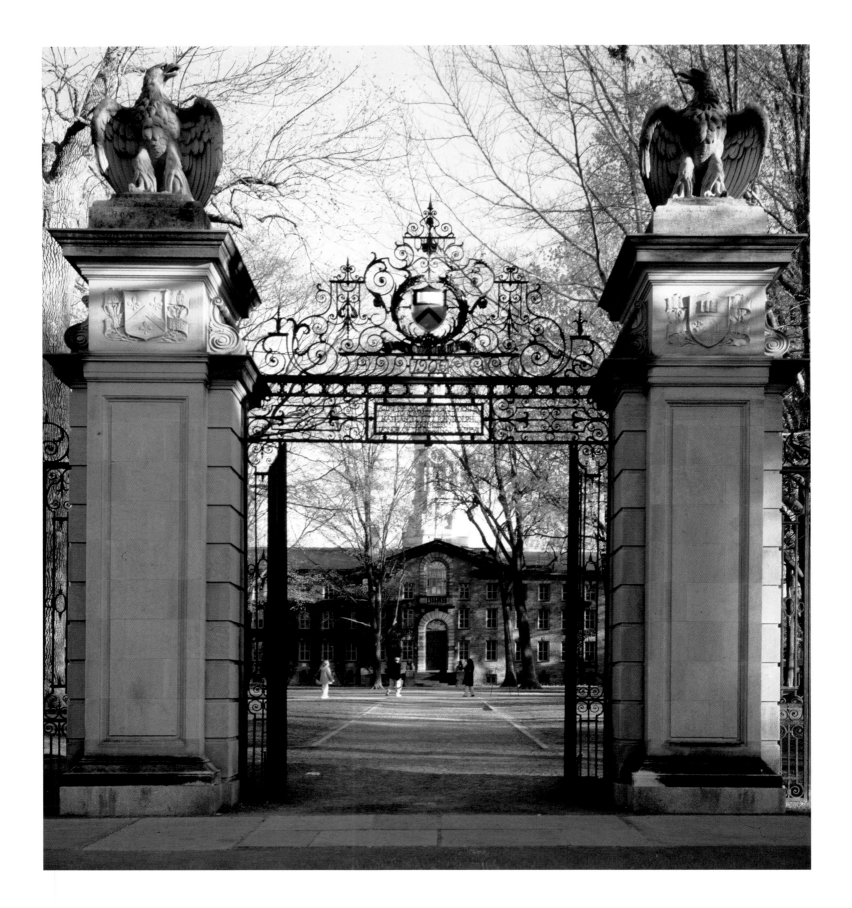

History of
Princeton University

Dei Sub Numine Viget
Under God's Power She Flourishes

The word Princeton conjures up many associations. It evokes feelings of excellence and intellectual inquiry in a spacious, tranquil setting. It is both a leafy, sylvan campus and an academic state of mind. Research, mathematics, the humanities, science, and theology. What other thoughts come to your mind? Like other institutions, Princeton University has greatly evolved over the past centuries. Some decades were tumultuous, some relatively somnolent, and others were lively periods of innovation. The energy here is palpable and permeates the campus and community in an increasingly purposeful and productive way.

The College of New Jersey was established by the church, as were its predecessors Harvard and Yale. In the case of Princeton, its presidents were Presbyterian ministers or sons of ministers. It is first and foremost a residential university, unlike many others around the world where students live at home and travel to classes. Even within the United States, the majority of students attending four-year universities do not live on a campus. Thus Princeton's residential experience is not an appendage to the academic program but is fully integral to it.

The American system of private education is unique in the world. It enables the education of individuals through a multitude of resources, both public and private. Princeton's endowment is one of the largest in the country and allows it to be independent of general public funds. Princeton has freedom in deciding what kind of

Opposite: The FitzRandolph Gateway of Princeton University, designed by McKim, Mead & White and built in 1905. Nathaniel FitzRandolph gave the land for the college and, more than any other citizen of Princeton, was responsible for raising the necessary funds to relocate the college from Newark where it had moved after its founding in Elizabethtown.

institution it wants to be and offers a liberal and scientific education of high quality to a select group of students. It has several distinctive features. First, the large endowment permits it to have a low student-to-faculty ratio. Second, it is committed to educating both undergraduate and graduate students in a single facility. Third, under Woodrow Wilson, Princeton introduced both the preceptorial system (where students and teachers come together in small discussion groups), as well as the honor system (under which students are responsible for their own behavior in exams and elsewhere).

The Princeton faculty includes professors of national reputation who are at the complete disposal of the students. Unlike other Ivy League universities with multiple graduate schools, Princeton focuses on its undergraduates.

Princetonians have assumed leadership roles in American history for over two centuries. The university's sixth president, John Witherspoon, came from Scotland in 1768 and was a staunch advocate of the rights of independent thinking. He was the only minister to sign the Declaration of Independence. During the Revolutionary War, he moved the college out of Nassau Hall, which then became a barracks for both British and American troops (in succession). After the war, Congress fled to Princeton in 1783 out of fear of mutiny by the troops over back wages that the Treasury was unable to pay. In the years following the war, the college faced serious challenges. There was a decline in student enrollment, college finances, and morale. In 1810 the Presbyterian General Assembly voted to establish a separate theological seminary. With this move, the college went into steep financial decline because it was cut off from English support and now from the church as well. Thus, it was forced to turn more quickly to its alumni for donations than most other colleges. In 1826 John Maclean founded The Alumni Association of Nassau Hall, with James Madison as its first president. Regional alumni associations were an American idea that, over the years, has greatly benefited universities. Few appear as loyal as those of Princeton.

During the early 1800s there was a period of unrest between the students and the faculty, which led the professors to impose even more strict regulations as well as evangelical preaching. Athletics became an important outlet for the students' energies, and one of the first gymnasiums in the country was built here in 1859. The college again turned to Scotland for its president in 1868, as it had a hundred years before. James McCosh took control of the situation and over the next twenty years doubled the college's endowment, tripled its acreage and facilities, and increased faculty salaries. The enhanced reputation of the college, combined with the financial success of its

alumni, resulted in an increase in alumni contributions. This was the development that propelled Princeton from behind to become one of America's leading universities. Its name was changed from the College of New Jersey to Princeton University at its sesquicentennial in 1896. At this occasion, scholars from Cambridge, Trinity (Dublin), Göttingen, Leipzig, Utrecht, and Edinburgh were invited to lecture. The trustees decided to make the university more international in its focus and chose the Collegiate Gothic style of architecture inspired by the buildings of Oxford and other European universities. Over a period of four decades, the Collegiate Gothic building style transformed the Princeton campus, from Blair Hall (1897) to Dillon Gymnasium and Firestone Library (1948).

At this time, other major American colleges were also changing. This evolution was due to several developments. First, major land-grant colleges were established in the Midwest and elsewhere. Second, there was the influence of German universities with broader curricula that required professors to specialize and not be authorities on everything. And, third, the sciences assumed an elevated position, in part inspired by the Darwinian theory of evolution. Under Woodrow Wilson, Princeton broadened the scope of its educational program and added graduate studies. One of his major contributions was the introduction of the preceptorial system. He also revised the curriculum so that the first two undergraduate years were well structured, while the last two were open for concentration in a major of one's choice.

Under John Grier Hibben, president of the university for twenty years (1912–1932), the university commenced a building program unparalleled elsewhere and supported by generous alumni contributions. It has been described as "Aladdin magic." The endowment fund rose almost 400 percent, bolstered by the national economy and the generous gifts of successful alumni. Ten new dormitories accommodated a 30 percent increase in undergraduate housing: Cuyler, Foulke, Joline, Henry, Laughlin, Lockhart, Pyne, and Walker, plus 1901 and 1903 Halls. But the list goes on! Six new instruction buildings: Dickinson, Eno, Frick, Fine, Green, and McCormick Halls. And there was more: Baker Rink, McCarter Theatre, McCosh Infirmary, Palmer Stadium, faculty apartments on College Road, five undergraduate dining halls, the North Court Quadrangle at the Graduate College and, most spectacularly, University Chapel. In all, thirty buildings were constructed during Hibben's tenure and the total area of the campus was doubled in size. The Gothic style of architecture was firmly established and became the prevalent one for American universities at the time. How many of us today can cite Dr.

Hibben for such accomplishments? How many know that the trustees named the nave of the new chapel in honor of him? The next time you are on campus, remember him. The next time you are dining at the Princeton Club of New York, salute him as he gazes down at the dinner tables in the Woodrow Wilson Room.

After the Second World War, the mood of the campus relaxed into a period of calm, which was followed by the social disturbances of the 1960s. The latter were initially attributable to the nationwide student unrest, but they were also due to concerns over career objectives and preparation for graduate studies. Women were first admitted in 1969. Since then, there has been a trend of growth and change combined with a desire for excellence and the preservation of tradition. The expectation of doing well is taken for granted at Princeton, and those who excel are not considered exceptions. Students are continually proving and testing themselves during their college years, but an important anchor is Princeton's firm hold on tradition. Thus, change is evolutionary, with the continuous review of the past to keep the best of the old and chart the optimal course into the future.

From a modest plot on Nassau Street and a single structure (albeit the largest in the colonies at the time), the university now owns over 900 acres and 160 buildings. The university—clearly the town's largest employer—has a total workforce of 5,500 that oversees 4,600 undergraduates and 2,000 graduate students. Princeton is a truly distinctive institution of learning and a uniquely inspiring intellectual home.

Opposite: Nassau Hall, completed in 1756. At that time, it was the largest stone building in America and was named in memory of King William III of England, member of the House of Nassau and Prince of Orange.

Robert Smith of Philadelphia designed the structure with twenty-six-inch-thick walls that withstood two years of military occupation during the Revolution (by both sides), plus the devastating fires of 1802 and 1855. When the Revolutionary War ended, Congress fled to Princeton in June 1783 because there were not enough funds in the treasury to pay the troops and they feared a rebellion. Their ensuing meetings during the summer took place in Nassau Hall, which thus was the new nation's capitol. During the graduation exercises of that year, in addition to parents and grandparents visiting the services, the entire Congress of the United States attended as well.

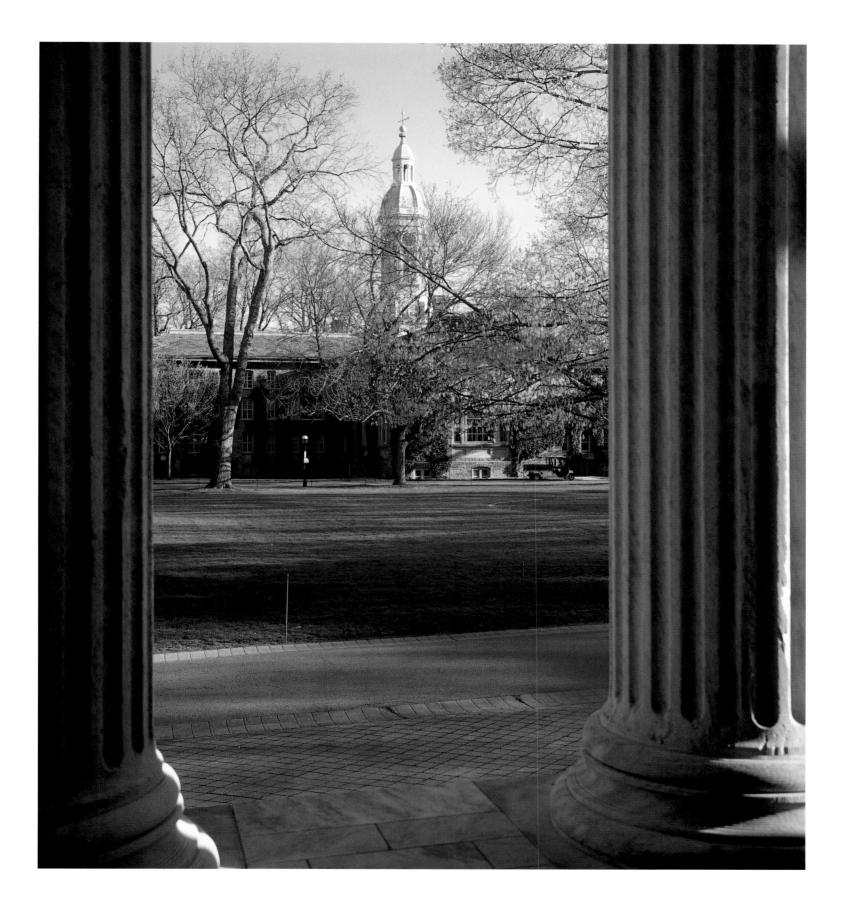

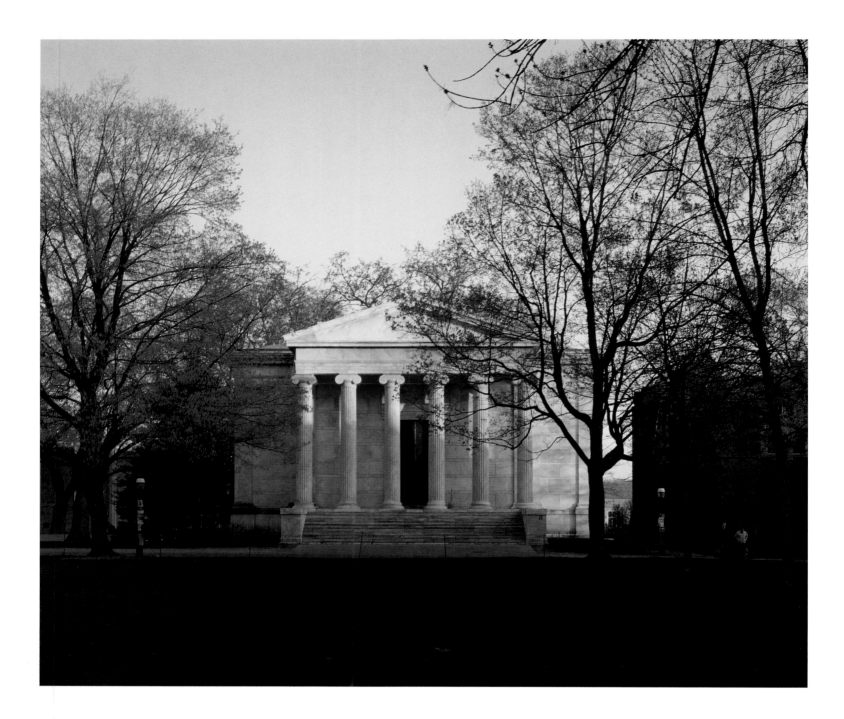

Clio and Whig Halls. Together, these were the homes of the American Whig Society, founded in 1769, and the Cliosophic Society, founded the following year. These are the oldest college literary and debating clubs in the United States. Their libraries were larger than that of the college during the nineteenth century, and they became colleges within the college. The societies merged in 1929.

Until the end of the Civil War, these two societies had their own classical structures, paid for with their own funds—not the college's—and designed by John Haviland of Philadelphia. Together, they marked the southern edge of the campus and completed Benjamin Latrobe's vision of a symmetrical, neoclassical quadrangle.

In 1889 the original buildings were replaced by the current handsome Greek temples designed by A. Page Brown, an apprentice of McKim, Mead & White.

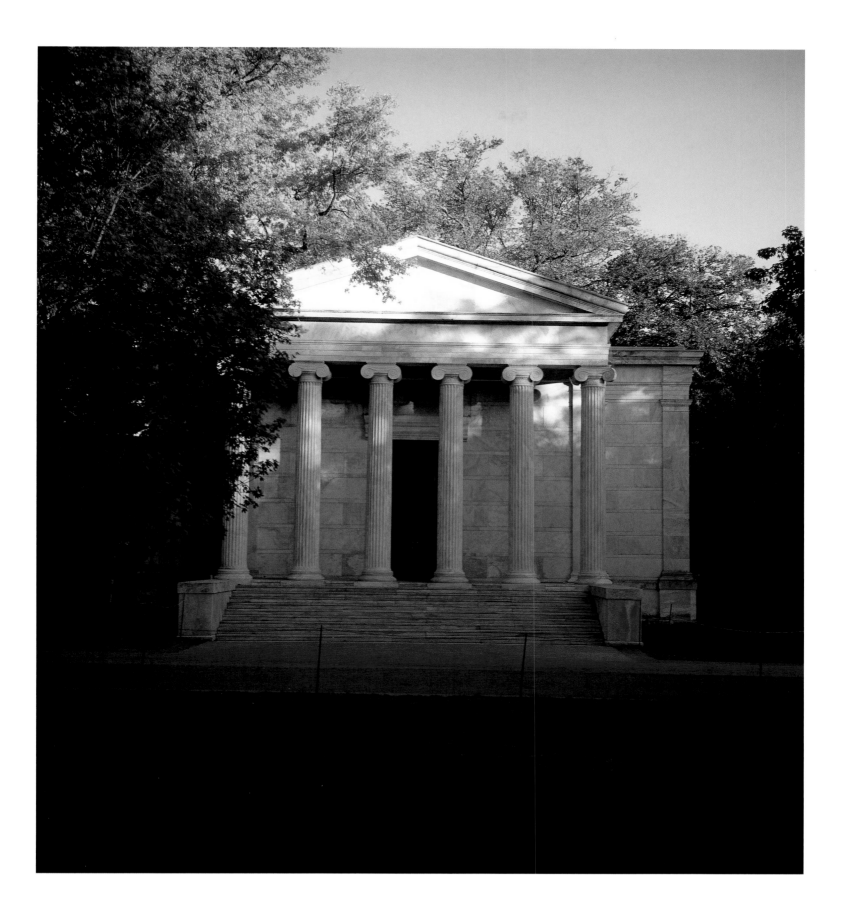

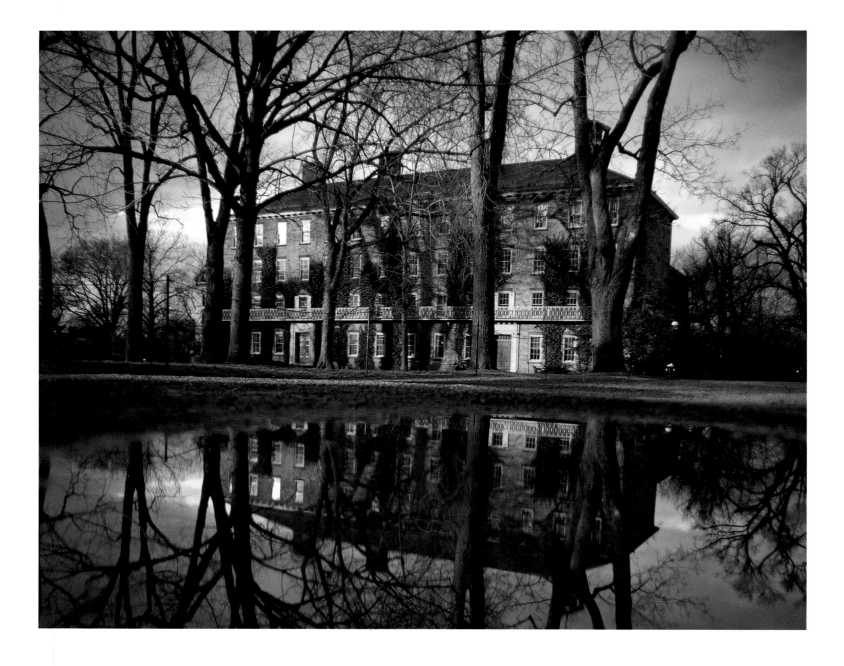

Above: West College, built in 1836, attributed to John Notman but most likely executed by a local builder, Enos Kesley. This was the college's second dormitory, after East College, which was razed during the construction of Pyne Library. It is now used for admission and other administrative offices. Thus, the early campus had Nassau Hall at its center and two pairs of complementary structures facing each other across what is now known as Cannon Green.

Opposite: Stanhope Hall, built in 1803 and named in honor of William Stanhope Smith, the first graduate of the college to become its president (1795–1812). Stanhope Hall has been known as the library, Geological Hall, and the college offices. It currently houses the Center of African American Studies as well as the Association of Princeton Graduate Alumni. This is the university's third-oldest building and was designed by Benjamin Latrobe, who designed the Capitol in Washington and supervised the reconstruction of Nassau Hall after a disastrous fire in 1802. Unfortunately, his other building, Philosophical Hall, which was an exact copy standing opposite, to the east, was razed in the early 1870s to make space for Chancellor Green Library.

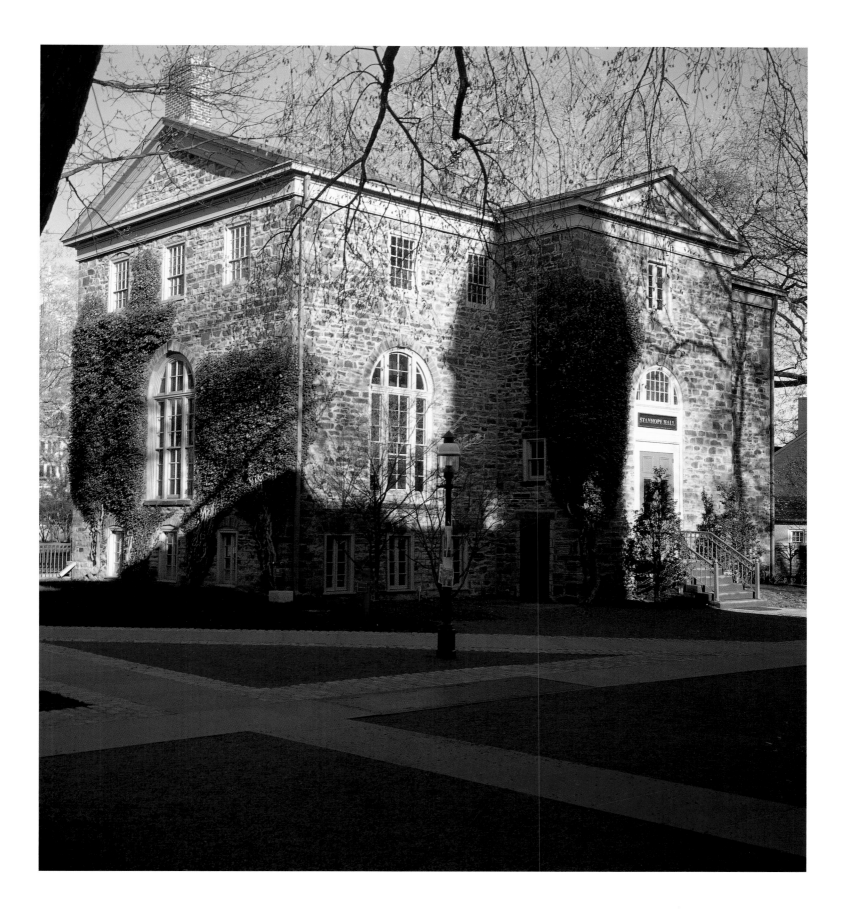

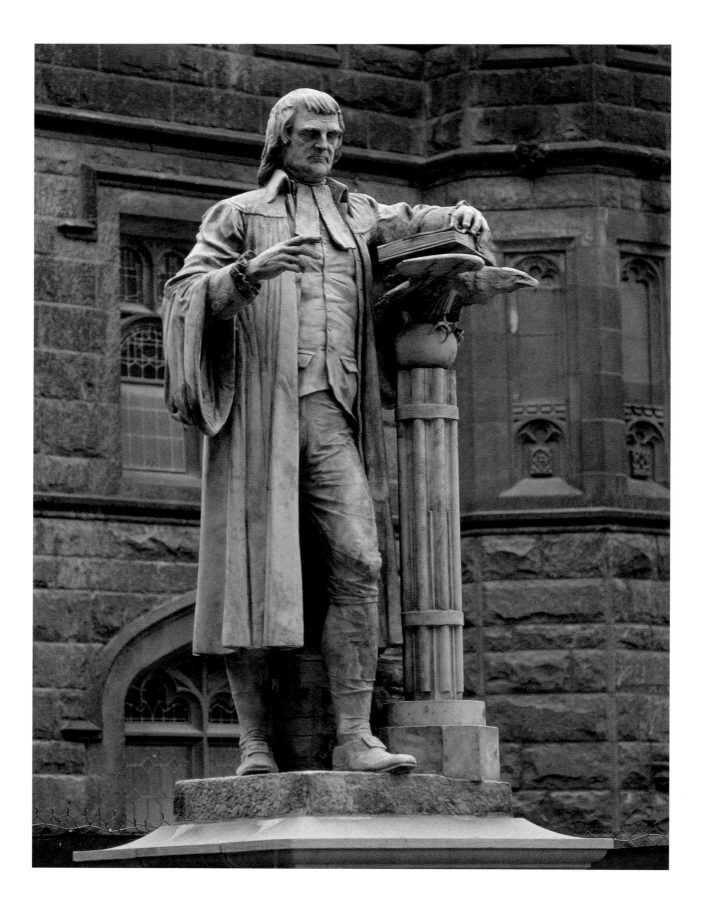

Statues of Witherspoon (*opposite and above, left*) and McCosh (*above, right*) at East Pyne. John Witherspoon, sixth president of the college, was a signer of the Declaration of Independence. He was president from 1768 to 1794. James McCosh was president from 1868 to 1888. Both were Presbyterian ministers from Scotland and played major roles in turning the school into the major institution it is today. Under Witherspoon, the curriculum was broadened, enrollment was increased, and additional endowment funds were obtained. Most importantly, Witherspoon held the college together during the Revolutionary years. During a journey to Virginia, he persuaded the parents of James Madison to enroll their boy at the college, and he also persuaded his friend George Washington to give fifty gold guineas to the college. Witherspoon called the college's pastoral setting a "campus," thereby introducing that reference into American vocabulary. McCosh, arriving almost a hundred years later, was faced with similar devastation in the aftermath of the Civil War. But he managed to shore up the college and engage in new building construction. Alexander, Edwards, Dod, and Witherspoon Halls were built during his tenure, as was the Chancellor Green Library. Furthering his predecessor's interest in the campus, both McCosh and his wife, Isabella, took particular interest in its landscaping. They were frequently observed strolling the campus and grounds around the president's home, "Prospect." The walk that leads from 1879 Hall down to the lower campus is named in honor of them.

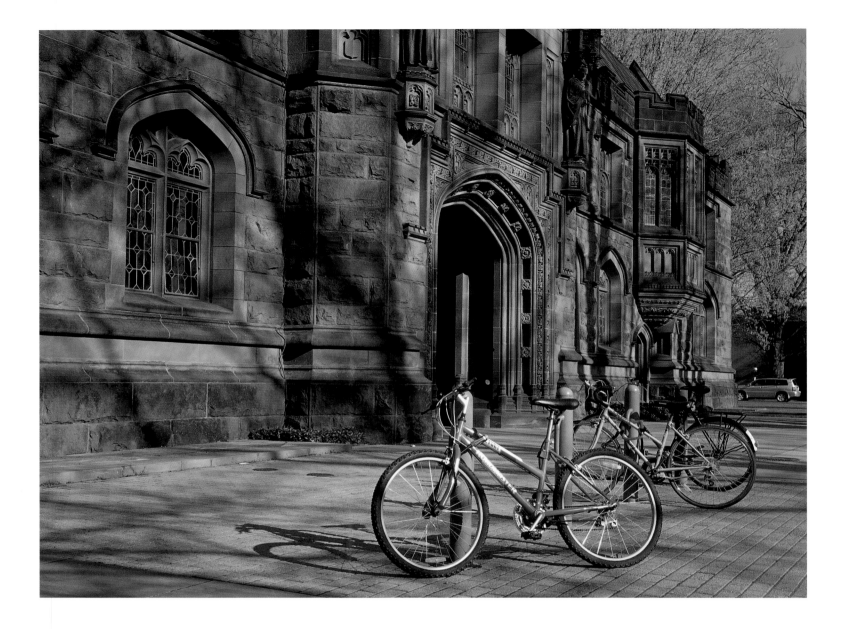

Above and opposite: East Pyne (1897). This building was designed by William Appleton Potter, who also designed Alexander Hall and Chancellor Green Library. Both East Pyne and Chancellor Green are now integrated into the Andlinger Center for the Humanities. The former is named in honor of Moses Taylor Pyne, class of 1877, who gave one of the largest endowments to the college of anyone at the time. His family were bankers and held extensive railroad interests. He and his wife, Margareta Stockton, a descendant of Richard Stockton, lived in "Drumthwacket." Pyne played an important role in organizing alumni support of the college, published its first alumni directory (in 1888), and helped to establish the *Princeton Alumni Weekly* as well as the predecessor of the Alumni Council. He became the first president of the Princeton Club of New York, which was designed to encourage the Princeton fellowship off-campus in the country's major city. To this day, it is the only regional association with its own facilities. Pyne helped to foster the desire of its members to obtain their own facility, a Cornelius Vanderbilt mansion on East Thirty-Fourth Street near to the Knickerbocker Club, the University Athletic Club, and the Manhattan Club. Pyne also was the benefactor of the Cap & Gown Club.

As part of the recent renovation of East Pyne and Chancellor Green to become two of the main buildings in the Andlinger Center for the Humanities, the central courtyard was bestowed with an underground seventy-seat auditorium for lectures and films on topics of interest to the humanities.

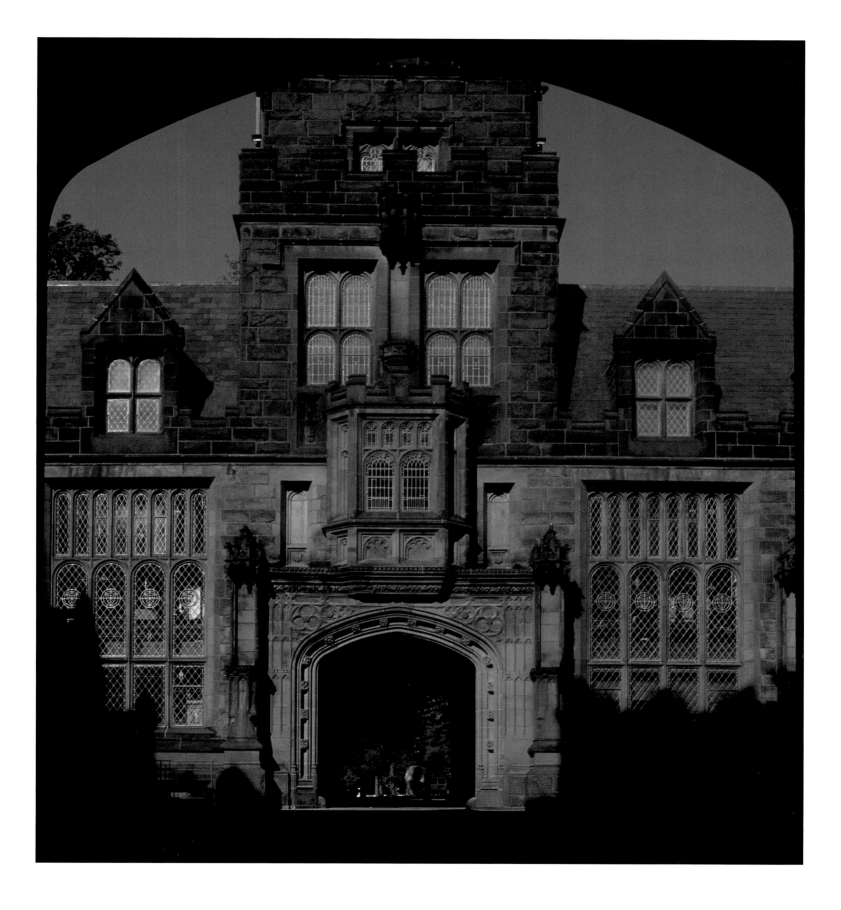

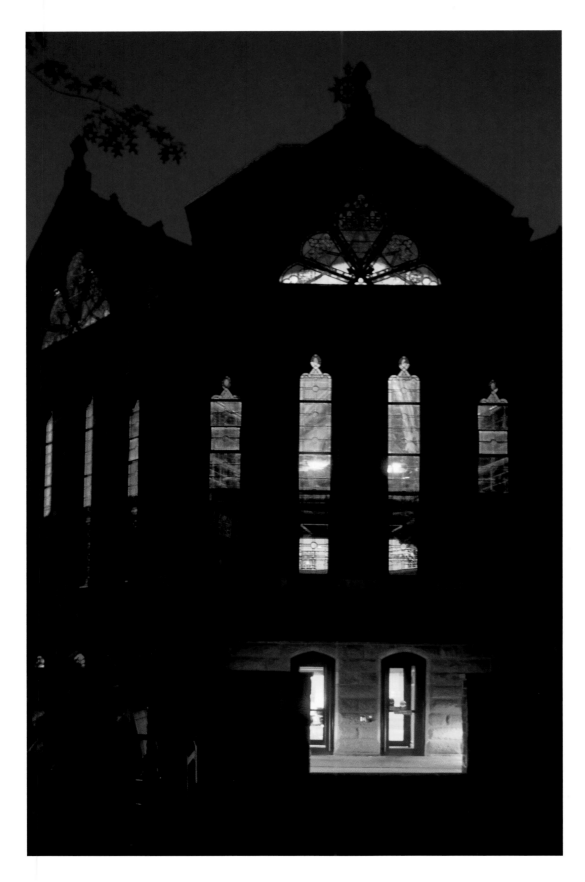

Left: Chancellor Green, designed by William Appleton Potter and completed in 1873. This was Princeton's first separate library building, designed to accommodate 150,000 volumes. It was given by John Cleve Green, in memory of his brother Henry Woodhull Green, class of 1820 and Chancellor of New Jersey. John Cleve Green was the college's greatest benefactor during President McCosh's tenure, even though he never attended the college. He was a member of the first graduating class at the Lawrenceville School and from there went straight to New York to work in foreign trade. He was a primary supporter of both the Lawrenceville School and the Princeton Theological Seminary.

Opposite: The ceiling of Chancellor Green. The extraordinary combination of angles and glass forms a kaleidoscopic masterpiece. It is best experienced at night under full illumination.

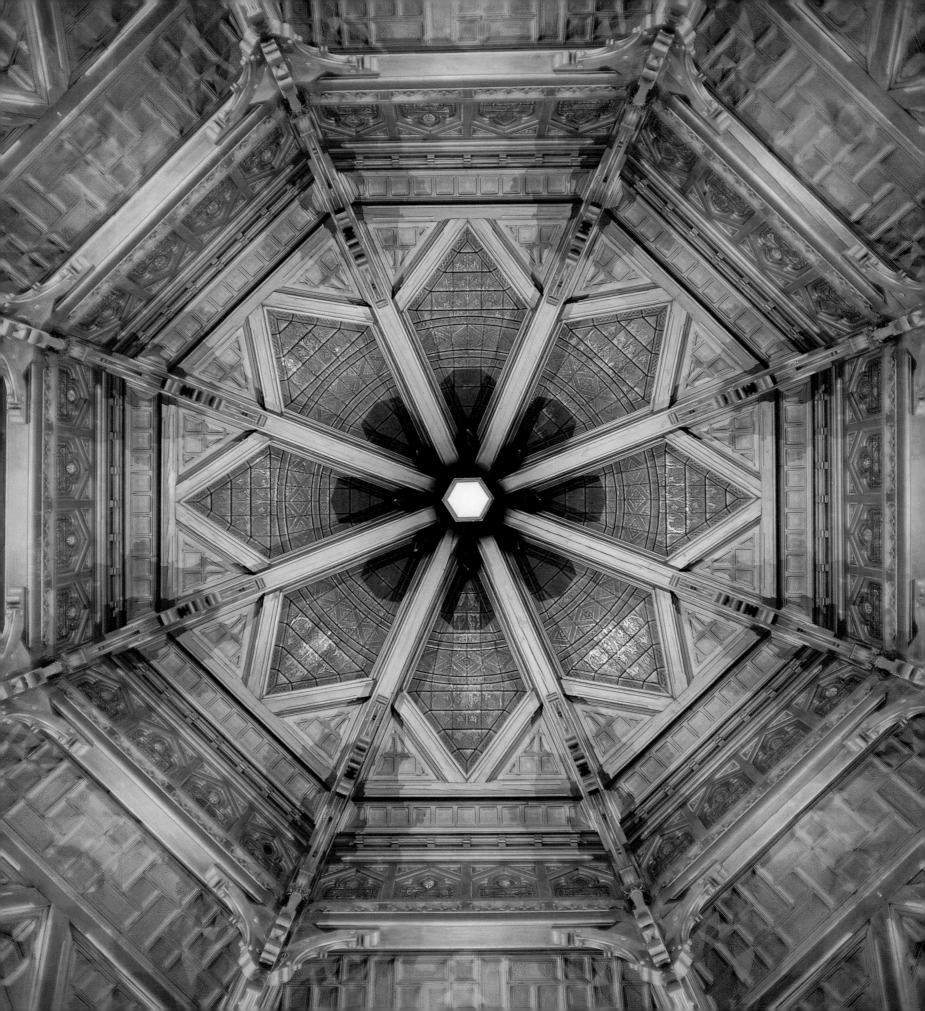

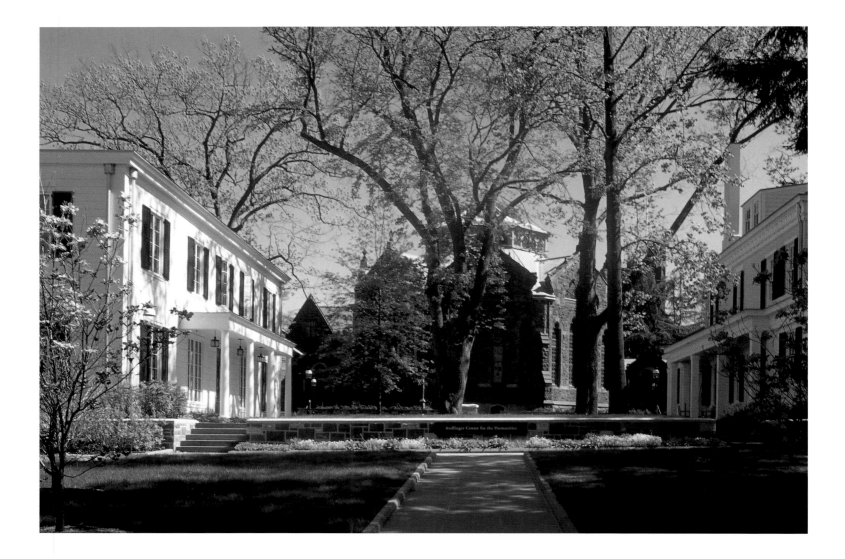

Above: Andlinger Center for the Humanities, located next to Firestone Library. This new center comprises East Pyne, Chancellor Green, Joseph Henry House, and the new Scheide Caldwell House. The center is named for Gerhard Andlinger, class of 1952. It houses all language departments, the Council of the Humanities, the Society of Fellows, and others. The center represents the university's commitment to the humanities. The Council of the Humanities was founded in 1953 to foster teaching, research, and intellectual exchange. Andlinger came to this country from Austria as the winner of a newspaper essay. After Princeton, he attended Harvard Business School and founded the eponymous private investment firm that gave $100 million in 2008 to make the center possible.

Opposite: The new Scheide Caldwell House, a gift of William H. Scheide, class of 1936, brings together a wide array of interdisciplinary programs. East Pyne houses language and literature departments, while the Chancellor Green rotunda and café offer space for study, discussion, and relaxation. Mr. Scheide's ties to the university are deep. He has endowed a professorship of music history and made possible the construction of the Arthur Mendel Music Library in the Woolworth Building. The Scheide Library, now housed in Firestone Library, contains books collected over three generations by his family, including copies of the first four Bibles ever printed, as well as musical scores by Beethoven, Bach, and others.

The Scheide Caldwell House was designed by Schwartz/Silver Architects of Boston in a style that complements the early nineteenth century character of the historic Joseph Henry House. It opened in 2004 and is named in honor of William Scheide's aunt, Gertrude Scheide Caldwell, whose husband, James Henry Caldwell, was a member of Princeton's class of 1898.

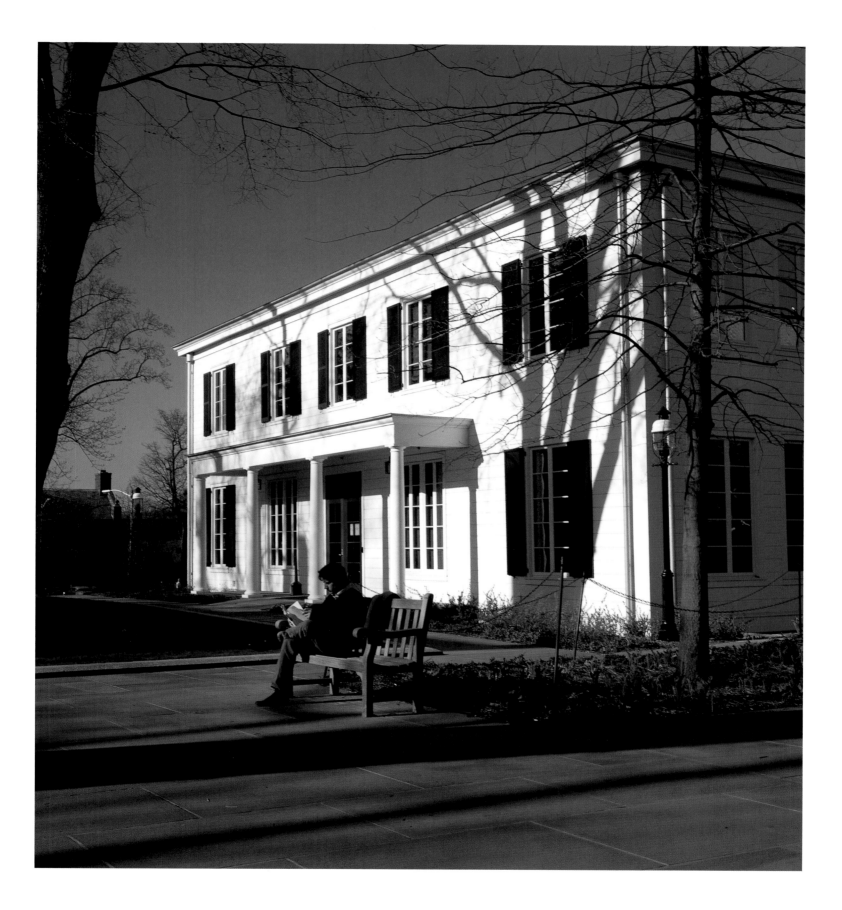

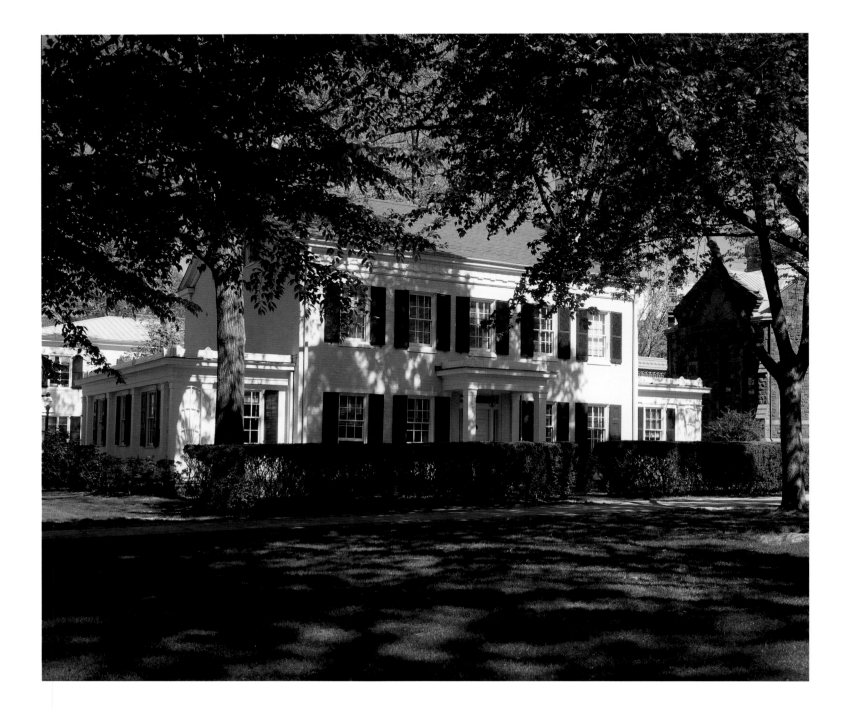

The Joseph Henry House (1838) on Nassau Street. After Benjamin Franklin, Mr. Henry was the leading American scientist of his day. He was the only American research physicist at that time. At the college, he was a professor of natural philosophy (i.e., physics). He designed and built this house for himself. He built the largest electromagnet in the world at the time, he discovered the principle of self-inductance in the flow of electric current, and he assisted Samuel Morse in the invention of the telegraph. He strung wires from his office to his home, indicating by telegraph code when he would be home for lunch. Subsequently, in 1846, Professor Henry left to become the first secretary of the Smithsonian Institution in Washington, DC. In 2004 this house became part of the university's Andlinger Center for the Humanities.

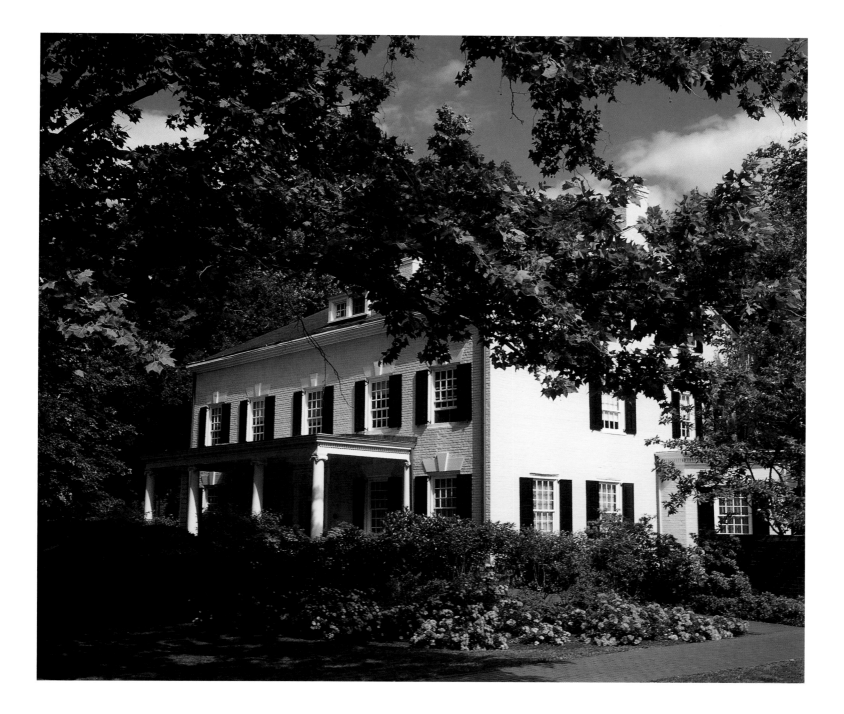

Maclean House (1756), finished in the same year as Nassau Hall, designed and built by Robert Smith. This was the official residence of presidents of the college until 1878, when "Prospect" was acquired. It is the home of the Alumni Council and is named in honor of John Maclean, class of 1816, founder of the Alumni Association. Maclean was a member of the faculty for fifty years, retiring as president. It was during the devastating fire in Nassau Hall in 1855 and the loss of a third of the student enrollment during the Civil War that Maclean held the college together and on a steady path. John Maclean's father was the college's first professor of chemistry in 1795, and his experiments were among the first conducted at any American college. During President Maclean's tenure, baseball began at Princeton, orange was adopted as the official color, and "Old Nassau" became its official song.

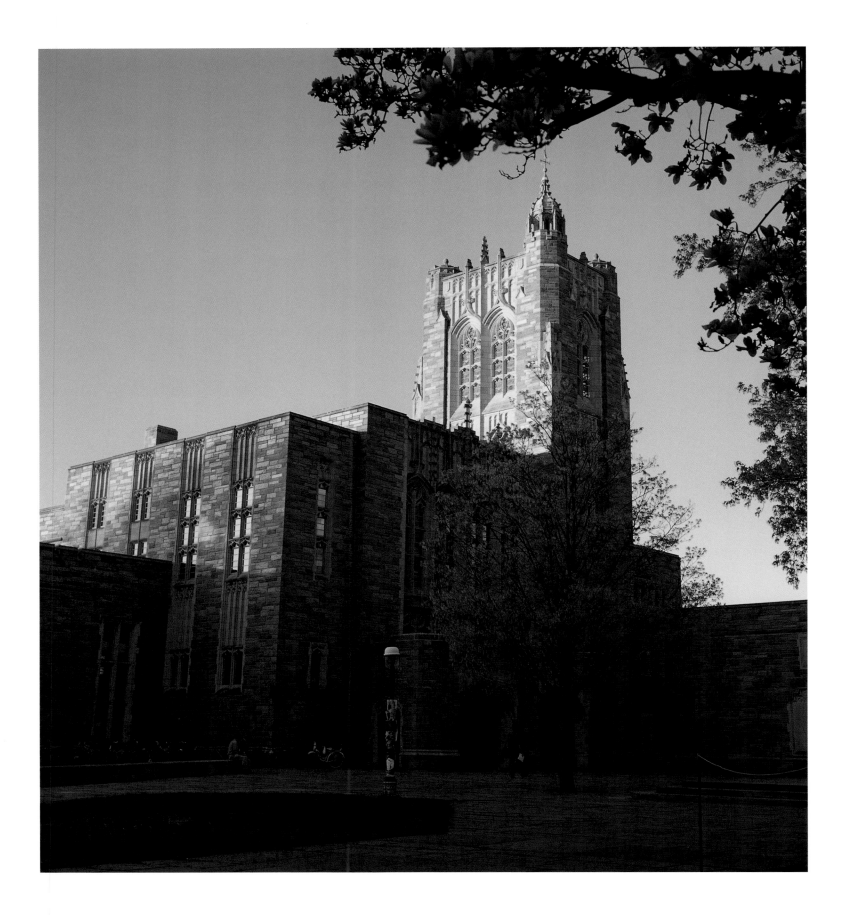

Firestone Library, designed by the firm of O'Connor and Kilham and completed in 1948, with major expansions in 1960 and again in 1988. This is believed to be the largest open-stack research library in the world. It is also the largest building on the campus. The library was given by members of the Firestone family in memory of Harvey S. Firestone, Jr., class of 1920 and chairman of the Firestone Tire & Rubber Company. It extends several floors underground in order that the neighboring University Chapel retain its prominence. Only about fifteen percent of its facilities are thus visible from this viewpoint.

183

Reading at Firestone Library. Princeton has the highest per-student circulation of any university in the United States (possibly the world). The library has fifty-five miles of open shelving, three million books and journals, approximately ten million manuscript items, and an additional four million microfilms, maps, and prints. Its premises contain over five hundred study carrels and several thousand study seats.

The University Chapel, completed in 1928. It is said to be one of the most beautiful Gothic chapels in America, and it is the third largest college church in the world. It was designed by Ralph Adams Cram, who also designed the Cathedral of Saint John the Divine and Saint Thomas Church in New York. Cram specified that no steel be used but instead that it be built in the same manner as the Gothic cathedrals of Europe. He was the campus architect from 1907 to 1929 and is credited with promoting the Collegiate Gothic style. On Baccalaureate Sunday the chapel is festooned with banners and filled to capacity. Within is a massive Skinner "Romantic" organ, given in 1928 by Helena Woolworth McCann in memory of her father, Frank Woolworth. The organ was delivered in its own railroad car from the Skinner works in Boston. It recently went overseas to London to be refurbished by the N. P. Mandler Company.

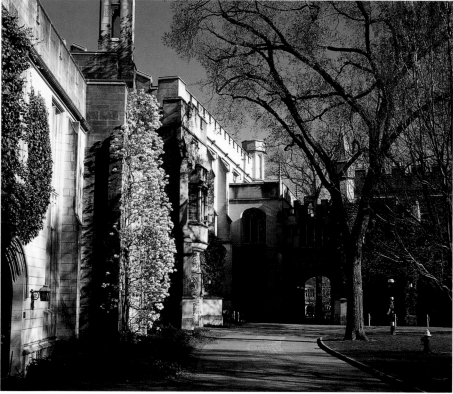

Above: Dickinson Hall, built in 1930, replaced the original structure, commissioned in 1869, that was located where Firestone Library currently stands. It was named for Jonathan Dickinson, the first president of the college. He was a member of the fifth graduating class (1706) of the Collegiate School of Connecticut, which became known as Yale College. Dickinson was a Presbyterian minister, and his library and parlor served as the college's first meeting rooms.

The photograph shows Dickinson Hall in the reflecting pool of the Woodrow Wilson School.

Right and opposite: Shown is a rare espaliered magnolia tree on the side of this handsome structure. Through the archway, which joins Dickinson and McCosh, one can see the Frist Campus Center, formerly the Palmer Physics Lab.

Above: McCosh Hall was built in 1906, and when it opened, it was the largest building on campus. James McCosh became the eleventh president of the college after immigrating to the United States from Scotland. He played a significant role in helping to restore the college's faculty, student enrollment, finances, and infrastructure after the draining years of the Civil War.

Opposite: The Mather Sundial. This is a replica of Turnball Sundial at Oxford's Corpus Christi College. Sir William Mather,

governor of Victoria University in Manchester, England, gave the sundial in 1907. This was the exclusive domain of Princeton University seniors until the 1950s. The pelican at the top is a religious symbol for Corpus Christi. Around the base is the following inscription:

> *Loyalty is e'er the same*
> *Whether it win or lose the game.*
> *True as the dial to the sun*
> *Although it not be shined upon.*

This page: The Princeton Art Museum. This building was substantially expanded in 1966 adding more gallery space, office space, classrooms, and a library. The architects for this expansion were Steinmann, Cain and White of New York. In 1984 another major expansion was commissioned. This one was designed by the firm of Mitchell/Giurgola of Philadelphia. It was a gift of Mitchell Wolfson, Jr., class of 1963, and other individual contributors. The Wolfson wing added over twenty-seven thousand square feet of gallery space and utility rooms.

Opposite: McCormick Hall, designed in 1922 by Ralph Adams Cram. The style is Siennese Gothic. This was one of the only structures built before the campus evolved to Collegiate Gothic. This handsome building was a gift of Cyrus H. McCormick, Jr., class of 1879, and his family.

Students studying at the Marquand Library, Firestone Library, and by 1903 Hall. Within the Art Museum is the Allan Marquand Library, named for a member of the class of 1874 who was the son of a New York banker and cofounder of the Metropolitan Museum of Art. He founded the Department of Art and Archeology at Princeton and was one of the first to introduce the serious study of art into the curriculum of American colleges.

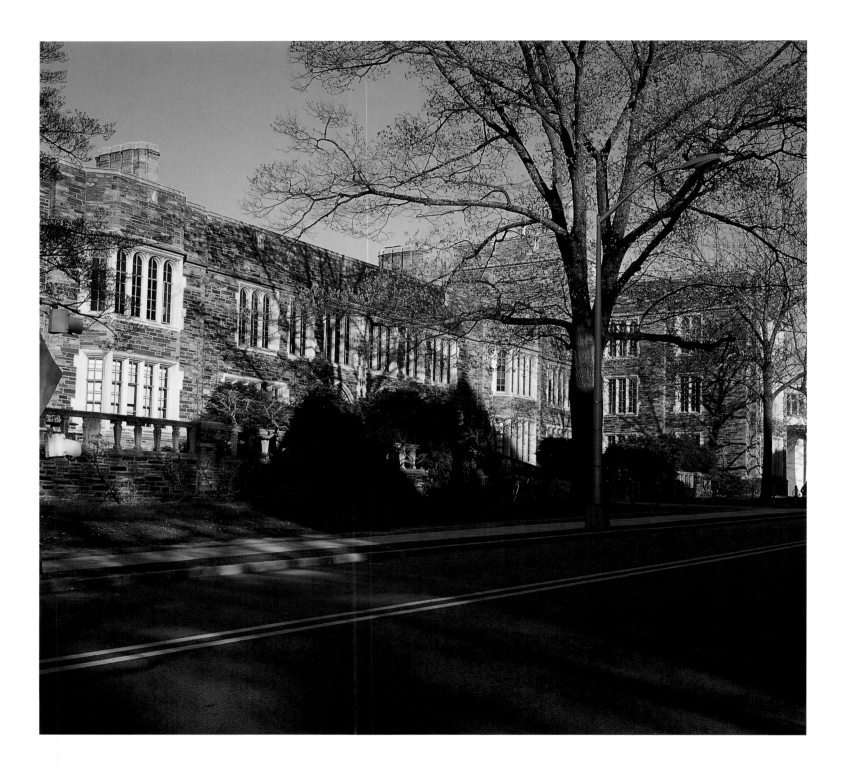

Twenty Washington Road. This was the original Frick Chemical Laboratory, donated by Henry Clay Frick. He was a Pittsburgh steelmaker who originally considered helping the university establish a law school. President Hibben persuaded him to donate a chemical laboratory instead. Built in 1929, this was one of the first functioning chemistry facilities at an academic institution in the country. The activities have now moved to the new Frick building further down Washington Road, and the space will be utilized for humanities, social sciences, and engineering.

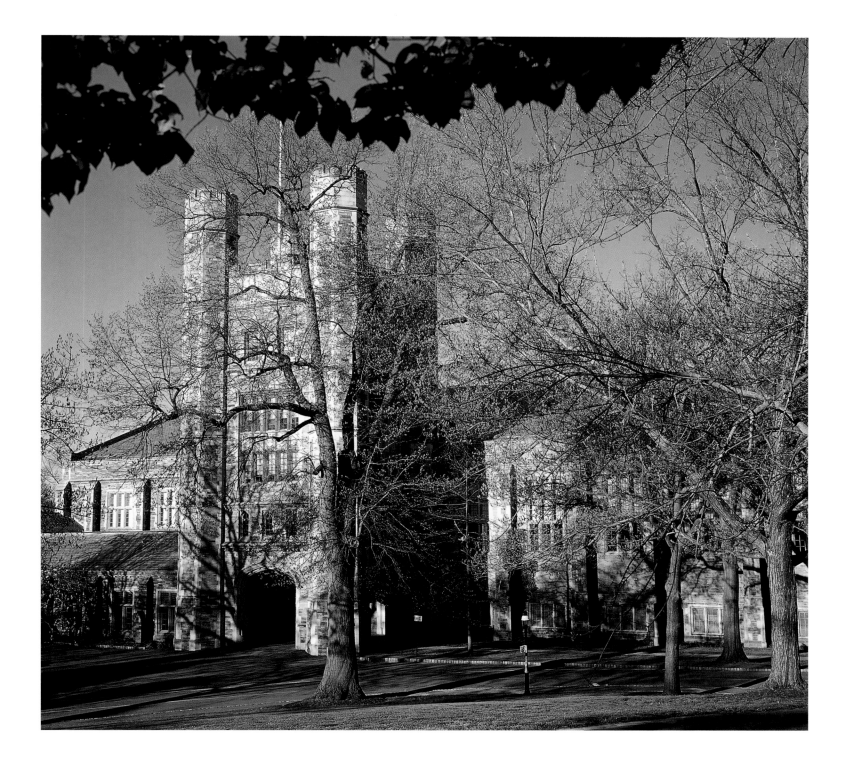

Dillon Gymnasium, completed in 1947 through the generosity of Herbert Lowell Dillon, class of 1907. This Gothic style building was completed at the same time as its counterpart on the northern edge of the campus, Firestone Library.

Predecessors of Dillon Gymnasium were University Gymnasium, which was the largest in the country when completed in 1903, and Bonner Gymnasium, the first built at an American college in 1869.

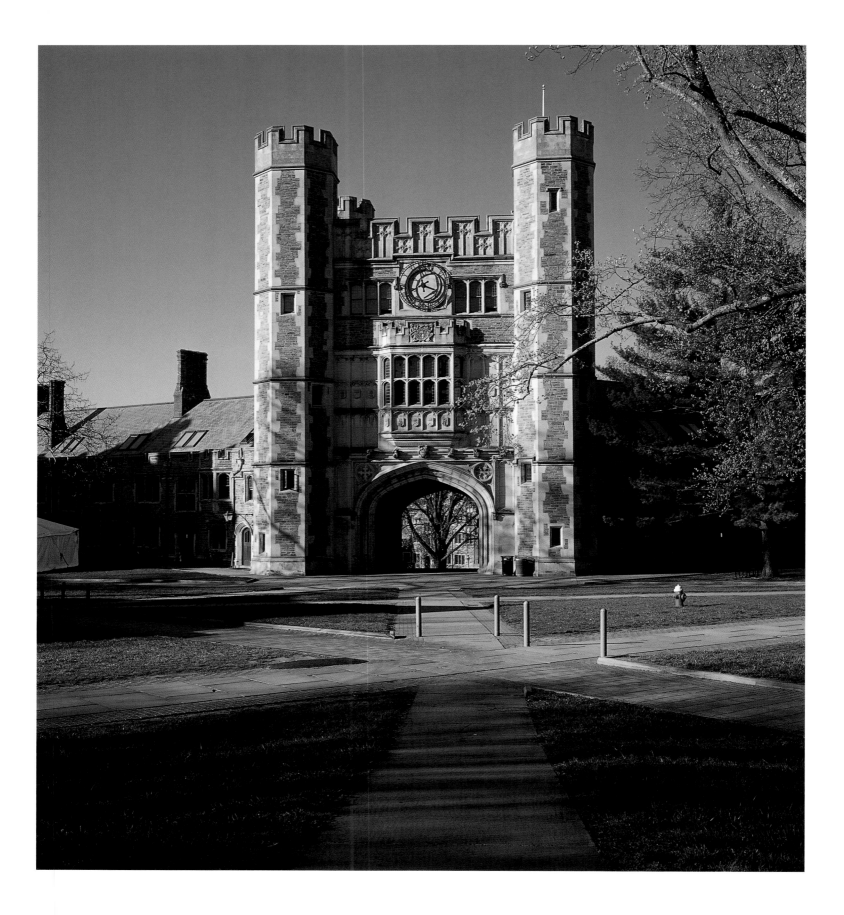

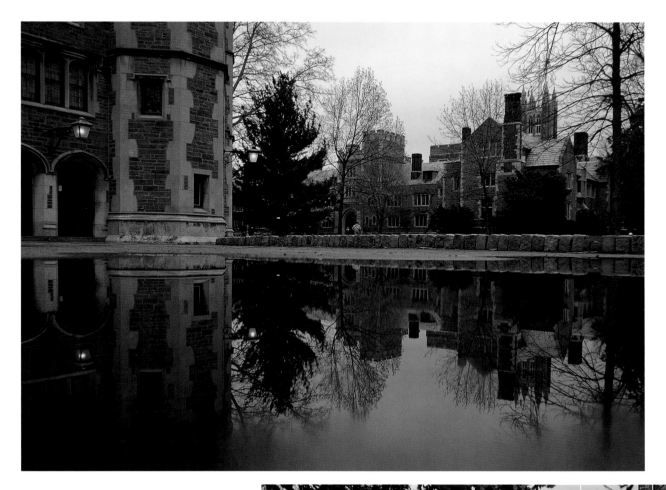

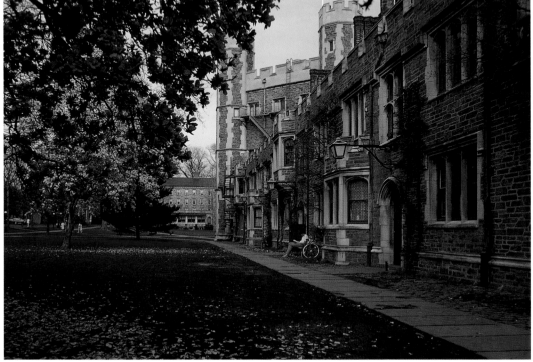

Above and opposite: Blair Hall, built in 1897, and designed by Cope and Stewardson of Philadelphia. This building, together with Little Hall, built in 1899, inspired the trend towards Gothic architecture on the American college campus. John Insley Blair was a trustee of the college from 1866 to 1899. He was of modest education, and when asked about his generous donations to Princeton, he said he spent most of his life learning addition but had come to the university to learn subtraction.

Above: This frieze on the south side of Alexander Hall was sculpted by J. Massey Rhind in 1897. The group represents the arts and sciences paying tribute to Learning, the central figure. Left of Learning are figures representing Language and Theology. To the right of Learning are Art and Sculpture.

Opposite: Alexander Hall, designed by William Appleton Potter. It was dedicated in June 1894 and it is based on the Romanesque designs of Henry Hobson Richardson. This imposing structure represents one of the last major buildings constructed before the university changed to the Collegiate Gothic style, as represented by Blair Hall. All graduation exercises were held at this location until 1922. The eponymous hall is named for three generations of Alexanders, all of whom had been trustees.

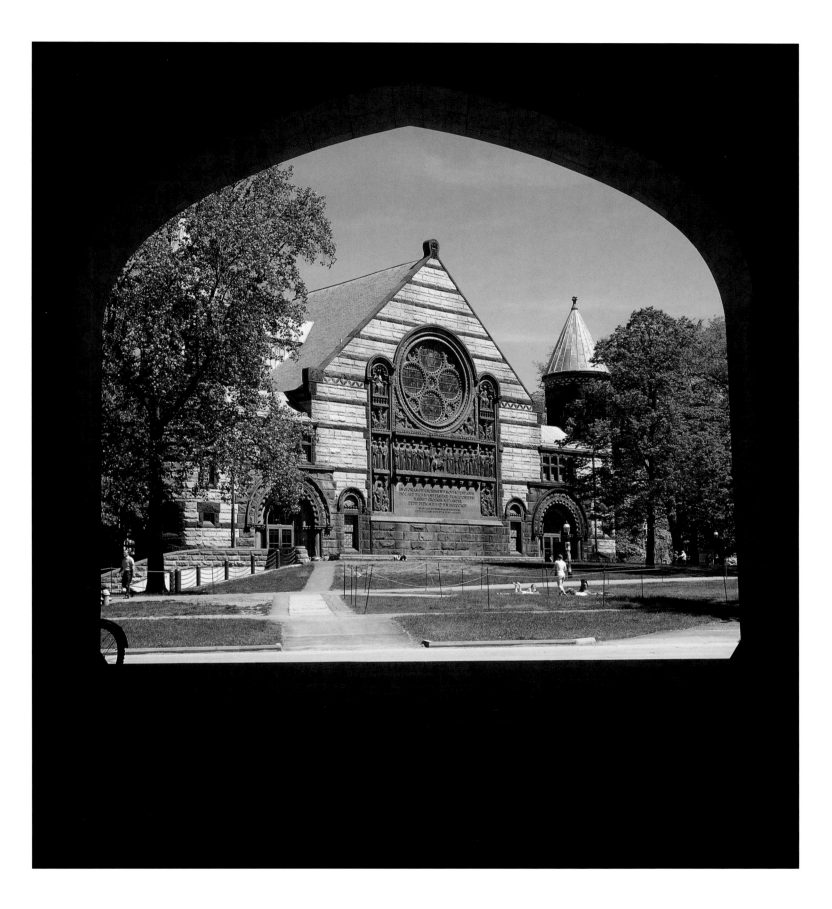

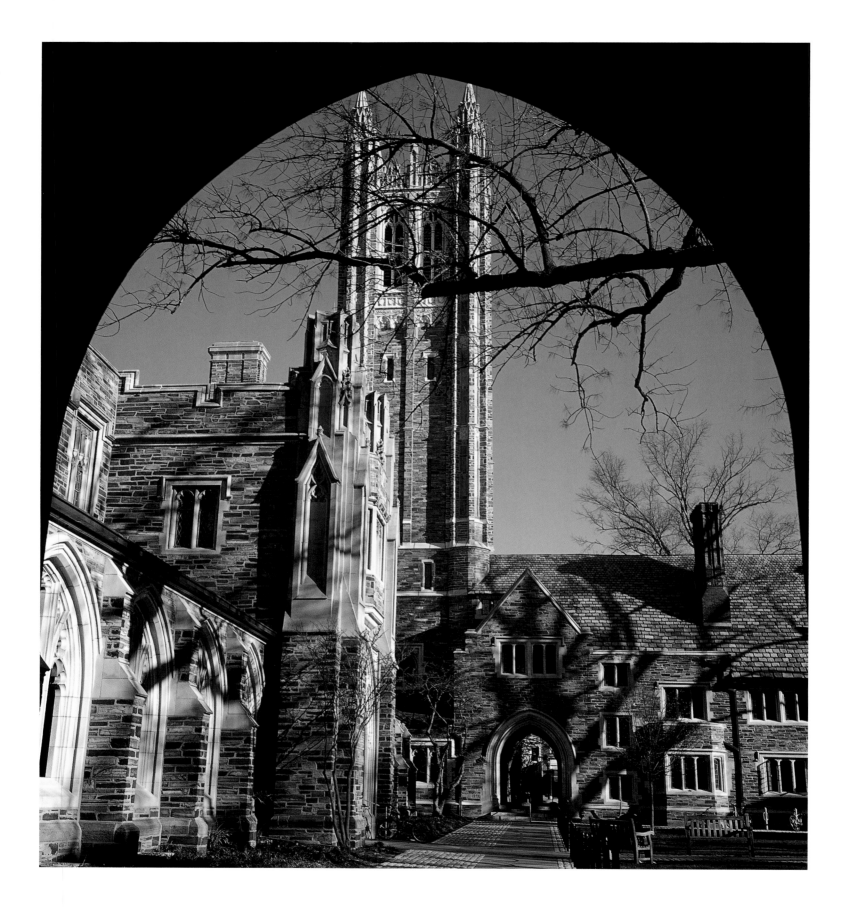

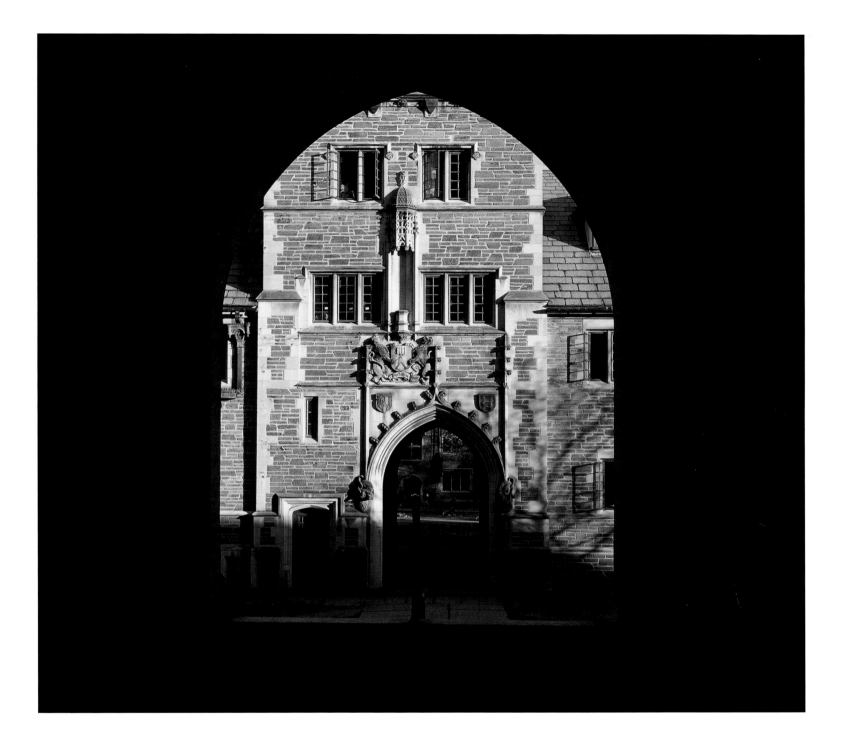

Holder Hall Tower (*opposite*), built in 1910. Like its larger companion, Cleveland Tower at the graduate college, this is a well-recognized landmark. It is modeled after Canterbury Cathedral and makes a strong statement of the university's respect for tradition. The Holder courtyard (*above*) is located on the original land donated by Nathaniel FitzRandolph. The buildings were a gift of Margaret Sage, widow of Russell Sage, in honor of Christopher Holder, a member of the Society of Friends in the seventeenth century. The buildings were designed by Day and Klauder in 1909. Campus master planner Ralph Adams Cram said, "The architects reach their highest point in authoritative interpretation of Gothic as a living style with these buildings."

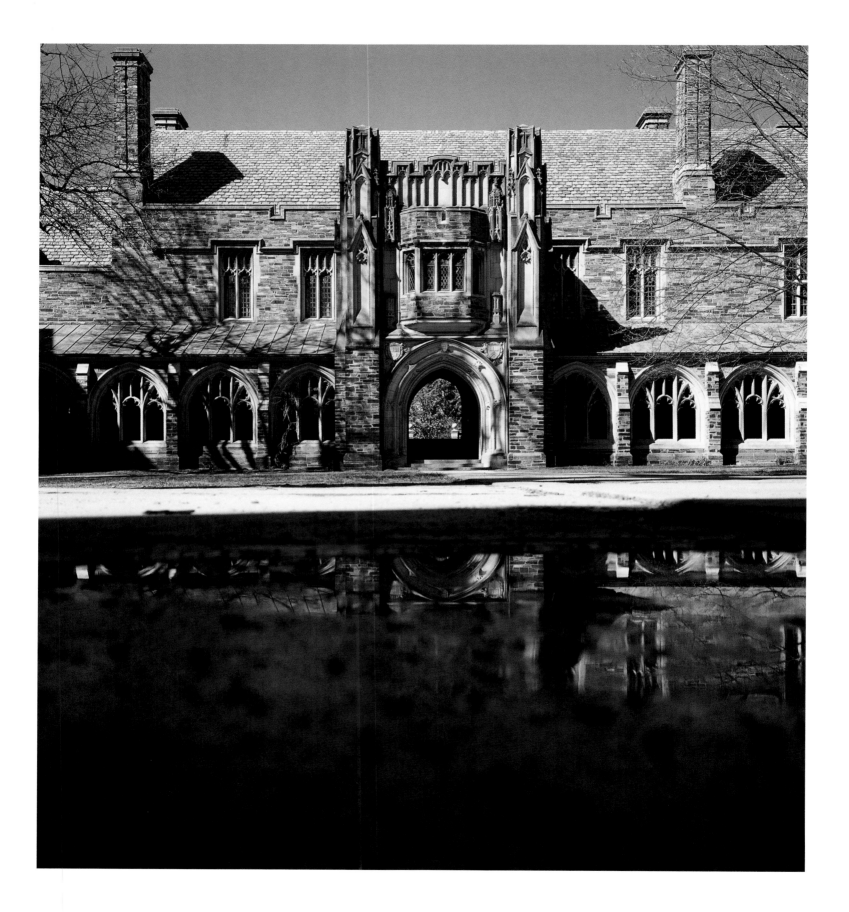

Above and left: Brown and Witherspoon Halls. David Brown Hall (*above*) was designed by John Lyman Faxon in 1892. The style is very loosely adapted from that of a Florentine palazzo. This was one of the last buildings in an eclectic architectural style before the university adopted the Collegiate Gothic standard. The dormitory was given by Susan Dod Brown (Mrs. David B. Brown) in memory of her husband. He was head of Brown Bell, shipbuilders in New York City.

Witherspoon Hall (*left*) is named for the sixth president of the university, and was commissioned in 1875. The architects were William Appleton Potter and Robert Henderson Robertson. At the time it was considered the most beautiful and luxurious college dormitory in the country. That was then. President McCosh built it with extravagance in the belief that it would lure wealthy students with the prospect of a good education in luxurious accommodations. It even had special corridors and rooms for servants. No expense was spared in McCosh's quest for funds to shore up the college's endowment after the decline of enrollment of southern students following the Civil War.

Opposite: Holder is now the principal residence of Rockefeller College, which includes Madison, Witherspoon, and part of Blair Hall. It is named for John D. Rockefeller III and Laurance Rockefeller, class of 1929 and 1932 respectively.

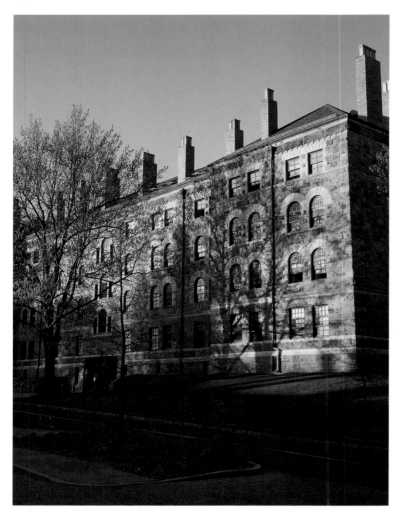

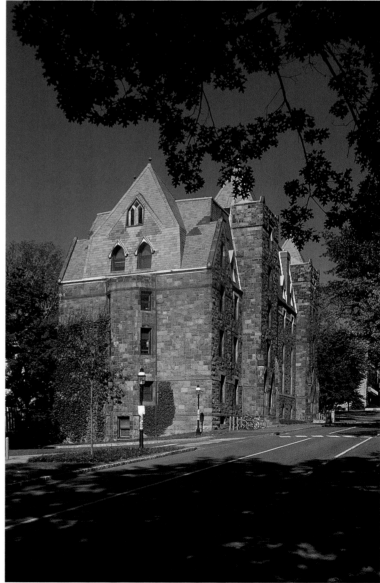

Above: Dod Hall was commissioned in 1888 and designed by John Lyman Faxon of Boston. It was given by Susan Dod Brown in honor of her brother, Albert Baldwin Dod, professor of mathematics. She also gave Brown Hall.

Right: Edwards Hall. This dormitory was commissioned in 1879 and designed by the firm of Prior and West. President McCosh had declared the need for "a new, plain dormitory" and this is what he got—High Victorian Gothic. After the extravagance of Witherspoon, this was a dormitory for those of more modest means. It cost about a third of the former. Funds were given by John Cleve Green in memory of Jonathan Edwards, third president of the university.

Opposite: The Walter L. Foulke Memorial Dormitory. This was designed by Zantzinger, Borie and Medary and given by alumni and friends in honor of Walter Foulke, a member of the class of 1905. It was completed in 1923.

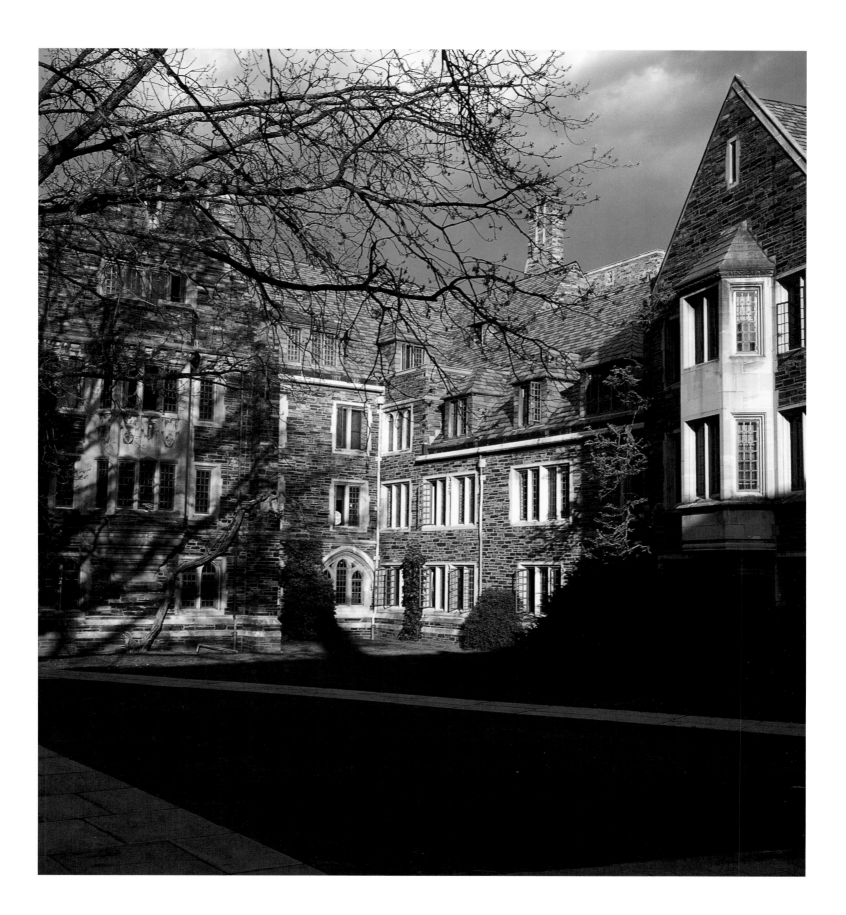

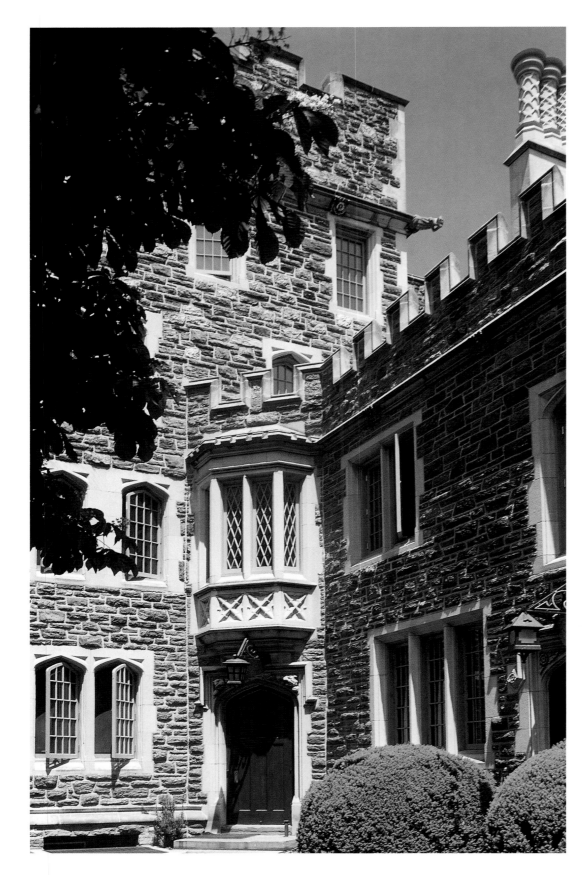

Left: Patton Hall. This dormitory was commissioned in 1905 and designed by Benjamin Wistar Morris, Jr. It is named for the university's twelfth president. He was appointed in 1888, immediately following the much-revered James McCosh. He came to the university from the Princeton Theological Seminary and was seen at first to be conservative and a bit stiff. Over the years he became popular with the students and trustees and brought about a doubling of the undergraduate student body as well as the faculty. His wisdom and wit soon became legendary among the students.

During a recent renovation, architects carved out an arched passageway between the second and third entries, creating an open pathway from Frist Campus Center to Whitman College.

Opposite: Stafford Little Hall, designed by Cope and Stewardson, built in 1899 with an extension in 1901. This was Princeton's second Collegiate Gothic building after Blair Hall, which was designed by the same Philadelphia firm. Stafford Little, class of 1844, was a founder of the New York and Long Branch Railroad. This dormitory together with Blair Hall set the architectural style on the Princeton campus for many years.

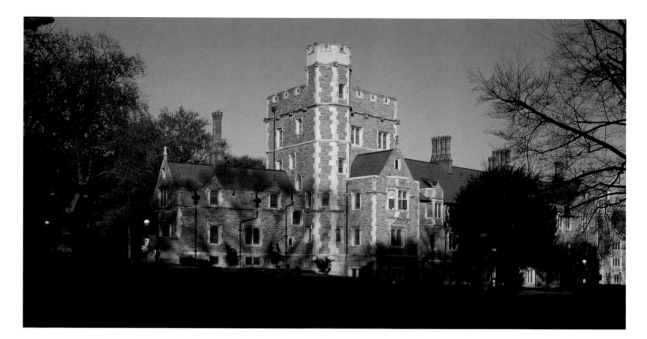

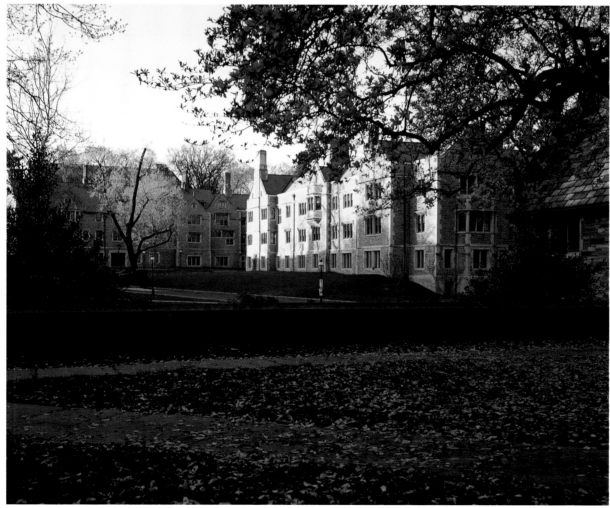

Left, above and below: Pyne Hall, designed by Day and Klauder and completed in 1922. This is one of the university's largest dormitories and was given by alumni in memory of Moses Taylor Pyne, class of 1877, one of the university's most generous benefactors. Together with Ralph Adams Cram, he took a strong interest in developing the distinctive Gothic building style on campus. He helped finance Woodrow Wilson's preceptorial system and built Upper and Lower Pyne dormitories on Nassau Street, as well as Pyne Library.

Opposite: Howard Henry Memorial Dormitory, also known as Henry Hall. This was designed by Zantzinger, Borie and Medary and completed in 1923. It was given by the class of 1904 as well as the families and friends of Howard Henry and Samuel Pyne. Howard Henry was a member of the class of 1904 and an all-American footballer. His father, Bayard Henry, was a trustee of the university for thirty years and the fifth generation of his family to serve in such capacity. He was descended from Nathaniel FitzRandolph.

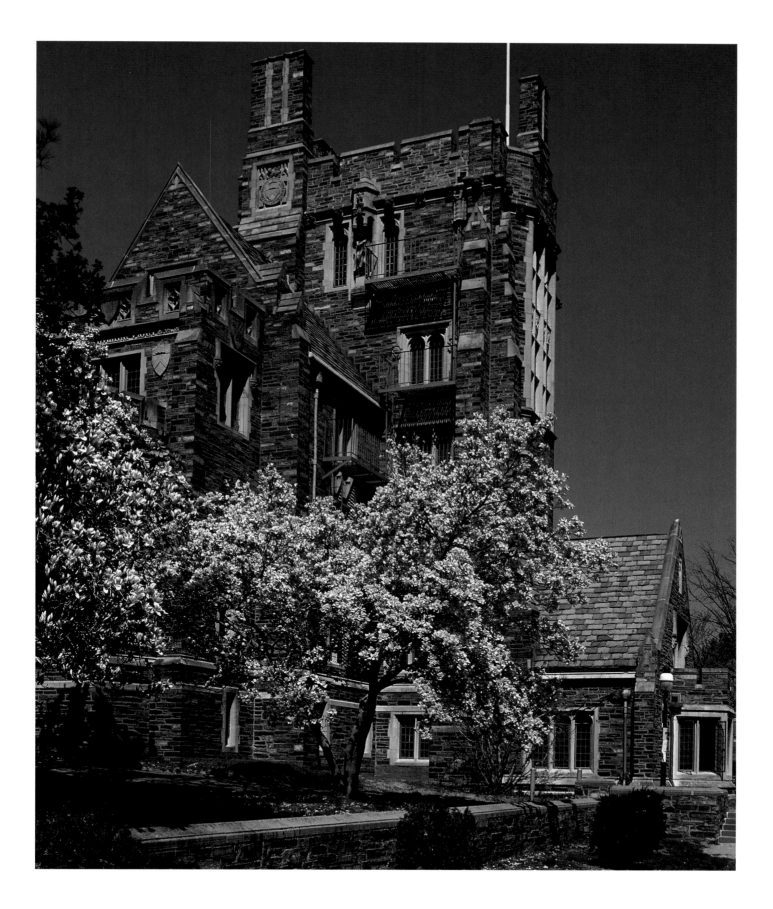

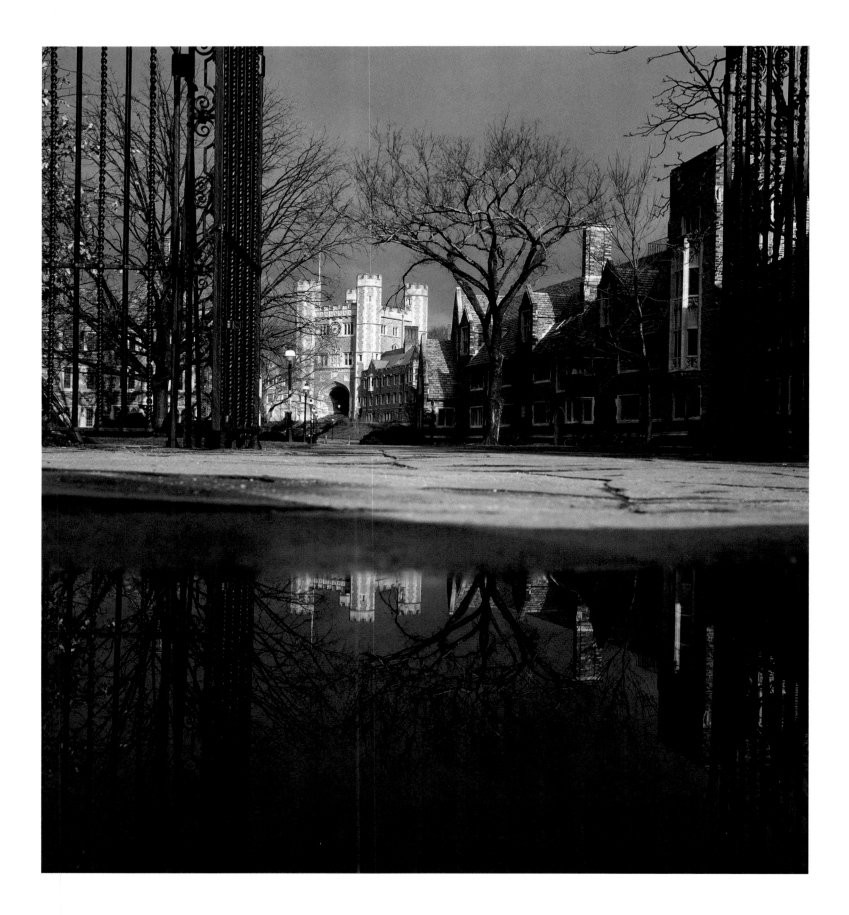

President John Grier Hibben, who succeeded Woodrow Wilson, was responsible for extending the Collegiate Gothic style to ten new dormitories: Cuyler, Foulke, Joline, Henry, Laughlin, Lockhart, Pyne, and Walker, plus 1901 and 1903 Halls. This permitted the housing of approximately 82 percent of the 2,200 students, a 28 percent increase. With these new buildings, the Princeton architectural style extended the full length of the campus, from Blair down to the relocated "Dinky" train station—which was also built to harmonize with its neighbors.

Opposite: The lower entrance to the campus shows Blair Hall framed by the Dodge Gateway. The gates were a gift from the parents of Marcellus Hartley Dodge, class of 1930. On the right may be seen Laughlin Hall.

Above: Henry Hall. Bayard Henry was among a small group of alumni of the McCosh years who were able to purchase a square mile of valuable land for the university at the beginning of the last century. He personally procured the land where Holder Hall sits, as well as the tract of land that extends along University Place. He was also responsible for procuring the land from Lake Carnegie all the way to US Route 1. Clearly, this handsome dormitory is a fitting tribute to such accomplishments.

Right: Laughlin Hall was designed by Day and Klauder, finished in 1926, and donated to the university by James Laughlin, class of 1868. He also gave a large amount of acreage on which the lower campus and playing fields are now located.

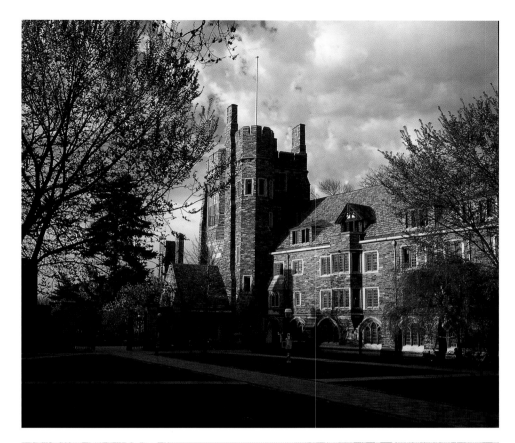

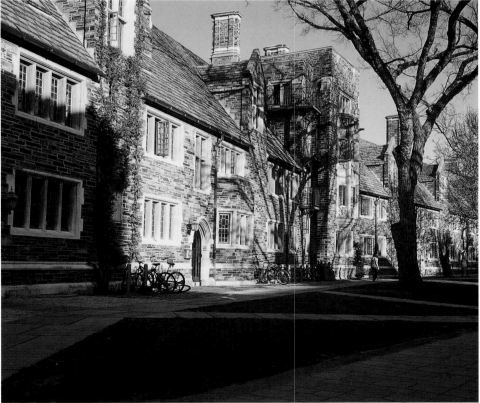

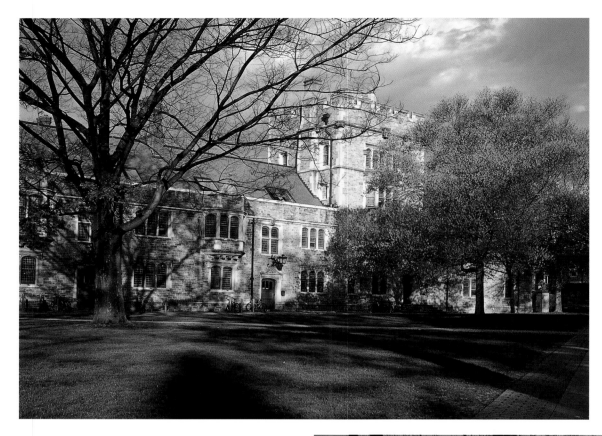

Above: 1901 Hall. This dormitory on the lower campus was designed by Charles Klauder and completed in 1925.

Right: Hamilton Hall. The classes of 1884 and 1885 donated funds for this Day and Klauder–designed dormitory, which opened in 1911. It is one of the smallest and yet one of the most elegant of the Gothic dormitories. Its honoree is John Hamilton, the acting governor of the Province of New Jersey, who granted the charter of the College of New Jersey on October 22, 1746.

Opposite: Cuyler Hall, designed by the Day and Klauder firm, completed in 1913, and named for Woodrow Wilson's classmate Cornelius Cuyler. He was a trustee of the university from 1898 to 1909. Architectural critics deem this to be the most handsome of the university's dormitories. The rich details of the oversized stone chimneys, the heavy slate roof, and the extensive ornamentation of the Pitney Archway, which opens up to Patton and Walker Halls, are all pure bespoke styling.

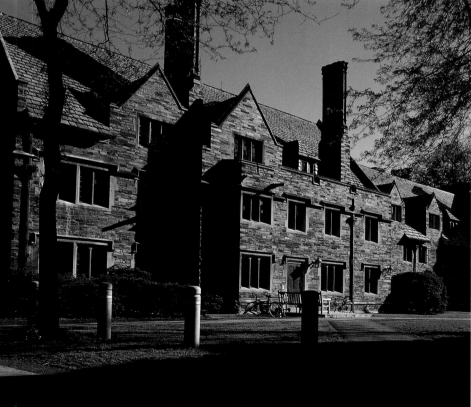

214

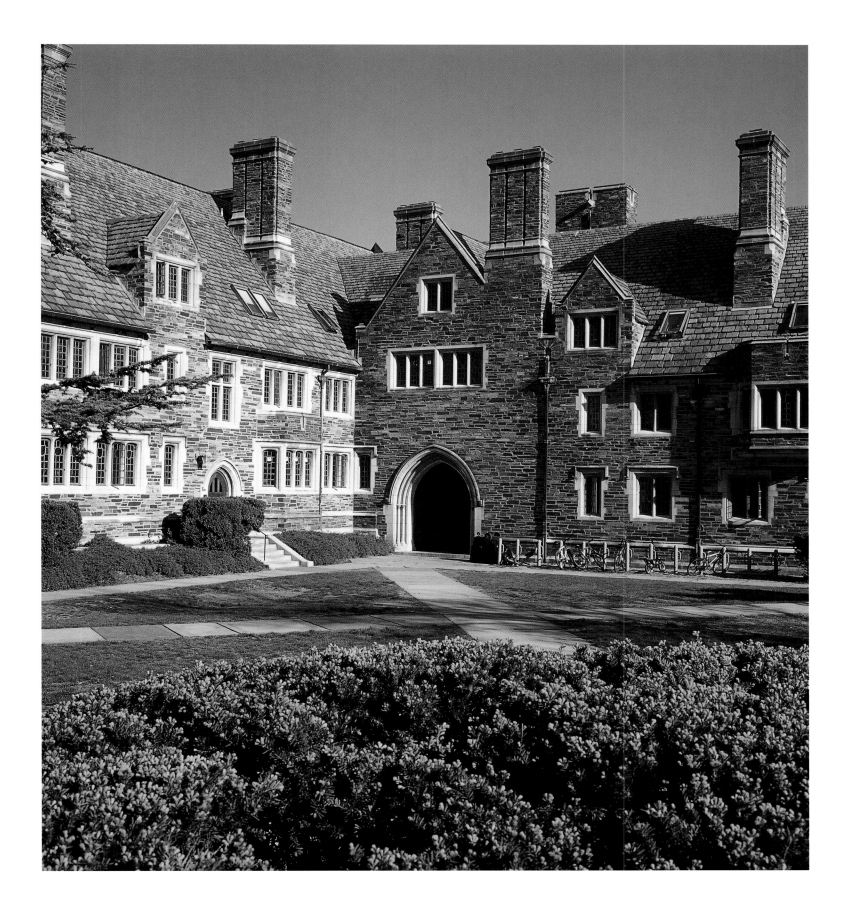

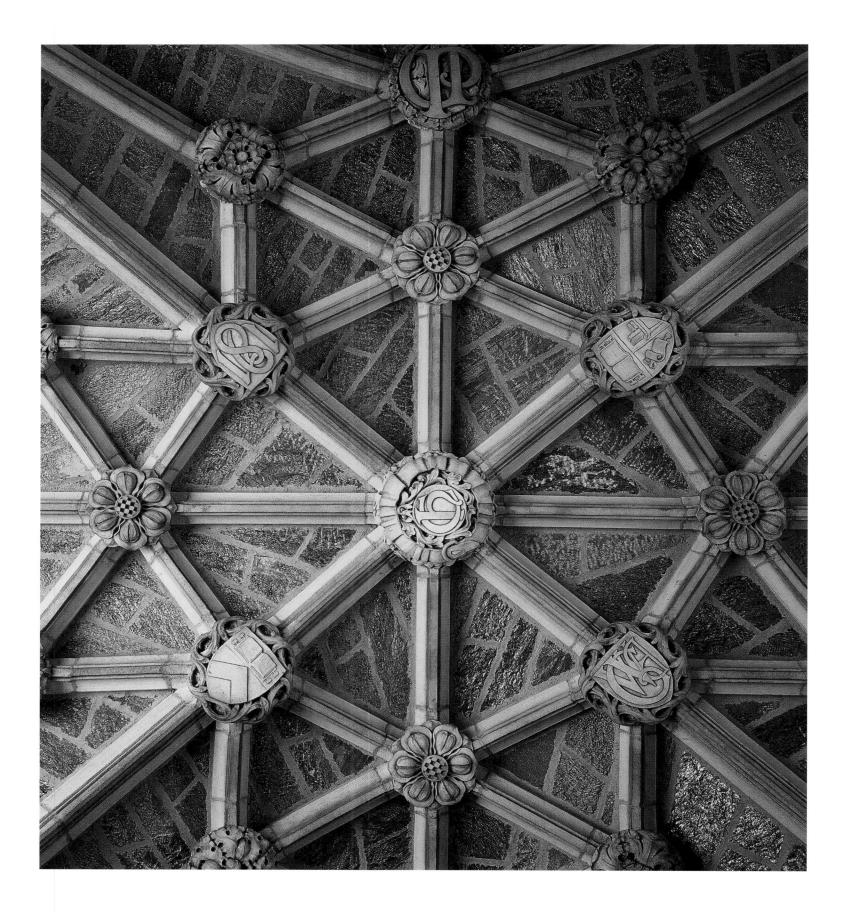

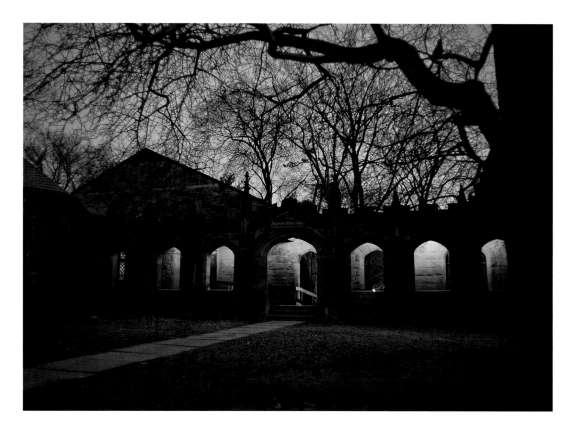

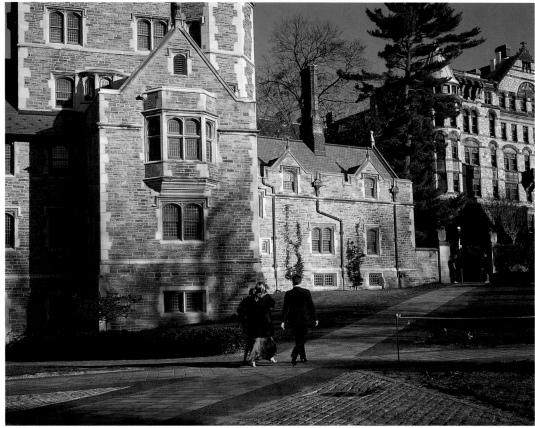

Opposite: Pitney Archway of Cuyler Hall. The magnificent vaulted arch is graced with many shields, coats of arms, and other decorations of the Pitney family, honoring its long relationship with Princeton. Among the members of the Pitney family commemorated are Henry C. Pitney, class of 1848 and Vice-Chancellor of New Jersey, Henry C. Pitney, Jr., class of 1877, Supreme Court Justice, Mahlon Pitney, class of 1879, and university trustee John O. H. Pitney, class of 1881.

Above: Murray-Dodge Hall, built in 1879 and 1900, respectively. Hamilton Murray, class of 1872, and the Dodge family gave the requisite funds. Dodge Hall (on the right) is the center for religious activities, and Murray Hall (on the left) is the home of Theatre Intime and other drama groups.

Left: Walking past Little Hall on their way to an evening event. In the background is the majestic Witherspoon Hall.

Spelman Hall, designed by I. M. Pei and completed in 1973. This is the first campus dormitory with individual apartments and kitchens for its residents. Laura Spelman Rockefeller, with her husband John D. Rockefeller, Sr., founded Spelman College in Atlanta, the first American college for black women. Their grandson, Laurance S. Rockefeller, class of 1932, gave $4 million to the university in 1969 to help institute coeducation.

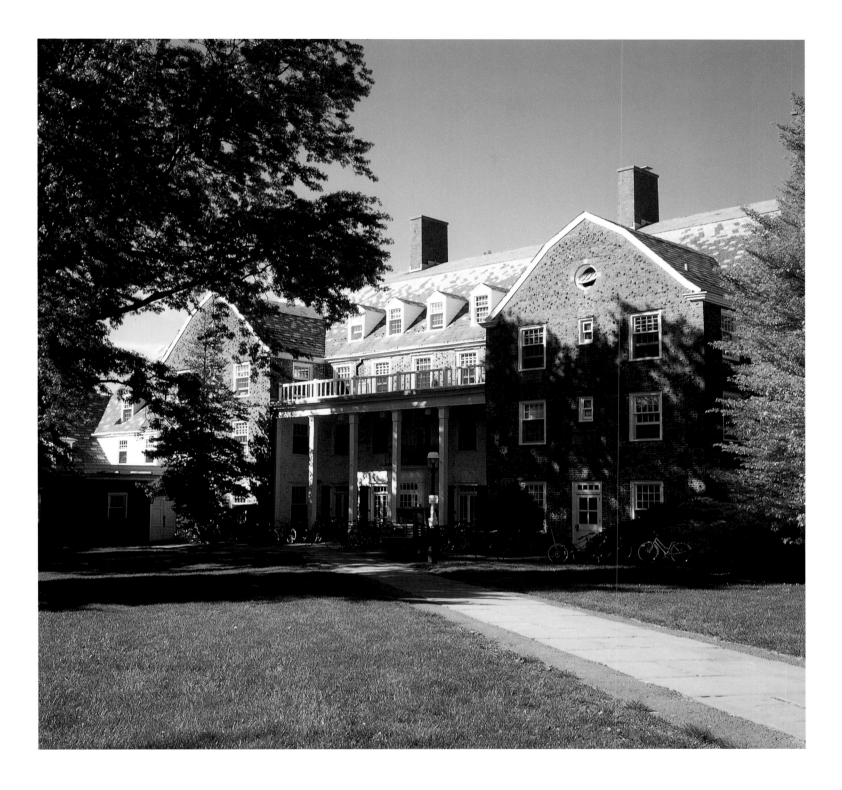

Forbes College, completed in 1924 by Andrew Thomas. For many years it was known as the Princeton Inn, a familiar landmark because of its gracious design as well as its setting overlooking the Springdale pond and golf course. In 1970 the university converted the inn into its first coeducational dormitory to address a shortage in accommodations. It was renamed Forbes College in 1985 in honor of Malcolm Stevenson Forbes, class of 1941, and his son, class of 1970.

Whitman College. The completion of one of the larger construction projects in Princeton history, Whitman College, marked the launch of the new four-year residential college system. This 250,000-square-foot Collegiate Gothic complex between Dillon Gymnasium and Baker Rink opened in 2007 after three years of intense construction work. Approximately five hundred students make it their home. It was designed by Demetri Porphyrios, class of 1980, and consists of eight connected buildings: Fisher, North, Community, Hargadon, Lauritzen, South Baker, 1981, and the Murley-Pivirotto Family Tower. On the eastern side of the college is an expansive green that is intended to embrace the rest of the campus with open

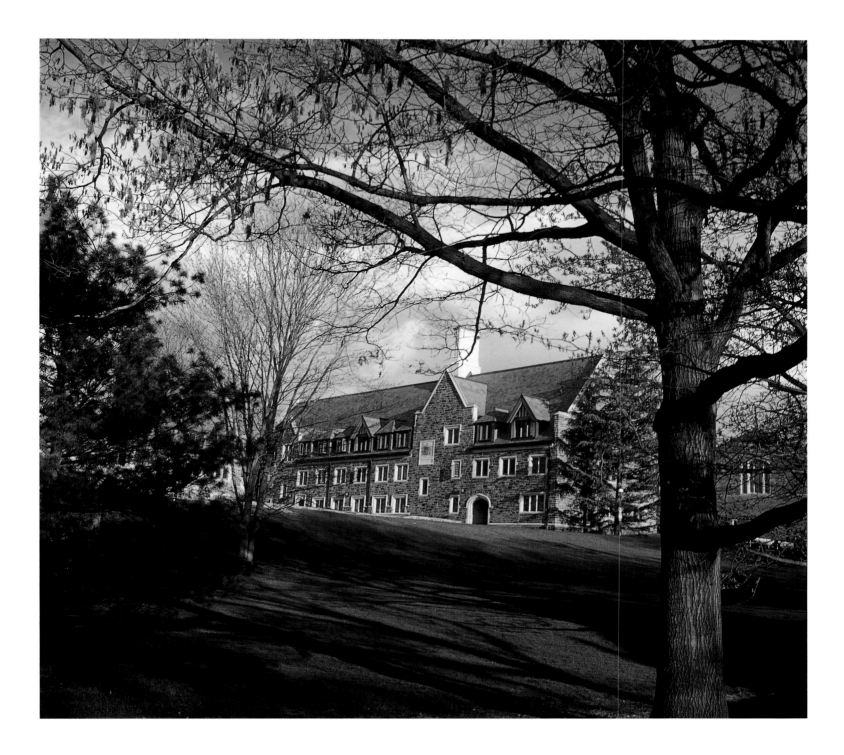

arms. Whitman College was a gift primarily by Meg Whitman, class of 1977, former university trustee and chief executive officer of eBay Inc. The buildings were constructed according to authentic medieval techniques, which required trained stonemasons. In some places the masonry is up to twenty inches thick—built to last hundreds of years. The Whitman construction was accompanied by several projects in other dormitories as part of the rollout of the new residential college system, which is intended to better serve students and to provide them with more options in various aspects of residential life.

Opposite: Laughlin Hall. This is one of our favorite dormitory images, showing a lone room lit up on a winter's night. Designed by Day and Klauder, this handsome building on the lower campus was given by James Laughlin, a member of the class of 1868 who gave the tract of land where many of the playing fields are located. It opened in 1926.

Above: Cuyler Hall. This handsome dormitory was commissioned in 1912 and designed by Day and Klauder. Cornelius Cuyler was a classmate and friend of Woodrow Wilson. He was a New York banker and a trustee of the university from 1898 to 1909.

Left: Dillon Gymnasium. This was designed by Aymar Embury, class of 1900, and completed in 1947 on the site of University Gymnasium. This gym is named in honor of Herbert L. Dillon, class of 1907 and former captain of the football team, hence the football gargoyle on the next page.

The many faces on the Princeton campus include gargoyles. Originally, gargoyles were carved figures serving as waterspouts on the great cathedrals of Western Europe. Their purpose was to direct rainwater away from the building in order that the mortar not be eroded. The name comes from an old French word meaning throat or gullet. On the campus are many fanciful stone carvings simply referred to as gargoyles. They impart a sense of whimsy to the older buildings and are certainly worth an upward glance during one's perambulations on the campus. Few universities can boast of such a wonderful and entertaining collection, often hidden from the casual eye, such as those on the outside of Thomson Hall of the graduate college.

Right and Opposite: Three gargoyles over the entrance to Dillon Gym. The most famous is the football player. Note the leather helmet and lack of face mask. While the gym was finished in 1947, its major benefactor, Herbert L. Dillon, was a member of the class of 1907 and a football captain. This equipment represents the style at that time. Other sculptures include the *Literate Ape,* looking up from his copy of Chaucer's *Canterbury Tales,* and a professor in similar attire. Joining these is a tiger, perched on a large shield and appearing to be using it as a surfboard.

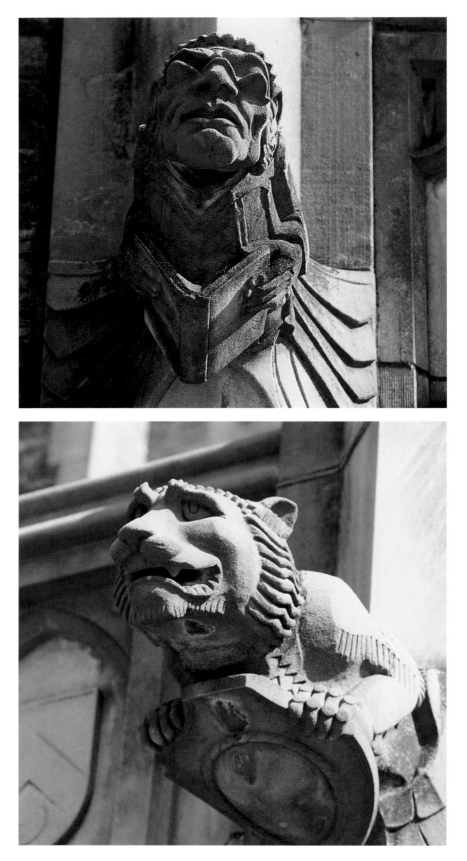

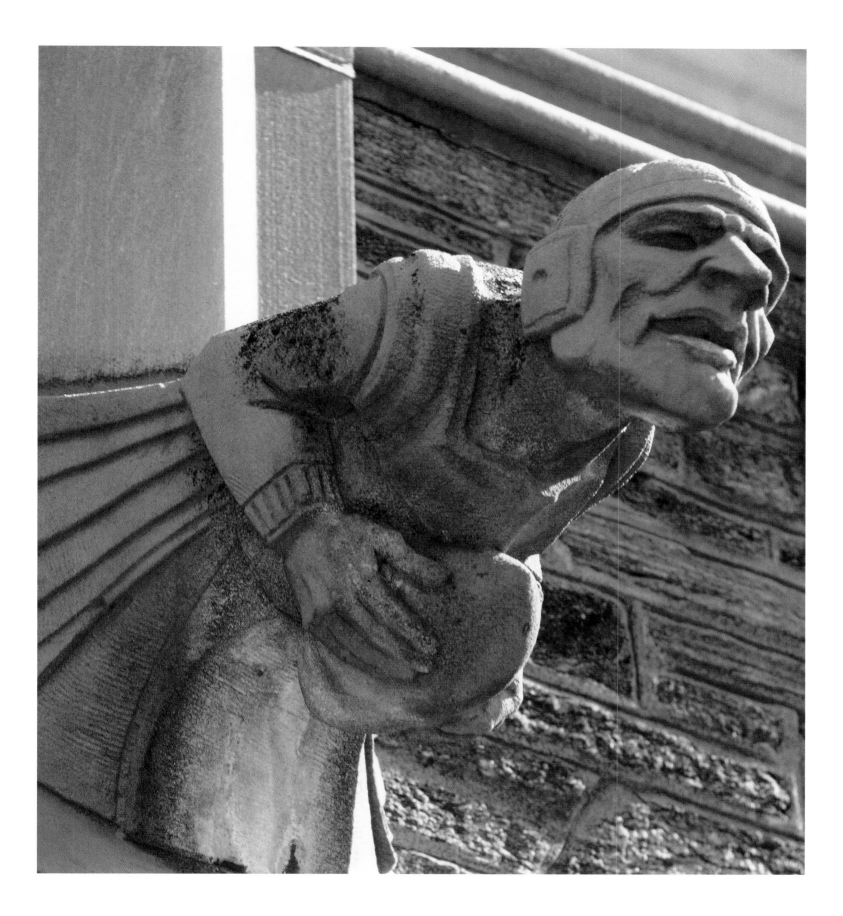

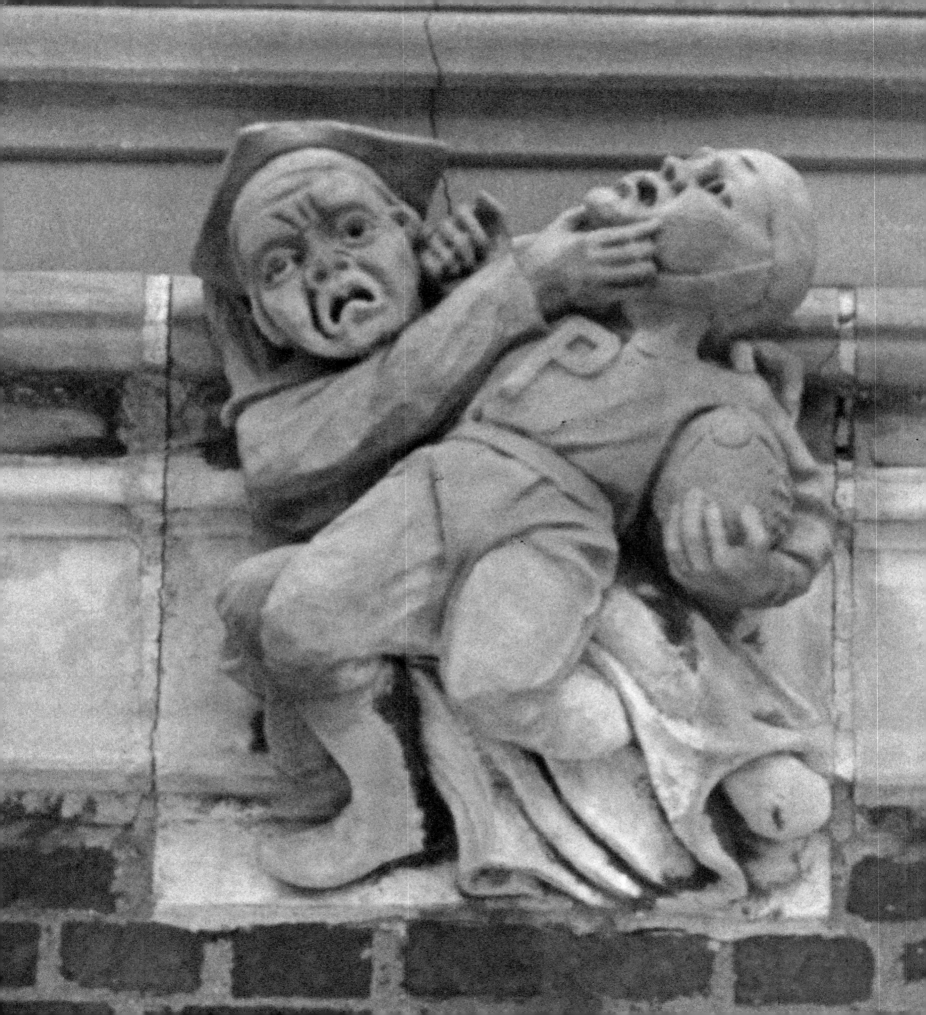

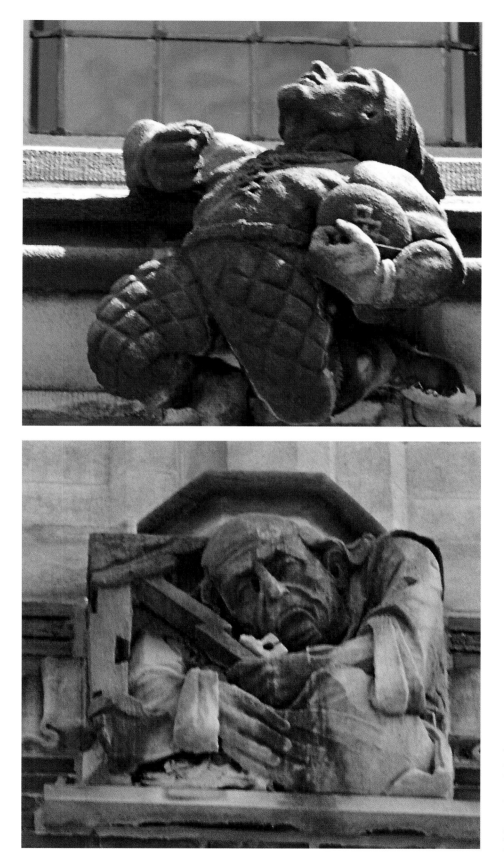

Opposite: A favorite of ours sums up the Princeton experience for many—the tug between studies and athletics—with a professor choking a football player.

Left above: Along the clerestory windows of McCosh Hall are numerous gargoyles, including a distinctive carving of a football player dashing to a touchdown. Dressed in quilted pants and a stocking cap, he is likely the interpretation of a sculptor not completely familiar with the sport, but nevertheless enjoying the play of the game.

Left below: Benjamin Franklin is depicted at the Frist Campus Center, holding a key while a lightning bolt appears to be striking from the left. A second set of arms is protecting him.

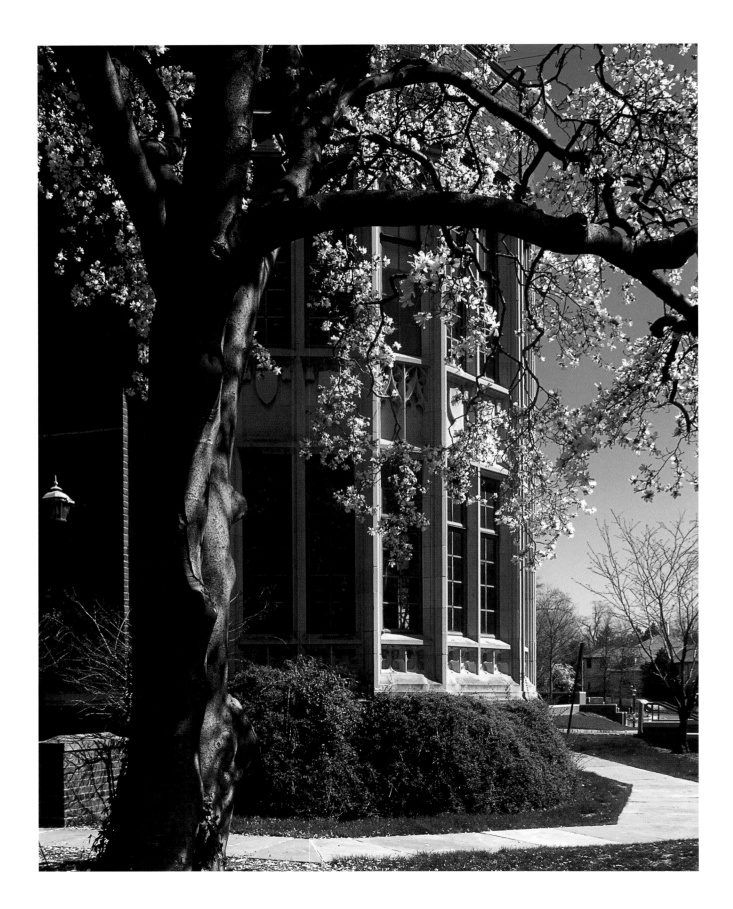

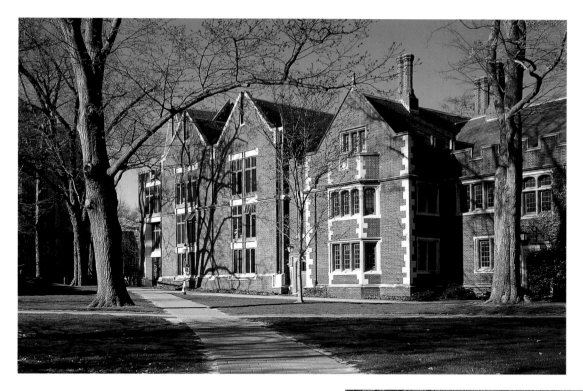

Opposite: The Isabella McCosh Infirmary was commissioned in 1923 and designed by Day and Klauder. It is named for the wife of James McCosh, eleventh president of the university. Mrs. McCosh took an interest in the undergraduate students who were sick, caring for them and writing to their families. In 1891 she persuaded the trustees to build a dedicated infirmary. The original building and this 1923 replacement were both named for Isabella McCosh. She also took an interest in the landscaping of the university, and hence McCosh Walk is named for both James and Isabella.

Above: Marx Hall. This addition to 1879 Hall was completed in 1993 and designed by Kallman, McKinnell and Wood of Boston. It is a gift of Louis Marx, class of 1953. He is president of a private investment firm based in New York. The wing named for him contains the University Center for Human Values.

Right: Eno Hall, built in 1924 and designed by Charles Klauder. This Collegiate Gothic building is used as a general science building and is the southernmost of its style on the campus. Originally, it was built for the Department of Experimental Psychology.

229

East and west views of 1879 Hall, completed in 1904 and given by the 170 members of the class of 1879 at their twenty-fifth reunion to Princeton and to their classmate Woodrow Wilson. When he was university president, Wilson had his office here. It was designed by Benjamin Wistar Morris, Jr. in keeping with the Tudor Gothic style, using red brick instead of the limestone that had been chosen for Blair and Little Halls. Originally, the building was a dormitory whose accommodations were in great demand because of their proximity to the eating clubs. It currently houses the Departments of Philosophy and Religion.

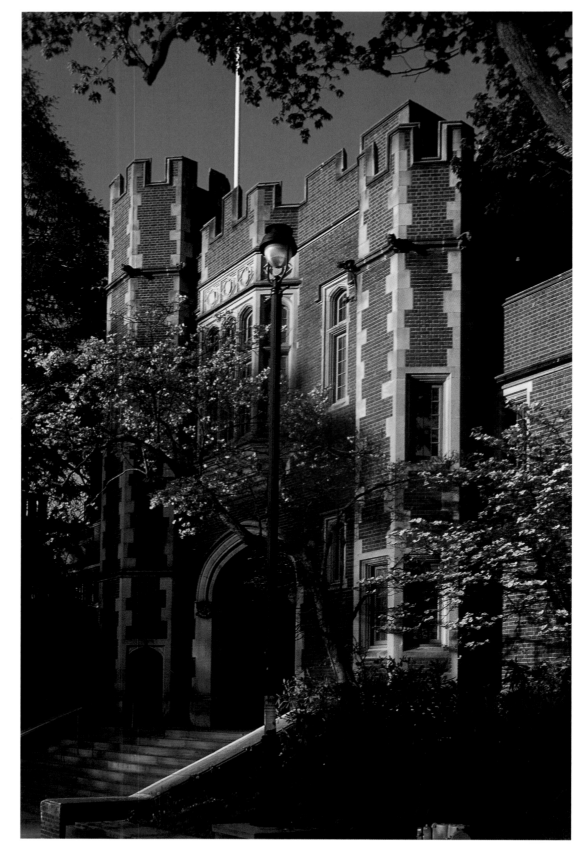

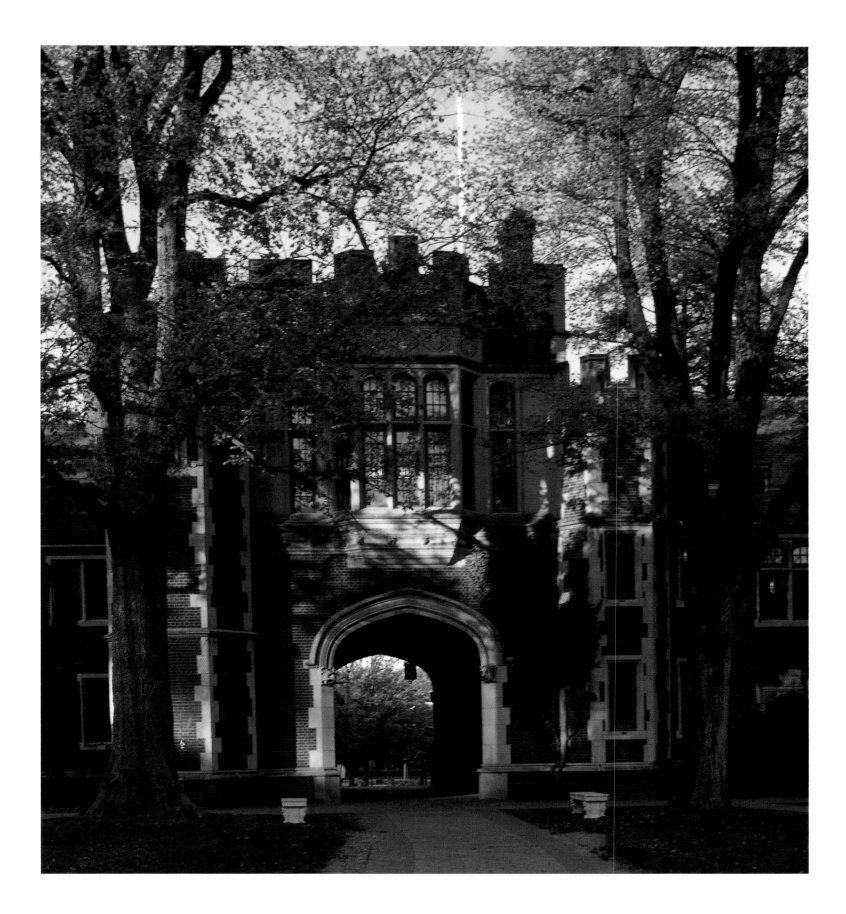

Above: Woolworth Center of Musical Studies. This building was designed by Moore and Hutchins of New York and completed in 1963 and extended in 1995. It was largely a gift of Fraiser McCann, class of 1930, and his sister in memory of their grandfather F. W. Woolworth. In addition to classrooms and offices, it contains listening rooms and individual ensemble practice rooms.

Opposite: School of Architecture and Urban Planning. This building was commissioned in 1962 and designed by Fisher, Nes, Campbell and Associates of Baltimore. Modifications were made in 1980. It houses a library, classrooms, drafting rooms, lecture halls, and administrative offices. The school was established in 1919, although the study of architecture began when physicist Joseph Henry arrived in 1832. In 1930 Frank Lloyd Wright gave his first lectures in the United States at Princeton.

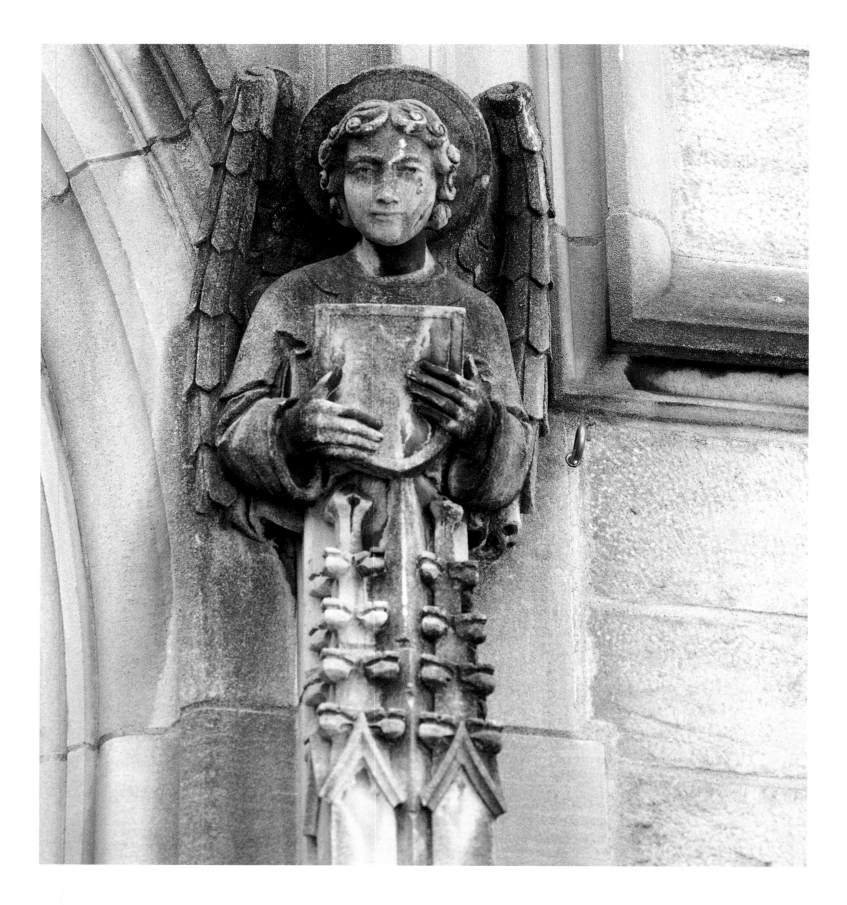

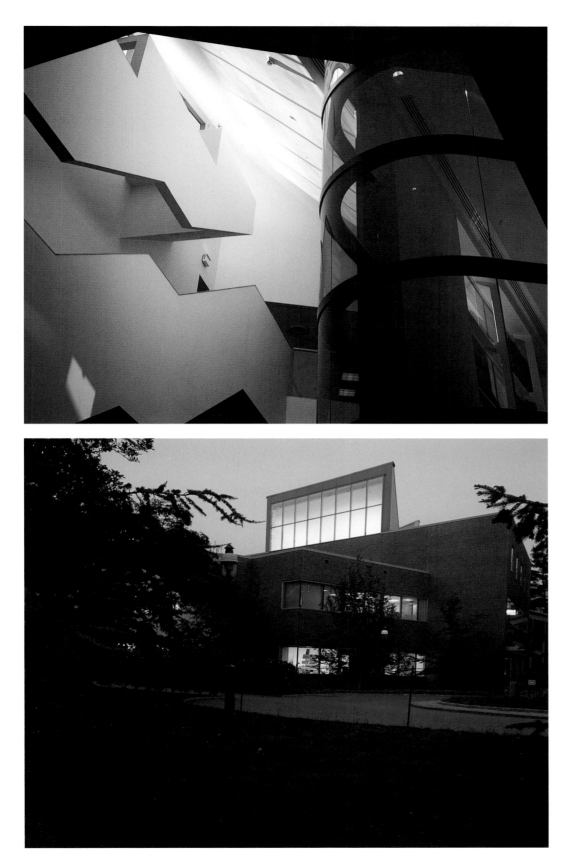

Opposite: An angel sculpture at University Chapel. He seems to be holding an attendance list and waiting for some stragglers. Required Sunday attendance was abandoned in the 1960s.

Above and left: The new extension at Woolworth Music Center. This was completed in 1995 according to designs of Juan Navarrow Baldweg, bringing light into the older building. The atrium houses the Mendel Music Library, named for the chairman of the Music Department from 1952 to 1967.

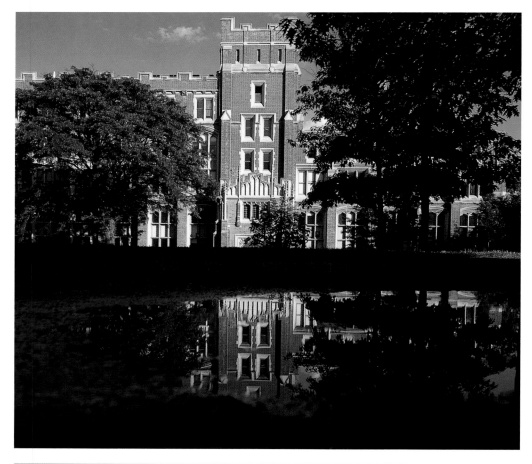

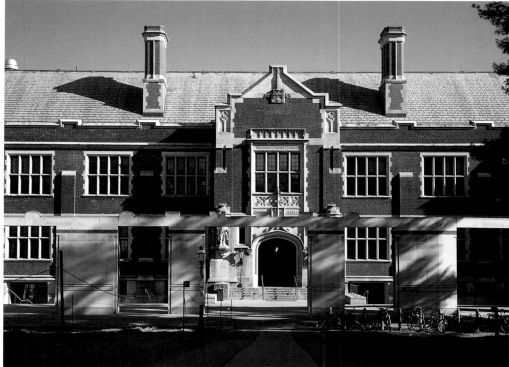

Above: Guyot Hall is named for the first professor of geology and geography, Arnold Guyot. It was given by the mother of Cleveland H. Dodge and designed by Parrish and Schroeder. It opened in 1909. The building contains two acres of floor space and approximately one hundred rooms. The ground floor was assigned to the Natural History Museum to draw the attention of students on their way to the lecture and laboratory rooms above.

The exterior design is in keeping with the Tudor Gothic style, after Little and Blair Halls, but incorporates the brick-and-limestone trim first used in 1879 Hall. Around the perimeter of the building are sculptures of many animals, both extinct and living. These gargoyle ornaments were created in the studio of Gutzon Borglum, sculptor of the Mount Rushmore presidential statues in South Dakota.

The Natural History Museum in Guyot, founded in 1856 by Arnold Guyot, was originally housed in the Faculty Room of Nassau Hall

Below: Palmer Physical Laboratory, completed in 1908 as a gift of Stephen Palmer, a university trustee. Originally, it housed the Department of Physics.

Opposite: The Frist Campus Center, named for and donated by the Frist family of Nashville. Five members of this family have attended Princeton, including former Senate Majority Leader William H. Frist, class of 1974, who has served on the university's board of trustees. In 2002 Palmer Hall was transformed into the Frist Campus Center. The new design by Venturi, Scott Brown and Associates maintains the integrity of Palmer's brick-and-limestone front façade, yet it transforms the building's interior space with a four-level plan of meeting rooms and lounges, libraries, classrooms, and offices for student organizations. Venturi's firm, based in Philadelphia, has designed several other major buildings on campus, including Lewis Thomas Lab, Fisher Hall, and Wu Hall.

Above: Sherrerd Hall is home to the Department of Operations Research and Financial Engineering as well as the Center for Information Technology Policy. The broad reach of these programs is reflected in the building's location at the intersection of the engineering and social science neighborhoods.

Its striking glass structure was commissioned in 2007 and designed by the award-winning Los Angeles firm Frederick Fisher and Partners. The glass façades mirror the architecture of the Friend Center for Engineering Education across Shapiro Walk. It is named for John J. F. Sherrerd, class of 1952, a Philadelphia investment banker and longtime university volunteer and trustee.

Below: Wallace Hall was commissioned in 1999 and designed by the architectural firm of Bohlin, Cywinski, Jackson. It is home to the Office of Population Research, the Center for Research on Child Wellbeing, and the Research Program in Development Studies. The Donald E. Stokes Library and the Ansley J. Cole Population Research Collection are located here.

Opposite: Friend Center for Engineering Education, designed by Henry Cobb of Pei, Cobb, Freed & Partners in 2001. This provides greatly needed classroom, meeting and library space not just for engineering but for the campus as a whole. Its modern, light-filled spaces have hosted countless classes and events from engineering to the humanities. The building was a gift of Dennis J. Keller, class of 1963, Chairman of DeVry University and a trustee of Princeton for many years. It is named in honor of his colleague and classmate, the late Peter Friend. Dennis Keller and Jay Sherrerd are among the university's most beloved and benevolent alumni of this century.

The Friend Center joins the Computer Science building to the northeast and extends toward the heart of the campus to the southwest. Within the Engineering Quadrangle is the Keller Center which opened in 2005. The center supports the development of courses and projects that cross conventional academic disciplines to prepare students in engineering, natural sciences, humanities, and social sciences to work side by side in solving global issues.

Connecting these three buildings is Shapiro Walk, dedicated in 2001 to President Emeritus Harold T. Shapiro. The walk represents an extension of McCosh Walk across Washington Road.

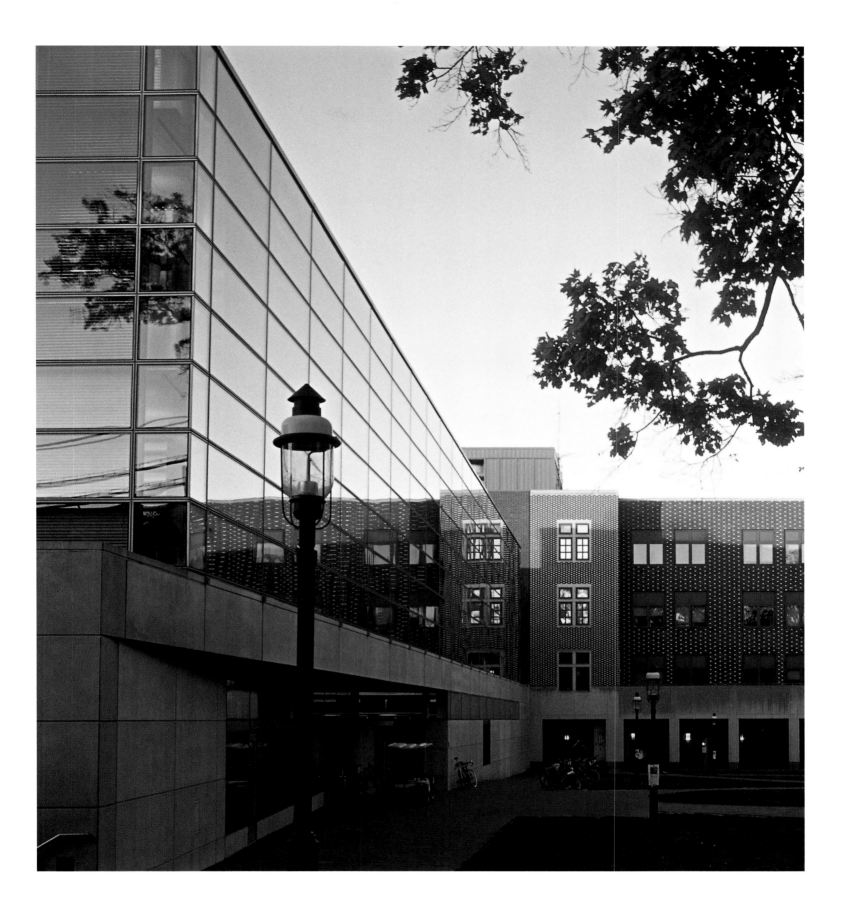

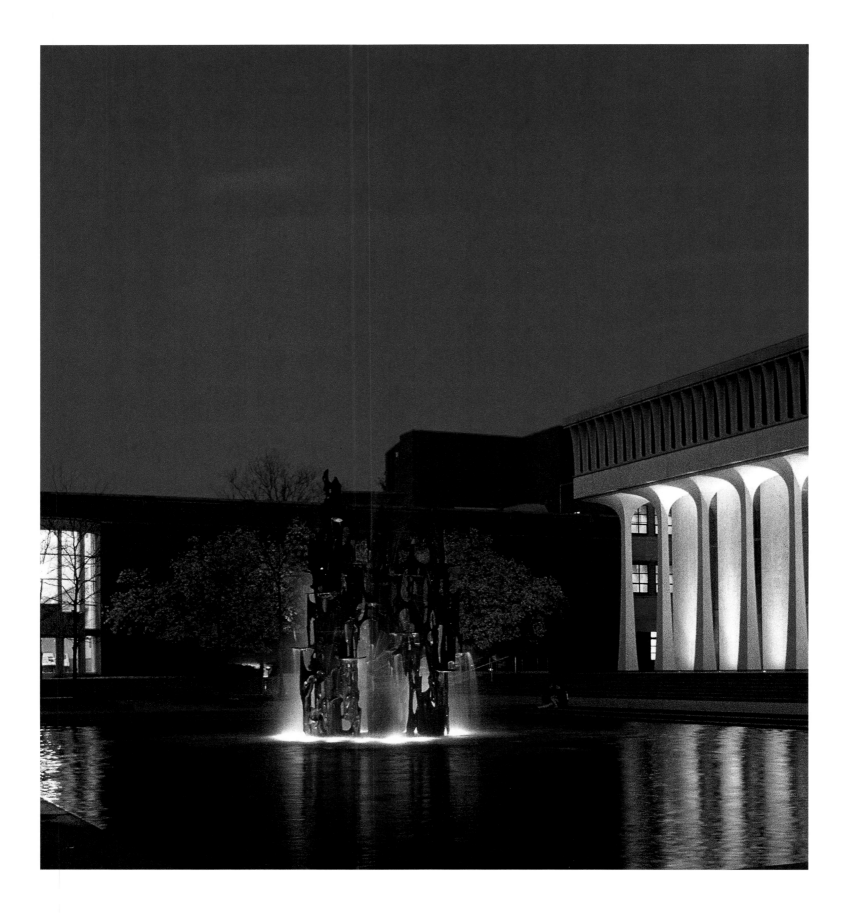

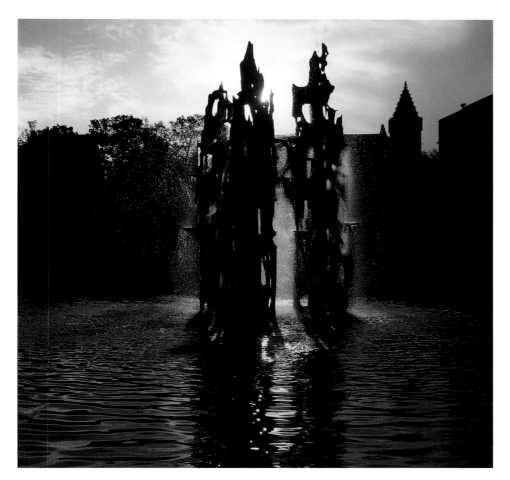

The Woodrow Wilson School of Public and International Affairs. The Woodrow Wilson School was founded in 1930 as a cooperative endeavor by the Departments of History, Economics, and Politics. It assumed its official name in 1948 when a graduate program was established. The school prepares students for careers in public service.

Opposite: The striking building with fifty-eight quartz-covered columns was designed by Minoru Yamasaki and dedicated in 1966. He was also the architect of New York's World Trade Center. The building was made possible in large part by a gift from Charles Robertson, class of 1926. It was substantially remodeled in 2002 and, in order to preserve its design integrity, was expanded with new classrooms and study areas below ground. Light is provided by strategically located skylights. The name of the building became Robertson Hall in 1988.

Above: Scudder Plaza contains a reflecting pool and the sculpture *Fountain of Freedom* by James Fitzgerald. The plaza is especially beautiful in the spring when the pink saucer magnolias *(Magnolia x soulangeana)* are in bloom. Numerous members of the Scudder family have attended the university over the years.

Below: Corwin Hall. Originally this was the center for the Woodrow Wilson School and occupied the location at the corner of Washington Road and Prospect Street. Corwin was built in 1952 and designed by Voorhees, Walker, Foley and Smith. In 1963 the building was raised, one inch per day, and slid onto railroad tracks to its current location, which enabled the new Yamasaki building to occupy its former space.

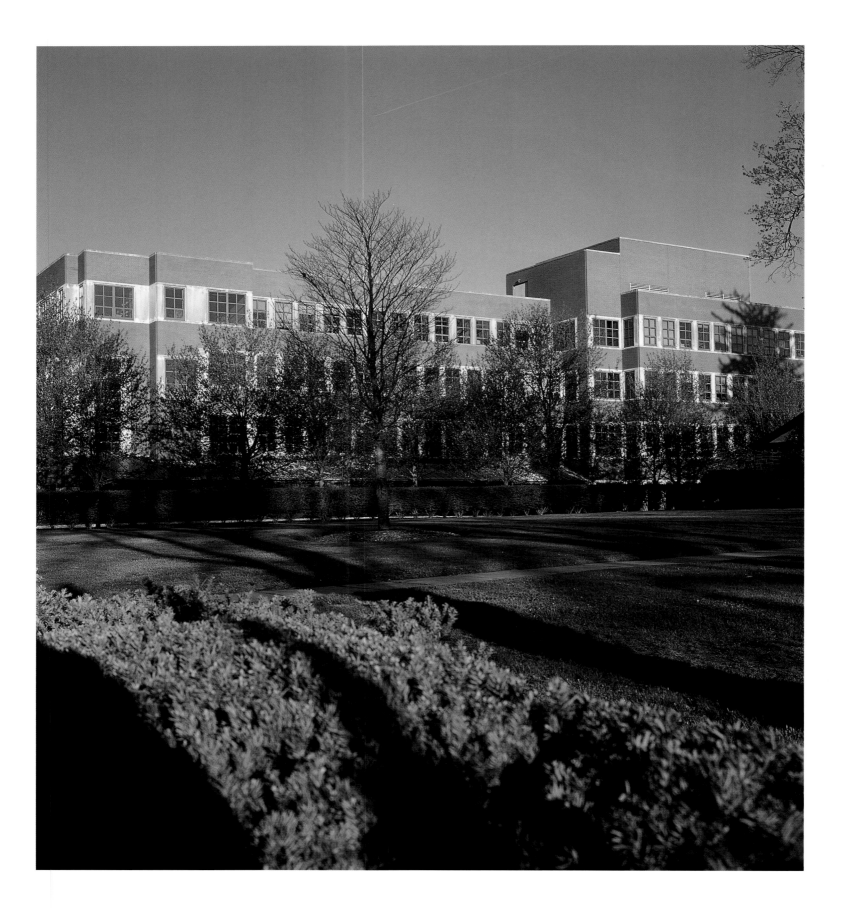

Opposite: Fisher-Bendheim Hall. Adjacent to Robertson and Corwin Halls, this houses faculty and administrative offices, as well as conference rooms and classrooms, for the Department of Economics. Designed by Robert Venturi, class of 1947, the building was dedicated by President George H. W. Bush in 1991. The Fisher family—including Robert J., class of 1976, William S., class of 1979, and John J., class of 1983—has been a major benefactor and also gave Fisher Hall at Whitman College. Robert A. Bendheim, class of 1937, was president of the M. Lowenstein Corporation, the textile manufacturers, and also made numerous gifts to the university. It is fitting that this striking building, appearing like an ocean liner on Prospect Avenue, is named for such generous people.

Above: The Scribner Building, 41 Williams Street. It was designed by Ernest Flagg and completed in 1911. This was for many years the home of Princeton University Press and was a gift from Charles Scribner, class of 1875, founder of the famous Fifth Avenue publishing firm. He was a trustee of the university from 1912 to 1930 and founded Princeton University Press.

Right: Upstart II and the School of Engineering. The sculpture by Clement Meadmore, executed in 1970, is designed to create a feeling of material lightness despite its size and weight. The Princeton School of Engineering was organized in 1921 as the university's second professional school, although courses in engineering had been in the curriculum since 1875. The engineering quadrangle was built in 1962 and contains over 120 laboratories, plus classrooms, offices, and a library. It was designed by the firm of Voorhees, Walker, Smith, Smith and Haines, at the time the largest architectural/engineering firm in the country.

Above: Fine Hall, designed in 1968 by Warner, Burns, Toan and Lunde. It is named in honor of Henry Burchard Fine, class of 1880, first dean of the Department of Science. Fine was instrumental in assisting Princeton to evolve from a college to a university. He also made Princeton the leading center for mathematical studies, and he fostered the growth of other branches of science.

Below: Bowen Hall was named for William Gordon Bowen, seventeenth president of the university from 1972 to 1988. The building was commissioned in 1991 and designed by the Hillier Group. Funds were provided by Gordon Wu, class of 1958, and other contributors. This is the Materials Research Science and Engineering Center. Of the Princeton experience Bowen said, "We believe that education should open minds rather than try to fill them up. It should prepare students to appreciate the beauty of ideas as well as the world around them, to understand both other people and themselves, and to be effective citizens in a democracy. We aim to educate the whole person." Under Bowen's leadership, the new residential college system began, five new buildings went up, others were expanded or renovated, and the university's endowment grew from $625 million to more than $2 billion at the time of his departure.

Opposite: Five Disks: One Empty by Alexander Calder. This sculpture was designed for Princeton in 1969 and installed in 1971 on the plaza between Fine Hall and Jadwin Physics Laboratory. The disks were originally painted orange but were later changed to black at the request of the sculptor.

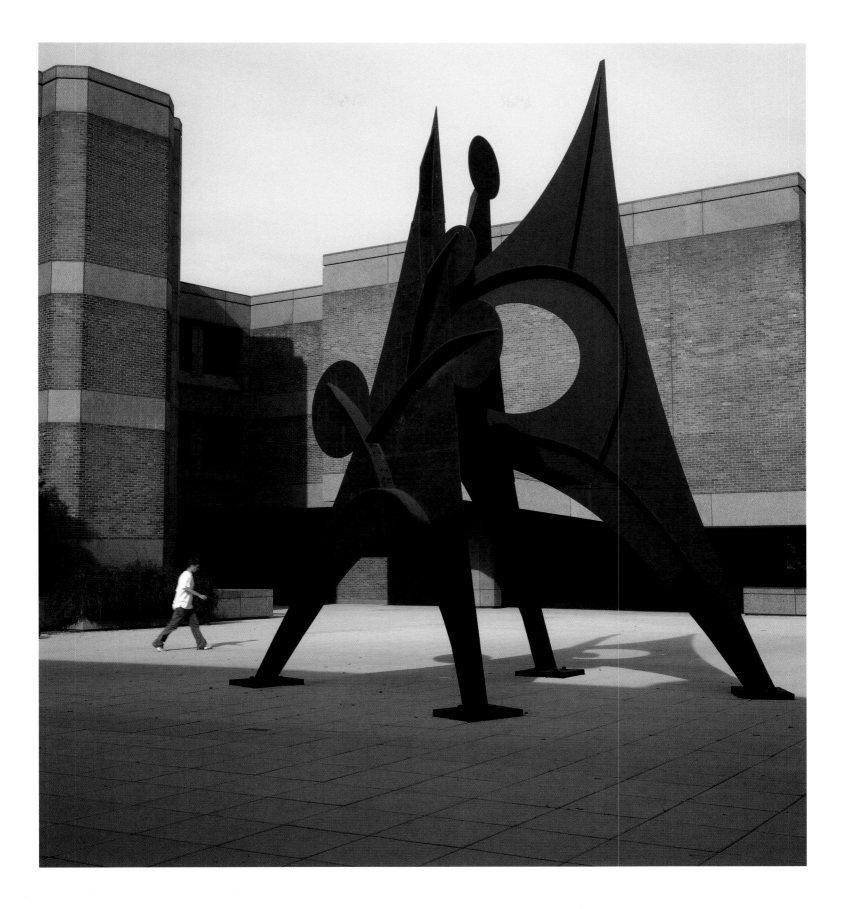

Opposite: Schultz Laboratory. This science building was commissioned in 1993 and named for George LaVie Schultz, class of 1940. It was designed by Venturi, Scott Brown and Associates together with Payette Associates, Inc.

Above: Lewis Thomas Laboratory. This is the Department of Molecular Biology building and was commissioned in 1984. It was also designed by Robert Venturi and is named for a member of the class of 1933.

Below: Wu Hall, the dining and social facility of Butler College. It was designed by Venturi, Scott Brown and Associates, completed in 1983, and given by Gordon Ying-Sheung Wu, class of 1958. Sir Wu is the chairman of the board of the major Chinese infrastructure firm Hopewell Holdings. The hall is the centerpiece of Butler College and received the American Institute of Architects Honor Prize in 1984. The original Butler College was dedicated in 1983 to Lee Butler, class of 1922, a supporter of residential colleges and a prominent businessman and civic leader in Washington, DC. His gift of $3 million at the time put the college on a sound footing. The new structures are a tribute to his original gift.

These three Venturi buildings—Schultz, Thomas, and Wu—form a prominent presence on the southern end of the campus. They represent the university's commitment to architectural excellence. Wu Hall is a vibrant, stimulating building designed by Robert Venturi, class of 1947, and was an immediate success with architectural critics and undergraduates alike.

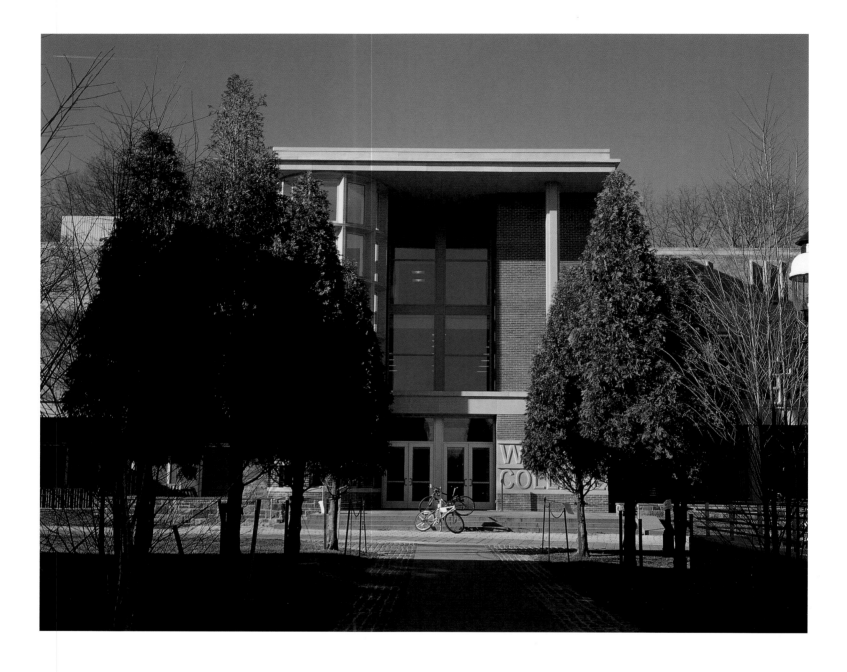

Above: Wilson College. This is the first of Princeton's six residential colleges. It began in 1957 when a group of students formed the "Woodrow Wilson Lodge." The University erected five new dormitories which were known as the "New Quad" centered on a central dining facility known as Wilcox Hall.

The residential halls of the "New Quad"—Gauss, Dodge-Osborne, 1937, 1938, and 1939 opened in 1960, followed by Wilcox Hall. This was the bequest of T. Ferdinand Wilcox, class of 1900, a senior partner of a New York brokerage firm and member of the New York Stock Exchange. Architects were Sherwood, Mills and Smith.

Opposite: The Lewis Science Library. This Frank Gehry–designed structure at the intersection of Washington Road and Ivy Lane opened in 2008. The building is named for Peter Lewis, class of 1955, university trustee and chairman of the board of the Progressive Corp. In 2001 he announced that he was making a gift of $60 million to support the construction and the programs of a new science library at Princeton. Gehry, known worldwide for his postmodernist work, has received the Pritzker Prize, the highest award in architecture. The building houses various science collections and is appropriately situated near Fine, McCormick, and Jadwin Halls.

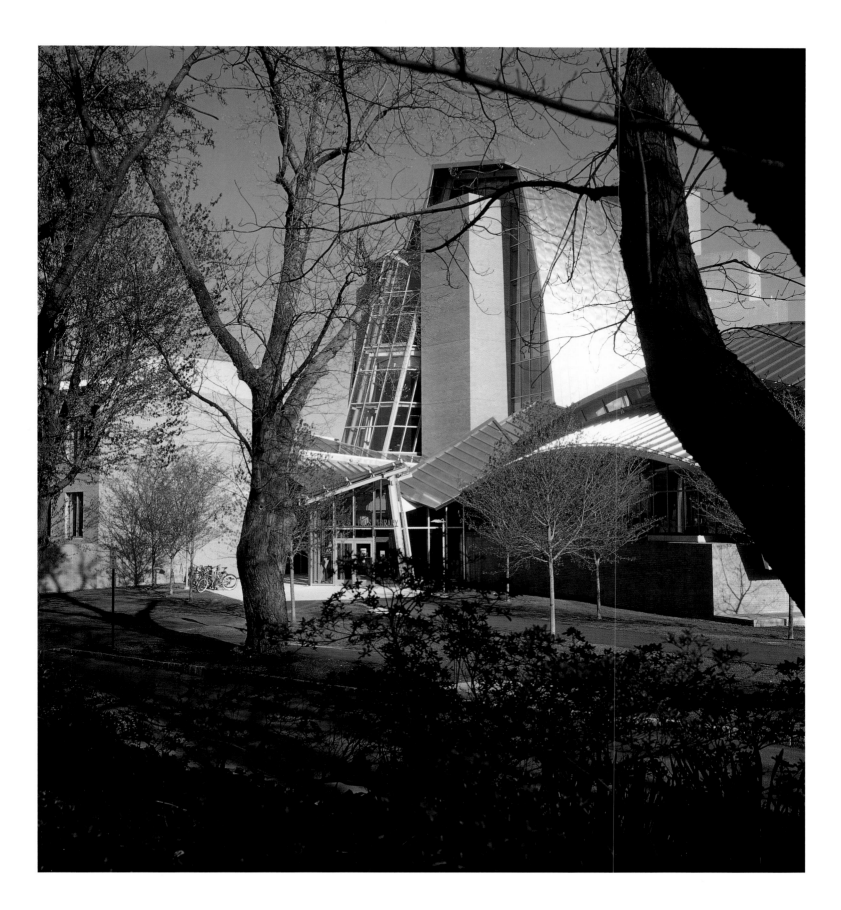

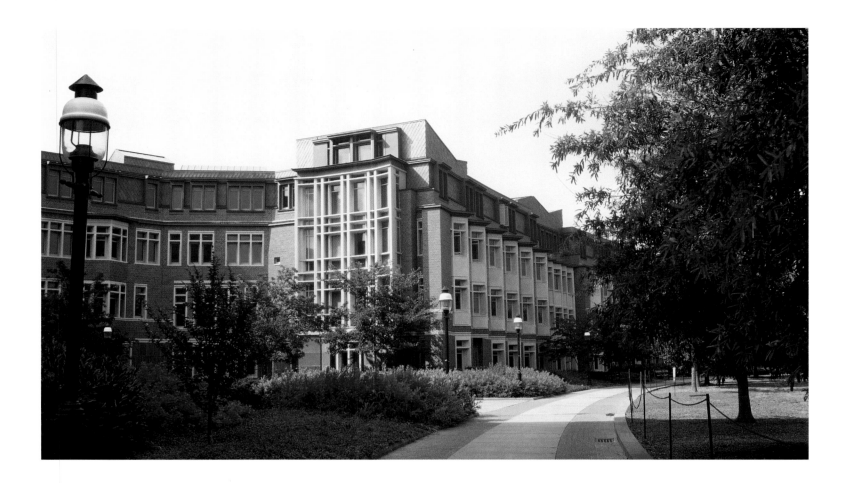

Above: Bloomberg Hall, completed in 2004, was designed by Michael Dennis & Associates and named for Emma B. Bloomberg, class of 2001. This new $36 million dormitory was a gift of Michael Bloomberg, founder of the eponymous financial information and technology firm and mayor of New York City.

Opposite: Butler College, designed by Henry Cobb of Pei, Cobb, Freed & Partners. Cobb also designed the Friend Center, albeit in a very different style. These new buildings replace dormitories built in 1964 (including Lourie-Love and 1922, 1940, 1941, and 1942 Halls). The university's new college system began in the fall of 2007 with the opening of Whitman College and the conversion of Mathey College into a four-year college. Butler College became a four-year college in the autumn of 2009.

All freshmen and sophomores live in six residential colleges, each with 450 to 500 students: Woodrow Wilson, Forbes, Rockefeller, Mathey, Butler, and Whitman. Dean Mathey, class of 1912, was a trustee under three university presidents and a successful investment banker with Dillon Read & Co. While Forbes and Whitman are all-inclusive colleges, the others consist of several dormitories. Mathey College, for instance,

comprises Hamilton, Joline, most of Blair and Little, and Edwards Halls. Butler College consists of the new dormitory plus Bloomberg, Wu, 1915, and Cuyler. Wilson College includes Walker and Feinberg, plus the cluster of dormitories located around Wilcox Hall, which was essentially the first draft at a separate college complex. The residential college system has now been fully implemented in order to create a sense of community in a diverse student population.

The Butler buildings are constructed of red brick, harmonizing with nearby Wu, 1915, and Bloomberg Halls. They vary in the number of stories, but perhaps their most distinctive aspect is the below-grade space. The buildings are all connected, and the underground space is filled with common areas, including a café, study zones, and seminar rooms. In a big departure from most dormitory basements, these areas have large windows and open out to courtyards.

This project represents a major emphasis by the university on sustainability. Approximately 95 percent of the nine thousand tons of material produced by the demolition of the older dormitories was reused or recycled. More than half of the new dormitory buildings have "green roofs," which are layered with vegetation to reduce heating and cooling needs.

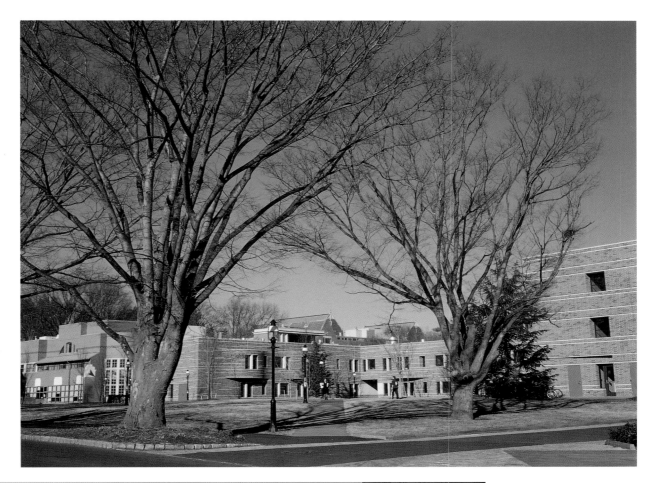

Above and opposite: Icahn Laboratory. This striking building was designed by Rafael Viñoly, completed in 2002, and named for Carl Icahn, class of 1957. The same architect was responsible for Princeton Stadium. Peter B. Lewis, class of 1955, gave a major gift to establish the Lewis-Sigler Institute for Integrative Genomics, named to honor his lifelong friendship with his Princeton classmate, the late renowned structural biologist Paul Sigler.

Lewis's other gifts to Princeton include the new science library, designed by Frank Gehry, and several gifts related to the arts. These include funding for performance and rehearsal space for extracurricular student arts groups, space for the student radio station WPRB in Bloomberg Hall, and a suite of studio spaces for the Program in Visual Arts at 185 Nassau Street. Lewis gave his first million-dollar gift in 1982 to create a gallery in the Princeton University Art Museum.

Above: Scully Hall reflection from the Icahn Laboratory. The interiors of Icahn Laboratory offer many opportunities to photograph. The activities of passersby and the shapes and angles within are an artist's pure delight.

Opposite: Icahn Laboratory at dusk across Pardee Field. Watching the sun set and seeing how elapsing time creates a different view every few minutes at sundown is what makes this image-taking sport known as photography so rewarding.

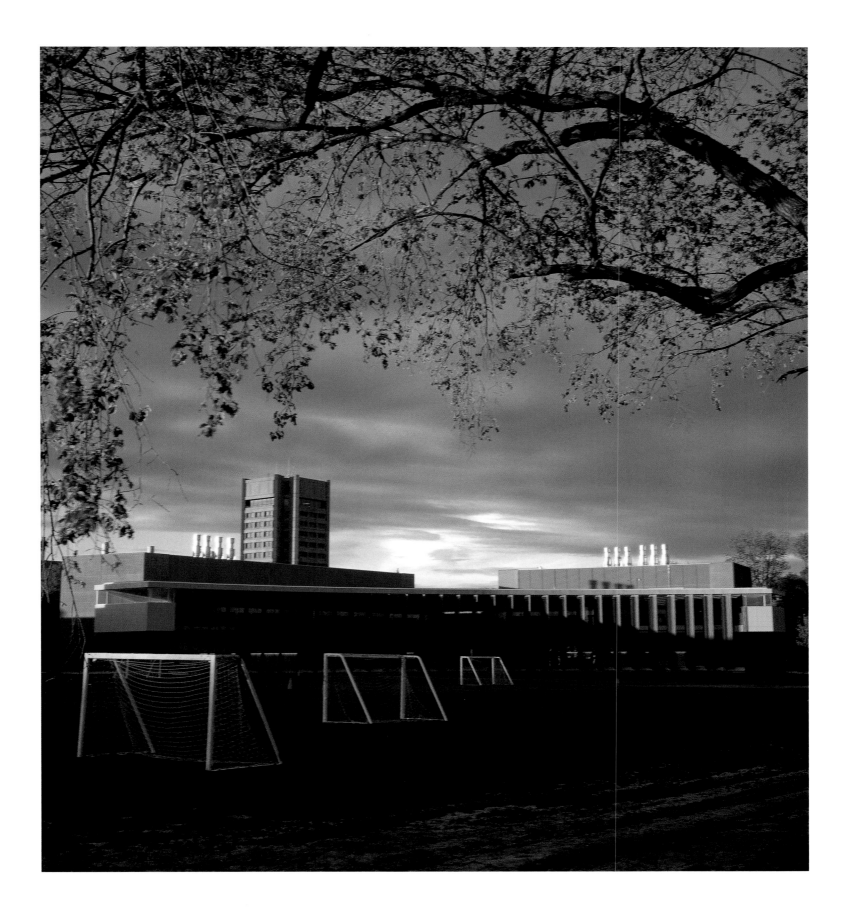

Bloomberg Hall *(above)* and Scully Hall *(opposite)*. Early morning views across the Poe and Pardee playing fields. John Prentiss Poe, class of 1895, was a football hero and the nephew of Edgar Allan Poe. Pardee Field was given in memory of Ario Pardee, class of 1897.

Shown above is a sunrise view of Bloomberg Hall, named for Emma B. Bloomberg, class of 2001 and daughter of Michael Bloomberg, financier and mayor of New York City. This four-story, 220-bed upperclass dormitory features kitchens, dining rooms, and outdoor terraces. It joined with Butler College in 2009. The building also houses student organizations, the WPRB radio station, and some performing arts groups.

Scully Hall, a gift of Charter Trustee Emeritus John H. Scully, class of 1966, named in honor of his parents, Vincent and Celia Scully. Mr. Scully was a founder of the university's investment company (PRINCO) and has also been a major benefactor of other programs, including the Scully Center for the Neuroscience of Mind and Behavior. The dormitory was designed by Rodolfo Machado of Machado and Silvetti of Boston in 1998. It is meant to suggest the characteristic windows and towers of Princeton's Gothic buildings but also tries to integrate the modern lines of the university's newest dormitories.

Above: Streicker Bridge, completed in 2010 and designed by Swiss engineer Christian Menn. A member of the class of 1964, John Harrison Streicker is also chairman of Sentinel Corporation, a major owner and manager of residential apartment buildings in the United States. The three-hundred-foot-long bridge spans Washington Road, connecting mathematics and physical sciences on the east (Fine, Jadwin, and the new Frick Chemistry Building) with natural sciences on the west (the Carl Icahn Laboratory and the new neuroscience complex currently under construction).

Opposite: Frick Chemistry Building, named in honor of industrialist Henry Clay Frick (1849–1919), who was a benefactor of the university. At 265,000 square feet, this new building on Washington Road, which recently opened, is the largest single academic building on campus, excluding Firestone Library. Energy efficiency has been optimized by incorporating state-of-the-art sustainability features, such as the exterior glazing that has sunscreens to optimize ambient daylighting of interior spaces while controlling heat gain. This system is also linked with sensors to control dimmable electric lighting. The building was designed by the London firm of Hopkins Architects in collaboration with Payette Associates of Boston. The Department of Chemistry relocated here from Frick Lab, built in 1929 and one of the oldest functioning college chemistry facilities in the country, and Hoyt Lab, built in 1979. These buildings are now being used for the humanities and social sciences.

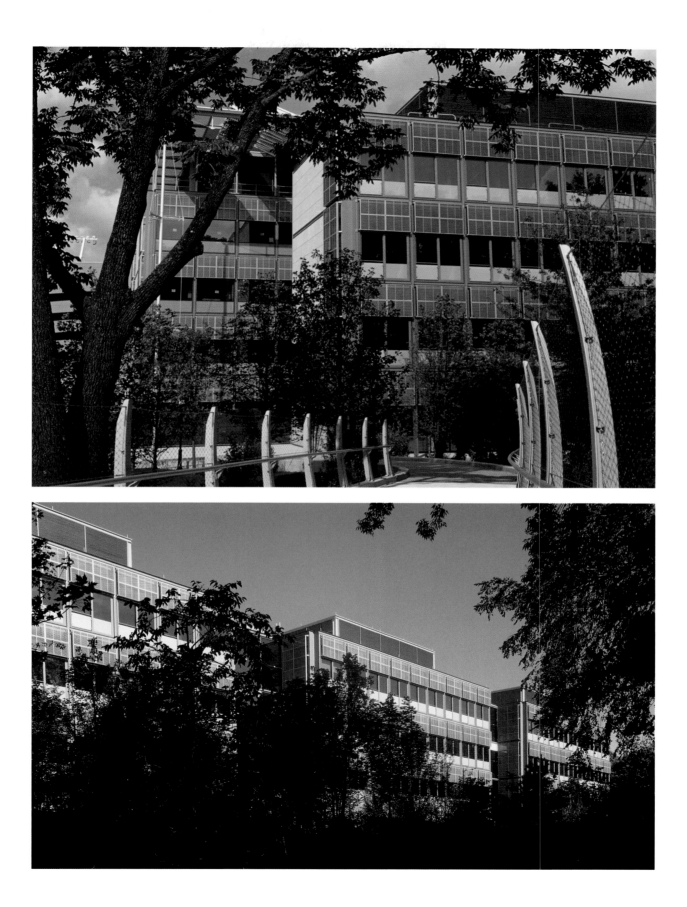

Left: The atrium at Frick is named Taylor Commons and the large auditorium is named Edward C. Taylor Auditorium, both in honor of the professor emeritus of organic chemistry, whose research led to the development of the anti-cancer drug Alimta in cooperation with the pharmaceutical firm Eli Lilly and Company. The atrium provides a dramatic interior space around which the classrooms, laboratories, and offices are located. The multiple cloth-covered forms are inspired by models of molecular structures. The group is by Kendell Buster, who calls it *Resonance.*

Above: Neuroscience and Psychology Buildings. These new glass-skinned structures, shown in the architect's rendering, were designed by the Madrid-based architect José Rafael Moneo. The Princeton Neuroscience Institute was established in 2005. The Department of Psychology dates from the 1860s. In fact, in 1924 Eno Hall became the first American university building devoted entirely to experimental psychology. The department moved to Green Hall in 1963 and will now move to its new quarters on Washington Road.

This page and opposite: McCarter Theatre and the Berlind Auditorium. McCarter Theatre was a gift of the Princeton University Triangle Club and of Thomas McCarter, class of 1888. It was commissioned in 1928 and opened in 1930, designed by D. K. Este Fisher, Jr., class of 1913. For many years it was used for pre-Broadway runs of new plays. In the 1930s and 1940s Helen Hays, the Barrymores, Cornelia Otis Skinner, and Katherine Hepburn all played McCarter. In 1950 the university assumed ownership of the theatre from the Triangle Club and expanded it in 1985–86. Currently, McCarter hosts a variety of performances, including dance, music, drama, film, guest appearances, and repertory productions.

Above: The Berlind Auditorium was designed by Hugh Hardy, class of 1954, and made possible by a grant from Roger S. Berlind, class of 1952. Construction began in 2002. The facility features a 350-seat theatre plus rehearsal halls, classrooms, and dressing rooms. Roger Berlind is a film producer, Broadway producer, and also a financier. He was one of Sandy Weil's original investment banking partners in the firm of Cogan, Berlind, Weil and Levitt. Both he and Hardy were members of the Triangle Club.

The university has thus gained more classroom and performance space for the Program in Theater and Dance, and the McCarter Theatre acquired a second stage.

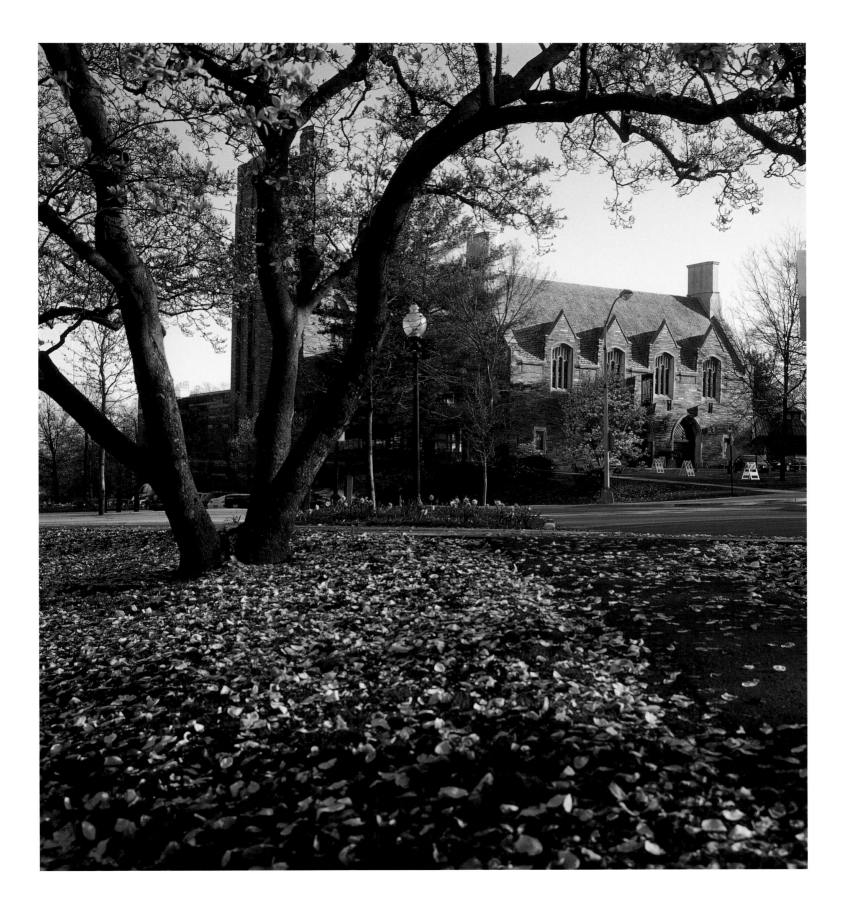

The Triangle Club performs regularly at its home base, McCarter Theatre. Originally organized by Booth Tarkington, class of 1893, the club annually produces and performs musical comedies with subsequent tours across the country. It has appeared on national television and has toured in Europe as well. When he was an undergraduate, F. Scott Fitzgerald wrote lyrics for the shows and performed in several of them. During the 1930s many aspiring actors, including José Ferrer and

Jimmy Stewart, as well as producers like Joshua Logan, were attracted to Princeton in part because of the popular club.

During most of the past century, Triangle regularly played Broadway and had national rail tours through the 1960s. The principal photographer of this book arranged its last rail tour and its last appearance on Broadway. Concert halls and buses have since replaced these but the shows go on, making Triangle the oldest touring company of its genre.

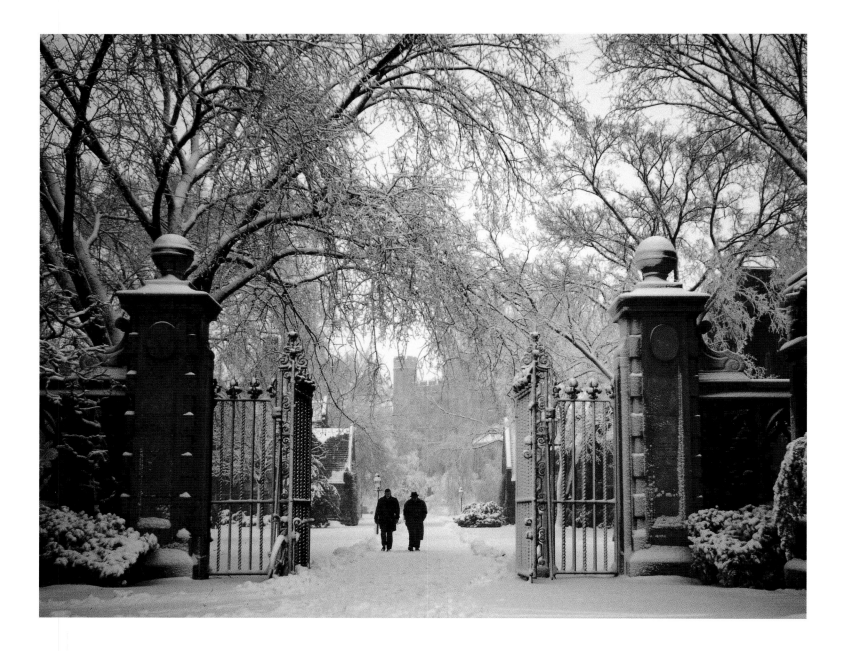

Princeton in the snow in 1962, taken by one of the photographers during his undergraduate years. *Above:* The view of the lower campus from the Dodge Gateway between Henry and 1901 Halls is timeless. The gates frame the tower of Blair Hall. They were a gift from the parents of Marcellus Hartley Dodge, class of 1930. At the turn of the last century, three imposing dormitories stood on the rise of the campus greeting visitors, who generally arrived by train. These buildings were Witherspoon, Blair, and Little. But the train tracks bound this edge of the campus, and when the station was relocated in 1918, an entirely new lower campus opened up for the construction of new dormitories. Since both John Blair and Stafford Little were railroad men, there is no doubt they were involved in helping the Pennsylvania Railroad to relocate its station.

Opposite: The view from 1879 Hall towards Palmer Physics Lab is dated only by the parked cars parked in front of the latter. When he was president of the university, Woodrow Wilson had his office over the 1879 archway, which was accessed by its own entrance. Since this building was given by his classmates, he felt entitled. The Palmer Physics Laboratory was dedicated in 1908. The Frist Campus Center, designed by Robert Venturi, class of 1947, now incorporates Palmer Hall.

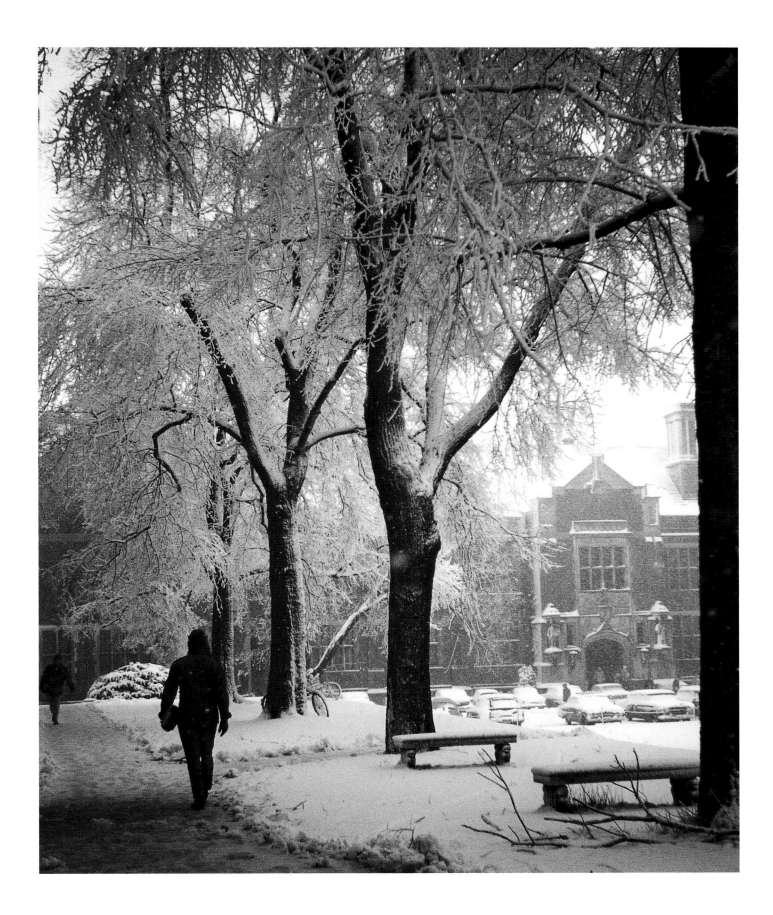

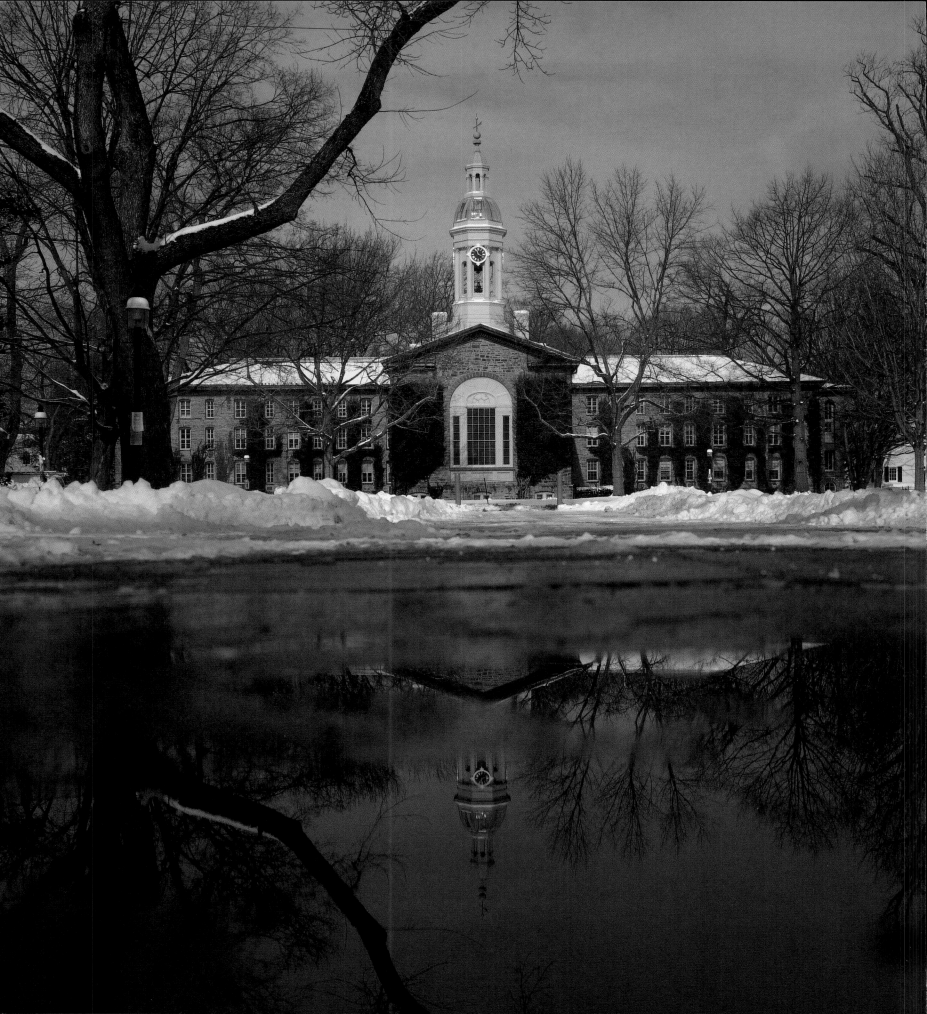

Opposite: Nassau Hall from Cannon Green. Cannon Green is the site of "Big Cannon," which was left in Princeton after the Revolution. In 1812 it was transported to New Brunswick to defend that city from a possible attack. A group of Princeton students and townspeople, including Winston Churchill's grandfather, recaptured the cannon in 1836. Four years later it was buried in its present spot in cement.

Left: Blair Hall in the snow. This handsome dormitory was completed to the designs of Cope and Stewardson in 1897. It is named for John Insley Blair, a trustee of the university from 1866 to 1899. He was a cofounder of the Delaware, Lackawanna and Western Railroad and later the Union Pacific Railroad. It is believed that he once owned more miles of railroads than anyone else in America. The main lines originally passed through Princeton, but when they were straightened, the main stop became Princeton Junction and the "Dinky" shuttle came into being in 1867. Soon after Blair Hall was built, the station was moved farther down University Place and took along with it the smoke and soot that used to blow into the students' rooms.

Left: In the archway connecting Murray and Dodge Halls, the viewer can see footsteps in the snow and a lost orange balloon from the festivities of the night before. Murray Hall, on the right in the photo, was completed in 1879 and designed by Richard M. Hunt. Its companion, Dodge Hall, was completed in 1900 and designed by Parrish and Schroeder. The style is Collegiate Gothic.

Opposite left: Alexander Hall. This Romanesque auditorium was completed in 1894 and represents one of the last major structures built before the university adopted its Collegiate Gothic style. It is best photographed in a raging snowstorm that softens its hulking structure. Richardson Auditorium within the hall is used for concerts, lectures, and other gatherings. From 1894 until 1922 all graduation exercises were held here.

Opposite right: The delicate filigree of the McKim, Mead & White gates at the entrance to the upper campus mirrors the bare winter branches. A lone student passes through the gateway, following in the footsteps of thousands before. Since 1905 the gates were opened only on ceremonial occasions, such as the annual P-rade. Recently, however, they have been opened permanently, symbolizing the university's embrace of the world beyond its campus.

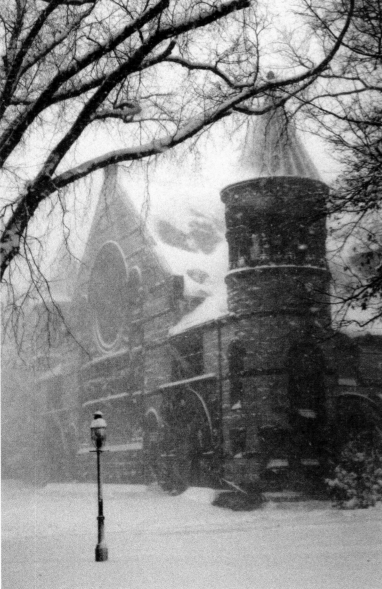

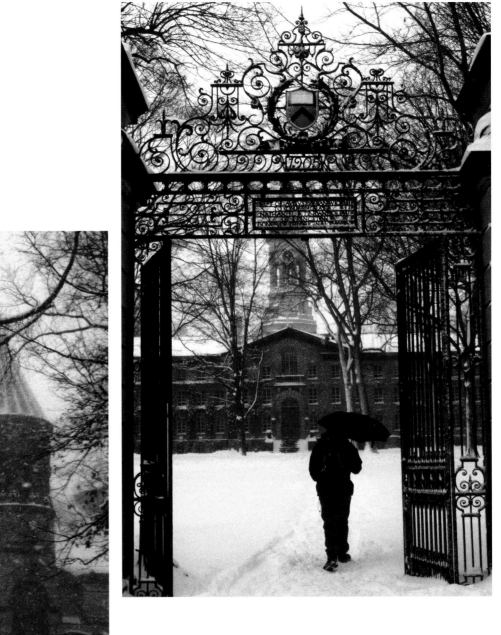

Above: Tigers in the snow. The two bronze tigers by Bruce Moore were installed in 1969. They are male and female to commemorate Princeton's becoming coeducational that year. Although the class of 1879 had given a pair of bronze lions for the front steps of Nassau Hall, the tiger became the official mascot of the university in the 1880s. Football teams wore stockings and jerseys with orange (House of Orange) and contrasting black stripes. A sports writer for the *New York Herald* called the football squad "the tigers" in reference to their attire. When the class of 1879 substituted its lions with tigers cast by A. P. Proctor in 1911, the symbol was confirmed.

Below: For generations, bicycles have been a popular mode of transportation at Princeton. However, there are times when even their snow tires are insufficient for the task at hand. This is a view in front of Henry Hall.

Opposite: Lower campus reflections. Midwinter afternoons offer interesting compositions with bare branches reflected in the melted snow and framed by Gothic style dormitories. This is the view looking south between Laughlin Hall on the left and Foulke Hall on the right. This section of the campus is a tribute to Bayard Henry, fifth generation university trustee and descendant of Nathaniel FitzRandolph. He personally procured the plot where Holder Hall sits all the way along University Place. This purchase, together with the relocation of the Pennsylvania Railroad tracks, enabled the lower campus to expand into what is enjoyed today. Henry was also responsible for the university's acquiring the land from Lake Carnegie all the way to US Route 1.

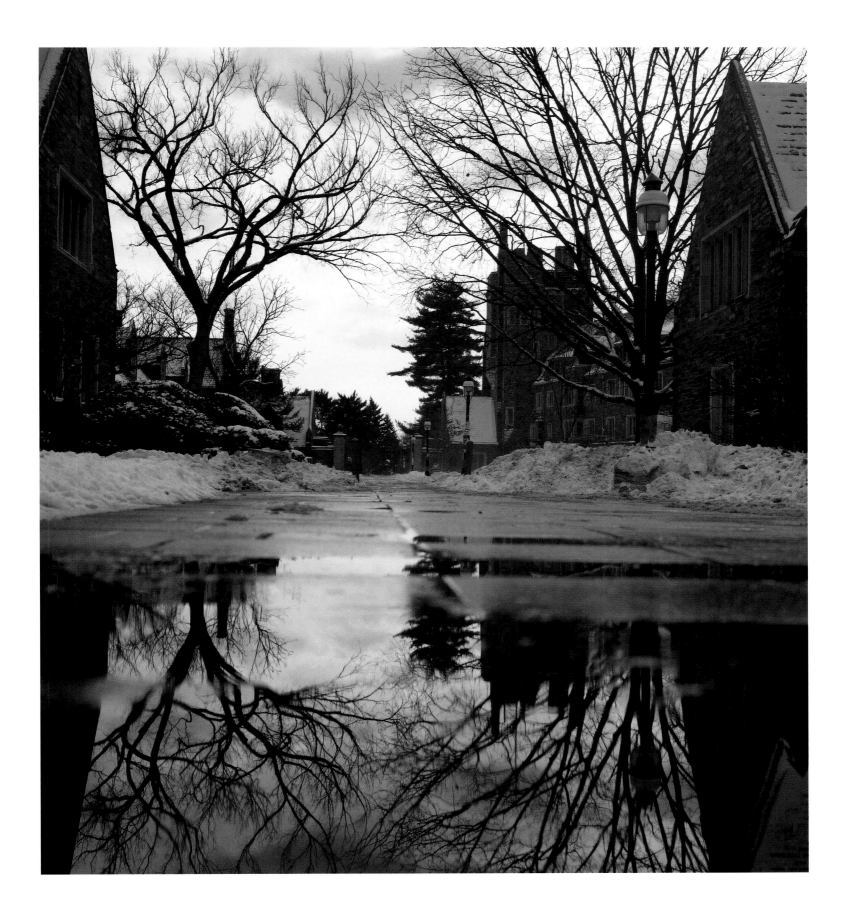

Dickinson Hall *(above)* and McCosh Hall *(opposite)*. Early morning sunlight captures this magnificent pair of buildings on the upper campus reflected in the melting snow. Dickinson Hall, completed in 1930, is named for the first president of the college. He was a Presbyterian minister and a member of the fifth graduating class (1706) of the Collegiate School of Connecticut, later known as Yale College. McCosh Hall opened in 1907 and was designed for small conference

rooms to accommodate preceptorials, which Woodrow Wilson introduced in 1905. It was the largest building on campus at the time which honor has been superceeded by the Firestone Library (1948) and the Frick Chemistry Building (2010).

James McCosh was the eleventh president of the college, coming to Princeton in 1868. He helped to restore its faculty, enrollment, and finances after the Civil War.

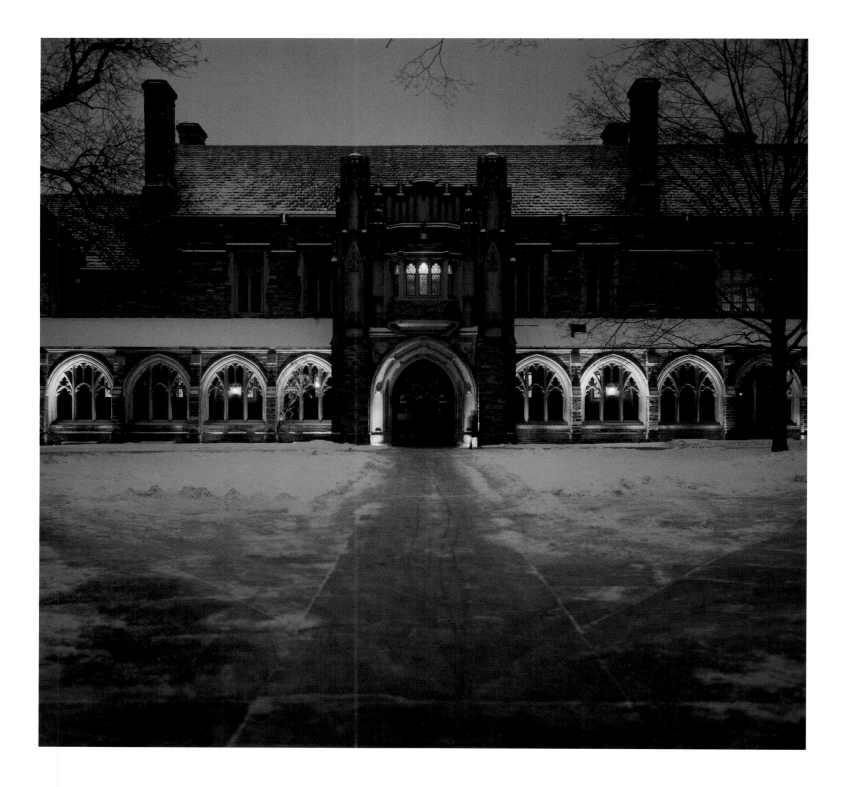

Holder Hall courtyard *(above)* and Holder Tower *(opposite)*. Holder Hall was designed in 1909 by Day and Klauder. Margaret Sage, widow of Russell Sage, gave this magnificent dormitory complex to the university to honor Christopher Holder, a member of the Society of Friends in the seventeenth century. The impressive 140-foot-tall tower is modeled after Canterbury Cathedral. It offers a statement to visitors both approaching and on campus that Princeton is an institution of depth and tradition.

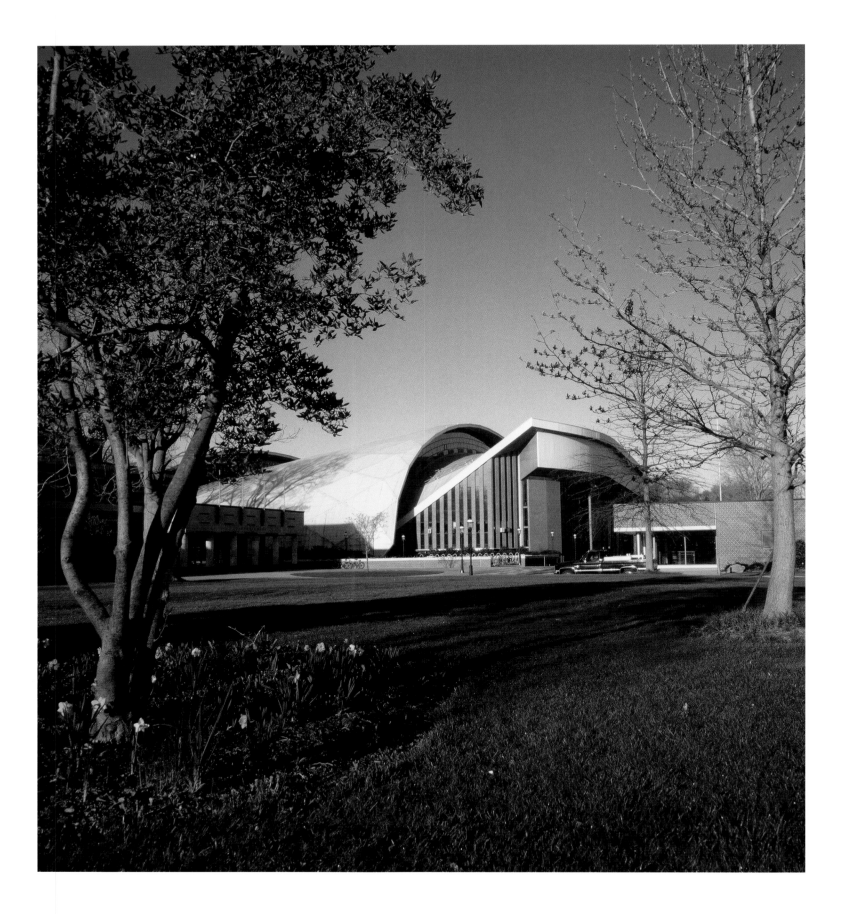

Opposite: Jadwin Gymnasium. This magnificent building with three large concentric clamshells was designed by Walker O. Cain & Associates and completed in 1969. The gymnasium is a memorial to Leander Stockwell Jadwin, class of 1928, who was a captain of the track team and died in an automobile accident shortly after graduating. It was a gift by his mother in 1965. The structure has enough floor space to incorporate eight football fields on two principal levels.

Above: The main basketball court of Jadwin Gymnasium reflects the Princeton name. Using temporary bleachers to supplement the permanent seats, over 7,500 spectators can be accommodated. For non-athletic events, as many as 10,000 can be seated.

Left: DeNunzio Pool. This building opened in 1990 and was designed by Cesar Pelli & Associates of New Haven in collaboration with Browning Day Mullins Deirdorf of Indianapolis. It was a gift of Ralph DeNunzio, class of 1953 and former chairman of Kidder Peabody & Co. He also made the gift of the top-floor press room in Princeton Stadium—a space seen by few but whose communications are appreciated by many.

Women's and men's lacrosse. Lacrosse was first played at Princeton in 1881 after being introduced to the United States by Canadian teams. The game originated among North American Indians and was developed by the French in Canada. They called the stick "la crosse" because it reminded them of a bishop's crosier. Women's lacrosse began in 1972. Over the years Princeton has enjoyed many championships in the sport.

Princeton Athletics

From modest beginnings with the construction of the first gymnasium at any American college in 1869, Princeton now offers eighteen different sports at thirty-eight varsity levels and thirty-six club levels. It regularly receives Ivy League championships including the league's unofficial all-sports points championship (over twenty-four years in a row) and team or individual national championships (over forty years in a row). The variety and depth of the athletic program shows the university's commitment to the whole education of the whole individual and the underlying belief that physical activity enhances the intellectual capacity.

The first organized physical activities in the form of team sports were not like those of today. In the early years under President Witherspoon there were hazings, occasional horse races inside Nassau Hall, and horn sprees. The latter were a rebellious answer to the rule that there be "no jumping, hollering or boisterous noise" in the college at any time. Horn sprees continued in one form or another for over fifty years.

A form of football was first played on Cannon Green in 1844 with the entire student body participating. The first intercollegiate game occurred in 1869 against Rutgers. In 1873 Princeton engaged Yale in what has now become the longest continuing rivalry in American football. Two years later, Columbia, Harvard, Princeton and Yale adopted the rugby-like game with clashing flying wedges and other strategies sufficiently brutal to cause President Theodore Roosevelt to step in and suggest some restraints in 1905. New rules were agreed upon to allow forward passes and other ways of moving the ball.

The game against Yale on Thanksgiving Day in 1893 was played in New York at Manhattan Field, preceded by a parade up Broadway with most undergraduates participating. Over fifty thousand fans turned out. Shopkeepers decorated their storefronts with Orange & Black or Blue & White, although many of them had scarce knowledge of the teams or the universities they represented.

Baseball commenced in 1874 with the first intercollegiate game played against Williams. Yale subsequently became the popular rival. In the same year, Princeton entered its first intercollegiate regatta in Saratoga despite the objections of Amherst that "a line had to be drawn somewhere." It was on this occasion that orange and black became the official colors of the Princeton sports team. Some years later a writer for the *New York Herald* noted the orange and black socks and sleeves on the football squad and called them "The Tigers." The rest is history.

Football at Princeton Stadium, which opened on September 19, 1998 with a victory over Cornell. The new stadium was designed by Rafael Viñoly who also brought us the striking Icahn Laboratory. It replaced the venerable but aging Palmer Stadium. The game of football originated in 1869 as a contest between the College of New Jersey (Princeton) and Queens College (Rutgers). Of the two matches played that year, Princeton won one and Rutgers the other. Over the years, Princeton has won five national championships playing in Palmer Stadium, predecessor to the present facility. In 1893, over fifty thousand fans watched the Princeton-Yale game at Manhattan Field in New York. The 1922 game in Chicago was the first football game broadcast on radio. And in 1934 Princeton was invited to play the Rose Bowl. This was when the Triangle Club played on Broadway. Things are different now, but the spirit remains strong.

Princeton Reunions

Kenneth S. Clark, class of 1905, wrote an easily remembered song, "Going Back to Nassau Hall." Even children can remember the words. In fact, a Princeton Presbyterian friend of ours recalls only two songs from his earliest years—"Jesus Loves Me" and "Going Back." The tune evokes the trip back to Princeton University for many celebrants. In its earliest days, the College of New Jersey was simply referred to as Nassau Hall. The phrase "clear the track" refers to the nineteenth century when the college was not only next to the railroad but many of its dormitories were given by railroad owners, including Messrs. Blair, Little, and Pyne. The famous "locomotive cheer," thought to be the oldest cheer of any American university, is another reflection of this era.

No other university has a more loyal, affectionate, and generous group of alumni than Princeton. Since 1826, when the Alumni Association of Nassau Hall was formed by John Maclean, the college's graduates have played an important role. The origins of the association were primarily economic because financial support was at the forefront of the college's needs, in light of the creation of a separate seminary that was able to draw on funds from the church. The college lost its major financial support and thus turned to its alumni sooner than might have otherwise been the case. At its 100th Commencement in 1847, over seven hundred alumni returned for a celebration. In 1856 the first separate class gathering occurred. Also at this time began the tradition of a formal procession to the Commencement Day Dinner. When the university scheduled its baseball games against Yale on the Saturday of Commencement, additional alumni were motivated to attend. Thus a more lengthy march to the baseball game ensued, which might be considered the origin of what is known today as the P-rade. Celebrating the 150th anniversary of the college, over eight hundred undergraduates and two thousand alumni joined in the procession. Inspired by this festive event, all graduate classes began returning for the "march to the game." Identifying badges, hats, and signs came next, distinguishing one class from the next. Beer jackets were first introduced in 1913 and by 1920 they were incorporating distinctive logos for each class. Over the years the costumes have become elaborate for the younger classes, while blazers for the older alumni have been popular.

What started as a simple walk to a dinner or baseball game has evolved today into a sociological event that defies stringent analysis. Reunion Weekend draws over twenty thousand alumni and their families. The P-rade is a sea of orange and black, wending its way through the campus and onto the playing fields. No time for baseball anymore. The Old Guard walk or ride after the twenty-fifth reunion class, followed by each succeeding class. The weekend, culminating in fireworks, is a ritual of reminiscing, marching, singing, and carousing. It is a chance for alumni to reunite with one another and bond further with the university. And unlike other universities, where reunions are usually tied to commencement, here the two are separate. Seniors have their own moment of glory, and the alumni have theirs. Reunions are better experienced than described.

The Princeton University Marching Band serenades at Reunions around College Green. The band was officially organized in 1920 and played Princeton songs during halftime of the Princeton-Maryland football game. Its attire has evolved over the years and was featured on the cover of *Sports Illustrated* in 1955. By this time, the band had grown to over one hundred members, who introduced satirical halftime shows. In 1969 the marching band benefitted from the first women to be admitted to the university. For many years it has led the annual alumni P-rade. The image above shows another of the book's photographers taking photographs, one of which appears on the left-hand page.

A Princeton Prayer.
*"Dear Lord make me a sophomore again,
just for tonight. Amen."*

A gathering on the front lawn of Nassau Hall. Orange and black umbrellas go up when the rain comes down, but the straw boaters remain intact. The number of attendees at Reunions is presently about 21,000. It is indeed quite an event to remember.

Opposite: Waiting for the P-rade to get under way, classes gather to reminisce.

Above: Members of the class of 1939 gather for a chat by Whig Hall.

Right: Freshmen roommates from Dod Hall in 1944, reunite after sixty years. One of the remarkable aspects of Princeton is the degree of friendship that spans all classes and eras.

Whatever one's age, Reunions offer a time to gather, have fun, and give the textile manufacturers of orange fabric a chance to celebrate, too. As a member of the administration recently observed, "Orange is my favorite color. And it's always on sale."

Faces young and middle-aged. Reunions now incorporate events for all concerned, from sandcastle construction and face painting to cocktails with classmates at Madison Hall. For some, the rest of the year is only a lead-in to the next Reunion event.

Above and opposite, above: The classes of 1992 and 1964 form masses of orange. The photograph of the class of 1964 was taken by one of the book's photographers while another was standing on the third row of the steps.

Opposite, below: Shown here are the president of the university, the chairman of the executive committee of trustees, and the heads of the Alumni Council.

The alumni parade originated in the 1890s and is held annually on the Saturday before Commencement. The P-rade, as it is affectionately called, begins with the twenty-fifth reunion class marching through the FitzRandolph Gates, which were historically closed until such events. At first the sole decoration worn by returning alumni was a badge with class numerals on it. Eventually classes distinguished themselves with the use of hats, balloons, and parasols. In 1907 the tenth reunion class dressed themselves as Dutch Boys and made quite a clamor with their wooden shoes. Over the years alumni have appeared as Mexican bullfighters, Roman gladiators, Apache dancers, French Foreign Legion soldiers, Japanese samurai, African hunters, firemen, chefs, baseball players, spacemen, and of course tigers. While rain is a frequent companion, only once was the P-rade officially cancelled due to weather. This was due to the 1953 hurricane.

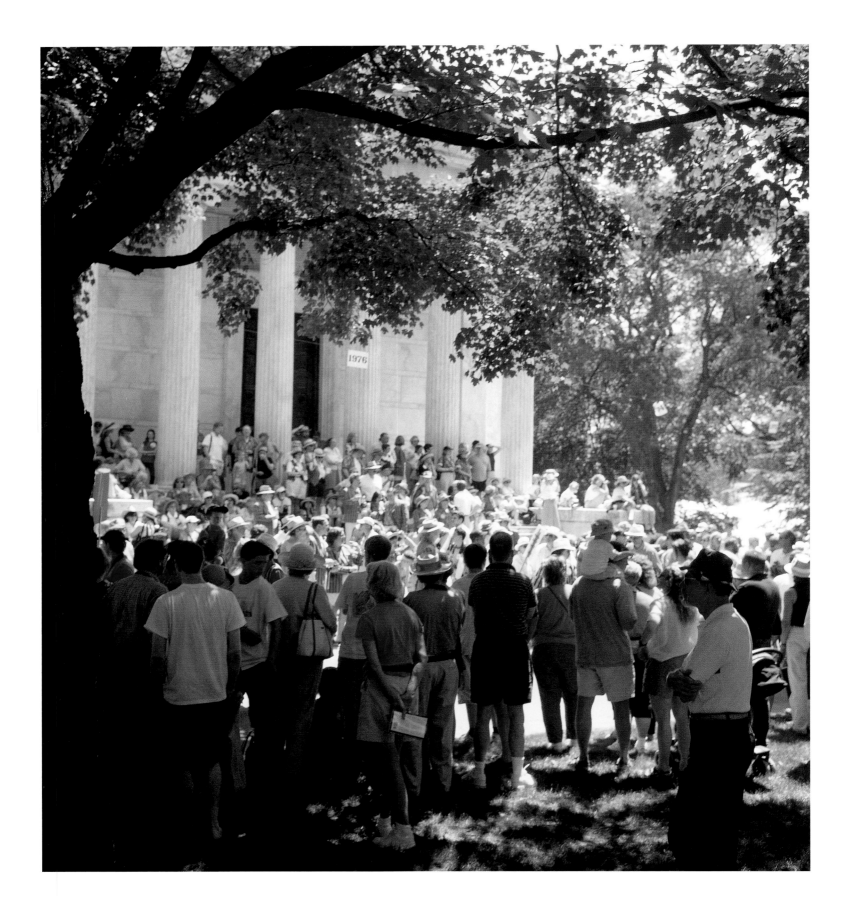

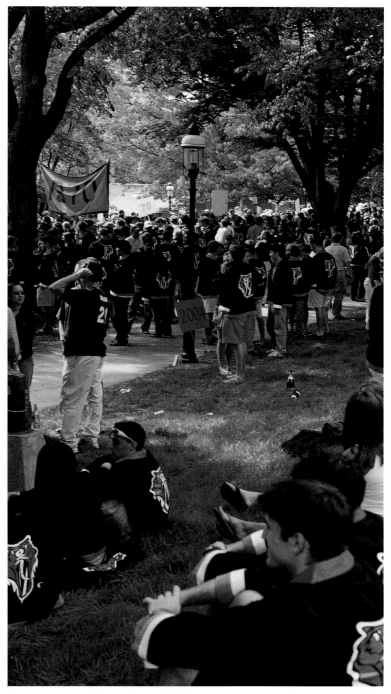

Alumni and their families gather on the upper campus to await their turn to march, while younger alumni wait further along the parade route. Classes march according to their year following the twenty-fifth reunion class. The Old Guard draws the biggest cheers and the younger classes, given their large numbers, have the most extended welcomes.

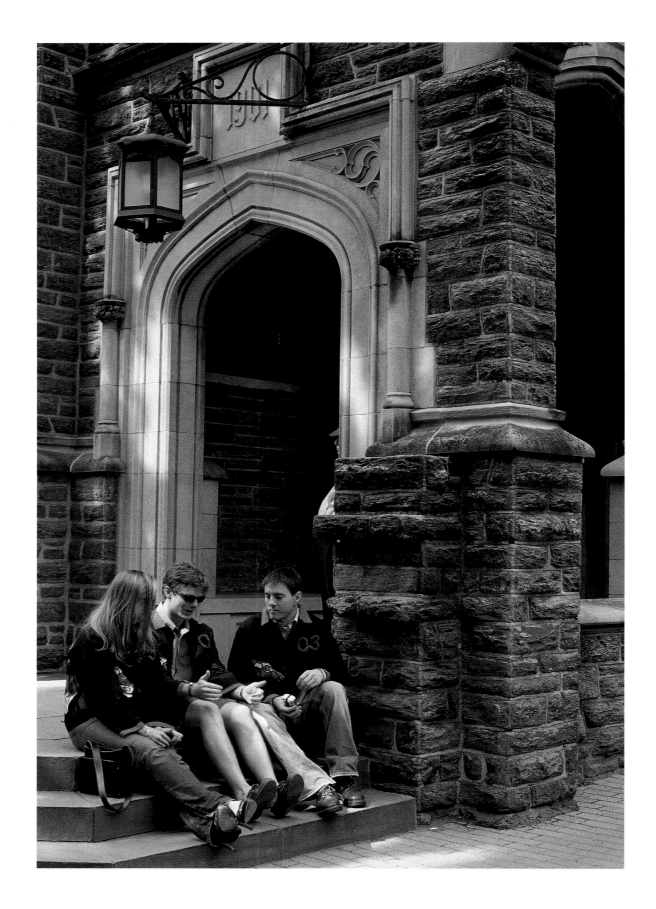

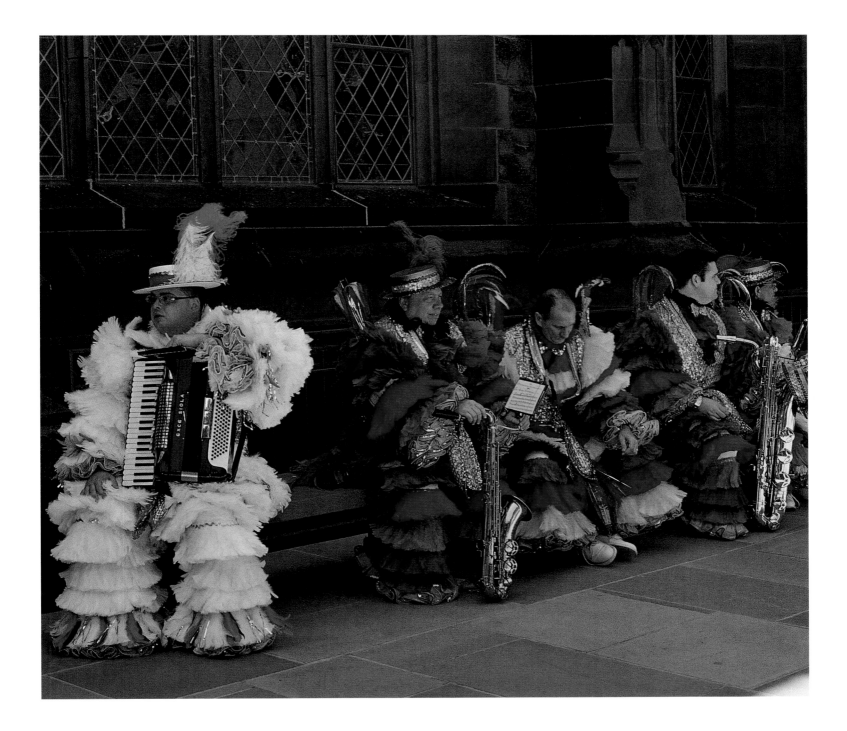

Opposite: Time-out for members of 2003 to reminisce in front of 1901. One hundred years apart but still relishing a loyal bond.

Above: Taking a break in the East Pyne courtyard is one of the many marching bands. This is a colorful Mummer Band from Philadelphia.

The day of graduation offers a chance for professors to flaunt their regalia. Colorful robes indicate the academic institution they attended. Many old friends return for this special occasion to celebrate another chapter in the university's long history book.

On Baccalaureate Sunday, the famous procession of trustees and faculty begins at Nassau Hall and proceeds through the East Pyne courtyard. Often it is led by a bagpiper. The Baccalaureate service originated in fifteenth-century England, where students graduating with the degree of Bachelor *(bacca)* were presented with laurels *(lauri)* at the conclusion of a sermonic oration. Today, the Baccalaureate ceremony is a service of worship and celebration of lives dedicated to learning and wisdom.

On these occasions the Princeton Chapel is filled to its eighteen-hundred-seat capacity. During the year, attendance on Sundays is more modest.

Hic ponderate. The end is at hand. Seniors listen to the graduation exercises. The salutation has been given in Latin since the first commencement in 1748. Students are given copies with notations as to when to applaud vociferously *(hic applaudite ardentissime)* or boo *(deridete)* or laugh *(ridete).* The parents, without such notes, are mostly clueless.

Princeton's commencements have been held in the spring only since 1844. Before that they took place in the fall since the college session lasted all summer long.

A recent addition to the Saturday P-rade festivities is the display of fireworks. These views were taken from the Washington Road Bridge and afford interesting reflections. The fireworks end the most celebrated day of the university's calendar.

Index

Italicized page numbers refer to illustrated material

Acknowledgements

Historical Research

Center for Theological Inquiry	Thomas Hastings
Educational Testing Service	Thomas Ewing
Institute for Advanced Study	Christine Ferrara
Lawrenceville School	John Gore, Jacqueline Haun
Princeton Day School	Katherine Schulte
Princeton Graduate School	Dean William Russel
Princeton Theological Seminary	Barbara Chaapel, Kenneth Henke
Princeton Township	Wanda Gunning, Lisa Flick
Princeton University	Lauren Robinson-Brown, Janet Temos
The American Boychoir School	Donna-jean Downing
The Hun School	Maureen Lemming
Westminster Choir College	Anne Sears

Design, Editing, Printing & Production

Design and Electronic Pagination	Carole Desnoes
Editing	Starling R. Lawrence, Elizabeth G. Heard
Photo Editing	Robert G. Gambee, Claire E.F. Gambee
Copy Editing	Inge De Taeye
Indexing	Alyson Avery
DNP America, LLC	Juan F. Ripoll, Kharis Gonzalez
Dai Nippon Printing Co., Ltd	Mutoshi Sakuta, Jun Fukumoto
Tien Wah Press (DNP)	Minoru Sekiya